Wisdom With Understanding is Better Than Rubies

Lurine Karon Greenberg
Fine Arts Collection

German Painting

from Romanticism to Expressionism

German Painting

from Romanticism to Expressionism

Ulrich Finke

with 163 illustrations
12 in colour

Thames and Hudson · London

*In memory of my father, Richard Finke
and for my mother, Margarete Finke.*

© 1974 *Thames and Hudson Ltd*

Printed in Great Britain

ISBN 0 500 49017 1

Contents

In writing this book I have addressed myself mainly to an English-speaking audience, to whom German 19th-century painting may well be less familiar than French painting of the same period. Three reasons can be given for this. Up to most recent times, the conventional view of 19th-century European painting has been oriented towards the history of French art, and this has inevitably meant that specific trends and peculiarities of the Schools outside France have often received short shrift. In the second place, 19th-century German paintings are to be found almost exclusively in public or private collections within the German-speaking countries, which tends to make general access rather more difficult. Finally, the abundant scholarly literature on the subject exists in the German language, and only recently have there been increased signs of study in the English language being devoted to German painting.

All this suggested the writing of an introduction to the history of 19th-century German painting, but one which might satisfy the generally interested reader as well as the student, for whom the detailed catalogue at the end of the book is intended.

By '19th-century German painting' I mean the work of German-speaking artists or those who joined the German cultural sphere. In the historical context of the 19th century, it is most important not to think of 'German painting' in terms of a clearly defined political-geographic entity. It is exactly in the complexity of the German-language culture that its weaknesses and strengths lie. In comparison with recent works on 19th-century art, such as the *Pelican History of Art* or the new edition of the *Propyläen Kunstgeschichte*, in which the 19th century is reduced to the period 1810–80, I look backwards to the departing 18th century and set 1910 as the caesura between the last century and our own. It was in 1910 that the first concrete examples of non-representational painting appeared, signalling the final abandonment of the traditional conception of space, which was still valid throughout the 19th century. Therefore I have devoted my Introduction to those forces at the end of the 18th century which heralded the 19th. My book ends with a forward view into the beginning of the 20th century, which is at the same time intended as a retrospective survey of the 19th century and particularly of Romanticism.

In dealing with 19th-century painting I shall follow the familiar classifications, such as Neoclassicism, Romanticism, realism, Impressionism, which have proved themselves to be still useful. Recent attempts to replace these chronological and stylistic concepts with structural ones refer us to neighbouring disciplines, such as psychology, sociology, and the like: thus, for instance, Rudolf Zeitler sought in his book, *Die Kunst des 19. Jahrhunderts* (1966) to

substitute for Romanticism and realism respectively the structural concepts of 'dualism' and 'monism'. In 1926 Wilhelm Pinder indicated an additional possible classification in his essay, *Kunstgeschichte nach Generationen* (Art history by generations), and I have followed this suggestion as a rule.

In the choice of artists and illustrations I have been guided by the wish to devote more detail to the better-known artists, in order to use the features of their work for a more accurate sketch of 19th-century German painting in its various phases. Where it has appeared useful to draw the reader's attention to the interrelations between paintings, on the one side, and art-theory, literature, history, etc., on the other, I have done so.

I would like to thank my colleague at Manchester University, Charles Sewter, who first brought me into contact with my publishers, Thames and Hudson. I must also express my thanks to Dr. Coenen and the Fritz-Thyssen Foundation in Cologne for a travel grant in the summer of 1969. I am deeply grateful to my friend Ralph Yarrow, who helped me with the translation of the German manuscript. Special thanks are also due to all those unnamed colleagues and friends who have always assisted me with their advice and sympathy.

U. F.

Introduction

In contrast to France or England, 19th-century Germany had no metropolis, and cultural life was centred in a number of state capitals or princely seats. One of the most important states in the 18th century was Saxony, with its capital at Dresden. Rich art collections, an Academy, a circle of important art experts and writers, and a ruling House that was sympathetic to the fine arts, made Dresden, in Herder's phrase, 'a German Florence'. At the beginning of the Romantic period, strong impulses originated from Dresden, where Caspar David Friedrich and his circle worked. On the other hand, Goethe lived in Weimar, and in Jena the circle of early Romantics grew around the Schlegel brothers.

The second half of the 18th century was the age of Neoclassicism. If one fails to recognize in this cultural phenomenon certain components which became important for Romanticism, then one misunderstands it, for Neo-classicism was regarded by its proponents as a social structure. It and Romanticism were not mutually exclusive style-periods; indeed, one might even say that Goethe's polemical formulation of the Neoclassical art programme in 1798 gave the early Romantics, Schlegel, Schelling, Novalis, Tieck and Runge, the first concrete occasion for 'secession'. The developments around 1800, which took place under the guise of a conflict between 'Art as imitation of the antique' and 'Art as the representation of nature' — the concept of nature in its widest sense — harked back basically to the quarrel between Johann Joachim Winckelmann and Charles Batteux. The French art theoretician had maintained, in his book 'Reduction of the Fine Arts to a Single Principle', that the imitation of antique works had hitherto served as a surrogate for the imitation of nature and a wall of rules had hindered the more recent artists from dealing directly with nature. In his epoch-making maiden work of 1755, *Gedanken über die Nachahmung der griechischen Werke in der Malerei und Bildhauerkunst* (Reflections concerning the imitation of Greek works in painting and sculpture), a title which refers directly to Batteux, Winckelmann took the opposing view in choosing the antique over nature. He proclaimed, as a proposition of experience drawn from nature, that the imitation of Greek works was 'more than nature' and that there was no other salvation for the moderns. The Greek masterpieces offered 'not only the most beautiful nature' but 'certain ideal beauties which, as an ancient expounder of Plato teaches us, are created from images traced only in the mind.' Winckelmann, the most sublime ideologist of Neoclassicism, took the view that the realistic painting of 17th-century Holland and Bernini's naturalistic sculpture had undermined the true meaning of art. Thus his essay on imitation was conceived in the first instance as a refutation of the Baroque which, in its late phase, rococo, had bestowed upon visual sensuality its highest tribute.

Winckelmann and his contemporaries looked upon Anton Raphael Mengs (1728–79) as the resurrected Apelles of the new art. Mengs' ceiling painting, *Parnassus* (1760–61), in the Villa Albani, Rome, gives a conception of painting permeated by the spirit of Greek art. Winckelmann went so far as to perceive the longed-for re-establishment of the antique in this work, which clearly renounced the tradition of illusionistic ceiling painting and sought, in its dull coloration, to approximate the effect of Greek sculpture. Winckelmann wrote: 'Raphael produced nothing that can be compared to it, nor did he give his works this high perfection.' There can be no doubt that this judgment was based on a misunderstanding: artistic intuition was replaced by rationalistic intention. Pompeo Batoni's *Hector's Farewell* (1761) and Gavin Hamilton's *Lamentation of Hector* (1761), contemporary with the Mengs painting, show a similar endeavour to clothe the antique inheritance in Neoclassical garments.

Plate 1

Johann Gottfried Herder performed the service of examining critically the art theories of Winckelmann and Gotthold Ephraim Lessing (author of the famous *Laocoön*, 1766), and correcting them on crucial points. His *Studies and Thoughts on Sculpture* (1778) contains invaluable observations on the nature of painting and sculpture. In contrast to Winckelmann and Lessing, Herder considered painting and sculpture two basically different arts. 'The inference from antique sculpture to painting is too uncertain, at least up to the present, and much too extensively taken for granted. Inferences from sculpture cannot be firmly drawn even in the case of large-scale drawing.' Thus Herder warned justifiably against the imitation of antique sculpture in the new painting because, 'no matter how much one may want to make painting sculptural or to paint sculpture, and to speak throughout of imitating the beauty of nature, in this context one is almost always speaking the most intolerable half-truths.' Herder missed the true concept of history in Winckelmann's system, for the latter evaluated everything solely by the Greek standard and had forgotten the fact that art is connected with time and environment. Hence the imitation of antique art could in no way guarantee the greatness of modern painting—which was exactly the same argument repeated later by Johann Gottfried Schadow and the Romantics Runge and Friedrich against Goethe's Neoclassical programme for art around 1800. Then it was 'not the objective reality that should be reproduced, but a reality transformed and clarified through our experience, the experience of a meeting between the I and the world.' Herder transmitted these dimensions of experience to the young Goethe when the two of them saw Strasbourg Cathedral in 1772 and the Gothic world in all its richness opened up to them: art became an expression of nature and a manifestation of God. Only later, at least after his Italian journey of 1786–87, did Goethe revert to the normative aesthetic of Neoclassicism.

Decisive for Herder's aesthetic were the established cultural inheritance of the 18th century and the humanistic attitude, but in his definition of art he liberated it from its connection with purpose—for aesthetics up to then had proceeded from the impression of art and its effects according to the Horatian formula of *prodesse* and *delectare*—and supplanted this with the artistic creator, sympathy and empathy, and the unknown.

10

A similar oscillation between the established and the new (i.e. the Romantic) can be seen in the work of Asmus Jakob Carstens (1754–98), who was only ten years younger than Herder. For him too the medieval existed beside the antique: 'In Gothic architecture one can see genius everywhere. In the new works only rules.' By 'new works' Carstens was undoubtedly referring to the School of Mengs. Herder, the poet and aesthetician, and Carstens, the painter, represent the generation of transition; both still stood within the framework of Neoclassicism, but already cast their glances towards what was new.

When Carstens sought to free himself from his duties at the Prussian Academy in Berlin, because he wanted to devote himself to painting in Rome, he wrote to the responsible Minister, von Heinitz: 'I belong not to the Berlin Academy, but to humanity.' The conviction became much more than the respective work. Thus the maxim could apply to him, 'that the choice of content and the poetry of discovery are the main thing, and where they fail or are neglected, a work of art, no matter how well executed, is mediocre.' Art became 'a language of feeling', which strove for the spiritualization of the material, which Carstens treated in drawings of large format, such as *The Argonauts, Priam before Achilles*, and *Night with Her Children* (1794, Weimar). *Plate 2* In spite of a noticeable eclecticism in his work, one cannot deny that his drawings have universality, beauty of line and plastic merit. In one essential point Carstens went even further than Mengs—he did without colour entirely and perceived only in drawing the means for realizing his poetic ideas. In the first half of the 19th century, Peter Cornelius referred to this sort of 'thought drawing' and called the pencil responsible for the ruin of painting! Broad areas of 19th-century German painting were defined by this Neoclassical principle of art. But one delicate bloom sprang from this weakness in German art: the illustrations of Schwind, Richter, Menzel, Rethel, and Slevogt.

While Mengs and Carstens adhered to the primacy of the human form in art and therefore to history painting, other artists who still belonged to the generation of Neoclassicism were moving in the fields of portraiture and landscape towards an artistic combination of inherited form and the study of reality. The rationalist search for rules was gradually permeated and superseded by a specific conception of form deriving from personal experience.

Mengs' early paintings in his Dresden period are distinguished by their freshness and direct observation, but these characteristics were later replaced by deliberation and sentimental gesture, which revealed the Baroque inheritance. This was true also of Angelika Kauffmann (1741–1807), the artist so highly rated in the courts of St Petersburg, Berlin, Vienna, London, and in Rome. Whereas her *Portrait of David Garrick* (1764) is distinguished by a most talented lack of constraint, her later portraits, such as *Ferdinand IV of Naples and His Family* (1782–84, Liechtenstein), indebted to Mengs' *Parnassus*, are weak in sharp observation, pale in their coloration, and soft in the play of fine curving lines.

When Goethe was staying in Italy from 1786 to 1787, Angelika Kauffmann and Johann Heinrich Wilhelm Tischbein both painted his portrait. He wrote in his journal on 27 June 1787, 'Tischbein's portrait of me is succeeding, it is a

good likeness, and everyone is pleased by its conception. Angelika is painting me too. But nothing comes of it. I am most distressed that it will not resemble and will not turn out.' Tischbein's portrait, *Goethe in the Roman Campagna* (1786–88, Frankfurt), has long been considered as the quintessence of the German longing for Italy; in this picture particularly did Tischbein give a very intelligible and easily perceived conception of the Roman antique and a sensuous popularization of the Neoclassical ideal of culture. The 'stillness and simplicity' demanded by Winckelmann found an impressive formulation here—even if only in the foreground. Near the elegiac landscape, in front of which Goethe rests in a mannered langorous pose, reminiscent of such British portraits as Thomas Gainsborough's *Philip Thickness* (c. 1755) or Joseph Wright, called Wright of Derby's *Sir Brooke Boothby*, there are those literary additions, such as the Iphigenia scenes on the sarcophagus fragment, which are intended to indicate that Goethe had completed his play *Iphigenia* during his stay in Italy. Iphigenia, the German longing for the South, for 'the entirely different'—how often this theme touched the work of 19th-century German artists: Overbeck in his *Italy and Germany*, Feuerbach in his *Iphigenia*, Marées in *The Hesperides*!

Plate 3

Gottlieb Schick (1776–1812) belonged for a time to the circle of German painters in Rome, after he had attended David's studio in Paris from 1798 to 1802. This training no doubt determined the style of his portraiture, though it was rejected by the Carstens group. Such portraits as *Frau Dannecker* (Stuttgart and Berlin), *The Humboldt Sisters* or *Frau von Cotta* (1802, Stuttgart) lead in a clear manner towards a synthesis of Neoclassical form-tradition with the realistic and poetic reproduction of nature, in which a knowledge of 18th-century English painting is reflected. Under the artist's hand the model was freely brought to life, especially in the impressive interplay of landscape, light, colour and life-like portraiture.

Plate III

Anton Graff (1736–1813) was the greatest German portraitist of the waning 18th century, and he laid the basis for the realistic portrait of the 19th century. This is already underlined in his early portrait, *Count Henry XIII of Reuss-Greitz* (1775, Munich), in which he transformed the portrait of appearance into the portrait of presence. The way in which the Count is placed before an imprecisely indicated space, the way Graff psychologically hints at and interprets the character in the restrained activity of the hands—these have a powerful effect. From 1800, Graff often gave his portraits a landscape background, e.g. the *Portrait of Karl Ludwig Kaaz* (1808, Hamburg), in which form and space are held together by the direction of light, the impression of immediacy is heightened by an abbreviated manner of painting, and communication with the observer is produced by the subject's bearing and the direction of his look. The fact that light in such paintings is not merely lighting, but also has a metaphorical significance, points, on the one hand, back to the English School of 'sentimental' painting, and on the other to the contemporary works of the Romantic Philipp Otto Runge, who was among Graff's pupils. In Graff's late *Self-portrait* (1813) the contours are soft and broad, the application of colour gives the effect of disintegration and yet is painterly

Plate 4

Plate 5

in the widest sense. Such observations can also be made of Johann Gottfried
Schadow's (1764–1850) watercolour *Self-portrait* (1838, Berlin). Along with *Plate 85*
Daniel Chodowiecki, Schadow belonged to the founders of Berlin realism,
which 'reprogrammed' the Neoclassical conception of form into a realistic
art of expression while retaining certain Neoclassical peculiarities. In Chodo-
wiecki's art too, e.g. in his small genre picture *Company at Table* (1758–62, *Plate 87*
Hamburg), the *Zeitgeist* of the era, in this case rococo, is present, but essentially
enriched through the realistic component.

We have already alluded to the connection between English and German
portrait-painting. Those specific English elements, which can be charac-
terized by the terms 'sentiment' or 'feeling', are to be found again particularly
in the German affinity to the English garden. The art of the English garden
became the symbol of a poetic attitude towards nature, a painterly trans-
formation of nature into art. The English garden was based on 'the beautiful
aspect of nature', on the reproduction of Claude Lorrain's landscape com-
positions *in natura*.

The feelings inspired in Goethe by this kind of landscape are described in his
letter to Frau Charlotte von Stein after he had visited the Park of Wörlitz, one
of the first imitations of the English park by Friedrich von Erdmannsdorf
(1768): 'Last evening, as we glided through the lakes, canals and little woods,
I was very moved by the way the gods had permitted the prince to create a
dream around himself. Travelling this way is like having a fairy-tale per-
formed before one and has entirely the character of the Elysian Fields' (14
May 1778). This reference to the Elysian Fields, that symbolic reflection of a
world of the gods, untouched by fate, is encountered earlier in George
Manson's *Essay on Design in Gardening* (1768). In his novel, *The Sorrows of
Young Werther* (1774), Goethe described such English gardens. And when he
settled in Weimar in 1775, he acquired his garden on the Ilm, and realized *Plate 6*
there his own Elysian Fields.

Whereas for people of the 18th century the garden became an image of
human life comprising the total humanistic cultural inheritance, the same
landscape garden became for the Romantics the essence of the tragic alienation
between man and nature. If the Gothic ruin signified to 18th-century man a
barbaric era overcome by the classical, so it became for the Romantic land-
scape painter, Caspar David Friedrich, a symbol of the decay of all earthly
things and an allegory of the Christian basis of existence.

In his article 'On the Garden Almanac for the Year 1795', Schiller reflected
on the layout of the gardens at Hohenheim and touched on essentially Roman-
tic aspects. For Schiller the garden is sentimental, because it artificially creates
a life out of fantasy, out of longing, out of the pathos of the inner wish for
possession. The inwardness of the observer produces the image of unity,
while the classical attitude was that of possession, which Schiller called naïve.
The conception of the sentimental as a quality of the Romantics will be more
fully discussed in connection with the Romantic landscape art of Caspar
David Friedrich.

What Schiller called the rescue of the classical spirit through the sentimental

spirit, i.e. by means of reflection and feeling, was achieved by Joseph Anton

Plate 8 Koch (1768–1839) in his landscape painting. His *Heroic Landscape with Rainbow* (1805, Karlsruhe) brought a new accent to this type of German painting. The motif of this heroic landscape, called by Koch himself a 'grand Greek landscape', was based on a quite concrete impression of nature. 'It is an area such as one imagines in Greece,' he wrote to Robert von Langer in 1814. 'I have the motif from the beautiful region near Salerno on the way to Paestum, with ancient villages on the hills in the striking light. One can also see the sea, with blue-shadowed mountains in the distance.' Koch transformed the concrete impression of nature into a Neoclassical landscape composition, a classical ideal landscape, in which the rainbow arches like an image over the life of nature and man. Insofar as this landscape, in terms of content as well as form, offers a structural order of world significance, it may be compared to Goethe's definition of the 'heroic landscape', in his note on 'Landscape Painting', as one 'in which a race of man of few needs and noble principles seem to live. Alternation of fields, cliffs and forests, interrupted hills and steep mountains, dwellings without comfort but earnest and respectable, towers and fortresses expressing no true state of war, throughout a world of no utility, no trace of field or garden cultivation, here and there a herd of sheep, indicating the oldest and most basic exploitation of the soil.'

Koch's achievement was to relate man in his existence to nature, which for its part reflects laws bestowed on it by mankind. In doing this he was deliberately referring to the tradition of classical landscape painting and created a new version of the idea of the past. The Romantic element in his work is, according to Schiller's definition of the sentimental, the rescue of the classical ideal at the beginning of the 19th century.

In contrast to the peaceful, observed state of the world in the heroic landscapes, Koch's later works, such as *The Serpentata at Olevano* (c. 1824, Inns-

Plate 9 bruck) and *Italian Vintage Festival* (c. 1830, Munich), are examples of a pictorial structure of powerful movement. The internal picture frame has vanished, the sides stand open and the element of space develops out of the centre of the picture's structure. The landscape is now interwoven with the Romantic feeling of nature; but since Koch remained faithful to the tradition of the heroic or idyllic landscape, at the same time activating it with feeling, he rescued the memory of the unity of man and nature in the classical sense.

The art critic Carl Freiherr von Rumohr said of Koch that he was the founder of German landscape painting, who taught how 'to give the earth determination, character and solidity'. The Romantics Karl Philipp Fohr and Ludwig Richter attached themselves to Koch's idyllic landscapes, which lived on directly in the work of Koch's pupil, Franz-Dreber, and in this way stimulated Arnold Böcklin to his impressive landscapes and nature mythologies. The successors to Koch's heroic landscapes were the works of Friedrich Preller and Carl Rottmann.

14

I Romanticism

Philipp Otto Runge

Philipp Otto Runge (1777–1810) is the central figure of north German Romantic painting. In some ways he carried on the work of Carstens, although he was not in fact acquainted with it. The Neoclassical forms originated by Mengs, which Runge studied during two years in Copenhagen, were purified by the strong impression made on him by John Flaxman's line engravings and became an important part of his artistic experience in his youth. Seeing Flaxman's engravings of the *Iliad*, he realized for the first time the graphic possibilities of pure line.

His *Self-portrait* (Hamburg), painted in Dresden in 1802–03, shows an avoidance of any kind of mannerism. By the use of bright and muted tones and in the sensitivity of the expression, conveying both firmness and extreme receptivity, Runge breaks free from the 18th-century style of representational portraiture, and raises a monument to his generation in capturing the delicate balance between melancholy and decisiveness in his character. *Plate 12*

It was in the same year that he began work on his sketch *The Nightingale's Lesson* (Hamburg), which served as the basis for two compositions in oil (1802–03 and 1805). The motif was a literary one: on the sheet he quotes lines from Klopstock's 93rd Ode—verses which he sent in a letter to his friend Conrad Christian Böhndel on 7 November 1801. In this preliminary working-out of his idea, he begins with the figure, which is conceived in complete conformity with the Neoclassical taste of the time. This is particularly clear in the gentle lyricism of the outline and the classical arrangement of the garments. The relief-like quality of the drawing is retained in the final 1805 version in oil (Hamburg), but here there are vividly contrasting primary colours: the shining dark blue of the dress, the light pink flesh tones, the dark green oak foliage, and the brown of the painted frame which surrounds the whole and gives it a decorative effect. *Plate 11* *Plate 14*

It is the realistic element in Runge's art that provides the link between Neoclassical form and Romantic ideas. This modification is shown especially in paintings like *The Hülsenbeck Children* (1805–06), *We Three* (1806), *The Artist's Parents* and his self-portraits. *The Hülsenbeck Children* is striking for the simplicity of the composition and the delicate coloration. *Plate I*

On 17 December 1805, Runge wrote to his father about the difficulty of combining landscape and portraiture. 'I've really made things a bit too difficult in this picture by putting landscape in the background; even though this kind of thing may be good practice, it is at best only learning by making mistakes, since either the landscape or the portrait must appear to be sub-ordinated to the other.' In the picture of the children, Runge grasps the essence of childhood and brings it out strongly. The play of light round the plastic, mobile forms of the children (reminiscent of German and Italian

15th-century masters like Konrad Witz or Masaccio) allows Runge to achieve a monumental effect which has nothing in common with Neoclassical plasticity.

Plate 13 In the portrait of his parents (1806, Hamburg), Runge forsakes Baroque representational portraiture and forges a direct link with 19th-century bourgeois realistic portrait-painting. This portrait displays a striking contrast between painstaking fidelity to detail and to the essential characteristics of the sitters on the one hand, and conscious distancing from his subject on the other; the result is that, like *The Hülsenbeck Children*, the portrait becomes exemplary, typical and objective in tone. This very internal fluctuation between the individual and the general, the characteristic and the typical, between portraiture and landscape, is at the basis of Runge's art.

In all these pictures there is a plasticity in the relationship between the figures. The rounded contours, although given sharpness of profile by the use of a clear line, emphasize the plasticity and physical reality of the figures, which stand out against the background, consciously brought into prominence by the use of line, plane and colour. Carstens had already attempted to achieve plasticity in his figures by means of line and modelling, but his attempt had failed because he made no use of colour. Runge started from there, giving colour and light the task of modelling and lending depth to the physical shape of the body. But this was not at all what he intended: indeed, his intention was to produce the effect of plasticity, which excludes the possibility that the interpretation put on it by modern observers as early *plein-air* painting can be right. Runge's plasticity places him nearer to the primitive Witz than to Impressionism. Much the same can be said about the realistic element in his pictures.

Although Romantic painting made use of literature and chose it as a source of inspiration, it is more than just illustration. Painting was to bring into being a visible language, something more than either words or pictures on their own; poetry was to give wings to imagination so that the painting should not just reproduce the literary subject but expand and deepen its meaning.

Plate 14 Klopstock's ode, 'The Nightingale's Lesson', certainly gave Runge the theme of his pictures of the same name, but the theme itself gained depth from his treatment. It is not an allegory in the Neoclassical sense, which is to render visual a concept or idea, but rather gives pictorial form to a poetic feeling which can be experienced on several different levels. First of all, the nightingale is shown as a female figure teaching its young how to play the flute; then the figure symbolizes for Runge the psyche and the soul; and finally, through the facial resemblance with his fiancée Pauline, it represents love. Thus the theme is extended to include both the spiritual and the personal. The figures round the frame are intended to elucidate the idea of the main picture: here one can see the spirit of the rose, representing physical love, stretching his arms out in vain longing towards the nightingale, while the nightingale flies on to the outstretched finger of the spirit of the lily, the symbol of the spiritual and the supernatural. The inference is that love and longing can only find fulfilment

on the spiritual plane. While the main picture makes use of the colours of reality, the surround is exclusively in grey. Compared with the original sketch, the landscape elements, such as the wood, the stream, and the glow of *Plate 11* the setting sun, have become much more a visual focus and introduce a variation of the basic idea of the picture. On 4 August 1802, Runge wrote to his brother Daniel: 'In connection with this I've noticed something . . . the picture has become what a fugue is in music. It has thus become clear to me that the same kind of thing can happen in our art-form, that is, how pleased one feels when one has isolated the musical theme that runs through a whole composition, and can see it coming up again and again throughout the whole in the form of variations. . . . At the bottom of the picture I allow a little bit of landscape to be seen. There is a dense wood with a stream rushing through deep shadow: this has the same function as the music of the flute in the shady trees at the top.' The 'music of the flute in the shady trees' is therefore the *leitmotif* of the picture. The equation of music and painting is an attempt to create synaesthesia by the participation of the observer. This is true German Romanticism.

Poetry, in this case a verse by Klopstock, thus had a formative and productive function in Runge's pictorial world; it provided the material which the artist makes visible.

In 1802, Ludwig Tieck had drawn Runge's attention to the mystical writings of Jakob Böhme, in whom Runge found the original source of his Romantic view of life, which identified the universal soul with the individual ego. The cosmic process can be experienced as the content of individual consciousness, and nature is seen as the mirror of the divine. On 9 March 1802, Runge wrote to his brother: 'When the heavens above me teem with countless stars, the wind soars through the expanse of space, the wave breaks with a foaming roar in the vasty night, the ethereal sky reddens above the wood and the sun lights up the world, the valley is filled with mist and I throw myself down on grass amid sparkling dew-drops, every leaf and every blade of grass teems with life, the earth is alive and moves under me, everything is sounding the same chord simultaneously, then the soul shouts for joy, and flies in the immeasurable space around me, there is no below and no above any more, no time, no beginning and no end, I hear and feel the living breath of God who holds and bears the world, in whom everything lives and works: here is the highest thing that we can ever know—God!' This is a basic mystical experience in which the individual soul unites with the universe, striving towards the infinite beyond time and space, in short, towards the absorption of the ego by the world. Thus the mere rippling of a brook becomes a vital experience; similarly, the motif of the fountain-head or spring inspires Runge to numerous compositions like *The Spring and the Poet*, *The Mother and the Spring* and *The Nymph and the Spring*, in which the spring gains symbolic quality as a pictorial element.

The mystical experience of nature which dominated Runge's ideas and imagination had to be rendered visually in an appropriate manner. But the Nightingale could not represent the psyche and love on its own; the mere

pictorial imitation of a spring could not in itself convey the notion of the metamorphosis of water into spirits. To make visible a further range of meaning in the object, hidden behind its external appearance, there was required a pictorial language other than mere imitation. To transmit that fundamental mystical experience purely by the formal means at its disposal (line, plane, colour and figure), painting had to have recourse to a symbolic language, for the symbol conveys a particular interpretation to the mind by means of a particular visual picture. The arabesque was to take over this function.

In his 'Essay on Arabesques' (1789), Goethe called the arabesque an 'arbitrary and tasteful combination in painting of the most varied subjects in order to decorate the interior walls of a building.' Runge's sketches for *The Triumph of Love*, for *The Nightingale's Lesson* and for *The Four Times of Day* were intended as room decorations, and possessed in addition to their decorative function ('tasteful pictorial combination') a further significance as to content ('arbitrary'): the arabesque, the hieroglyph or the symbol—to give various terms for the same thing—had the task firstly of representing natural pheno-mena pictorially, and secondly of providing, in this visual form, the means of realizing an additional dimension not immediately perceptible from the surface of the phenomena. The object 'spring' was to remain a spring; but at the same time, by a process of artistic transformation of its essential nature, it was to take on mystic significance as the primal source of life.

Runge believed he 'had reconciled the arabesque with nature and poetry, and thus reclaimed for art a field which had for a long time rarely produced anything but weeds.' In a letter to Tieck, he expressed his hope that the ara-besque would ultimately become a new form of landscape-art. 'For the moment things are leading more towards the arabesque and hieroglyph, but landscape ought to be the logical consequence of this' (1 December 1802). By landscape, the Romantics did not mean the landscape picture in the traditional sense, but a visible simile of life.

Tieck had heralded the new dimension which landscape-art was to take on as an allegory of life in his novel *Franz Sternbalds Wanderungen* (Franz Sternbald's Travels, 1798). In the novel Lucas van Leyden advises the young painter Sternbald not to go to Italy: 'you will not become an Italian and you will not be able to remain a German. My dear Sternbald, we are not in favour of antiquity. We don't understand it any more. Our subject is Nordic nature.' Here, in outline, is the whole problem of German artists who wanted to find their style by close association with Italy. While the other two young painters in the novel, Rudolph and Franz, are still thinking primarily in terms of a landscape with figures, Anselm, the demented artist, is forming his vision of the new art. 'Oh, my friends, if only you could let into your painting this wondrous music which the heavens are composing. . . . If I could only paint, speak, or sing that which moves my real self, that would be the salvation of myself and of others. . . . All art is allegorical.' The new kind of landscape-art was not to be a mere copy or transcription of nature, but a comprehensible symbol aiming to express the mystic unity of man and nature.

All the same, Tieck and Runge began to doubt whether the arabesque as pure interplay of lines and planes, with the addition of symbols which were somewhat difficult to unravel at first sight, might not damage the role of art as the visible and thus comprehensible representation of nature. Tieck later turned away from Runge's kind of hieroglyphs and adopted Friedrich Schlegel's idea of Christian history painting, as first formulated in Schlegel's journal *Europa* (1803–05). The Schlegel brothers, Tieck, Novalis and Schleier-macher had already sketched the programme of Romanticism in the journal *Athenäum* (1798–1800), and had deliberately turned against the Neoclassical programme which Goethe propagated from Weimar.

Runge's different interpretations of *The Times of Day* in the period between 1802, when the first pen drawings of the cycle were composed, and 1809, when the second oil version of *Morning* (Hamburg) was almost completed, show an important increase in the realistic and thus visible elements in his art. *Plate 15* A comparison of the various versions of *Morning* clearly shows this development: from the abstract and symbolic representation of the earth 'as a ball rotating in the morning mists' to a concrete depiction of a flat landscape near Hamburg, and finally to a completely realistic landscape in which the morning light illuminates the whole landscape, as in the second version of *Morning*.

The subject of the picture *Rest on the Flight to Egypt* (1805–06, Hamburg) *Plate 16* was one of the favourite themes of early German art. Runge adopts the theme not for its historical significance, but with reference to his conception of 'landscape'. It is another version of the picture *Morning*, for everything here— the morning sunshine, the 'roses of dawn', the child in the tree who offers the lily to the Christ-child, the Egyptian Nile landscape, the Biblical theme— symbolizes the idea of *Morning in the Lands of the Rising Sun*; whereas the complementary picture, *Evening in the Lands of the Setting Sun*, never got beyond the stage of the sketch *The Spring and the Poet* (Hamburg). The close unity established between landscape, figure and light, and the choice of content whose implications extend beyond the Biblical subject and return to it en-riched by poetic associations charged with mysticism, make the painting more than just 'history': it is truly 'landscape' in Runge's sense of the word. Similarly, in the painted version of *Morning*, the new-born child lying on the ground bears the main emphasis in the interpretation of the picture. In the summer of 1805 the artist wrote to his friend Schildener: 'I had not originally thought of it like this, but it seems to me now that MORNING and EVEN-ING could form a really nice pair of complementary pictures. In addition the meaning of EVENING (in the Spring) lies in the combination and contrast of colours; it would be an EVENING IN THE LANDS OF THE SETTING SUN, following on from this MORNING (on the flight), with the sun still glowing beyond the wood, and the unspoken Word drawing the man on like music with inexpressible melancholy . . . in MORNING the focal point of the whole picture is in its centre; here too (where, as is self-evident, the figures have as yet no inner spiritual integration) everything would weave and twist itself even more closely into this central point, so that the child's hand would emerge from the shadow to play in the first rays of the

sun. The child must become the most mobile and vital moment of the picture, in order that THIS life here may be seen likewise as a new dawn rising over the country depicted before him.'

Plate 17 Runge's one-time teacher, the parson and poet G. L. Kosegarten, commissioned Runge to paint the picture *Christ Walking on the Water* (1806–07, Hamburg). *Rest on the Flight to Egypt* is mainly lyrical; but here the artist becomes a dramatist, symbolically relating the forces of nature, like the raging sea and the moonlit calm, to the events described in the Bible, and thus giving religious history painting a new slant. Here too the element of 'landscape' threatens to dominate, in that human activity is related to the forces of nature. The expressive linear form makes nature and human figures closely analogous to each other, and transcends their separation to produce a visible thematic unity. Runge's poetic rendering of nature differs from the English or French Romantic feeling for nature, as in Turner's *The Shipwreck* of 1805 or Géricault's *Raft of the Medusa* of 1817, where an extreme human situation is created by the overpowering might of nature. In contrast, Runge aims to make visible the divine element in all the phenomena of nature, just as in his works the moon always stands for the Comforter, the Holy Ghost illuminating the darkness of doubt.

Thus Runge's work clearly becomes more visual and more concrete, without departing from the allegorical foundation on which he bases his art.

The Four Times of Day stand at the centre of the Romantic movement and display a combination of poetic and visual art. The first sketches (1802, Hamburg) were an attempt to obtain a 'philosophical and religious artistic expression by means of the ornamental arabesque' (Tieck). They aimed to make visible simultaneously the changing phases of nature, the seasons and finally the epochs of world-time. The paintings were planned on a large scale as part of an interior decoration and sought to make this philosophical viewpoint completely perceptible. Runge used colour to convey religious mysticism, and flowers and spirits as symbols of the forces of nature. While composing the cycle Runge never lost sight of their original intention as decorations for rooms, although even here he saw decoration as the poetic part of architecture. The four compositions make up a cycle 'which is worked out in detail like a symphony'. 'When it is fully developed it will be an abstract, pictorial, musical fantasy of a poem with choruses, a composition for all three arts together; and architecture should contribute a special building in which to house it' (Runge, 22 February 1803). On seeing the Gothic cathedral in Meissen, Runge was confirmed in his vision of a monumental *Gesamtkunstwerk* (total work of art). The essential qualities of these three art forms were to be reproduced in words, lines and colours; but the accompanying music by Runge's composer friend Ludwig Berger and Tieck's poem were never completed.

The Romantic hieroglyph found in the drawings and etchings of *The Four Times of Day* was given more objectified substance (and hence was made more immediately intelligible) in the planned, but only partly completed, painted

versions—especially *Morning*—by the use of colour and space to achieve a *Plate 15*
three-dimensional quality. Runge himself has left a poetic explanation of his
Four Times of Day, which he later called *The Four Times*: 'Morning is the
unbounded illumination of the universe. Day is the unbounded creating and
forming of the creature which fills the universe. Evening is the unbounded
dissolution of existence into the source of the universe. Night is the unbounded
profundity of the realization of the imperishable existence in God.' *Morning*
is shown both in its concrete visual aspect and in its abstract symbolic aspect:
flower-spirits greet the new-born child, who reveals his innocence by his
unity with nature, two further rose-spirits flank the figure of Aurora, who is
being crowned with a white lily of light complete with attendant spirits, and
above her head are three spirits around the evening star. Since Aurora is the
bearer of light, the picture contains the possibility of a Christian interpreta-
tion: Aurora as the Virgin Mary and the new-born child as the Saviour.

In the last painted version of *Morning*, light and colour had an interpretative
function. Colour had taken on a mystic dimension in Runge's view of art:
'Colour is the last of the arts and it is still mystical and must remain so; we
understand it only from flowers, by a curious kind of intuition.' Colours as
they appear in nature are related to spiritual aspects of life. Hence the function
of colour is enlarged beyond the merely descriptive and expressive to include
the symbolic, and it is endowed with spiritual and mystic significance. 'Here
in fact [i.e. *Morning*] everything is based on the contrasting effects produced
by light and colour. This is perhaps most clear from the surround, which also
has its own arrangement of colour: the dark deeps of the regions below the
earth (where the sun is eclipsed) give way via the medium of the blood-red
amaryllis to the dazzling white of the lily, and finally lead up to the silvery blue
of the sky in which angels move and which represents the divine light. Thus
here, too, on the surround is a symbolic representation of the mystery of the
creation of light, which receives a more worldly interpretation in the main
picture. And the disposition of colours on the surround is much the same as
that in the picture: the green of the meadows leads up to the red and yellow
of the morning sky (ritardando of the grey cloud bank) and merges at the top
into bright ultramarine which then becomes darker: so the earthly light,
broken up into yellowish red, is enclosed by the oppressive darkness below
and the celestial glory of the heavenly light above, which is itself transfigured
on the surround.' This sympathetic description of the last, uncompleted
version of *Morning* is in P. F. Schmidt's book on Runge.

The plan to execute *The Times of Day* on a large scale in a great tall building,
whose style was to be a development from the Gothic, would have resulted
in a work typifying German Romanticism: picture and symbol of the
Romantics' mystical view of reality in which the Godhead, the world, and
man were united. But the work remained a fragment—perhaps the vision
was beyond the power of the artist to realize.

On 2 June 1806, Goethe wrote to Runge: 'I am not altogether in favour
of art following the path you have taken, but it is nevertheless most pleasing
to have proof that a talented individual can develop his own particular ability

to such an extent that he achieves a degree of perfection which commands admiration. We are not quite sure that we completely understand your most significant pictures, but it gives us pleasure to spend time looking at them, and we often immerse ourselves in their mysterious and charming world.'

For Runge religion was the implicit basis for his art, his metaphysical refuge. His colour theory should have been developed into a doctrine on the production of harmonious effects, but neither in theory nor in practice was it completed. The contemporary and following generations took their inspiration not from the north German Runge, but from the Nazarene Cornelius, whose history painting re-awakened interest in the Renaissance.

Runge brought early Romanticism to its fulfilment in the domain of painting. His synaesthetic vision of the various arts was not fruitfully developed and perfected until much later, at the beginning of the 20th century. The tendency shown in his work to move from abstraction to a realistic portrayal of landscape, which managed to retain symbolic depth, was followed by Caspar David Friedrich. His personal vision remained uncompleted, but his presentiment of an art which would give physical shape to spiritual values and cosmic laws, and would emancipate personal experience, was not forgotten: this aspiration is one of the most characteristic ingredients of German art.

Caspar David Friedrich

The landscapes of Caspar David Friedrich (1774–1840) represent the clearest expression of north German Romanticism. Man and nature come together in a new intimate relationship: the human figure and the Gothic ruins often found in his paintings take up the Baroque concept of the vanity of the world and endow it with enhanced subjective significance. Apart from these allegorical landscape pictures whose mood is essentially poetic, Friedrich also captured the transitional phases of nature (twilight, late autumn, cloud-studies) for the first time in many of his works, which prepare the ground for a type of landscape painting which is content to observe natural phenomena in all their purity. Carl Gustav Carus described Friedrich as follows: 'His life was of the same order as his art: characterized by strict integrity, uprightness and seclusion. German through and through—at no time did he even attempt to learn one of the modern foreign languages, and he was a stranger to any kind of ostentation as well as to all forms of self-indulgent social life. He was scarcely ever seen in company, and I can recall only one evening when we were able to persuade him to join us in the small family group. Twilight was his element, he would take a solitary walk at early dawn . . . these were his only distractions, otherwise he brooded almost continuously in a dark room over his works.'

When the French sculptor David d'Anger visited Friedrich in his studio in 1833, he was moved to cry out on seeing Friedrich's landscape, 'Here is a man who has discovered the tragedy of landscape.'

Long before Friedrich painted his first well-known picture in oils, the *Tetschener Altar* of 1808 (Dresden), which established his fame as a painter, he was already known for his drawings in pencil and sepia. The groundwork for his studies was done in the open, from nature; in the studio he went over and transformed them into finished compositions. It was the artist's imagination which played the principal role in the creation of the picture. 'The painter,' Friedrich wrote, 'should not just paint what he sees in front of him, but also what he sees within himself.' External images, impressions and experiences are collected and metamorphosed by an internal imaginative process into a work of art. The studies from nature are distinguished by their extreme fidelity to the subject.

Plate 19

In 1805, when he was nearly thirty years old, Friedrich took part in the Weimar competitions, and the two landscape sepia drawings he entered in the free-choice section (*Pilgrimage to the Crucifix* and *Fishermen resting by the Sea*, Weimar) won a half-share of the prize. Goethe had introduced these competitions in his journal *Propyläen* (1798–1805), which he used for the revival of German art on the bases of Neoclassicism. Among the reasons for Goethe's failure in this attempt, not least was the fact that the Romantics had turned away from the dogmas of Neoclassicism. Coming into contact for the first time with an almost completely developed Romantic in Friedrich, Goethe classified the works as belonging to the sphere of landscape-art, which he regarded as harmless. The detailed criticism of the two drawings in the *Jenaische Allgemeine Literatur Zeitung* (1806) praised the 'artist's inventiveness', and, in the theme of the *Pilgrimage to the Crucifix*, an 'ingenious narrative element', although this was subsidiary and not meant as a concrete acknowledgment by Friedrich of his dependence on Christian images.

The Eldena motif, the ruins of a settlement of Danish Cistercians in the neighbourhood of Greifswald dating from the 13th century, which had pursued Friedrich since his youth in line-drawings, sepia, and watercolours, appears again in the painting *The Abbey in the Oak Forest* (1809, Berlin). Together with *Monk by the Seashore* (1808–09), *The Abbey in the Oak Forest* was shown in the autumn exhibition of 1810 at the Berlin Academy; and the young Crown Prince of Prussia, who had a strong leaning towards Romantic ideas, obtained both pictures for his collection. Thematically the picture goes back to *Winter* (1808, formerly in Munich). Architecture and foliage are made to look very much alike in colour. The ruin appears as a silhouette, and light floods forward through the broad opening in the walls where the door would have been, and through which a monk's funeral procession enters the interior. Thick fog lies over the lower part of the picture while the middle part displays a light sky with a thin sickle moon and evening stars; towards the top the sky darkens again with grey snowclouds. The top third of the painting, which is completely empty, is balanced by the middle part with the bare oak trees, whose branches stand out grotesquely against the bright sky. Among the symmetrically arranged trees the Eldena motif assumes the central position in the picture. The painting is enriched by the scene of the monk's burial. This human activity does not have a merely supplementary function, but acts as a

Plate 21

symbol for the bleakness of winter. The winter landscape, evocative enough in its own right, thus gains elegiac and tragic overtones: the action makes nature a symbol of human existence. Winter and death are directly linked.

In 1808 Friedrich sent several drawings to the exhibition in Dresden, among them one entitled *The Cross in the Mountains* (Berlin). The composition was enthusiastically received by the young Countess of Thun who wished to have the sketch turned into a painting for her private chapel in Tetschen (1808, Dresden). The sketch was, most remarkably, favourably received by Goethe and his circle, although in form and conception Friedrich's composition was absolutely Romantic and in no way approached Weimar Neoclassicism.

What was praised by the Weimar art society in the sketch as the 'poetic content of the conception' was bitingly attacked and rejected by Rumohr in the *Zeitschrift für die elegante Welt* in 1809 as 'the mysticism of the new art'. Rumohr purported to be attacking Friedrich's irregularity in using an aerial perspective, but his criticism was really aimed at the heart of the new religious Romantic art. He argued: 'It is truly presumption when landscape painting tries to slink in to the church and crawl on to the altar'. He opposed the Romantics' view, which caused them to elevate landscape into a vehicle for the expression of a personal intimation of God.

Friedrich adopted the traditional form for an altar picture in the external aspect of his painting, especially in stressing the role of the frame; but in replacing pure depiction (i.e., of saintly figures), landscape itself takes on a new dimension as a fitting subject for an altar picture. The Cross on the Mountain is set against the infinity of heaven; it seems as if an imaginary curtain has been drawn back from the scene of the picture, which rises up steeply right in the foreground and leads up to the Cross. The Cross with Christ is the motif which gives meaning to the whole picture, a symbol providing the key to the composition. The objective value ascribed to religious symbols was discounted by Friedrich in favour of a new consciousness of personal experience. Nature is represented symbolically: the presence of God is hidden in the phenomena of nature and only made visible in the figure of the crucified Christ which reflects the light, symbol of the *logos*, as Friedrich himself explained in a comprehensive description of his picture. God was made subjective through personal interpretation, conferring on nature the status of the transcendent, and the Cross is a sign of this. The picture was later

Plate 20
reformulated as *The Cross in the 'Riesen' Mountains* (1811, Berlin). Here Friedrich uses the motif of the Cross to indicate also the highest point of the mountain-range which has been climbed by a female figure leading her male companion; the visual experience of nature is thus transformed into a metaphor of subjective religious experience. In *The Cross in the Mountains* (1811, Düsseldorf) Friedrich placed the Cross between an accessible foreground and a vaguely defined area containing the gable-end of a Gothic church. The Cross is attainable only by an emotional projection—as in *The Cross in the 'Riesen' Mountains*, where the female figure is the first to embrace the stem of the Cross, embodying as she does the essential nature of emotion or feeling,

while the man follows her—and it leads the eye on to the vision of the divine, either in the form of the Gothic church or in the infinity of space. W. Sumowski (1966) has indicated the complexity of this kind of spatial composition and has linked it with Romantic transcendental philosophy. 'There is a deep meaning behind this kind of form. It may be understood as a symbolic disorganization of space and time, which Friedrich Schlegel has isolated as "the distinguishing characteristic of the transcendental".' In his later works Friedrich limited himself to representing nature without including obvious symbols like the Cross, but still hoped to convey the religious nature of landscape.

In Friedrich's pictorial world, architecture and the human figure occupy a prominent position since both have acquired the allegorical function of representing Romantic feeling and consciousness. The Gothic ruin, especially the motif of Eldena, appears frequently in Friedrich's works in the years from 1800 to about 1810. His interest in Gothic ruins is much more than an anti-quarian enthusiasm for old monuments. The Gothic ruin, of course, is also seen as the Baroque symbol of the vanity of the world. One thinks of Ruys-dael's *Jewish Cemetery* (Dresden), about which Goethe wrote in his essay 'Ruysdael as a poet' (1816): 'The most important idea of this picture also makes the greatest painted impression. The collapse of huge buildings has been allowed to choke up, dam and divert from its course an otherwise regular stream.' While the stream, winding through the graveyard, symbolizes life for Goethe, the opposite pole is provided by the decaying graves. But what distinguishes Friedrich's work from such a typically Baroque treatment of the theme of ruins? Why did Goethe credit Ruysdael with achieving complete symbolism while only being able to guess at the presence of gloomy religious allegories in Friedrich's works? The Gothic ruin, as it appears in *The Abbey in the Oak Forest* (1809), is a symbol of decay. The work of man is in the process of returning to nature and of re-uniting with the universe. The ruin is thus a vehicle for tragic emotions since it usually appears in conjunction with the themes of winter and death. Friedrich's fondness for the ruin-motif may be explained by his tendency towards melancholy, solitude, and quiet.

Plate 21

The classical architecture in Poussin's paintings depicts the heroic aspect of antiquity; Claude Lorrain's heightened Arcadian portrayal of the Italian countryside combines the picturesque and the emotive effects of ruins; Ruysdael's emphasis on the elegiac, tragic qualities of landscape is based on his use of natural phenomena as general symbols of human life. In contrast to all of these, Friedrich endows the motif of the ruin with Romantic implica-tions. The constituents of the picture are still totally picturesque in the classical sense, and it is indeed this which makes them Romantic, that is, wild, stimu-lating to the imagination; but they reflect that Christian frame of reference which was foreign to Baroque landscape painters. The latter had given an objective picture of the tragic or heroic nature of man's situation by their use of landscape and ruins; but Friedrich used Gothic ruins to stir memories of a dark past, to show how great the past was compared with the sickly present, and as a symbol of the medieval Church, since disrupted by the Reformation, as may be seen in an unfinished sketch for the interior of a ruined church

(1836), based on Meissen Cathedral. According to Friedrich, 'The glory of the temple is past and from the ruins spring forth a new age and a new longing for clarity. High, slender, evergreen firs are growing from the rubble, and among the decaying pictures and crumbling altars stands an evangelical priest, a Bible in one hand. With his right hand on his heart and his eyes raised to the blue heavens, he gazes meditatively at the light, fleecy clouds.' In Friedrich's works, Gothic architecture is the outward expression of internal religious fervour which can no longer be satisfactorily expressed by conventional Christian history painting.

Plate 22 *Morning Light* (1806, Essen) is the title of one of Friedrich's pictures in which a young woman, her back turned to the observer, has taken a few steps along a path in order to greet the morning and its light with her outspread arms. In front of her extends a wide meadowland prospect, with individual trees and the soft forms of a mountain range on the horizon, behind which the rising sun sends out its rays like a fan. The human figure is no mere accessory in the traditional sense; it has a much too emphatic central position for that to be the case, and the gesture of the outstretched arms is too closely related to the natural event taking place. The young woman has gone out into nature, and is, at the same time, seeking nature. Her posture represents Schiller's definition of 'the sentimental'. When mankind finds himself in accordance with nature his attitude is naïve, when finite man stands before infinite nature and seeks lost unity, as Friedrich does here, then his attitude is 'sentimental'. And in this sense, the attitude of the majority of the figures in Friedrich's pictures is sentimental, for they are attempting, most of them with their backs to the observer, to restore the unity of man and nature by means of a silent contemplation of nature. The figure in *Morning Light* is standing still, letting time pass, in deep thought and contemplation. The formal relationship of figure and picture plays an important role, for the female figure forms part of the axis of the picture and takes up two-thirds of its height. Its symmetrical shape, its linear outline, which gives the effect of a silhouette, is formally related to the use of line in the landscape base and in the sunrays, and thus brings together several spatial planes in one surface figure. But in addition, the contemplative act of union with the boundless landscape comes to stand for a general way of looking at things. This figure, seen from behind, stirs the ideal observer to join with it in contemplation.

The concrete occurrence of the sunrise is the *leitmotif* which unites man and landscape. Light blossoms from the darkness, appears in the landscape, and is then concentrated in the middle of the picture where the young woman is standing. We may be justified in considering light not just as a natural phenomenon but also as having metaphysical significance. Light illuminates the observer, mentally and physically. Runge also used light in a similar manner Plate 15 in his *Morning*.

In Friedrich's *Landscape with Rainbow* (1809, Weimar), the rainbow has been chosen as a motif embracing both the landscape and the person looking at it. In spite of all the superficial resemblance to Dutch Baroque landscapes, perhaps those of Koninck, the decisive note is again Friedrich's extension of

26

the Baroque to make it Romantic. The contemplation of nature brings that inner peace whose final aim is mystical identity with nature. In *Two Men gazing at the Moon* (1819, Dresden), the moonlight shines silver through brownish mists. The shimmering mists float mysteriously as two young men, Friedrich's brother-in-law, C. W. Bommer, and his pupil, August Heinrich, lose themselves in contemplation of the moon and swear a silent oath of eternal friendship. Romanticism attributed conciliatory powers to nature, especially to moonlit nights.

Plate 23

A little later comes *The Ploughland* (1820–30, Hamburg). Above a broad stretch of land, half meadow, half ploughed, the evening sun has carved out swaths of light in the cloudy sky. A deep bluish brown and a lush green contribute to the picture's effect on the emotions. In front of the expanse of ploughland, marked by the traces of human labour, delicately painted trees stand out in the half-light, reminding us of Chinese landscape paintings. The eye is led along the strongly rhythmical curves of the ploughed land towards the horizon, where it encounters a human figure, which, set against the imposing manifestation of the latent powers of nature, becomes symbolic of the solitude and defencelessness of man before the might of nature.

In the charming picture *Summer* (1808, Munich), which, along with *Winter* (1808, formerly in Munich, now destroyed), was probably intended as part of a cycle of the four seasons—Friedrich had already made some sketches on this theme in 1803—a pair of lovers are sitting in a landscape flooded with light: they represent change in nature, like the old monk in *Winter* who plods through the snow beneath bare oak trees in front of a ruined church. Human existence is determined by the cyclic changes of nature. Such figures still have something literary about them, too, and this comes up later in another form, e.g. in *Arctic Shipwreck* (1824, Hamburg), also known as *The Wreck of 'Hope'*, in which a ship has run aground on ice-floes. The theme may have been suggested to the artist by a drift of ice on the Elbe in 1821; but one cannot altogether exclude the possibility that the name 'Hope' also contained allegorical significance. Finally, one should mention the painting *Oak Tree in the Snow* (Berlin), exhibited in Dresden in 1829. It is a variant of a similar picture in Cologne (1822). The motif has here been freed from its earlier associations with the picture *Prehistoric Grave in the Snow* (Dresden), or with *Winter*, and has become solely an emotive element.

Plate 24

Plate 25

Plate 26

In 1815, Friedrich's admirer, the painter Louise Seidler, approached him on behalf of Goethe, to ask him to do the illustrations for Goethe's investigations into cloud-forms. Friedrich had already made a close study of cloud formations in 1806, in order to understand nature better. But for him art was not mere reproduction of natural phenomena; it was not enough to look at nature purely from a scientific point of view. He therefore declined Goethe's offer, saying that this would mean to him the 'ruin of landscape painting'. Louise Seidler gave Goethe a detailed account of Friedrich's reaction on 8 October 1816—'Believe me when I tell you that he immediately saw the overthrow of landscape painting in this system, and feared that henceforward the free and airy clouds would be slavishly forced into rigid order.'

For Friedrich, painting was still the realm of subjective imagination: observation of nature was, so to speak, the raw material which he moulded to give expression to his subjective ideas. However exact the details of his landscapes might be, his personal artistic vision of the structure of nature always took precedence. Landscape contained interpretable material and was not just a visible world, but a world composed of ideas. For the theologist and doctor Gotthilf Heinrich Schubert, nature was the manifestation of the dramatic history of the earth. Such ideas, expressed in lectures on 'The Dark Sides of Scientific Knowledge', no doubt later influenced Carl Gustav Carus's idea of landscape painting as the art of the natural history of the earth. The nature philosopher, Friedrich Wilhelm Schelling, formulated similar ideas—'Since even philosophers admit that all one's experience is an extension of one's internal imaginative life, in every flower we see, or should see, the living spirit which man invests it with, and in this way landscape will come alive.' Thus Romantic nature philosophy became a total way of looking at the world. Nature can be seen in man, and man in nature. Landscape became a symbol of life.

The experience of nature was decisive for Friedrich, for it developed his inner vision: not an *a priori* vision or set of ideas, but first of all direct contact with the natural event—the sunrise, a moonlit night, a thunder cloud, a rainbow, a snowstorm. The experience stimulated the creative exteriorization of the emotions felt and provided a point of contact between nature and man. In response to Friedrich's *Monk by the Sea* (1810, Berlin), his friend, the poet Kleist, wrote: 'With its two or three mysterious objects, it looks like a picture of the Apocalypse, and since nothing except the frame limits the foreground of its uniformity and unboundedness, it is as if one's eyelids have been cut off.'

Many of Friedrich's landscapes are gloomy and sunk in melancholy. They are frequently preoccupied with the thought of death, but there are also clear *Plate II* spring- or summer-like landscapes in his work. *Meadows near Greifswald* (1818, Hamburg) is one of his most serene and symbol-free works, as is the picture *Chalk Cliffs above Rügen* (Winterthur). Both were painted in 1818, when Friedrich took his fiancée Karoline (née Bommer) to Greifswald, to *Plate 27* show her the countryside around his home. *River Bank in Fog* (1820–30, Cologne) is one of a series of small pictures in which Friedrich remained completely faithful to the evidence of his eyes. The lightness of touch in the application of colour, the merging of the outlines, and the balanced interplay of rectangles and diagonals give the landscape a spatial atmosphere reminiscent of Far Eastern watercolours.

The best known interpreter of north German Romanticism alive at the time was Carl Gustav Carus (1789–1859), whose *Nine Letters on Landscape Painting* were written between 1815 and 1824, and published in 1831. Acting on Friedrich's advice, Carus learned to paint himself, and has left several very beautiful works, which are completely Romantic in subject and style. Many of his sketches from nature have a notable freshness and are free of any literary

allusions. *Boat Trip on the Elbe near Dresden* (1827, Düsseldorf) shows a certain *Plate 28* affinity with Friedrich's *Communal Sea-voyage* in Leningrad (Hermitage); but Carus adapts the high Romantic view of painting, as it appears in the works of Turner or Delacroix, to the late Romantic preoccupation with everyday things, by presenting the theme as a pleasure-trip across the Elbe with a view of Dresden in the background.

Originally, the nine letters on landscape painting were based on Friedrich's ideas and works. The first five deal with the mood or emotional response generated by innocent observation of nature and art, and the others discuss the formal aspect of landscape painting. Influenced no doubt by Goethe's theory of morphology, Carus had discussed his views on landscape painting with Goethe. Carus's conception visibly differed from Friedrich's. All elements of mysticism or musicality have disappeared from contemplation, so it is not surprising that Carus praises Goethe's observations about cloud-formations and his cloud poem, but remains silent about Friedrich's art.

In landscape, life manifests itself to the senses in many forms. Landscape painting does not therefore restrict itself to simply depicting externals, but presents an interpretation of the metaphysical significance of nature. Carus's idea of landscape-art is basically pantheistic. The life of nature must be re-created, without restrictions, in the artist's mind. The contemplation of nature enables the individual to transcend his limitations and experience union with nature. By becoming completely aware of any one natural object, the individual experiences in himself the whole evolutionary process of nature. The fragmentation of nature can now also be seen as a totality, and this is reflected by the sentimental mood evoked.

'Sometime', wrote Carus, 'landscapes will be painted of a nobler, more significant, beauty than those of Claude and Ruysdael, and yet they will still be faithful representations of nature, but of nature perceived with the inner eye and greater truth': an ideal which finally overcame the dualism of nature and the individual ego and which was realized in the landscape paintings of Cézanne.

The Norwegian, Johann Christian Clausen Dahl (1788–1857), settled in Dresden in 1818, after completing his training at the Academy in Copenhagen. Dahl, who was a friend and close colleague of Friedrich's, brought a completely new element into Dresden landscape painting. It is the treatment of nature by exact observation of atmospheric phenomena, without any Romantic ideology in Friedrich's sense. Light and atmosphere are chosen and rendered visually for their own sake. In this, Dahl is one of the first to prepare the way for naturalistic landscape painting. His oil studies in Dresden, such as *The Landscape Study* (1819, Dresden), commend themselves by their softness and *Plate 30* harmony. This study, which stems from the time shortly after Dahl's arrival in Dresden, shows the town in the background. The figure standing on a piece of rising ground on the right is still reminiscent of Friedrich's figures, as in his *Landscape with Rainbow* (Weimar); but the unity of man and nature typical of the Romantic view of the world seems to have given way to some

extent to greater concern with the technical problems of rendering nature exactly.

From 1820 to 1824, Dahl studied in Italy. On his return he took up again emotive Romantic landscape subjects, like misty valleys or moonlit scenes. *Plate 29* The scientific interests reflected in his cloud studies (1832, Hamburg) and his pictorial traits, which link him with Carl Blechen, the forerunner of the naturalistic attitude to landscape, would seem to indicate a cast of mind similar to Goethe's and Carus's. He had a direct influence on the Norwegian, Thomas Fearnley (1802–42), and the German, Christian Friedrich Gille (1805–99).

Dahl spoke feelingly of Friedrich's landscape art: 'The elegies of landscape, still natural life as a kind of tragic mysticism, dream-like pictures of an unknown world which possess their own profound poetry.' His own realistic and impressionistic way of seeing things caused him to try to present a more immediate kind of poetry of natural phenomena.

August Heinrich (1794–1822) and Ernst Ferdinand Oehme (1797–1855) belonged to the small circle of Friedrich's pupils. Heinrich was born in Dresden and spent some time in Vienna in 1812 before joining the circle around Friedrich and Dahl in Dresden in that year. In 1820 he left with Oehme on a study trip to Salzburg, but he never returned. In comparison with Friedrich he chose to depict individual and limited natural forms in his landscapes, in order that nature's vastness might be deduced from the particular.

Oehme spent the years 1819–25 in Italy where he joined the Nazarenes, but he turned away from their style and attitude again as soon as he got back to Dresden. His Romantic mood-pictures, with graveyards, ruins and moonlit landscapes, are derivative of Friedrich, but he nevertheless transforms his subjects into almost literary interpretations. This links him with the superficial trappings of Romanticism in the pictures of architectural monuments by Karl Friedrich Schinkel (1789–1841). An exception to this is Schinkel's *Plate 31* *Cathedral above a Town* (1813, Munich), in which the Gothic cathedral towers above the fictional town with its ancient monuments and Renaissance buildings.

Friedrich played an indirect part in establishing the School around him— indirect because his own artistic contribution could be only partially passed on. Either artists took from his work its quality of emotional and poetic response and turned it into mere background effects which thus failed to retain the mythical terms of reference, or else they adopted his naturalist approach to the reproduction of nature which, in some cases, led to astonishingly early Impressionist pictures. The forces which Friedrich united in his works, external form and inner meaning, were divided into painting with ideas superimposed, or early naturalist painting. Friedrich himself was soon forgotten, not to be rediscovered until the Centenary Exhibition in Berlin in 1906.

German Romantics in Italy

Italy, and especially Rome, had an important influence on the history of German 19th-century painting. Rome, as the centre of the classical past, which had already tempted Goethe during his Italian journey to write the phrase, 'I, too, was in Arcadia', had also been instrumental in aiding Winckelmann, Mengs and Carstens, in the 18th century, to link up again with the great tradition of classical art. As the Holy City, the seat of the Catholic religion, Rome was to become the most important centre for a renewal of Christian art.

The conviction that only in Italy was it possible to mature into a true artist became widespread after 1800. It was one of the essential points of view of the 1800s and lasted until the time of Böcklin, Feuerbach and Marées. But the idea that a nation's art could not be developed in the fatherland, but rather in Rome, could only have been conceived by Germans, who, at least from the time of Winckelmann, had seen Italy as their natural homeland. It is true that the beginnings of a new kind of painting in north Germany, especially in the work of Runge and Friedrich, appear to embody an opposite tendency to the programme of the Nazarenes in Rome, but in reality they have close internal links.

There were two elements in this feeling about Rome. It was not only 'the flight from the dark mists surrounding the academies filled with negative, eclectic "art junk",' as Peter Cornelius put it, but also the vision that it was necessary to come into contact with the world of classical art to make direct observation of art and nature, and also to strive together to bring about a renewal of art.

Men like Wilhelm von Humboldt and the Prussian ambassadors Niebuhr and Bunsen encouraged the circle of German artists in Rome. Between 1800 and 1830 Rome really became the artistic capital of Germany. Here the pattern was established and the main lines laid down for 19th-century painting. In spite of their strong ties with Italy, the German painters were aware of the fact that they ought not to leave their fatherland. Cornelius proudly signed his letters from Rome with the words 'pittore tedesco', and left the Holy City as soon as he was invited to Munich by the Bavarian Crown Prince Ludwig. Schnorr von Carolsfeld also looked forward to the day when German artists would no longer flock to Rome, 'when we shall have established a German "Rome" in our own country.' His acknowledgment of the fact that German artists were never more German than when they were in Rome is very accurate.

The plan to reform German painting aimed at producing an ennobled type of painting, in which both content and form had been purified, based on the early Italian and German painters, including both Dürer and Raphael, who were not yet spoiled. It was hoped that a synthesis of style could be achieved which would link the essential elements of north and south, depicted by Overbeck in his *Italy and Germany* as two sisters. The first to describe this synthesis of Italian and German art in the context of reviving Christian art had been

Plate 32

31

Wilhelm Heinrich Wackenroder in his little book, *Herzensergiessungen eines kunstliebenden Klosterbruders* (Outpourings from the Heart of an Art-loving Monk, 1796), which was looked on as the original programme of German Romanticism.

The Germans in Rome also sought reform through the medium of wall paintings, which was to become a new basis for German art in order to give a worthy direction to the great era and the spirit of the nation. This was nothing more than a 're-introduction of fresco painting as it was in the time of the great Giotto, right up to the "Divine" Raphael'—in the words of Cornelius. The fresco symbolized the essential quality of Italian monumental art, but had always been foreign to northern artists. The wall paintings of the Nazarenes in the Casa Bartholdy, Rome, are the first works which fully express the period of European restoration. They took their lead, in formal terms, mainly from Raphael. For the first time artists tried to link up with his style from a historical point of view by considering it as the basis of a freely chosen tradition. But this dependence on Raphael's mature art was in contrast to the simplicity which was intended to be at the basis of the Nazarenes' movement. This initial discrepancy led later to the degeneration of history painting, as can be seen in those works which bear merely a superficial resemblance to the Renaissance style. To the 'Brotherhood of St Luke', as the Nazarenes called themselves, Carstens had given the watchword for the younger generations: the artist should not copy dead models but should himself give birth to the new art.

In the Academy at Vienna, under the direction of Heinrich Füger—one of Mengs's pupils—Neoclassical dogma was being taught at the beginning of the 19th century in a similar way to that in the Academies of Copenhagen or Dresden. Among the art students in the Academy who were critical of this were Friedrich Overbeck (1789–1869), from Lübeck, and Franz Pforr (1788–1812), from Frankfurt. The illustrations to Goethe's *Götz von Berlichingen*, which Pforr drew for the most part while still in Vienna, are of primary importance. He took as his model Dürer's marginal drawings for the Emperor Maximilian's prayer-book (Munich), which Strixner had published as lithographs in 1808. Goethe himself was sent Pforr's drawings by J. D. Passavant, but he was somewhat reticent about them and regarded them as symptomatic of the age. He reacted rather similarly to the *Faust* illustrations of Peter Cornelius (1783–1867), of which the preparatory sketch, made in *Plate 34* Frankfurt in 1811, to Goethe's *Faust and Mephistopheles at the Rabenstein* (Berlin), appeared in Weimar, after being engraved by Ferdinand Ruscheweyh in 1816, along with a further five studies made in Frankfurt and a final six studies made in Rome. Goethe said of the pen-and-ink drawings, which S. Boisserée showed him in 1811: 'Drawings . . . which are really wonderful. They are scenes based on my "Faust". The young man has really immersed himself completely in the old German style, which suits the Faustian circumstances extremely well.' But he also warned Cornelius, in a letter of 8 May 1811, that such German 16th-century art should 'not be taken as perfectly preserved works'. Delacroix later illustrated the *Faust* material in

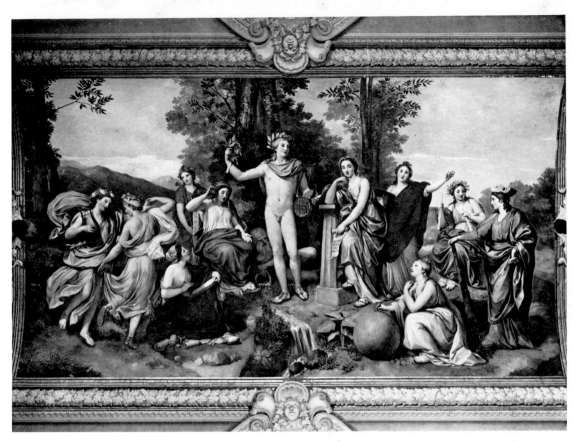

1 ANTON RAPHAEL MENGS *Parnassus* 1761

2 ASMUS JAKOB CARSTENS *Night with Her Children* 1794

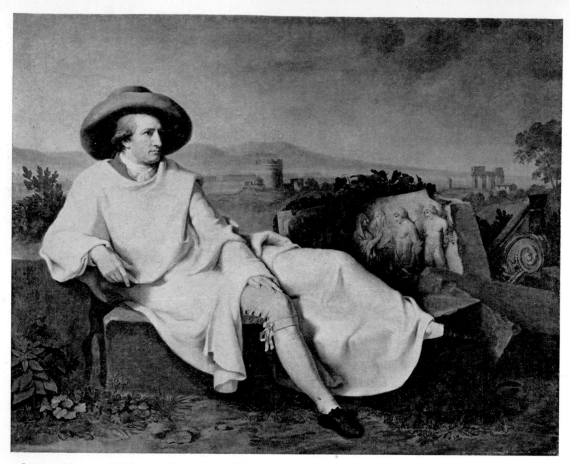

3 Johann Heinrich Wilhelm Tischbein *Goethe in the Roman Campagna* 1786–88

4 Anton Graff *Portrait of Count Henry XIII of Reuss* 1775

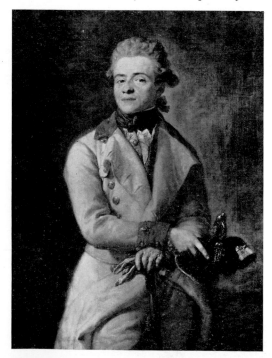

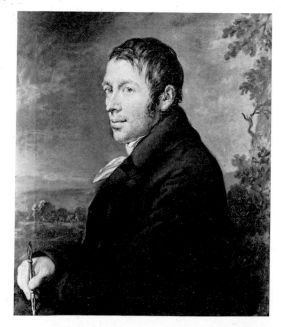

5 Anton Graff
Portrait of the painter Karl Ludwig Kaaz 1808

6 Photograph of Goethe's garden in Weimar

7 JENS JUEL *Inner Alster* 1764

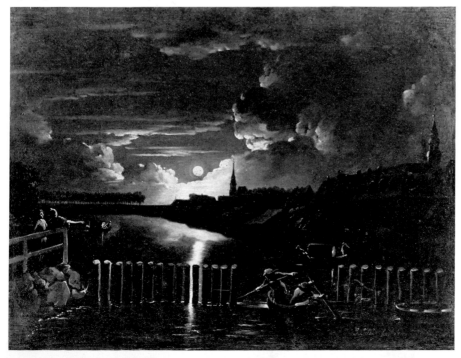

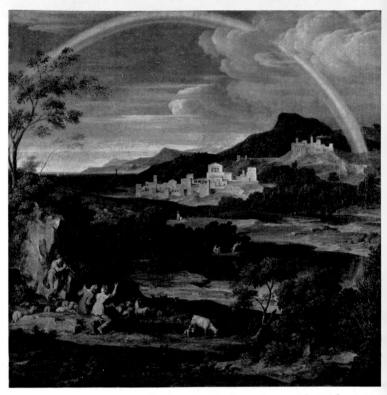

8 JOSEPH ANTON KOCH *Heroic Landscape with Rainbow* 1805

9 JOSEPH ANTON KOCH *Italian Vintage Festival c.* 1930

10 Friedrich Preller the Elder *Odysseus and Nausicaa* 1869

11 Philipp Otto Runge
The Nightingale's Lesson (drawing) 1801

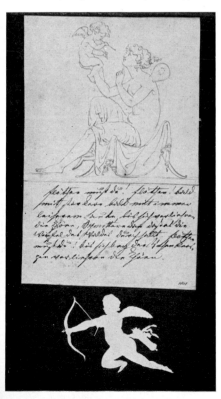

12 Philipp Otto Runge *Self-portrait* 1802–03

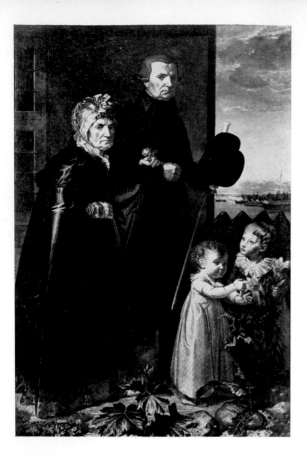

13 PHILIPP OTTO RUNGE
The Artist's Parents 1806

14 PHILIPP OTTO RUNGE
The Nightingale's Lesson 1805

15 PHILIPP OTTO RUNGE
Morning 1809

16 PHILIPP OTTO RUNGE
Rest on the Flight to Egypt 1805-06

17 PHILIPP OTTO RUNGE
Christ Walking on the Waters 1806-07

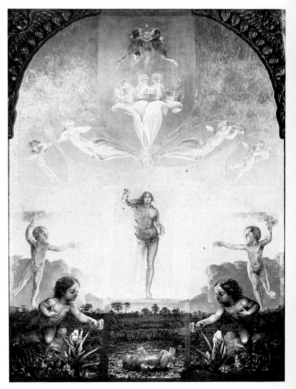

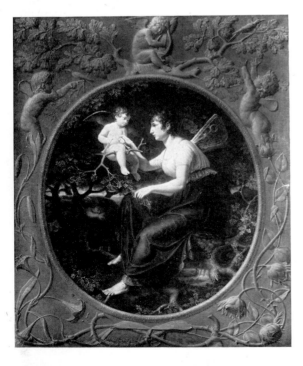

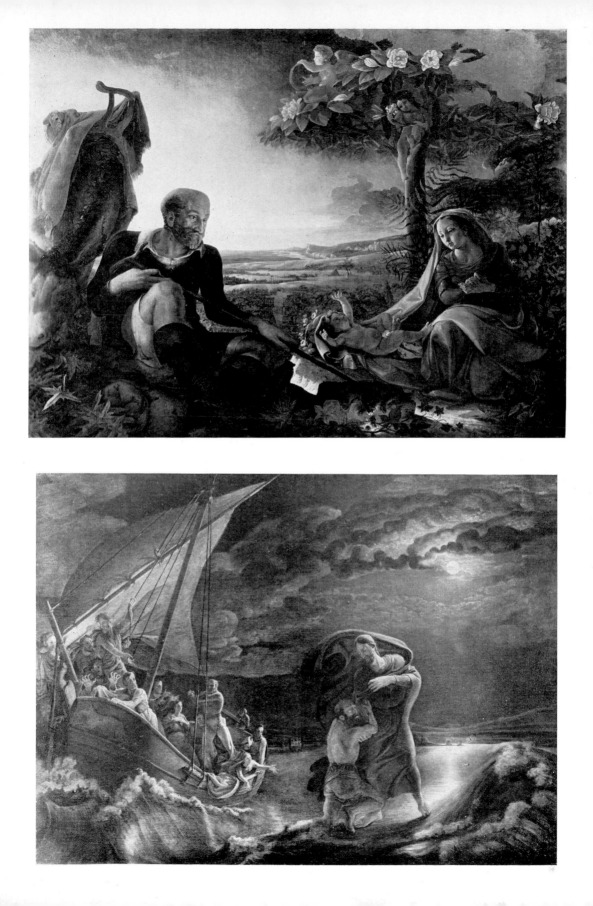

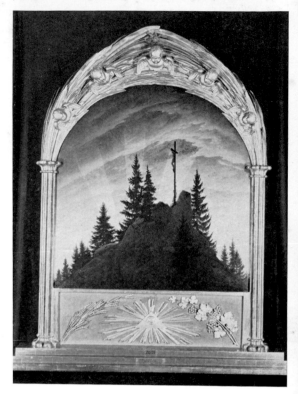

19 CASPAR DAVID FRIEDRICH
Cross in the Mountains ('Tetschener Altar') 1808

18 FRANZ GERHARD VON KÜGELGEN
Portrait of Caspar David Friedrich 1805-10

20 CASPAR DAVID FRIEDRICH *Cross in the 'Riesen' Mountains* 1811

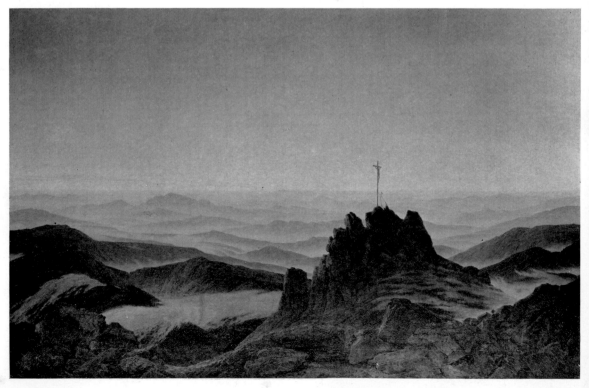

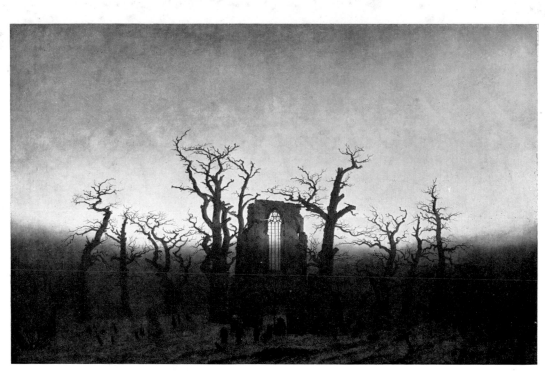

21 CASPAR DAVID FRIEDRICH *Abbey in the Oak Forest* 1809

22 CASPAR DAVID FRIEDRICH *Morning Light* 1806-07

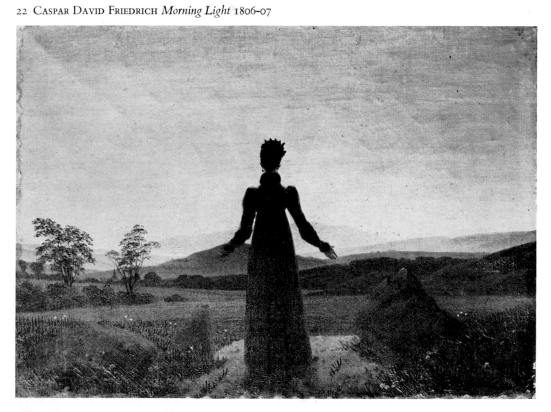

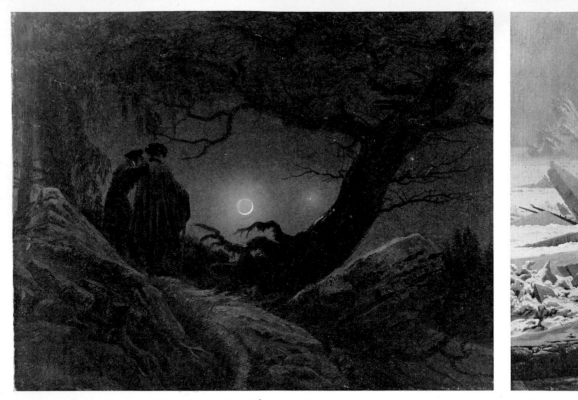

23 CASPAR DAVID FRIEDRICH *Two Men gazing at the moon* 1819

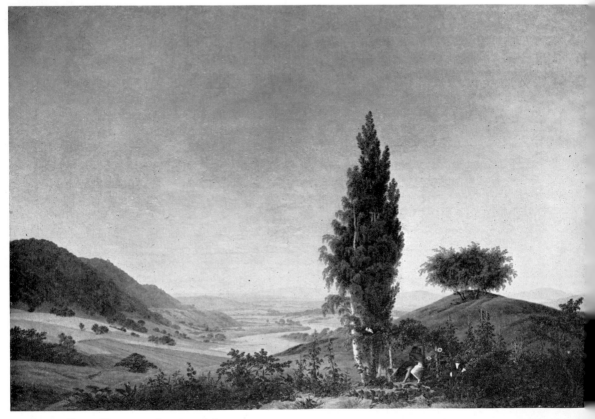

24 CASPAR DAVID FRIEDRICH *Summer* 1808

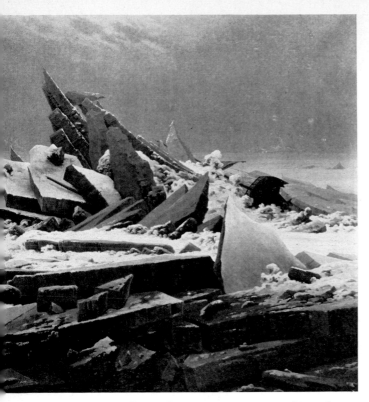

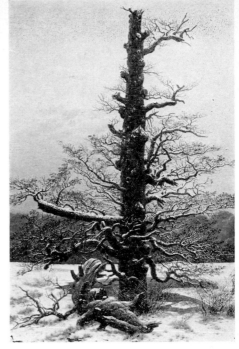

26 CASPAR DAVID FRIEDRICH
Oak Tree in Snow 1829

25 CASPAR DAVID FRIEDRICH *Arctic Shipwreck* 1824

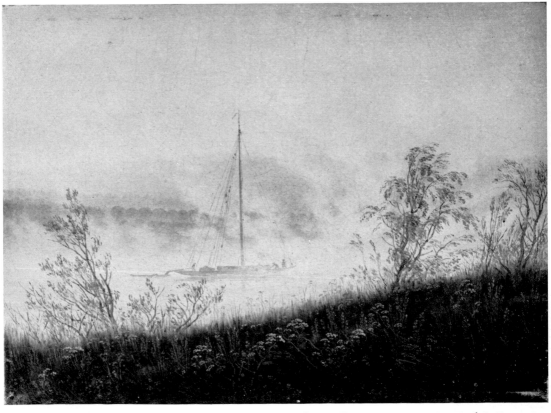

27 CASPAR DAVID FRIEDRICH *River Bank in Fog c.* 1822

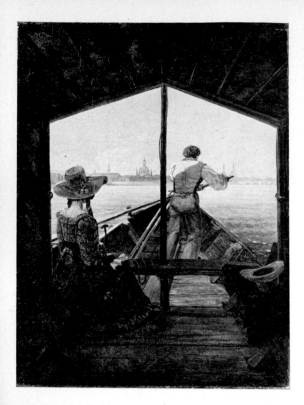

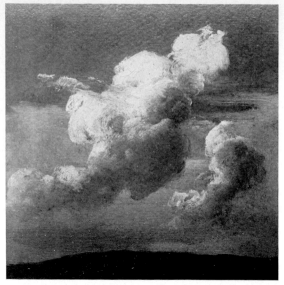

28 CARL GUSTAV CARUS
Boat Trip on the Elbe near Dresden 1827

29 JOHANN CHRISTIAN CLAUSEN DAHL
Cloud Study 1832

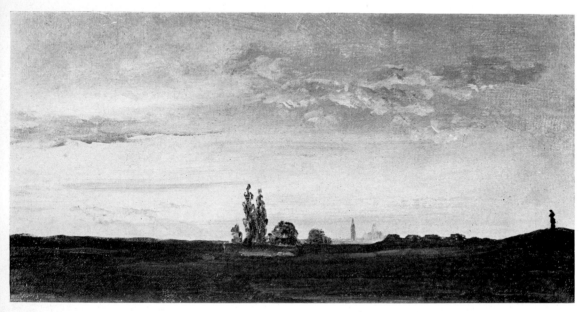

30 JOHANN CHRISTIAN CLAUSEN DAHL *Landscape Study* (View of Dresden) 1819

31 KARL FRIEDRICH SCHINKEL *Cathedral above a Town* 1813

32 FRIEDRICH JOHANN OVERBECK *Italy and Germany* 1828

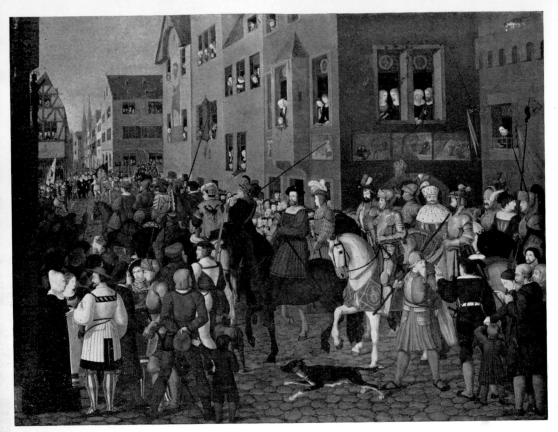

33 FRANZ PFORR *Entry of the Emperor Rudolf of Habsburg into Basle* 1810

34 PETER VON CORNELIUS *Faust and Mephistopheles at the Rabenstein* 1811

35 JOSEPH ANTON KOCH
View of Dante Room, Villa Massimo, Rome 1827-29

36 JULIUS SCHNORR VON CAROLSFELD
Ariosto Room, Villa Massimo, Rome 1818-27

37 FRIEDRICH JOHANN OVERBECK *Joseph is Sold by His Brothers* 1816-17

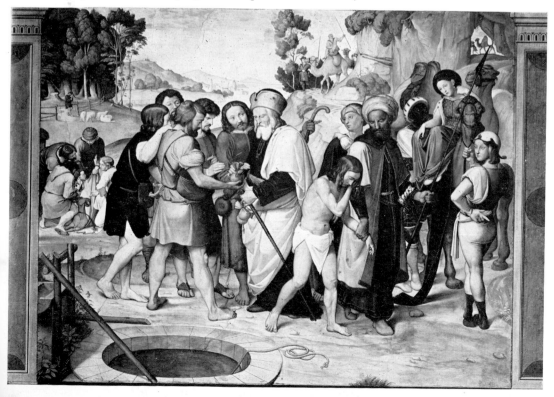

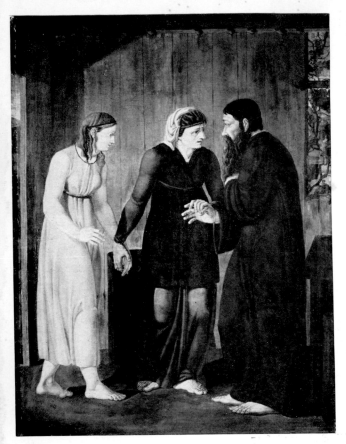

38 JOSEF WINTERGERST
Sarah leading Hagar to Abraham 1809

40 PHILIPP VEIT
Portrait of Baroness von Bernus 1838

39 JULIUS SCHNORR VON CAROLSFELD
Flight to Egypt 1828

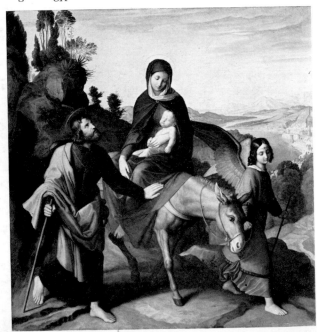

1828 and met with Goethe's partial approval, though the poet did not entirely renounce his reservations: 'Engraving and poetry usually parody each other.'

All these young artists felt themselves restricted and hampered in their youthful, enthusiastic search for artistic expression by the stiff, eclectic forms of teaching. They did not want to copy pictures, sketch costumes and study anatomy, but to create something from within themselves to bring reality to their subjective ideas—a mixture of emotions and deep feelings and aspirations. Overbeck and Pforr, who had known each other from their early student days in Lübeck under Peroux and now met again in Vienna, dreamed of a great painting which would take its subjects from the Bible and German sagas. They were acquainted with Wackenroder's *Outpourings of an Art-loving Monk* and demanded artistic feeling instead of rational understanding. Noble art ought primarily to be a thing which could be felt.

Soon like-minded students joined with Overbeck and Pforr. The more mature painter, Eberhard Wächter (1762–1852), who had studied in David's studio in Paris and had then painted in the Neoclassical style in Rome, supported the young men in their efforts. Lucas Vogel (1788–1879), Johann Konrad Hottinger (1788–1828), Josef Wintergerst (1783–1867) and Joseph Sutter (1781–1866) joined the circle. On 10 July 1809, the anniversary of their first meeting, they founded the 'Brotherhood of St Luke' in memory of the saint who was the patron of the medieval painters' guilds and according to tradition painted the Virgin Mary. Wackenroder's art-loving brotherhood of monks now became a reality. Cornelius wrote to Carl Mossler from Rome in March 1812, 'the Brotherhood of Monks is a company of quite admirable people who have formed themselves into a brotherhood to promote art and, in an exemplary way, to love one another'. On 20 June 1810, the young painters, excepting Sutter, left for Rome after the Academy had refused to accept them. When they arrived they were able at first to stay in the Villa Malta, due to the friendly intervention of the Director of the French Academy, and then three months later they found a permanent home in the Irish-Franciscan College of San Isidoro, which had been secularized by Napoleon. The members of the Brotherhood—Overbeck, Pforr, Vogel and Hottinger— each inhabited a cell here, came together for communal hymn-singing and prayer and for communal sessions of painting from models. Sketching was as much a ritual as prayer. Their programme was completed by excursions into the nearby Sabine hills and to Olevano, and by visits to the Vatican and particularly by study of the frescoes of Raphael and Pinturicchio. Their obviously German dress, their long flowing hair and their piety, gained these Fratelli di San Isidoro the nickname of 'Nazarenes', and it is by this name that they are remembered in the history of German painting.

This turning away from the Academy was not just an ostentatious protest against dictatorial teaching methods in the Neoclassical manner, but also indicated a hope that, by means of naïve piety, the lost unity of art and life could be regained. Before painting could be renewed, the heart must regain its original purity by turning back to the Catholic religion, and accordingly the members of the Brotherhood of St Luke were converted to Catholicism.

Their art was therefore not justified by any aesthetic system, but by their religious faith.

On leaving the Academy the four young painters had each brought a half-finished painting with him to Rome. Friedrich Overbeck brought *An Entry into Jerusalem*, which he completed in 1824, and Franz Pforr a painting called *The Entry of the Emperor Rudolf of Habsburg into Basle in 1273* (1810, Frankfurt). Overbeck concentrated almost exclusively on the religious content of the picture, but Pforr was more concerned with bringing the medieval world to life. Since German Romanticism was fond of taking inspiration from German history, such a national theme was entirely legitimate for a history painting—but at a time when Roman and Greek events in the Neoclassical sense were still the only subjects of history painting as taught in the Academies. Pforr's picture shows how spontaneously and naïvely the artists at first undertook the mastery of this new material. Although Passavant had sent Pforr on request a sketch of what Basle actually looked like at the time of the Emperor Rudolf, Pforr placed little value on it because it did not fit in with his Romantic idea of the medieval town. The fact that a 13th-century event should be depicted in 16th-century costume did not seem an anachronism to the Romantics, since they were concerned with creating a total impression from a combination of known fact and free invention, which would have its effect on the senses. The artist doubtless took the motif of the entry from late medieval representations of Christ's entry into Jerusalem or from Martin Schongauer's engraving of *Christ carrying the Cross*. Keith Andrews points out that the figures look as if they came from a picture-book, and refers to woodcuts in Münster's *Cosmography* and A. Holbein's *Nollhart* (1517). The picture aims to conjure up the spirit, the general mood and total piety of the Middle Ages, rather than to represent an historical occurrence and render it credible. Thus Pforr's picture is a conscious attempt to bring to life the early German style of painting, and also the late Gothic era. The deliberate naïveté of both subject and form emerges from Pforr's nostalgic admiration for the Middle Ages as the flowering of Catholicism and Christianity, when consciousness had not yet been split into the two extremes of the individual ego and the world, and religion was still the universal basis for life and art.

By deliberately turning away from the dominating spirit of modern times, and by the intense emotional attempt to return to the primitive, naïve state of medieval man, for whom Christianity was something sacred, the Nazarenes hoped to dedicate their life and work to the Catholic religion. At first their work appears naïve, as for example in Josef Wintergerst's first oil, *Sarah leading Hagar to Abraham* (Berlin), which he painted in Vienna in 1809 under the guidance of Eberhard Wächter and Friedrich Overbeck. In spite of obvious formal deficiencies, the work has an air of sincerity and determination which gives it a genuine, spontaneous appeal. But when the Nazarenes tried to take over the art of a mature epoch, like that of Raphael, the difference between their naïve simplicity and intellectual knowledge of a perfect art form, which had not been achieved by naïveté but by the reflection and intellectual effort of a genius, became evident.

Plate 33

Plate 38

The Brotherhood of St Luke thought of themselves as a brotherhood of friends, and that too is completely Romantic. They gave each other portraits as proof of their friendship, as for instance Overbeck's *Portrait of Pforr* (1810–12, Berlin), which shows him in a Gothic interior, surrounded by symbols of friendship and Christian love. Cornelius and Overbeck drew each other side by side in 1812 (Munich), for their common friend D. Christian Schlosser. The double portrait is one of the most precious documents of Romantic portrait drawing, in which the heritage of the German Renaissance lives on through Cornelius's and Overbeck's individual styles.

Pforr's *Sulamite and Maria* (1811, Schweinfurt), a subject taken from the Song of Solomon and from an ode by Klopstock, and in which Sulamite, represented by Overbeck, symbolizes the south, and Maria, represented by Pforr, the north, is an allegory of their friendship, which Overbeck tried to reproduce in his *Italy and Germany* (1811–28, Munich). This was intended as *Plate 32* the complementary picture to *Sulamite and Maria*, and was to have been a present for Pforr, but it was not finished until 1812, by which time Pforr was dead.

The Overbeck picture is probably based on two sketches by Pforr entitled *Allegory of Friendship* (1808, Frankfurt), in which two brides wearing wreaths embrace each other. At the request of Friedrich Wenner, Overbeck resumed work on the picture in 1815 and completed it in 1828. Its historical importance derives more from its subject than from the artistic form. Although it was primarily intended as an expression of his friendship for Pforr, Overbeck extended the meaning to include an allegory of friendship and a symbol of the desired synthesis of style of German and Italian art.

On 31 January 1829, Overbeck wrote to Wenner, 'The fact that I chose precisely the idea of a "Germania" and an "Italia" arises from my particular position here as a GERMAN IN ITALY. It gives the two elements at once and though, on the one hand, they stand in opposition to one another, it was my task to unite them, at least in the exterior form, and I always think of them as being united by an intimate and beautiful friendship. . . . What I really mean to portray, to put it in a more general way, is the yearning which the north always has for the south, for its art, its nature, its poetry, and I wanted to portray this in the form of a bride adorned for her wedding, which would represent both her own yearning and the object of her love.'

When Franz Pforr died in July 1812, the Brotherhood was really at an end. The Brothers gave up their cloistered isolation in San Isidoro and the threads which bound them together became looser. In 1811, Peter Cornelius had joined the circle, taking the place of Hottinger. In addition, the brothers Rudolph and Wilhelm von Schadow and the brothers Johann and Philipp Veit also joined the circle of the 'Dürerists', as they were now known. Cornelius became the leader, and it was his intellectual and artistic gifts which were employed to develop and extend the work of the Brotherhood in the public sphere. The pious life in the monastery developed into a movement of renewal in German painting which was desirous of obtaining commissions and recognition.

These painters, most of all Cornelius, wanted to erect a monument to themselves and to the times in which they were living, and this monument was to be a building in which all the arts were united.

This tendency towards the monumental was intimately bound up with the awakening of German national feeling at the beginning of the 19th century. The Nazarenes dreamed of a new edifice of German art, a holy temple, and they believed they had paved the way towards this. It was on Italian soil that they found the first patrons who provided them with commissions for monumental frescoes. Cornelius had convinced the Prussian Ambassador in Rome, Barthold Georg Niebuhr, of his enthusiastic idea of a renewal of fresco painting, and Niebuhr tried to get the Berlin authorities to offer commissions for frescoes in the new Berlin Cathedral, designed by Schinkel; but success was long in coming. It was the Prussian General Consul in Rome, Jakob Salomon Bartholdy, who in 1815 offered the Nazarenes a little room in his residence, the Palazzo Zuccari (now the Bibliotheca Hertziana), and invited them to decorate it with frescoes. Cornelius and Overbeck, who had the principal part in carrying out the work, were not thinking merely of decorating the room in ornamental fashion. They saw here the opportunity to relate the Old Testament story of Joseph in majestic forms. Overbeck had already been working, in 1812, on *The Finding of Joseph* and *Joseph's Blessing*.

Plate 37 In the Casa Bartholdy he had the job of painting the frescoes *Joseph being sold by His Brothers* and the lunette *The Seven Lean Years*. Cornelius chose to do *The Finding of Joseph* and others who offered their services were Wilhelm von Schadow, Philipp Veit, and the landscape painter Franz Catel, who designed the landscape lunettes above the doors. The frescoes were begun in 1816 and completed in 1817. (In 1887 they were transferred to the National Gallery in Berlin.) They are the first communal work of the Nazarenes. In many of them the compositions are reminiscent of Raphael and Pinturicchio, whose work the German painters admired in the Vatican and in the Villa Farnesina. If one takes into consideration the fact that the technique of fresco painting had been forgotten for a long time and that the young painters were at first unskilled in this type of work, one must admit that the Bartholdy frescoes represent an amazing technical achievement.

In addition to the effectively decorative, late Gothic style of Philipp Veit's work (*The Seven Fat Years* and *Joseph and Potiphar's Wife*) and the academic, slightly gauche creations of Wilhelm von Schadow (*The Blood-soaked Robe* and *Joseph in Prison*), the frescoes of Overbeck and Cornelius are particularly
Plate 37 powerful and impressive. Overbeck's *Joseph being sold by His Brothers* appears to be the most typical work of the whole cycle. Although one can point to many Italian motifs, the whole composition is nevertheless in the style of German painting. We know that Overbeck and Pforr had already had the opportunity to become acquainted with early Dutch and German painting in the Emperor's Gallery at the Belvedere in Vienna. The reticence in the coloration which, at best, shows a variation in the shades of brown with the addition of yellows and reds, makes clearer the fine linear qualities of the composition, whose theme is divided into two separate moments; on the left-hand side the

52

brothers are bargaining and on the right Joseph is being led away. Overbeck's second work for the Casa Bartholdy, *The Seven Lean Years*, is divided sharply in a rhythmical manner and has a very formal architectural structure.

Cornelius is the most theatrical of the Nazarenes: the way in which he places groups of figures in front of pieces of architectural scenery, and also creates a pseudo-Baroque or mannered world of forms out of gesture, is extremely important. His *Interpretation of Joseph's Dream* stresses particularly the clarity of the figures: most of all in the stress laid on contour which leads one to feel that this may be derivative of the work of Signorelli. Cornelius has arranged his figures in front of pieces of classical architecture as if they were engaged in learned disputation. The area of the picture has become like a theatrical set on which actors move about. His second fresco, *Joseph is Recognized by His Brothers*, is also distinguished by a consciously formal struc- *Plate IV*
ture; whereas in the preparatory sketch (Vienna, Albertina), the frame of the picture encloses the figures in the circular manner, in the fresco he uses parallel planes by arranging individual architectural elements as a kind of set, in order to allow the eye to penetrate to the background behind the figures. In comparison to Overbeck, his use of colour is richer and has a greater fullness of nuance. The scale of colours ranges from light green via blue and yellow to red. In the bearded man kneeling, in his long cloak with many folds, one can see traces of early German style, but the figure approaching from the right displays rather mannered elements with his exaggerated gesture. The whole composition, especially the interplay between classical architecture and the figures, is very reminiscent of David's Neoclassicism.

When the frescoes were finished, German artists and critics agreed that German painting had discovered its way to monumental art. In their enthusiasm over the fact that German painters had now at last managed to erect a fitting monument to themselves and their generation, people forgot that there was no genuine *magnum opus* among the work. The individual compositions were far too derivative of previous styles. They lacked that originality which would have given the chosen theme and form the desired impetus towards monumentality. Basically, the works were the result of a naïve intention and an eclectic, somewhat false manner, although many compositions, like those of Overbeck, certainly approach greatness. But the works of the Nazarenes could scarcely hold their own in the city where the frescoes of Raphael and Michelangelo were to be seen. Thorvaldsen and Canova did indeed praise the Bartholdy frescoes, and the latter secured for Philipp Veit a very honourable commission, that of painting a fresco in the Museo Chiaramoni in the Vatican, in honour of the Pope, to be entitled *The Triumph of Religion*. But those frescoes were to have an important influence on German history painting in the 19th century, where the cartoon became more important than the use of colour and movement.

The Germans had hardly finished their work in the Casa Bartholdy when they obtained a further commission, this time from the Marchese Carlo Massimo. In the absence of indigenous artists he had turned to Cornelius and asked him and his friends to decorate his garden house near the Lateran Church

Plate 35

with frescoes illustrating the works of Dante, Tasso, Petrarch and Ariosto. Four rooms were originally planned, but only three, and those after considerable delay, were eventually completed in 1829. The whole undertaking was constantly disturbed by interruptions, largely caused by Cornelius going to Munich, in 1819, at the request of Crown Prince Ludwig of Bavaria. Cornelius had first of all designed the ceiling for the Dante room and this preparatory idea was to contain a summary of Dante's *Divine Comedy*. While the more picturesque and narrative motifs from the poem were meant to figure on the side walls of the room, the ceiling was conceived as containing major figures from the work gathered around the Holy Trinity. The didactic element is stressed, rather than the visionary one, as, for example, in Delacroix' *Dante and Virgil* (1822, Paris). Cornelius chose Franz Horny to do the lunettes and he wanted to decorate them with motifs from plants and flowers. When Cornelius left for Munich, Horny was also most generously freed from his obligations by the Marchese Massimo. Following this, therefore, the work in the Villa Massimo remained in the hands of Overbeck, who had already begun work on the Tasso room. As a replacement for Cornelius, the Marchese Massimo turned to Joseph Anton Koch, who, although he refused the work, declared himself ready to act as intermediary. The choice finally fell on Philipp Veit, who had already made himself a considerable reputation as a result of his works in the Casa Bartholdy and in the Vatican. Veit, however, agreed only after long hesitation, because he knew what Cornelius had planned in his cartoon and did not feel adequate to undertake such a great task. In his Dante ceiling, the great rhetorical gesture of Cornelius has been reduced to a rather summary accumulation of standing figures. The unity of space and movement envisaged by Cornelius was disrupted by the fact that the picture did not harmonize sufficiently with the architectural structure, and also because the individual figures were too large for the total conception. The disproportion in Veit's picture can also be put down to the fact that his stepfather, Friedrich Schlegel, had advised him that the individual figures should reflect their mystical experiences; but this, although Veit tried to indicate it by various additional attributes, nevertheless robbed the whole of its freshness. Veit managed only with difficulty to complete the ceiling, and thereupon told the Marchese that he would be unable to complete the further work which he had agreed to do. In this difficult situation, Massimo asked Koch to complete his Dante room. Touched by this appeal, Koch finally agreed to complete the remaining work. His real *métier* was landscape painting; so far he had not tried his hand at figure painting. He knew the *Divine Comedy* well and tried to treat the material in a genuinely Romantic way. His numerous illustrations to Dante's works had already shown a kind of translation of Flaxman's outline illustrations into early German style, but in essence their form was still based on the Neoclassical inheritance, as can be seen in his landscape paintings. His more than life-size figures fill up the walls, and the element of landscape, as in the *Ship of Souls* and *Mount Purgatory*, provides an additional motif, while the figures, in an imitative classical style, which can be seen in their dress as well as in their gestures, possess a certain naïve modesty,

and their draperies remind one of the softness of Raphael. The frescoes *The Sleeping Dante* and *Dante is Freed by Virgil* do, however, finally show more landscape, and these two scenes are both composed on the same wall. Landscape is used here as a backcloth and although it still reflects Koch's ideal landscape-art, it already points forward to late Romanticism, as for example in Moritz von Schwind's *Count von Schleichen* (1864, Munich). Fantasy dominates nature: tree roots are torn out of the earth, foliage and fir trees set against the light of Heaven, plant forms stylized until they become ornamental. And all this indicates an essentially illustrative extension of nature and space.

Plate 35

Meanwhile, Overbeck had decorated the back room of the Villa Massimo, which looks out over the garden, with the pictures from Tasso's *Gerusalemme Liberate*. In the fresco *Preparation for the Siege of Jerusalem* one can find motifs taken from Raphael's *School of Athens*—for example, the group of people standing on the right-hand side—and these motifs are freely linked with German elements. In one sense, Overbeck has made here a stylized development from his picture *Joseph being sold by His Brothers* in the Casa Bartholdy. The picture has gained in clarity and depth, the groups are more clearly differentiated; but the initial arrangement still has the function of making the picture into a kind of relief.

Plate 37

When the Marchese Massimo died in 1827, Overbeck released himself from his obligations and hurried off to Assisi in order to dedicate himself again to religious art; he painted *The Miracle of the Rose* in the Church of St Mary of the Angels. He was inspired by religious conviction, having been converted from the Protestant faith to Catholicism in 1813, and felt that he had neglected this in undertaking the cycle of frescoes in the Villa Massimo.

Overbeck's artistic inspiration derived from the works of the young Raphael and from Perugino. His conversion was the external acknowledgment of his inner dedication to Catholic art. By paying homage exclusively to the old masters and by choosing religious subjects, he made his work the very epitome of German 'intellectual painting', which exerted a not inconsiderable influence on the English Pre-Raphaelites and the Frenchman P. J. Chenavard. Though Overbeck was the honoured leader of the German artists' colony, his works soon degenerated into the sentimental in their exaggerated fidelity to Raphael. They display the external signs of Romanticism's religious sensibility, which adopted a historical style in order to take on the old master's way of thinking. This fundamental discrepancy is the cause of the failure of his art.

Finally, Josef von Führich completed the work which Overbeck had begun in the Tasso room, but it cost him great effort. Julius Schnorr von Carolsfeld (1797–1872) had come to Rome in 1818 and joined the Nazarenes. He remained the only one, however, who was to stay true to his Protestant faith. It fell to him to decorate the third room in the Villa Massimo with scenes from Ariosto. This was the only room which one single artist had undertaken on his own, and this means that it preserves a considerable unity. In his picture illustrating *Orlando Furioso*, Schnorr stresses the poetic and lyrical element,

and the extremely mobile scenes reflect the historical aspect. It is generally considered that Schnorr's frescoes mark the beginning of his decline as a painter, and this certainly did occur later, for instance, in the frescoes illustrating the Siegfried saga in the Munich Residenz; however, this view is only partly justified. Schnorr remained true to his personal ideals, as can be seen, *Plate 39* for instance, in a religious picture like the *Flight to Egypt* (1828, Düsseldorf).

Overbeck had executed his frescoes in the early German style. Cornelius had achieved in his a synthesis of late Gothic and Italian Renaissance, but Schnorr was the only one to succeed in reformulating in a personal and convincing manner the formal doctrine of the Renaissance. He was also the only Nazarene painter who was not dominated by the style of the 'sweet' Italians. His fresco *Charlemagne's Army in Paris* has a continuous development in depth, in which the figures can move freely and thus gain a certain mobility. The architectural elements on the sides form a frame to the picture and direct the eye towards its depth. Various effects are used to give the fresco an illusion of depth in which the observer participates, and the basis of this is a Baroque quality which can also be found in Schnorr's *Battle of the Adouza*. Whereas Koch's figures stand out larger than life-size on the walls, Schnorr has achieved a degree of harmony between the figures and space. The Ariosto room is the most pleasing of the Villa Massimo ensemble; here one feels that Schnorr has been able to produce narrative effects in an easy manner. In an ideal landscape, reminiscent of Carl Philipp Fohr (Schnorr had lived together with Fohr in the Palazzo Caffarelli, and this might be an explanation of the similarity), one finds figures which have an ornamental mobility. The theme of battle offers the possibility of all sorts of foreshortened positions which are based on models from the Renaissance, from Raphael to Tintoretto.

On seeing Schnorr's frescoes in 1824, Karl Friedrich Schinkel exclaimed that they were 'by far the finest. The colour, if perhaps not finer or more stylized, is stronger than in any other of the old pictures of the new period, as they appear to us today. One can see here that the Protestant Schnorr has achieved much greater effects of delicacy and originality than the two Catholics, Veit and Overbeck.'

The Nazarenes' programme, especially that of Overbeck and Pforr, was uniquely determined by the Christian ethos. In this they followed the programme of German early Romanticism, as laid down by Tieck, Wackenroder and Friedrich Schlegel. But it was too easy for the pious intention to deteriorate into tendentiousness and finally into ideology. What followed the early works of the Nazarenes in Rome began to look more and more like sentimental, falsely pious painting, which unfortunately lent weight to the growing prejudice against them. Their idea of forming a Brotherhood replaced the profane institution of an Academy; art was to be renewed by means of emotion and feeling. Although at the beginning they protested against the eclectic methods of academic teaching, later on, when most of them obtained professorships in the most important German Academies, they themselves preached their ideas as irreversible dogma. In place of the Neoclassical idea of restoration based on Antiquity, they propounded the restoration of the

I PHILIPP OTTO RUNGE *The Hülsenbeck Children* 1805/06
II CASPAR DAVID FRIEDRICH *Meadows near Greifswald c.* 1818
III GOTTLIEB SCHICK *Portrait of Frau von Cotta* 1802

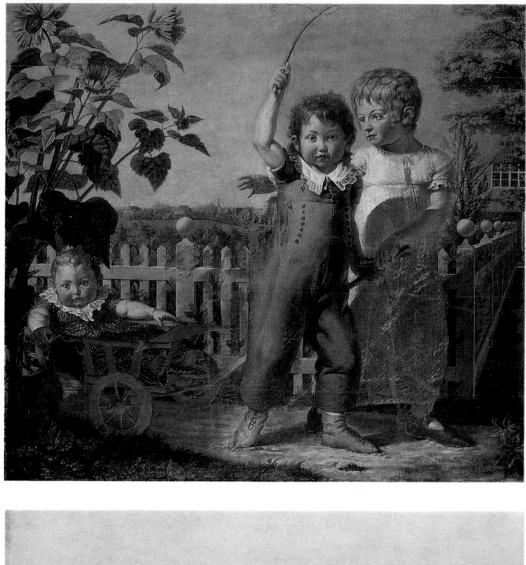

I

II

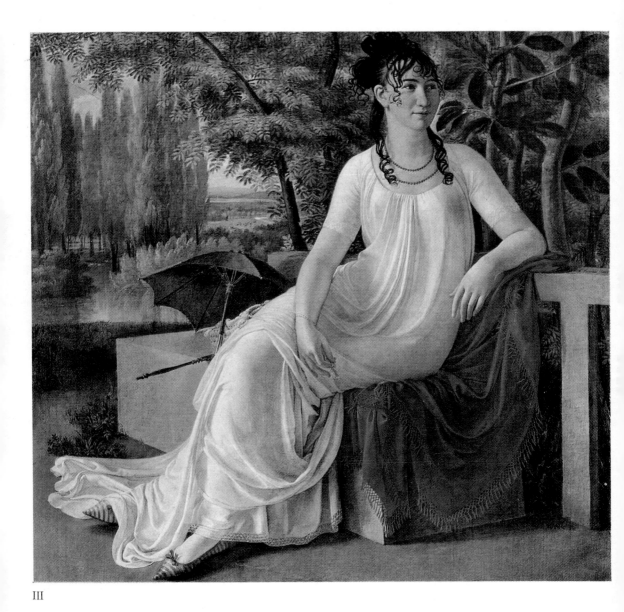

III

IV

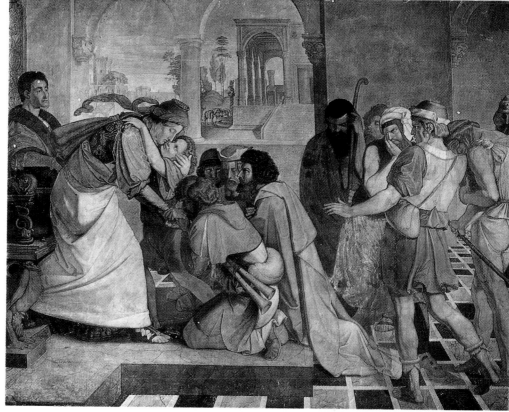

V

VI

VII

Christian Middle Ages, too often in a poor imitation of the Renaissance. The way they exclusively followed forms already in existence in the frescoes of Giotto up to Tintoretto and in history painting made their work eclectic because they lacked the element of direct perception of nature.

The longed-for synthesis of Italian and German art styles was bound to fail because of the obvious contrast between deliberate naïveté, which is so striking in the art of the Primitives, and the knowledge of perfect form in the flowering of the Renaissance; and this contrast could not be resolved. It is the conflict between feeling and thinking.

The Romantic elements of the Nazarenes' work are mostly to be seen in their piety, naïveté and somewhat precocious ability, which all too often led to a truly Romantic end through tuberculosis.

There were a number of young German artists in Rome who certainly sympathized with the Nazarenes, but nevertheless distinguished themselves from them by taking as their inspiration direct observation of nature. For them, nature was the decisive formal experience, whereas for the Nazarenes Christian religion and history had laid down the lines on which their art developed. The attempt at monumental art failed, but there were two fruitful results of this earlier period of Rome-based German painting—portraiture and landscape art. The latter, in contrast to the pictorial innovations of Caspar David Friedrich, bears the stamp of an idealistic or heroic attitude to landscape, which had developed in Italy from the time of the Caracci, Domenichino and Poussin, and had been revived by Joseph Anton Koch. The young Romantics —Fohr, Schnorr von Carolsfeld, Horny and Ramboux—who had come to Rome between 1816 and 1818 brought with them a new freshness of observation and a spontaneous approach. Unburdened by the ideologies which characterized the Nazarenes, they painted landscapes and portraits which revealed a hidden treasure of German Romanticism in Rome.

The pencil, which had only just been invented, allowed a technique of line as exact as Dürer had achieved with the pen. 'One could not sharpen the pen too much for them,' remarked Adrian Ludwig Richter. The line, an abstract form of sensuous appearance, is an old artistic medium, but it never achieved such purity as in the works of these artists. For Friedrich and Runge the observation of nature contained an element of predominantly religious subjectivity: for the Nazarenes Overbeck, Pforr and Cornelius, observation of nature was too often merely a secondary result of the study of religious paintings of earlier epochs, but Fohr and Horny made immediacy of perception of natural objects, the musical element in the choice and use of line and colour, and a gracious nobility of individual forms, the characteristic qualities of their art.

The most brilliant representative of these Romantics was doubtless Karl Philipp Fohr (1795–1818), who was born in Heidelberg, a city with many Romantic associations. Unfortunately his almost excessively rich talent was never fully developed, for when he was 22 years old he died bathing in the Tiber. The *Self-portrait* of 1816 (Heidelberg) was probably drawn before *Plate 41*

Fohr's departure for Italy in the same year, and was intended as a departing present for his parents. Stylistically it is very similar to the portrait sketch *Ludwig Simon in front of the Friedrich Building in Heidelberg Castle* (Detroit), which also dates from 1816. It is a fine example of that delicate and sensitive portrait-sketching of the Romantics in which the world of youth acknowledged its own qualities, especially that of the perfection of youth itself. This, too, was a typical part of the Romantic view of life. Long hair frames the delicate, spiritual face; the eyes are sunk in reflection; the soft but firmly drawn line follows the contours of the face from the right eyebrow over the bridge of the nose and the mouth to the chin. The technical qualities of this drawing are rich in their simplicity. It is just this restraint in the use of line and hatching which serves to contrast light and dark areas, and promotes an interplay of delicately graded shading.

In Rome, where Fohr joined Schnorr von Carolsfeld and Koch, he planned to execute a group portrait of all the German artists in the Caffè Greco near the Spanish Steps: he intended this to be an etching. It was never completed because of his death, but a series of impressive portrait sketches has survived, as well as two sketches for the final composition, in which the artists are grouped round the old Koch on the left, and round Cornelius and Overbeck on the right. There is no feeling of forced monumentality or literary stiffness, as was the case in most of the group portraits of the time. The studies for the individual portraits are executed with great freshness and spontaneity; they are among the best portrait drawings of this epoch.

Johann Anton Ramboux (1790–1866), who was born in Trier, came to Rome in 1816. The ties he first established with the Nazarenes were loosened by his acquaintance with Schnorr von Carolsfeld, Fohr, Horny, and Koch. His art of portraiture demonstrates his switch from the Neoclassical type of portrait-painting to the Romantic type, which Ramboux was largely instrumental in extending. His drawings show an intensification of the spiritual qualities and a heightening of the dignity and importance of the human face, and this is achieved by the use of contours whose line is razor sharp, by delicate modelling and by exact observation of the subject. One can see echoes, conscious or unconscious, of early German painting in the ornamental treatment of the hair, in the penetrating glance, and in the deliberately emphasized simplicity. The *Portrait of the Eberhard Brothers* (1822, Cologne) was no doubt the crowning point of his portraiture, and it is of the popular 'double' portrait type. In the same year, Ramboux returned to Germany, and from that time onwards devoted himself principally to drawing ancient monuments in his home town of Trier, and publishing the results as lithographs. The frescoes of *Life in the Country*, painted between 1826 and 1828, for the town-house of the vineyard proprietor M. J. Hayn of Trier, are among the few monumental paintings of the early epoch to be found in Germany, in which grace and richness of form are pleasingly combined.

In his portraiture Overbeck shows himself to be a true Romantic, and in this sphere he achieved very sensitive small-scale masterpieces. The *Portrait of*
Plate 42 *the Painter J. C. Eggers* (1816–20, Karlsruhe) seems to link stylistically with

Overbeck's early portraits in his Vienna days, such as the *Portrait of a Young Man* (1807, Hamburg).

Julius Schnorr von Carolsfeld's portrait sketches are of extraordinary artistic quality. He was accustomed to signing his drawings in the manner of the Old Masters, and the balance of formal arrangement, the interplay of light and shade, and the ornamental quality of line are certainly still derivative of early German portraiture, but they have taken on Romantic qualities. Among the German artists working in Rome he was the most gifted draughtsman. His outline was faultless, the hatching feather-like, expressing the unconscious grace of the female body. His study of a *Female Nude* (1820, Dresden) *Plate 44* shows the delicacy of the interplay between fine but firm outline, and the enclosed hatching. The early German graphic element has been transformed by the infusion of Romantic feeling. The plasticity of the body arises from the interplay of clear line and delicate gradations of light and shade.

Portraits have rarely achieved such a high degree of refined delicacy and suppleness of contour in the finished painted versions. However, Schnorr's picture of *Frau Bianca Quandt* (1820, Berlin) is a particularly beautiful example, *Plate 43* which unquestionably goes back to the type of painting Raphael created in, for instance, *Joanna of Aragon* in the Louvre. From the fact that the portrait is unfinished, as for example in the right hand and in the viola, we can deduce that it was to have been completed by a definite date, during the time that the Quandts were spending in Rome during the winter of 1819–20. Poetry, nature and music come together in the portrait. The Raphaelesque composition has taken on Romantic elements especially in the rich glowing red of Bianca Quandt's dress. The posture serves as a lyrical link with the mountainous landscape in the background.

Heinrich Maria von Hess (1798–1863) lived in Rome on a grant in the years 1821 to 1826 after training in the Munich Academy, and he was then appointed Professor in Munich. His portrait of Vittoria Caldoni (1823, Lübeck), one of the favourite models of the German painters in Rome, is among the best of its time. Hess's contact with the Nazarenes may account for the noble posture, but this work can be distinguished from their portrait-painting in its strong, delicate feeling for nature, as we have seen already in Schnorr's work.

Koch had rediscovered and renewed heroic landscape painting, and had invested it with Romantic feeling for Nature; thus his landscape sketches from the later years possess great clarity and precision in the use of line, which have the effect of making the geological structure appear like a diagram. It is a different matter with those other artists of the generation of Fohr and Horny, although they looked on Koch as their teacher and master in the art of landscape, and followed his lead even to the point of working together with him in his studio. In spite of this, they saw and interpreted nature in a different way. In Fohr's *Landscape near Rocca Canterano* (1818, Darmstadt) we find the *Plate 45* synthesis of Koch's ideal landscape and north German nature and Romanticism. In this as well, Fohr and Horny are different from the Nazarenes because the latter showed no interest in landscape but felt that history painting was the most important aspect of art.

Fohr studied first under the landscape painter Friedrich Rottmann in Heidelberg, and from 1807 to 1810 he learned landscape painting in the Dutch style of the 17th century. This consisted of very faithful representation of landscape with accessories. The painter Georg Wilhelm Issel became interested in the young Fohr, and persuaded him to study 'free' nature. In 1813 the historian and pedagogue, Philipp Dieffenbach, introduced him to the Court in Hessen, and Fohr prepared his famous sketch-books, filled with subjects drawn on a journey through Baden and the Neckar region, for the Crown Princess. Dieffenbach tells us of the pilgrimage on foot, which they made together in 1814. 'His delight was almost boundless. No wonder—even the sight of a not particularly beautiful region, or of a beautifully formed tree, could move him to tears. For the first few days our friend was rendered speechless; all he could do was just look. When he had returned home, his first thought was to get down on paper everything which he had seen and felt.' This artistic expression of feeling is a typically Romantic activity and transforms observation of nature into a kind of musical nature poetry, as in *Plate 46* his unfinished watercolour *Hornberg on the Neckar* (1814, Darmstadt). In the balance of light and shade, and in the gradations of the pictorial area produced by a delicate watercolour technique which lays stress on the qualities of painting rather than on those of drawings, Fohr is here paving the way for his mature watercolour landscapes, executed on his walking-tour in the Tyrol and during his stay in Rome.

Plate 8 During a visit to Munich in 1815, Fohr had the opportunity of seeing Koch's *Heroic Landscape with Rainbow* (1805, Munich), and this was an illuminating experience in relation to his artistic vision. His journey through the Tyrolean mountains also became a decisive experience for him. All this served to detach him further and further from the late Baroque style of landscape art. The watercolours he executed in the Tyrol have broad washes of colour, and a use of line which is not just intended to clarify individual details, but is used rather in a structural manner to transform appearance into artistic form.

Fohr came to Rome in 1816, and it was there that he painted his greatest landscape. His *Waterfalls at Tivoli* (1817) was a heightening of the heroic aspect of landscape seen in Koch. It was no longer the subject which came first, but observation of the space of the landscape, and its infinite extent was given poetic interpretation by means of formal reduction or intensification. This is not abstraction, because the freedom of the subject is increased rather than diminished. It is poetic because the imagination can conceive a feeling of space in depth, and at the same time can transcend this. Reduction therefore means freeing the individual motif from its shackles in detailed existence and, by means of artistic form, extending it and giving it a new freedom, thus not only retaining its individuality but also giving it general significance within the chosen pictorial context. That is the secret of Fohr's landscape art, and it can best be seen in his last and almost completed great picture, *Landscape near* *Plate 45* *Rocca Canterano*. In the last year of his life, while working on this landscape, Fohr had been studying the use of colour in the paintings of the Venetian School, especially Titian, and the *Landscape near Rocca Canterano* seems to

reflect the almost autumnal tones of Giorgione's world, where this young Romantic, who was so soon to die, took leave in a lyrical, melancholy fashion.

Fohr had made his landscapes grandiose constructions of areas of colour and freely flowing lines, but Franz Horny (1798–1824) was more concerned to bring out the specific qualities of individual things. From 1819 onwards he lived in the village of Olevano, which he used as a subject for numerous studies. In his *View of Olevano* (1822, Berlin), trees are used to frame the picture and to lead the gaze into the depth and breadth of space. The architecture, shown centrally in the picture, often has a crystal-like structure and is encircled by foliage which serves as delicate and sensitive ornament. Strong southern light appears as shimmering white. Horny started with individual forms and created the effect of space from his appreciation of the movement of these forms. *Plate 47*

Both Fohr and Horny succeeded in translating space into a kind of weightless hovering. In the landscapes of both artists, movement is used to define space, whether it be in linear succession, as in the case of Horny, or in the use of rhythmical planes, as in the case of Fohr; and both these techniques give space the illusion of movement and thus enhance it so that it becomes symbolic of pure spirituality. Friedrich's landscapes frequently aimed to reproduce the motif of contemplation by using a figure seen from behind in contemplation of nature; but in the landscapes of Fohr and Horny, contemplation of nature itself has become the subject of the picture.

It was Friedrich Nerly (1807–78) who continued the tradition of Fohr and Horny in the late 1820s. His are picturesque interpretations of the Italian landscapes. There is no doubt that these sketches also contain elements of Claude Lorrain and the English watercolourists. Nerly belongs to the generation immediately following the period of high Romanticism, such as Gensler, Morgenstern, Richter, Schwind or Wasmann, who first transformed the feeling for nature unleashed by Romanticism into picturesque nature studies, and later caused it to become more or less stylized. Although Nerly's early landscape studies of the Rome countryside are very much in the tradition of, say, Horny, and his watercolours, e.g. *View from Olevano* (*c.* 1830, Bremen), are distinguished by painterly skill in the use of form, his later *vedute* executed in Venice lack this originality and are merely typical *vedute* painted to order with some Romantic accessories. *Plate 48*

Elements of artistic appreciation, pictorial interpretation and a realization of the possibilities of space continued to flourish and to maintain the tradition of the German painters in Rome during the Romantic period. The brothers Olivier were of a similar cast of mind to the artists who lived in Rome and painted Romantic landscapes. Ferdinand Olivier (1785–1841) composed his landscape drawings and lithographs more in the style of Dürer, and never in fact visited Italy, although he was adopted by the Nazarenes as a member of their Brotherhood. Olivier's sketches of the Salzburg landscape, carried out between 1814 and 1817, like *Clay-pit in Vienna-Matzleindorf* (1814–16, Vienna Albertina), are characterized by an exceptionally painstaking technique, in which hair-thin strokes in rigidly ordered groups create clearly *Plate 49*

defined spatial areas and body outlines—displaying the same tendency as in Horny's sketches of Olevano, although Horny uses a fluid line and water-colour technique—and thus revive the German 15th-century style of sketching. However, the tendency to objectivity already anticipates late Romanticism. Olivier's landscapes from Salzburg and the Berchtesgaden region provided genuine inspiration for such late Romantic landscape painters as Ludwig Richter. His later works, however, came under the influence of the ideal landscape painting practised by his brother Friedrich, who had been to Italy. Friedrich Olivier (1791–1859), who lived in Rome from 1813 onwards, was more in the tradition of Koch's ideal landscapes. *Campagna Landscape with Mount Soracte* (1818–23, Munich) was probably painted during Olivier's stay in Rome, under the influence of the painting of Koch and Fohr. There is no doubt that Ferdinand was the greater painter; his landscape-art developed a magnificent use of abbreviation and artistic shorthand, and is among the most beautiful German Romantic painting. However, neither of the Oliviers managed to attain that degree of musicality which Fohr's and Horny's land-scapes possess. They acted as intermediaries and also had the function of stimulating new interest in Vienna, Rome and Munich; they played an important part in ensuring that drawing continued to be one of the most important forms in late Romanticism, in the works of Schnorr von Carolsfeld and Moritz von Schwind.

Plate 50

II Late Romantic Painting 1830–50

For a long time German artists had understood form to be essentially deter-
mined by the subjective approach. The subject of the picture became the
vehicle for the expression of emotion. The late Romantic, Ludwig Richter,
admitted in his *Memoirs*: 'Never before had I experienced so deeply, seen so
clearly, that art is only nature infused with all the qualities of the soul which
reflects it, and that thus it is of the greatest importance, in respect of artistic
appreciation as well, that a man furnish himself inwardly with a particular
and pure development of his manner of perceiving and thinking.' Many of
the works produced in the late Romantic period were intended for the
bourgeoisie. Even where the arts flourished in Court surroundings, as in
Munich and Berlin, they were mostly used for the benefit of the public.
Monuments were erected, murals painted in halls and council-chambers
specially built to hold them, the public were allowed free access to Court
art-collections. The 19th century is not only the age of historicism, but also of
public patronage of painting and sculpture. Exhibition pamphlets and cata-
logues interpreted the fine arts to the public, who played an important role in
influencing the choice of subject-matter. If the artist hoped to sell his work via
the medium of an art club, he had to choose a subject which interested and
appealed to the buyers. For the public approached the fine arts most easily by
way of subject-matter—literary, historical, etc.—which stimulated its desire
to read.

One of the most interesting aspects of late Romanticism is that a 'modern'
conception of form already existed in the sketches in oils of Dillis, Blechen,
Wasmann and Menzel, which prefigured realistic painting in Germany; but
the same technique was seldom applied to finished pictures. Menzel, who
produced some beautiful sketches himself, condemned the French Im-
pressionists because they showed no zeal for finished painting. Not until the
days of the following generation, which included Leibl and Marées, was this
theoretical stand translated into practical terms. Late Romanticism inherited
two things from the Romantics: the subjective stress on the experience of
nature, which was less marked in the sketches, and the tendency to use a
traditional historical style in which objects pregnant with intellectual signifi-
cance predominated. Or to put it another way, the use of intellectual and
literary associations in the finished work of art, and the stress on the optical,
visual qualities of the artist's impressions of nature in the sketch, are the twin
poles of late Romanticism.

Fairy-tale, saga and idyll played an important part in German Romantic
poetry. The poets Tieck, Arnim, Brentano and Uhland provided much
material for the painters of late Romanticism. The collection *Des Knaben
Wunderhorn* was published in 1811, and in 1812 followed the Grimms' fairy-

tales *Kinder und Hausmärchen*, in which appeared the figures of Red Riding-hood, Sleeping Beauty, Snow-white, Hänsel and Gretel and Tom Thumb, who became part of the national heritage by means of the oral folk tradition. Fairy-tale and saga are typical forms of the Romantic view of the world, in which nature and history merge with myth. 'A region where spirits walk is romantic, whether they remind us of times past or move around us on their secret business' (Uhland). In fairy-tales life is romanticized; it becomes poetry, revealing the wonder behind the phenomena of reality, and thus expanding human experience. Schwind's and Richter's masterpieces owed their inspiration to a mixture of poetic sensibility, musicality, and naïve joy; and they became part of the folk tradition because they were drawn from the store of the common heritage and were addressed to that same communal awareness. In their cycles of pictures, their small oil-paintings and not least their numerous woodcuts, the fairy-tale and saga characters became an integral part of late Romanticism. Here the qualities of the heart, the secret language of nature and the ingredients of the supernatural become poetic symbols of a happy and trouble-free existence. In an age of spiritual poverty, late Romanticism, in the works of Schwind, Richter and Spitzweg, restored a belief in the magic and poetry of human existence. Recently this age has come to be referred to as 'Biedermeier'. This description originally referred only to Austrian domestic culture between 1815 and 1848, but it is now used to describe the style of all those works of art which express comfort, good cheer and a loving understanding for the small things of life. It seems better, however, to restrict the term 'Biedermeier' to Austrian domestic culture, and henceforward to use the term 'late Romanticism'.

The Dresden artist Adrian Ludwig Richter (1803–84) produced some charming landscape idylls and woodcut illustrations in the folk style. In his *Memoirs* he recounts his experiences as an artist. He first became alive to the importance of German architecture on seeing Strasbourg Cathedral in 1820. Goethe, as we have seen, had had a similar experience in his time, except that Richter also did justice to the interior of the cathedral. His artistic development was decisively influenced by landscape painters and etchers like Rohden, Catel and Erhard, whose works displayed a synthesis of realism and poetic interpretation. In 1823 Ferdinand Olivier had published his sequence of landscape lithographs, *Seven Views in the Neighbourhood of Salzburg and Berchtesgaden*, which were based on two rambles through the Salzkammergut in 1817/18, and where 'the stylized plasticity of Koch's southern, Neoclassical landscapes is combined with the north German tendency to attribute a religious significance to nature in painting' (A. von Arnim). In the landscape etchings of Johann Christoph Erhard (1795–1822), published in the form of sketch-books, and especially in his *Views in the Vicinity of the Snow-capped Mountains* (1818) and *Studies from the Salzburg Region* (1819), Richter saw 'a more logical model than the Dutch painters. . . . Every line glowed with a loving understanding of nature, the charming and lively treatment expressed a faithful sensitivity to every little detail and every manifestation of beauty. That's the way I wanted to study nature.' From such landscape sketches, and

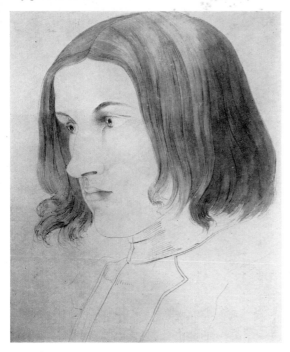

41 KARL PHILIPP FOHR
Self-portrait 1816

43 JULIUS SCHNORR VON CAROLSFELD
Portrait of Frau Bianca von Quandt 1819-20

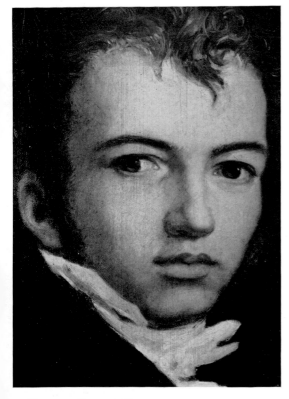

42 FRIEDRICH JOHANN OVERBECK
Portrait of the painter Johann Carl Eggers 1816-20

44 JULIUS SCHNORR VON CAROLSFELD
Female Nude 1820

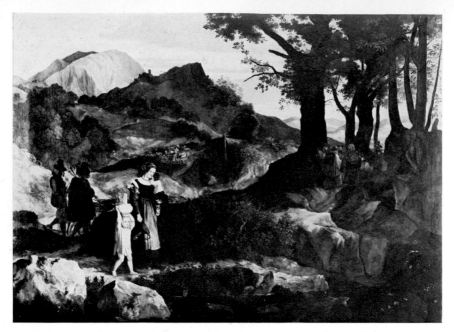

45 KARL PHILIPP FOHR *Landscape near Rocco Canterano in the Sabine Hills* 1818

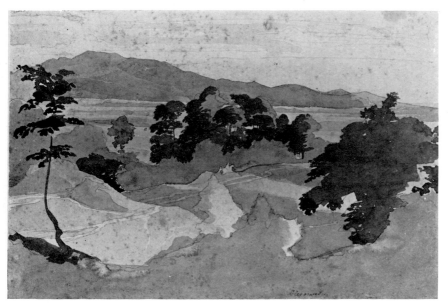

48 FRIEDRICH NERLY
View of the Volsker Mountains from Olevano c. 1830

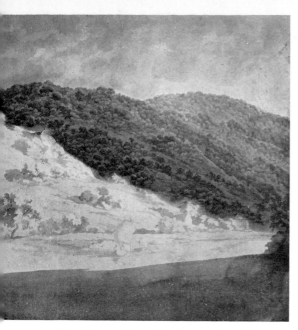

46 KARL PHILIPP FOHR *Hornberg on the Neckar* 1814

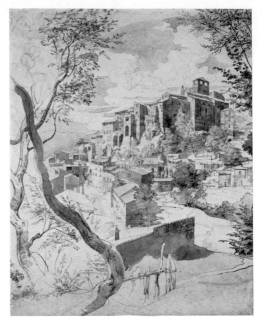

47 FRANZ HORNY *View of Olevano* c. 1822

49 JOHANN HEINRICH FERDINAND VON OLIVIER
Clay-pit in Vienna-Matzleindorf 1814-16

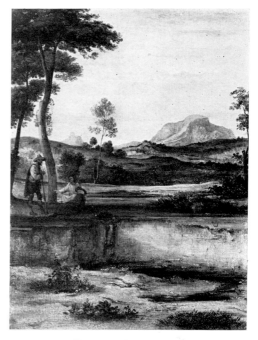

50 FRIEDRICH WOLDEMAR VON OLIVIER
Campagna Landscape with the Soracte 1818-23

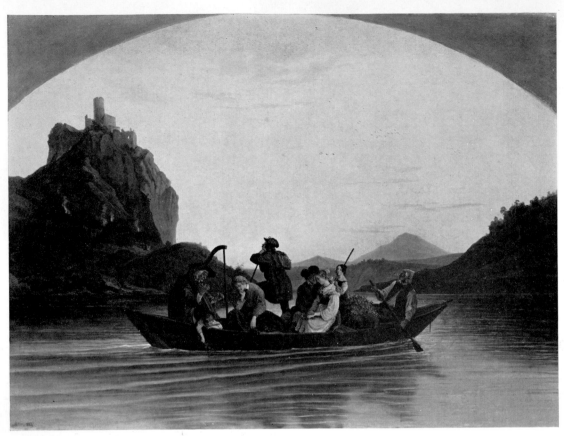

51 ADRIAN LUDWIG RICHTER *Crossing the Elbe at Schreckenstein near Aussig* 1837

52 ADRIAN LUDWIG RICHTER *Spring Evening* 1844

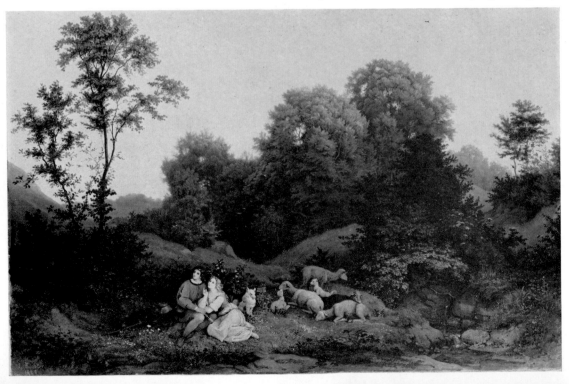

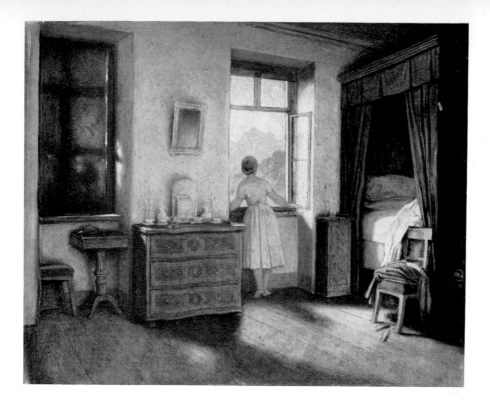

53 MORITZ VON SCHWIND *Morning Hour c.* 1858

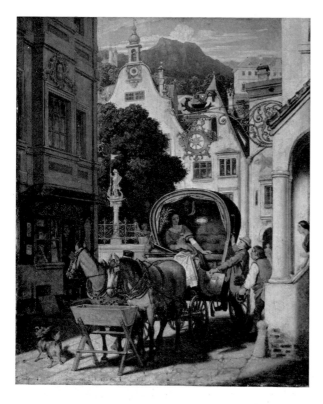

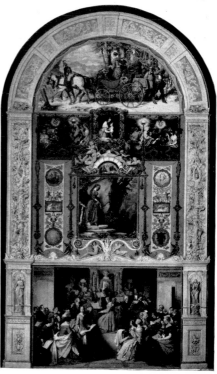

55 MORITZ VON SCHWIND
The Symphony 1852

54 MORITZ VON SCHWIND
The Honeymoon Journey c. 1855

56 CARL SPITZWEG
The Love Letter 1845-46

57 CARL SPITZWEG
The Widower c. 1850

58 WILHELM VON KOBELL *Siege of Kosel* 1808

59 JOHANN MARTIN VON ROHDEN *Ruins in Hadrian's Villa near Rome c.* 1796

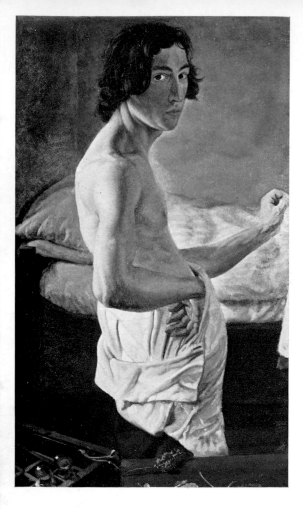

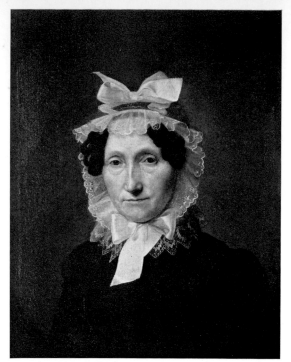

65 VICTOR EMIL JANSSEN
Self-portrait in Front of Easel c. 1828

66 JULIUS OLDACH
Catharina Maria Oldach, the Artist's Mother c. 1824

67 JOHANN JACOB GENSLER
Shore of Elbe with Sun behind Clouds 1840

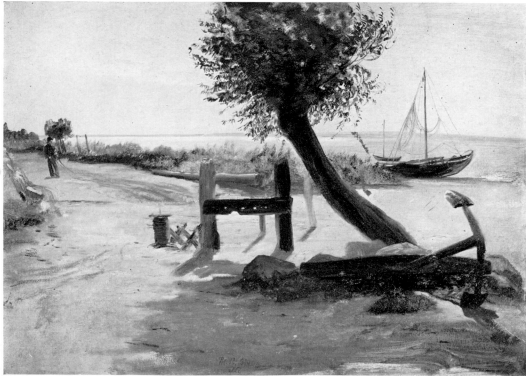

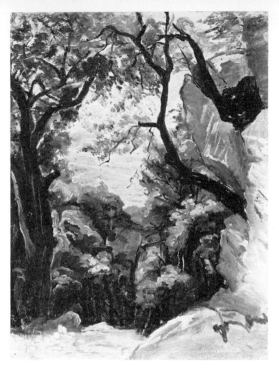

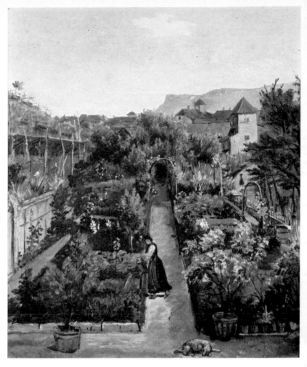

68 FRIEDRICH WASMANN
View through Wooded Hillside c. 1833

69 FRIEDRICH WASMANN
Flower Garden in Meran c. 1840

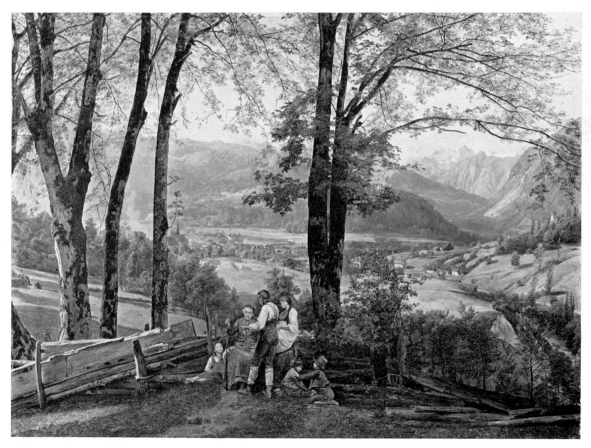

70 FERDINAND GEORG WALDMÜLLER *View of Ischl 1838*

71 FERDINAND GEORG WALDMÜLLER *Mother and Child* 1835

72 FRIEDRICH VON AMERLING *Portrait of Carl Christian Vogel von Vogelstein* 1837

73 CARL BLECHEN *Studio of the sculptor Ridolfo Schadow in Rome* 1829

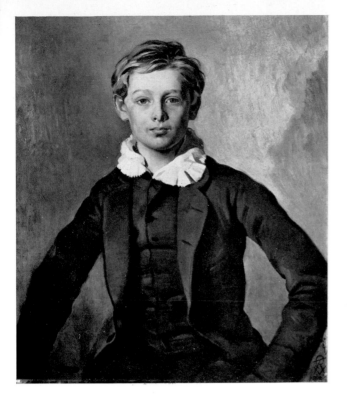

74 FERDINAND VON RAYSKI
Count Haubold von Einsiedel 1855

75 PETER VON CORNELIUS
Four Horsemen of the Apocalypse 1846

76 CARL BLECHEN
Rolling Mill near Neustadt-Eberswalde c. 1834

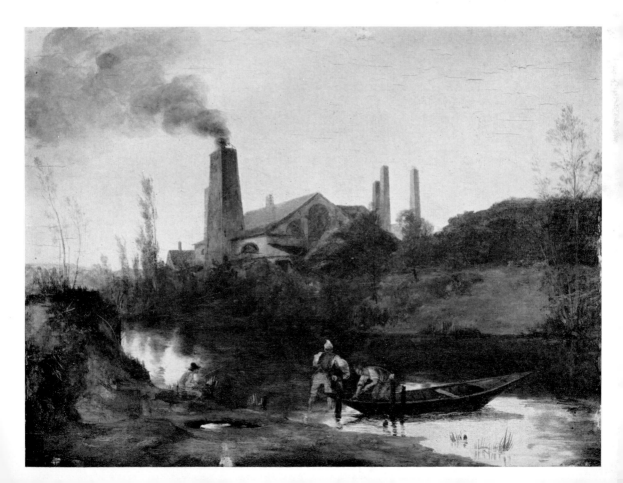

77 KARL THEODOR VON PILOTY
Seni and Wallenstein's Corpse 1855

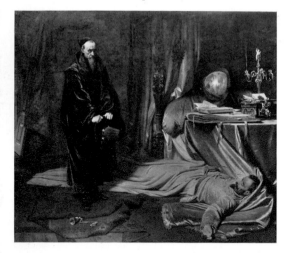

78 FERDINAND THEODOR HILDEBRANDT
The Murder of Edward IV's Sons 1835

79 CARL FRIEDRICH LESSING *Hussite Sermon* 1836

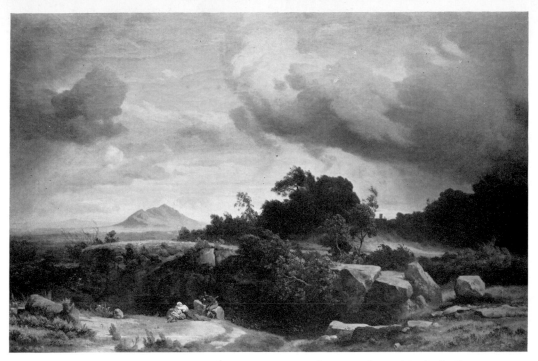

80 JOHANN WILHELM SCHIRMER *Storm rising in the Campagna* 1858

81 JOHANN WILHELM SCHIRMER *Morning c.* 1839-40

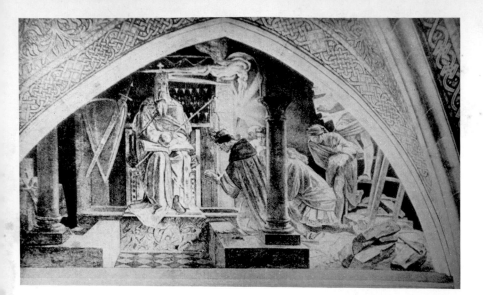

82 ALFRED RETHEL
Otto III's Visit to Charlemagne's Vault 1847-52

83 ALFRED RETHEL
Monk by the Corpse of Henry IV c. 1844

84 ALFRED RETHEL
The Triumph of Death 1848-49

even more from his intensive study of the writings of Tieck, Wackenroder and Schlegel, arose the desire to follow the muse to Rome, and to study nature in order to elevate the commonplace into the significant. In 1823 he arrived in Rome and made a pilgrimage to the 'spring gardens of the new German art', the Casa Bartholdy and the Villa Massimo. The works of the Nazarenes, however, did not match Richter's ideal. In them he found 'considerable inflexibility and harshness of outline, lack of body in the forms and thin application of colour'; and he turned for advice instead to Koch and to Schnorr von Carolsfeld, who had already freed himself from the Nazarene style. Richter created the landscape idyll, a kind of synthesis from the historical landscape art of Koch and the landscape *veduta* of Catel.

In 1827 Richter returned to Dresden. There he drew on the sketches he had made in Italy as the basis for the landscapes *Storm on the Serone* (1830, Frankfurt), *Forest Well near Ariccia* (1831, Berlin), and *Mountain Encampment* (1833, Munich). In these works, the accessories become more and more an integral component of the composition, which makes the structure of the landscapes strongly reminiscent of Koch and Fohr. His lively relationship with Dahl soon led Richter to devote himself again to the German landscape. *The Crossing of the Elbe at Schreckenstein near Aussig* (1837, Dresden) was based *Plate 51* on a visual poetic experience. Richter reported in his *Memoirs*: 'As I was crossing the Elbe near Sebusein one beautiful morning the thought came to me: why persist in seeking in distant lands for what you can have near at hand? Just learn how to master the particular qualities of this beauty, and it will give pleasure to others, as it does to you ... as I continued to stand on the bank of the Elbe after sunset watching the activity of the sailors, my attention was caught particularly by the old ferry-man who was in charge of the crossing. The boat, laden with people and animals, traversed the peaceful river, in which the golden evening sky was reflected. Thus on one occasion the boat arrived, filled with a colourful collection of people, among whom sat an old harpist, who instead of paying for the crossing was playing the harp for all he was worth. From this and other impressions, arose later the picture *The Crossing at Schreckenstein*, which was my first attempt to make figures bear the principal emphasis.'

The old harpist, who recalls Goethe's harpist in *Wilhelm Meister*, was chosen to provide a contrast to the figure of the ferry-man. All the people on the ferry are listening intently to the harpist's delicate music, for example the elegiac youth reclining near the harpist with his head supported on his right hand in a pensive pose, and the rural bridal couple who have their arms round each other. The standing figure of the wanderer leaning on his staff occupies the central axis of the picture and dominates the other figures. He thus becomes symbolic of the dominant poetic mood of the picture, which is invoked by the musical experience and by the beauty of the landscape. The music grips the people and makes their experience of the landscape more profound. This kind of intention is clearly Romantic, and is reminiscent of the landscapes of Caspar David Friedrich, in which figures are completely absorbed in the contemplation of nature: Richter, however, makes the expression of mood the

basis of the picture, and so he is directly concerned to influence the observer to share that mood. This is an externalization of the original Romantic sensibility of Friedrich and Horny—to name but two Romantics—and makes this sensibility a kind of 'literary leitmotif'. The way in which Richter gives external expression to the Romantic feeling for nature testifies to both the 'folk' character of his work and the degree to which it is derivative. Like his woodcuts, Richter's pictures are a reflection in idyllic terms of the small world of peasants and ordinary townfolk, a world imbued with a serene *Plate 52* piety. In *Spring Evening* (1844, Düsseldorf), shepherds and shepherdesses are camping near their flocks, the blue mists of evening and the rays of the setting sun create an atmosphere of natural, care-free existence. Here Richter combines the folk-song character of the theme—which is also known as *Evening Song*—with a compositional method derived from Romantic landscape art. He consciously chooses objects from folk poetry or music. This can also be observed in other pictures painted in the 1840s, such as *Genevieve* (1841, Hamburg), whose subject is taken from Tieck's tragedy *Leben und Tod der heiligen Genoveva* (The life and death of St Genevieve, 1799), or *Bridal Procession in Spring* (1847, Dresden), whose theme was taken from Richard Wagner's finale to *Tannhäuser* (Act I).

Moritz von Schwind (1804–71), born in Vienna, was a close friend of the playwright Franz Grillparzer and the composers Franz Schubert and Franz Lachner, with whom he 'had passed a few fleeting years of poverty-stricken happiness and friendship in singing and making music.' His cycles of paintings, *Cinderella* (1854), *The Seven Ravens* (1857/58) and *The Tale of Fair Melusine* (1860s), are direct transpositions of the poetry of the fairy-tale into the realm of painting. After settling in Munich in 1828, Schwind became acquainted with the formal intentions of the Nazarenes from the works of Cornelius and Schnorr von Carolsfeld, assisted in the decoration of the Munich Residenz and Hohenschwangau Castle, and later painted frescoes in the Wartburg (*Festival of the Singers*, 1853/55) and the Vienna Opera House (illustrating Mozart's *Magic Flute*, 1866/67). These large-scale pictures, as well as others like *The Count of Schleichen* (1849, Munich) and *The Rose, or the Artist's Journey* (1847, Berlin), are lacking in strong coloration. Schwind's compositions followed the style of Gothic glass-painting in according prime importance to line, whereas colour had only a secondary illustrative function. From the following remark, made during his stay in Rome in 1835, one can see how much he was preoccupied with giving expression to medieval mythology: 'I went to the Sistine Chapel, looked at Michelangelo's work and went back home to work on *Sir Kurt*'—a theme which he had developed from a ballad by Goethe.

Schwind did indeed devote much attention to nature, but this was not so much in order to study it as to dream about it and compose poetic fantasies. His use of colour is completely dominated by the poetical and musical elements of the scene. He possessed the extraordinary gift of making the exquisite figures of his fairy-tales seem to hover in the air, and of infusing reality with his own poetic vision. In this Schwind is close to Richter. In the large-scale

compositions the use of oils is harsh, smooth, and dry, inhibiting the freedom and lightness of his poetic imagination; but in the smaller pictures this is enhanced to produce a marvellous blend of poetry and music, in addition to a happy combination of landscape and figures. There is a Viennese charm about Schwind's *Travel Pictures*, together with warm humour and delicate irony, which reminds one of the short stories of Gottfried Keller. In 1862 Schwind wrote about his *Travel Pictures* to Cornelius: 'I am working on a collection of lyrical pictures—about forty in all—which have been painted in good moments from my youngest days onwards, and which constitute an integrated whole. A little volume of poems (oil paintings) under the title "travel pictures" would be something similar—modern, ancient, romantic, all mixed up together.' Most of these pictures were acquired by Adolf Friedrich von Schack for his gallery in Munich at the end of the 1860s.

The Morning Hour (1858, Munich) is a fine example of the *Travel Pictures*. *Plate 53* The artist's daughter had just risen from her old-fashioned four-poster bed in the villa on the Starnberger See, and has gone over to the open window in bare feet to greet the morning. Warm yellowish light streams into the room; green, brown and red are used to give this warmth of colour. The motif of the figure seen from behind is faintly reminiscent of Caspar David Friedrich. For Friedrich the figure seen from behind was a symbolic means of expressing the relationship of man and the cosmic forces of nature; but in Schwind's picture it merely indicates the act of observing nature, the theme being the spontaneous joy produced by the influx of morning light. In *The Honeymoon Journey* (c. 1855, Munich), Schwind appears as the newly-married husband *Plate 54* taking leave of his friend, the composer Lachner. An intimate, almost idyllic mood is created by a background of old-fashioned gabled houses.

The external structure of Schwind's composite picture, *The Symphony* *Plate 55* (1852, Munich), is the same as that of the fairy-tale cycle, but the orientation of the planes is now vertical, rather than horizontal. The picture is of the type known as *sacra conversazione*; in his youth Schwind had painted a similar picture in the style of Bellini. Inspired by Beethoven's *Fantasia in C for Piano, Orchestra and Chorus*, the picture was intended to form part of a Beethoven wall in a music room where pictures of Haydn and Mozart were also to figure: it was meant as a veiled tribute from King Otto I of Greece, who had commissioned the picture, to the court opera singer Karoline Hetzenecker. In a letter of 14 December 1849 to Franz von Schober, Schwind explains his picture in detail: 'The whole thing should be thought of—since everything must serve some purpose—as the wall devoted to Beethoven in a music room, and it was thus based on a piece of Beethoven's music: "Fantasia in C for Piano, Orchestra and Chorus", the only such work he wrote, hence recognizable from the picture, and in any case the title appears on the singer's score. The whole thing is based on this musical concept, and thus divides naturally into four parts, analogous to the traditional four parts of a symphony —Allegro, Andante, Scherzo and Allegro. The scene is a rehearsal of the piece in a private theatre, where the orchestra and the chorus are concentrating very hard, and the girl who gets up to sing a short solo (a bold stroke, this!)

arouses the attention of a young man—a meeting where the two sides must remain apart—a miniature masked ball, where our pair express their feelings; and at the end a moment from the honeymoon, where the happy husband shows his wife the castle in which they are to live. Corresponding to the chorus-part, which is a song in praise of the joys of nature, the whole picture is enclosed by a decor of woods and sky, open to the four winds; and the time of day, the pleasure of bathing and the mountain air, the delights of travel and so on, appear as motifs in the ornamentation which links the whole composition. Ganymede, symbolizing the birth of Spring, occupies more or less the central position . . .' The couple are 'The nightingale of Munich', Karoline Hetzenecker, a member of the Munich court opera from 1839 to 1849, whom Schwind particularly admired, and Privy Counsellor von Mangstl (standing in the orchestra on the right). One can still see here the Romantic idea of synaesthesia: music is the subject of the picture and the force which motivates the lovers; poetry explains and elaborates the idea, especially in the allegorical medallions; architecture provides the form which unites and encloses; painting serves to make the whole thing visual. In his work, Schwind was thus directly extending Runge's idea of a total work of art, but Runge's high ideals have given way to a more purely illustrative technique. Although in his pen-and-ink drawings Schwind often approaches the realm of dynamic transcription of perception, his paintings are never free from intellectual or literary influences.

Edward von Steinle (1810–86) shares with Schwind a highly developed sensitivity for music. Although he lays most stress on religious art, Shakespeare, Goethe and Brentano also figure in varying degrees in his work. *The Violinist* (1863, Munich) illustrates a story from the life of Tartini, on the occasion when he was presumed missing in Padua, only to be discovered unexpectedly playing at the top of a tower. The way in which the artist is immersed in what he is doing, quite cut off from reality, is symbolic of the Romantic desire to experience unity with the universe through art.

Richter's and Schwind's technique was an adaptation of the linear style of the Nazarenes. The Munich artist Carl Spitzweg (1808–85) introduced a new element into his work, that of colour. Spitzweg began to paint late in life, having first trained as a chemist: after a serious illness he followed the advice of his doctor and devoted himself fully to his hobby, painting. Since he was already too old to study at the Academy, he began to study on his own; he copied the Dutch painters in the Alte Pinakothek, prepared his own colours and observed the busy life in the old quarter where he lived. He used his impressions of market-places, old gabled houses, staircases, picturesque inn signs, quiet corners, balconies, pots of flowers, and so on, to provide the background to his old bachelor figures: the bookseller, the postman, the writer, the hermit, the hypochondriac, the librarian, the cactus-grower, etc. This is the idyll of 'the good old days', the banality of everyday life transformed into a symbol of peaceful contented existence. Spitzweg's characters are lone wolves, but they share a common humanity, and their attitude enables goodness, creative imagination and pleasure in the apparently trivial

things to become the theme of the pictures. Indeed, Spitzweg himself seems to be the lonely individual of his pictures. His first publicly exhibited work, *The Poor Poet* (1839, Munich), was not accepted by the Munich art club. It was angrily rejected by the public who thought it was making a mockery of poetry. The poet is lying in bed in broad daylight, scanning with fingers stiff with cold the four-line stanza he has just written, while an open umbrella protects him from the rain which drives in through the dilapidated roof of the garret. *The Poor Poet* was one of the first of the 'types' which Spitzweg invented with such ease, painted straight on to the canvas with a fine brush in the Dutch fashion. *The Love Letter* (1845/46, Berlin) is reminiscent of *Plate 56* Erasmus Engert's *Garden of a House in Vienna* (1828, Berlin); Spitzweg has, however, allowed greater range to the play of light and colour. The way in which the light falls on the wall, the still-life effect in the arrangement of the straw hat, the watering can and the spade, and the peaceful domesticity of the two women in a corner of the garden are handled with great charm; as is also the canny twinkle in the postman's eye as he furtively slips the long-awaited love-letter over the wall. *The Widower* (c. 1850, Munich) goes back to an *Plate 57* earlier version in Frankfurt (1844). The Munich picture is only slightly modified, and the influence of Joseph Navrátil, whom Spitzweg had visited in Prague in 1849, can be seen in the departure from the type of glazed miniature painting of the earlier period. Brown is used for the landscape, with certain areas picked out in ochre, and the blue of the sky can be seen through the foliage of the trees. The old widower is watching the two young girls who are strolling in the park. The narrative element is retained and serves to suggest the overall mood, but it is the way in which landscape and figures are treated which makes the work a masterpiece. Light penetrates all the compositional elements in varying forms, throwing into relief the group of girls, lighting up the statues, and transforming the groups of trees behind the widower's bench into a multitude of splashes of colour. The whole area of the picture is an interweaving of colour and light.

Spitzweg's journeys with his friend, the painter Eduard Schleich the elder, to Venice in 1850 and to Antwerp and London in 1851, gave him a good knowledge of French painting too. He was particularly encouraged in his own search for a style in which colour played the major role by the Barbizon painters and Delacroix. In addition to the accuracy with which he reproduces settings, it is his use of colour which raises his paintings above the level of anecdote and gives them the quality of intimate and exact contact with, and understanding of, colour and form. But his works remain Romantic—even his later landscapes, which are without figures. He often repressed the literary element in this way; along with Eduard Schleich and Dietrich Langko he even copied Isabey's *Women Bathers by the Seaside near Dieppe* during an exhibition in Munich in 1860. But his main purpose remained the poetic interpretation of life and nature. In this he does approach the impressionistic style, and in many respects anticipates its development in Germany, but his paintings always remain an idealization of the world: either as an idyll inhabited by the lonely individual, or as a poetic treatment of nature on its own. It is perhaps

their very humanity which makes the lonely individuals of Spitzweg's pictorial world so credible and so sympathetic.

Schiller observed in a letter of 14 September 1797 to Goethe that the intellectual approach to art could lead to empty idealism in painting, and that painting closely determined by reality could become mere aping of it: 'The poet and artist must do two things: he must rise above reality and he must remain within the bounds of sensuous experience. Where the two come together, that is aesthetic art. But where his nature is unfavourable and uncontrolled, he is only too ready, in leaving reality, to leave the realm of the senses and to become purely idealistic, or, if his reason is weak too, utterly fantastic; on the other hand, where his nature impels him to remain within the boundaries of sensual perception, he is all too easily persuaded to remain bound to reality as well, and to become realistic in the restrictive sense of the word, or, if he is quite lacking in imagination, slavish and banal. In both cases he is not aesthetic.'

The beginnings of realistic painting in Germany go back to early Romanticism. Runge had already stipulated that art should henceforward take nature, rather than the ideal of the human figure, as its point of departure. The chief task of painting should be to represent 'air, light and dynamic life'. Light and colour were the two central features. In his theory of colour as well as in his works, Runge had given up the colour technique employed in studio painting and turned his attention to the production of natural colour. Light was chosen as the means to emphasize the physical presence of the objects in the picture. Fabrics and material objects were seen as solid bodies which light simply illuminated; it was not realized until later that light had the quality of changing the object, and this discovery was reflected in the treatment of colour and shadow in regard to objects. Study of this aspect of light and colour began early in the 19th century. The realization of the interplay of light, atmosphere and colour is intimated in the sketches of Dillis, Wasmann, Blechen and Menzel, but there are few finished pictures which follow up the consequences. The new optical experience was first of all the subject of experiments 'in the impure state', before finding a corresponding form in the finished works. Some important progress in this field did take place in Germany, but in the absence of a communal centre where artistic ideas could crystallize—such as Paris or London—artists had to come to terms as best they could individually with these new experiences; and so they were all too prone to relapse into acceptance of the doctrine propounded by Cornelius and his School. These external circumstances seem to have retarded the development towards Impressionism in Germany.

Wilhelm von Kobell (1766–1853), who lived in Munich, was one of the important landscape painters who preserved and handed on to the 19th century the heritage of Dutch painting. His early landscape, *The Ford* (1798, Kassel), is a paraphrase of Albert Cuyp or of Paul Potter; and in the battle pictures he painted for the Crown Prince Ludwig of Bavaria, such as *The* *Siege of Kosel* (1808, Munich), light floods the panoramic space, giving the

Plate 58

figures clearly defined and individual existence, and casting long shadows which link figures and pictorial space in a static manner. Although the area is open on all sides, light and shade here make landscape appear architectonic, which enables one to see Kobell's landscapes as a variant of Neoclassicism. For light is used to emphasize the static corporality of figures and space, a method rather similar to Runge's. In the contemporaneous works of the Munich artist Johann Georg von Dillis (1759–1856), light is no longer used merely as illumination but has become a part of the compositional process. In *Triva Castle in Munich* (1797, Munich), the individual forms are woven *Plate 61* together to form an interrelating colour structure, in the composition of which light and colour play complementary roles. In the *Portrait of Herr Neumayr* (1809, Munich), Dillis has broken away from any kind of late Baroque or Neoclassical pose and has restricted himself to reproducing human physiognomy in painting. A similar trend can be seen in Anton Graff's portraits of about the same time, e.g. the *Portrait of K. L. Kaaz* (1808, Ham- *Plate 5* burg), and anticipates important elements of Impressionism. Here, as also in Dillis' *Views from Rome* (1818, Munich), one example of which is the *View of St Peter's from the Villa Malta in Rome*, each stroke of the brush has become an *Plate 62* autonomous expression of vital artistic form; more extensive areas of colour are also intimated, and individual objects like houses, trees, and paths are dotted about on the bright surface wash. This technique indicates things vaguely rather than describing them exactly. Atmosphere and light have joined forces with colour. Waldemar Lessing described Dillis not unjustly as 'a Bavarian Corot'. He succeeded admirably in reproducing the immediacy of impression. Although most of these works are only sketches, and serve as private notes on colour and objects, the picture has in most cases been carefully integrated, as in *View of the Quirinal*, where the impression of nature is subordinated to a rhythmic use of coloration. A comparison with the *Four Views of Rome from the Villa Malta* (1829–35, Munich) by Johann Christian Reinhart (1761–1847) illustrates how great an artist Dillis was. Ludwig I had commissioned Reinhart to paint the four large-scale views and planned to use them to decorate rooms in his Munich Residenz. Basically they are enlarged topographical *vedute*, clearly derivative of 18th-century painting of this type. Reinhart devoted equal attention to detail right from the foreground to background, whereas in Dillis' various views only the middle-ground is clear and distinct and fore- and background are contrastingly vague.

Landscape painting in Munich in the first half of the 19th century developed under the influence of Dutch 17th-century painting, and at first, as in the sketches in oils of Carl Rottmann or Eduard Schleich, had affinities with the style of Dillis, although seldom attaining the same heights in the balance and delicacy of colour. But these large-scale landscape compositions did carry on the tradition of Koch. Max Joseph Wagenbauer (1774–1829), who found favour with King Max I, constructed his landscape-art mainly in the Dutch style, and his painstaking detail occasionally becomes almost schematic. Many of his pictures, like *Flock with Shepherd and Shepherdess* (1812, Darmstadt) or *Cattle Grazing* (Bremen), are nevertheless distinguished by a pictorial light

which breaks up individual forms, especially in the case of groups of trees, in a way reminiscent of Kobell and Friedrich. Franz Ludwig Catel (1778–1856), born in Berlin, renewed the Italian style of landscape *veduta* at the beginning of the 19th century. For his landscapes, which in many respects are reminiscent of Koch, particularly in the construction and articulation of space, but which lack Koch's heroic pathos, Catel chose scenes from the life of the common people, which subsequently influenced the young Richter. In his famous picture, *Crown Prince Ludwig in the Spanish Tavern in Rome* (1824, Munich), Catel followed what he referred to as the 'bambocciastic' manner of the Dutch Baroque painter Pieter van Laer.

Some of the landscape sketches of Carl Rottmann (1797–1850) are of considerable artistic merit, but the commissioned works and finished landscapes soon slip into the reddish brown tone of studio pictures, and conventional technique and theatrical effect replace the original painterly impression of the sketches. In sketches like *View of Murnau and the Mountains with Rain Cloud* (1843, Munich), spatial depth harmonizes with the blue-grey of the sky and

Plate 63 gives an impression of vastness; or in the *Plain of Marathon* (1834–35, Munich), a study for the *Greek Landscapes* in Munich, light is laid on like colour by means of lively brush strokes, and the landscape is rendered with a kind of instinctive dynamism.

Christian Ernst Morgenstern (1805–67) was born in Hamburg but belongs to the Munich School, where he was among the founders of realism in painting. Early works, like the *View of St George's Church in Hamburg* (1825, Hamburg), derive from 18th-century *veduta* painting and their effect is largely topographical. *Waterfall in Upper Bavaria* (1830, Hamburg) has a motif similar to many of Koch's landscapes, but the treatment is much freer and there are no accessories, as is also the case in *Waterfall near Tivoli* (1837, Berlin): here one finds an increasing brightness of colour corresponding to the

Plate 64 visual experience of space in depth. In *Starnberger See* (1840, Munich) blue and ochre combine, and light becomes the real theme of the picture. Visual points of reference, like the footbridge in the left foreground, the light-coloured area of bank in the right, the tree-stumps in the water whose shadows reinforce the horizontal orientation of the picture, the dark island which projects horizontally as far as the middle, and finally the Alps in the background, create a surface tension, and the interplay of the eye between these points establishes the spatial area of the picture. In late paintings, like *Isar Landscape* (1869, Darmstadt), or *Coast of Heligoland* (1863, Munich), Morgenstern tends to arrange landscape elements in an artistic manner and to use light not as a compositional means but more for its effect, in the Romantic or illustrative sense.

Eduard Schleich the elder (1812–74) was dominated by the influence of

Plate 120 Rottmann and Morgenstern. His sketch-like wood and water landscapes, mostly on small wooden panels in a style which foreshortens the subject, are somewhat like the works of his friend Carl Spitzweg, but they lack the latter's richness of colour. This particular line of development in the Munich School of landscape painting in the first half of the 19th century came to an

end with Adolf Heinrich Lier (1826–82). By instigating the intimate style of landscape, Lier made a decisive step towards the adoption of the open-air technique. *Stone-breaking near Paris* (1861, Munich), painted during Lier's stay in that city, seems to reflect the landscape style of Courbet.

A strong tendency to realism could already be seen in early Romanticism in Hamburg. Runge's work displayed an awareness of natural colour, extreme accuracy in the reproduction of detail and the use of light to model bodily outlines. The following generation, particularly Janssen, Speckter and Oldach, who all died young, as well as Friedrich Wasmann, developed the heritage of Runge. Their works are distinguished by their great accuracy in the observation of nature, greater freedom and refinement of technique, the expressive and decorative qualities of line and the penetrative analysis of human physiognomy. In the *Portrait of Jakob Wilder* (1819, Hamburg) by Johann August Krafft (1798–1829), objective realistic techniques are used at an extraordinarily early date and transform the late Baroque representational portrait into bourgeois realism. Characterization replaces idealization, impartial observation of the objective world supersedes the earlier more superficial style of painting. In the portraits of Julius Oldach (1804–40), bourgeois traits are combined with a certain humour. Despite a somewhat excessive over-refinement of external features, no doubt a consequence of realism, the faces of the women he paints reflect a strong degree of introspection. Their *Plate 66* mode of dress is like that in Old Master portraits, without being deliberately historical. Contact with Cornelius's art led Oldach to degenerate in his later works into an eclectic dependence on the Nazarene style, particularly in his illustrations to Goethe's *Faust* and *Hermann and Dorothea*, which were conceived as miniatures and also reflect the influence of the works of Josef von Führich. The Hamburg works of Erwin Speckter (1806–35), particularly his portraits of citizens of that city, show a kind of artlessness. In his religious pictures, *The Good Shepherd* (Hamburg), and *Christ Appears to the Women at the Grave*, the figures have a plasticity of line reminiscent of Carstens.

Victor Emil Janssen (1807–45) is notable for an improbable degree of obsession with reality. In his *Self-portrait* (c. 1828, Hamburg), he adopts the realistic method of Runge, but radicalizes its effect. The portrait is set off by a greenish-grey and pink background. The immediacy, the almost brooding air of self-questioning reminiscent of Dürer, the complete absorption in the objective world (the violet lying on the table in the foreground and the paint-box on the left stand out in contrast to the austerity of the room), the impressive treatment of light and shade on the naked upper half of the body; all these Janssen combines in order to build up a realistic portrait in contrast to the more traditional idealization, and the abundance of truthful detail is a mark of a more intensively analytical subjectivity. Self-destructive doubt and internal conflict caused this strong masculine talent to adopt the soft linear style of the Nazarenes after coming under the spell of Cornelius in Munich.

The realistic tradition was continued by the Hamburg landscape painter Johann Jacob Gensler (1808–45). A painting like *Shore of the Elbe with Sun Hidden* (1840, Hamburg) points forward to later open-air painting. The picture *Plate 67*

was in fact painted in the open air, which is indicated not least by the exact date. A slate grey shadow falls over the right foreground, the trunk of the willow is likewise grey. The spatial area of the picture opens out to left and right of the foreground, and halfway towards each side are placed a boat and the figure of a fisherman. Colour, in addition to describing the objects, also gives the spatial area a unity of atmosphere. Gensler's small-scale landscapes are a development of Johann Christian Dahl's and testify in a similar manner to a growing interest in open-air painting in the 1830s and 1840s.

Friedrich Wasmann (1805–86) could have made the decisive step from landscape sketching to open-air landscape painting, but his strong character did not prevent him from following the current. Wasmann's personality and work are typical of German painting of this epoch: he was extremely talented, almost visionary in his sketches; then suddenly there was a complete reversal in his approach when commissions from the bourgeoisie persuaded him to start painting in the style of the early German portraitists. Though in his numerous portraits, painted in Hamburg and in the Tyrol, Wasmann kept to a closed form which he himself described as 'early German style', his landscape painting is spontaneous, free and painterly. His mature portrait style, which was preceded by a realistic-Romantic phase, as for example in the *Portrait of the Artist's Sister* (1822, Hamburg), dates from the early 1840s. His portraits, among them *The Artist's Mother and Sister* (1844, Hamburg) and *Portrait of Johann Ringler* (1841, Hamburg), are museum pieces of late Romantic bourgeois portraiture, notable for their careful treatment of objects and for a certain perceptiveness of interpretation as compared to the mostly superficial, flattering and elegant portraits of the Viennese school, especially Ferdinand Waldmüller. His portrait sketches, e.g. *Girl Looking Up* (1844, Winterthur), follow the portrait-sketching tradition of German painters in Rome, especially Overbeck, Fohr and Schnorr von Carolsfeld.

The technique of Wasmann's landscape sketches, such as *View through Wooded Hillside* (c. 1833, Hamburg), differs almost totally from that of his portraits. He did indeed experiment with the same technique in such figure studies as *Italian Girl* (1832, Hamburg), but renounced this free style of painting in favour of sketching. In his *View through Wooded Hillside* the brush strokes are applied broadly and freely; the way in which they harmonize with the subject is not descriptive but organic. Different areas of colour are juxtaposed in an apparently unrelated way, which gives the picture an open perspective. Dark brown tree branches, set off by a background of grey-green undergrowth, divide the bright blue of the sky like bars across a window in the middle- and foreground. In the distance the colours merge to give a unified impression of space, and colour has become the means of suggesting variations of light. The idea of a 'view from a window', which is basic to the composition, is revealed in Wasmann's *View from the Window* (1833, Hamburg). The pictorial genesis of this device begins with Altdorfer (cf. *Wild Man*, London), and is frequently used in the 19th century by Friedrich, Johann Christian Dahl and others right up to Hans Thoma; in choice of subject and in technique it prefigures open-air painting. In Wasmann's *View through*

Plate 68

94

Wooded Hillside objective forms are completely transcribed into artistic forms. Nevertheless, the Romantic device of the decorative plane still lurks behind the structure of the picture. Wasmann's artistic relationship to the objective world is not determined by the objects themselves, as for example in the case of Friedrich, but by colour. The structure of the picture arises from a close study of nature.

Ferdinand Georg Waldmüller (1793–1865) was the principal exponent of the 'early Viennese school' of painting, which was contemporaneous with Austrian Biedermeier (1815–48). Nowadays Waldmüller's works are often erroneously described as examples of open-air painting. In the early landscape *Prater Meadow* (1830, formerly in Berlin) a group of trees is the principal subject of the picture. The bright sunlight enables one to see each individual leaf of the foliage, without its losing its entity. Waldmüller taught how to paint bright sunlight and how to make exact observation of nature the only goal of painting; he himself devoted remarkable attention to the study of nature, so that finally his pictures are nearer to naturalism than to open-air painting. Naturalistic elements can already be seen in his early works, particularly in the traits he inherited from Baroque art. His *Boy with Lantern* (1824, Hamburg) is close to the Dutch Caravaggists, and *Mother with Child at the Window* (1820s, Munich) is purely *trompe-l'œil* painting. In these early works, which are very useful in aiding interpretation of the later work, painting is imitation of reality with the addition of illusionistic effects. Waldmüller makes unusual efforts to obtain lightness of colour and strength of light, as for example in *View of Ischl* (1838, Berlin), a picture which is in the Romantic tradition of landscape painting and is illuminated from all sides. The details of the landscape are exactly reproduced throughout, the aim being an almost photographic accuracy. Waldmüller is always drawn by reality rather than by the pure visual experience, as Dillis or Wasmann were. In late landscapes, such as *Spring in the Vienna Woods* (c. 1861, Berlin), the figures are grouped towards the front as accessories and the works become genre pictures. Both his numerous portraits, e.g. *Mother and Child* (1835, Berlin), in which the French type of portraiture has been transformed into the superficial elegance and appealing grace of the Viennese School, and his still-lifes, derivative of the Dutch tradition, testify to his desire to reproduce the material world. Waldmüller's theoretical writings, in which he came down on the side of direct study of nature and against all forms of idealization, led to a rift with the Vienna Academy, where he had been appointed professor of landscape painting in 1830. His paintings illustrate what he meant by his injunction to 'paint bright sunlight'. By means of an extremely smooth treatment of the surface, light is spread like a preserving film over the material constitution of objects, leaving the quality of their colour intact. This technique differentiates Waldmüller from the aims of Wasmann, Blechen, and Menzel. He believed that the stability of the material state of the object could not be altered by the play of light. This explains his affinity with Dutch Baroque painting.

Friedrich von Amerling (1803–87), likewise from Vienna, was in many respects similar to Waldmüller in that his portraits—e.g. *Rudolf von Arthaber*

Plate 70

Plate 71

and His Children (1837, Vienna)—also continue the Dutch group portrait tradition, but his principal considerations are elegance, charm, and the ability to please. However, his *Young Girl with Straw Hat* (1830/35, Munich) shows evidence of greater artistic concern. As has often been remarked, English influence may possibly have had something to do with this: Amerling had studied in London under Sir Thomas Lawrence in 1827. In the *Portrait of Carl Christian Vogel von Vogelstein* (1837, Berlin) Amerling rejects artificial posture in favour of close attention to the features, by setting the head against a grey ground and modelling it by delicate interplay of light and shade.

Plate 72

Rudolf von Alt (1812–1905), Matthias Rudolf Toma (1792–1869) and the writer Adalbert Stifter (1805–68) also belong to the 'early Viennese school'. Stifter was a self-taught painter; although he associated himself with the Vienna School, he remained independent as far as his own attempt at painting went. His little studies can be compared stylistically with those of Blechen or Dillis, although his works do not attain the same standard. In this connection, Stifter is interesting in his role as novelist. In his novel *Der Nachsommer* (Indian Summer) he gives an impressive and precise description of the programme of the new painting: 'Until now I have sketched objects from the point of view of my scientific interest in them, and from this angle the particular characteristics of the object were its most important feature. These characteristics had to be expressed in the sketch, and indeed the greatest emphasis was laid on those which distinguished the object from the others related to it. Even when drawing faces I was always conscious of their lines, their physical aspect, their division into areas of light and shade. In this way my eye had become practised in distinguishing what was really essential about even distant objects, however indistinct they might be; and I was also accustomed to pay less attention to the variations imposed on them by atmosphere, light and haze, was indeed more inclined to discount these things as hindrances to exact observation than to make them the subject of my attention. My friends' advice had made it suddenly clear to me that it was now time for me to observe and get to know that which had hitherto always appeared insubstantial to me. Atmosphere, light, haze, cloud and other objects in the vicinity all affect the appearance of an object: these I now had to investigate, and I would have to make these influences the subject of my study, if possible to the same extent as I had formerly studied obvious characteristics.' According to this, the artist should not reproduce the object from a rational point of view, but rather in the way he sees it in its intimate relationship with light, air, and other objects. The pictorial object has to measure up not to intellectual but to visual criteria.

Carl Blechen (1798–1840) at first underwent a 'Romantic interlude', in which literary elements tended to influence the mood. A period of study in Italy (1828/29) enabled him to see the Italian landscape not, according to preconceived notions, from a classical, heroic or idealistic point of view, but purely with an eye to artistic, pictorial qualities, as Dillis had done previously. Blechen had no doubt learned his technique from Johann Christian Dahl in Dresden, for Dahl too had disposed colour and light according to optical

96

criteria, giving an overall evenness of tone, in contrast to the standard practice at the Academy, which involved a gradation from dark in the foreground to light in the background. His *Studio of the Sculptor Ridolfo Schadow* (c. 1829, *Plate 73* Bremen) shows a sculpture in front of a dark ground which attracts the attention, while the picture is given structural unity by the linear perspectives of the house on the right, the flower-bed and the vine-covered pergola. This static compositional system is modified by the impressionistic application of colour. In *Palm House* (1832, Berlin) too, this architectonic compositional structure is what chiefly reveals Blechen's early training as a painter of views. A strong realistic light characterizes his smaller pictures, painted in Italy and shortly afterwards in Germany: e.g. *View of Roofs and Gardens* (c. 1828, Berlin). *In Terni Park* (c. 1830, Düsseldorf), and *Rolling-mill near Eberswalde* *Plate 76* (1834, Berlin). The latter is one of the earliest examples in German painting of a factory used as motif, though other artists were shortly to show a similar interest in this subject-matter. In Blechen's picture, however, the mill is simply a pictorial motif, and not the politico-social motivation for the work. The numerous studies for *In Terni Park*, with girls bathing, are examples of early open-air painting, but remnants of a realistic approach to the study of nature and some traces of early German styles can be seen. A particular characteristic of Blechen's painting is the way he renounces absolute accuracy in favour of a kind of shorthand of colour, or the coalition of several motifs into one colourful element. In *Park of the Villa d'Este* (c. 1830, Berlin) Blechen is wrestling with the problem of point of view. While the figures in the foreground take up a good deal of room, the Villa d'Este is added as a kind of scenic effect behind the figures strolling in the park, so that there are two points of focus. Blechen used this technique of abbreviation at least from 1828, but later it gave way increasingly to an objectivity of observation, until finally his bold bright coloration was exaggerated to produce a theatrical effect. This may be explained by the fact that the later pictures do not arise directly from nature, but were painted in the studio. In the early sketches his attitude to painting is essentially one of realism, even where the subject is taken from the theatre and bears almost Goya-like traits, as in *Pater Medardus* (Berlin). Blechen had begun by painting landscapes which communicated a mood in the Romantic manner, had shaken off the mantle of poetic or literary-orientated north German Romanticism during his stay in Italy in 1828, and had turned his attention to the phenomena of light and colour. In spite of the impressionistic coloristic technique his pictures and sketches remain Romantic, since no new pictorial form emerges from the new way of perceiving.

In Dresden, Ferdinand von Rayski (1806–90) was the first to apply the new methods of painting to portraiture. His stay in Paris (1838/39) no doubt inspired him to study French painting, and to produce a synthesis of French and German art. French art had a liberating effect on German artists—liberating in the sense that their conception of form became more precise. It would be historically inaccurate to speak of a one-sided dependence of German artists on French painting. The contact with French art worked rather as a catalyst, giving free reign to the ability to organize pictorial form,

in the sense of thorough articulation of the surface area of the picture. Thus Rayski's *Mounted Guard* (1838/39, Munich) appears to have become more or less painterly in style under the influence of Géricault. In the portraits, like
Plate 74 *Bernhard of Fabrice* (1845, Munich) and *Count Hans Haubold von Einsiedel* (1855, Berlin), the application of colour is delicate and balanced, the modelling of head and body aims to produce an effect of plasticity and of decorative surface harmony. Rayski's work in the 1850s stands at the point where realism was becoming Impressionism. But historical circumstances allowed this great painter to become forgotten and it was not until the beginning of the 20th century, at the Centenary Exhibition in Berlin (1906)—after Impressionism had become established in German painting in the works of Max Liebermann—that his work was rediscovered.

The Paris *Salon* was the official market-place of art, where the connoisseurs and the public had the opportunity of reviewing the year's production. The pictures were arranged according to their thematic approach, and first place was given to history painting. In his ironic account of the Paris *Salon* of 1831, Heinrich Heine says: 'Modern evening dress is so inherently prosaic that the only way it can be used in a painting is to parody it. Painters who hold this opinion have therefore turned to picturesque costume. The fad for old-fashioned historical materials is no doubt particularly well served by this tendency, and in Germany we find a whole School, who are indeed not lacking in talent but who are constantly engaged in dressing the most modern people with the most modern sentiments in the clothes of the Catholic or the feudal Middle Ages, in cowls or in armour.' If Heine rejected the 'old style' of history painting, as practised particularly by the Nazarenes and their disciples, he did see a new beginning in the kind of history painting initiated by Paul Delaroche: 'Perhaps if it [i.e. the conception of history painting] were to be used in its most natural sense, which is to describe pictures treating events from world history, this word "history painting" would give an accurate idea of the type of art which is now growing apace, and whose first flowering can be seen in the masterpieces of Delaroche.' Romanticism had been the last attempt to propose a transcendental view of the world. The void which succeeded its passing was filled with a number of substitute myths. Friedrich Theodor Vischer analyzed this situation in his *Critical Approaches* (1844): 'We paint gods and Madonnas, heroes and peasants, in the same way as we build in the Byzantine, Moorish, Gothic, Florentine, Renaissance and rococo styles, without having any style we can call our own. We paint everything in the world catalogue; we are jacks of all trades and masters of none, there is no central point, no dominant style, no main dish among all the side-dishes, sweetmeats and confectionery under which the table is groaning. The artist stands pondering and wondering what to choose from all the wares that have ever been available, and can't see the wood for the trees.' Vischer's criticism is particularly accurate as far as historicism is concerned.

Until the end of the 18th century, historical painting took its themes from classical and Christian mythology. By presenting man in an idealized way,

the historical process was objectified and endowed with exemplary ethical traits, so that the hero personified the greatest perfection. The approach to history altered radically with the advent of Romanticism. National history came to be all-important. Herder was one of the first to praise German national literature; Klopstock instigated conscious nationalization in painting and sculpture. At the end of the 'Sturm und Drang' period and during the classical period Goethe's and Schiller's dramas were based on characters from German history. About 1770 Benjamin West and John Singleton Copley had done the same thing in England. While Johann Gottfried Schadow drew caricatures of Napoleon, Caspar David Friedrich incorporated contemporary political allegories in his pictures, and among the Nazarenes there was a hard core who helped to bring about a renewal not only of religious art, but also of national art. Pforr had wanted his *Entry of Emperor Rudolf of Habsburg into Basle in 1273* to be understood as an event of national history, although the Plate 33 costume is that of the 16th century. Cornelius had at first planned a great historical programme for the decoration of the Casa Bartholdy, but this was altered by Overbeck's objection and became instead the story of Joseph. The frescoes in the Villa Massimo are the highpoint of this interest in history, which was poetically and philosophically idealized. Cornelius had already set the trend for later history painting in his illustrations to *Faust* and the *Nibelungen*. He became the spokesman of a 'new German art', whose main objective was the re-introduction of fresco painting. Here history was to be made available to the people as a whole and thus to become folk art, which would also include the function of popular education. While in Rome, Cornelius was already dreaming of a national form of history painting: 'so that benevolent old patriotic figures should look down with renewed freshness and vigour in lovely colours from the walls of lofty cathedrals, quiet chapels and solitary monasteries, town halls and commercial premises, and that with them the spirit of our fathers should be re-awakened and the Lord our God should be reconciled with his people.'

Under King Ludwig I of Bavaria, new sacred places were erected, like the Glyptothek built by Klenze in the Neoclassical style, for which Cornelius painted the murals of the Prometheus saga and the Trojan war. The artistic purpose of these frescoes was principally expressed in the subject, which aimed to put the observer in the right mood to appreciate the classical works of art on display. It was an attempt to clothe classical mythology in the language of Neoclassical form. In contrast to the frescoes in the Casa Bartholdy, Cornelius's compositions are flat and mannered, and the obvious lack of strong coloration was doubtless intended to harmonize with the Neoclassical architecture, even though it was criticized by his contemporaries. This, however, marked the beginning of an increasing schematization of Neoclassical style which later produced cartoons of a languid and dreary elegance that dominated German history painting for a long time. Cornelius decorated the Alte Pinakothek with pictures on the theme of *The History of Painting*, using subjects taken from Vasari and S. Boisserée. In the frescoes in the Ludwigskirche, for which he designed among others the *Last Judgment*

(1829–39), anti-illusionary surface elements represent a renunciation of the Baroque style of ceiling painting. The work on the *Last Judgment* led to a split with the Bavarian King. The intrigues at the court, principally on the part of the architect Klenze, made a longer stay in Munich impossible for Cornelius, so that he was only too willing to move to Berlin, drawn in 1840 by the reputation of King Friedrich Wilhelm IV of Prussia as 'the Romantic on the throne of the Caesars'. A campo santo was planned for the newly constructed cathedral, and was to be an imitation of the famous Campo Santo in Pisa. In 1843, Cornelius was commissioned to decorate the chapel. By about 1844

Plate 75 all his designs were completed, among them the *Riders of the Apocalypse*, whose compositional elements go back to Dürer's famous *Apocalypse* and to Phidias's Parthenon sculptures in the British Museum, which Cornelius had studied closely. Although the theme had been popular ever since Holbein's illustrations of the Dance of Death and Dürer's woodcuts and engravings, and the cartoons found favour at first, the public soon turned away from Cornelius and instead praised Wilhelm Kaulbach's frescoes of *World History* in the Neues Museum, which were originally to have been offered to Cornelius, as a comprehensible and pleasingly colourful pre-history of the German spirit. At this time the Belgian history painters Louis Gallait and Edouard de Bièfve became very popular in Germany because of their strong use of colour, which was derived from Rubens. Cornelius's tragedy may be explained by the fact that he shared the ideals of high Romanticism, but this was in opposition to the tendency of his own age to seek for 'painted reality', as a reaction to the Nazarene theories of art. Carstens and Cornelius, though filled with a sense of the seriousness of their mission, failed because their notions could not be put into practice. One can hardly imagine Carstens's *Procession of the Argonauts* and Cornelius's *Riders of the Apocalypse* as completed works; this may well indicate the extent of their achievement and its limitations.

Düsseldorf, where Wilhelm von Schadow had been Director of the Academy since 1826, soon became the centre of German history painting, aided by the liberal attitude of the bourgeoisie and its opposition to Prussian domination, and by the close economic ties with France and Belgium. History and genre painting had started to flourish in Düsseldorf about 1830 and received fresh impetus in the years that followed from French and Belgian painting. The Frenchman, Paul Delaroche (1797–1856), was the founder of a new history painting, which concentrated on the events leading up to or succeeding a major historical tragedy, in contrast to the method of Delacroix, who always depicted the event at its height. Heine wrote of Delaroche's *Cromwell before the Corpse of Charles I* (1831): 'Looking at Cromwell one was mainly inspired to wonder what his thoughts were as he stood by the dead Charles's coffin. . . . The lid of the coffin is also badly drawn and makes the coffin look like a violin-case. For the rest, however, the picture is painted with incomparable mastery and displays van Dyck's delicacy and Rembrandt's bold treatment of shadow.' The history paintings of Delaroche, Gallait and Bièfve all have the air of an artificial 'slice of life', and the resulting effect is

theatrical rather than historical, decorative and flattering rather than stylistic or serious. Nevertheless, such works delighted Jacob Burckhardt: 'Here we are presented with human beings and with reality so true to life that it appears almost illusionary.'

The centre of the new European history painting was no longer Rome, but Paris and Antwerp. The art historian Carl Schnaase, the historian Friedrich von Uechtritz and the poets Karl Immermann and Christian Dietrich Grabbe directly encouraged the history painters in Düsseldorf. The artistic opinions of the 'Junges Deutschland' movement (Heine, Börne, etc.) also played a role in making history painting a bourgeois art. The realistic elements in the Düsseldorf School can be explained by the influx of Berlin artists like Theodor Hildebrandt, Eduard Bendemann, Carl Ferdinand Sohn, Adolph Schrödter and Karl Friedrich Lessing, who had followed Wilhelm von Schadow to Düsseldorf, and in this way transplanted to the Rhineland the ferment of a view of reality about which Goethe had been deliberately scathing. The first great communal work of the Düsseldorf history painters was the painting of Heltorf Castle near Düsseldorf (1829–30), which Karl Stürmer had begun with a picture from the story of Barbarossa. In these works by Carl Friedrich Lessing, Karl Müller and Hermann Freihold Plüddemann one can still see a certain hesitation between fresco and oil painting.

The widespread success of the Düsseldorf history painters can be attributed to their choice of historical and literary subjects which appealed to the public's craving for reading matter; and their close attachment to reality, especially prior to 1848, had the effect of gradually bringing genre painting into favour. Hildebrandt's *The Murder of Edward IV's Sons* (1835), Bendemann's *The Sorrowing Jews in Exile* (1831) and Lessing's *Sorrowing Royal Couple* (1830) were judged by contemporary opinion to be masterpieces. Carl Friedrich Lessing (1808–80) came to Düsseldorf in 1826 and soon made a name for himself as a history painter. His *Battle of Ikonium* (Heltorf Castle, 1829) directly influenced Alfred Rethel's *Battle of Cordoba* (1849, Aachen). Taking his inspiration from the historian Uechtritz, Lessing became preoccupied with the figure of Jan Hus and his efforts to liberate his country: in 1834 he finished the cartoon for the *Hussite Sermon*, which was executed in oils in 1836 in Düsseldorf for King Friedrich Wilhelm IV, as he later became. Pictures of *Hus in Kostnitz* (1842) and *Hus in Front of the Wreckage* (1850) followed; these, however, were strongly criticized by Catholics and reactionaries on account of their tendentiousness. For Lessing was among those whose turn of mind helped to create the spirit of liberalism which led to the 1848 Revolution, and he was a founder of political history painting. From 1827, along with Johann Wilhelm Schirmer (1807–1863), he had attempted some landscape studies, which had seized the spirit of Dutch 17th-century landscape painting and partly transformed it by the use of broad brush work, as for example in Schirmer's *Times of Day* (c. 1839/40, Cologne). The Dutch influence, in combination with a growth of Romantic, theatrical Baroque-type elements, was to reappear later in the landscapes and seascapes of Andreas and Oswald Achenbach. In 1854, Schirmer left Düsseldorf to take up a teach-

Plate 78

Plate 79

Plate 81

ing post in the newly founded Academy in Karlsruhe; Lessing followed in 1858. Here they took much interest in the circle around the young Thoma.

Hildebrandt's *Warrior and Girl* (1831, Düsseldorf) has a very stimulating sensuous effect due to the contact of contrasting substances like flesh and iron—

Plate 78

a favourite theme later with Lovis Corinth; Hildebrandt's *The Murder of Edward IV's Sons* (1835, Düsseldorf) takes up the style of Paul Delaroche's picture of the same name (1831, Paris). Hildebrandt's coloration is close to that of the Belgians (e.g. Gustav Wappers). The fact that the picture does not depict the moment of the murder, but the highly charged dramatic moment immediately preceding it, was in accord with public taste, and this attitude on the part of the public to some extent justified the Düsseldorf School's characteristic weakness for the sentimental. Carl Ferdinand Sohn's (1805–67) *Torquato Tasso and the Two Leonoras* (1839, Düsseldorf) was later to stimulate Anselm Feuerbach. Adolf Schrödter (1805–75) preferred to choose the subjects for his pictures from Cervantes's *Don Quixote*, but in his case the novelistic element is stronger than the satirical slant emphasized by Daumier. Finally, one should mention Johann Peter Hasenclever (1810–53), whose pictures, such as *Job as Schoolmaster* (1845, Düsseldorf), are variations on 17th-century Dutch and Flemish genre painting and on the satirical tales of Hogarth.

Alfred Rethel (1816–59) began painting in the tradition of the Düsseldorf School as a thirteen year-old. His work is at once a fitting climax to Romanticism and also leads on to the renewal of realistic history painting. His first pictures had religious themes and were very much in the Nazarene style, like his 'Boniface cycle' (1832–36); but in 1836 he left the Düsseldorf Academy in order to continue his studies in Frankfurt under the guidance of Philipp Veit. In his four pictures of Emperors in the Römersaal in Frankfurt (1839–43) he broke loose from the linear style of the Nazarenes. His *Monk By the Corpse*

Plate 83

of Henry IV (c. 1844, Düsseldorf) depicts a monk praying at the Emperor Henry's coffin. The Emperor died excommunicated in Liège in 1106, and not until 1111 was he given Christian burial in Speyer cathedral. Irene Markowitz has indicated the possibility that Rethel was inspired by the poem 'Monk before the Corpse of Henry IV', which his friend Wolfgang Müller von Königswinter wrote in 1838 and published in 1842. Rethel had already dealt with the figure of Henry IV in his work in 1835 on the cycle of Rhenish legends by Adelheid von Stolterfoth. In the picture Rethel cuts down on detail and links the figures on the surface by aligning them through the use of rectangular and diagonal perspectives which give a monumental effect. Aided by the broadly applied dark colours, this helps to create a tragic mood, intensified by the dramatic way light is contrasted to the gloomy landscape background. The interpretation of history by personal experience is Romantic, but the picture does not make any formal borrowings from the Nazarene or Baroque-derived history paintings of German artists of the time. The summit of this history painting, which is Romantic and monumental in the best sense, is found in Rethel's frescoes of Charlemagne in Aachen.

In his history paintings and woodcuts, which were at first influenced by the Düsseldorf School and particularly by the works of Lessing and Schirmer,

Rethel soon developed a monumental style, which surpasses the theatrical arrangement of the Düsseldorf painters. In the Charlemagne frescoes, which take up the growing feeling of nationalism and give expression to the desire for national unity so strong in 1848, Rethel brought German Romantic history painting to a fitting climax. His woodcuts, particularly *Another Dance of Death*, have a folk quality which can only be compared to the woodcuts and engravings of Dürer, with whom he has certain stylistic affinities, except that his Romantic sensitivity leads him to a somewhat exaggerated realism. For Rethel history does not mean reproducing the present in a historical light, but bringing the past up to date—and in this he is similar to Menzel, however different their formal approaches may have been. In 1843, in a competition on the occasion of the millennium of the Holy Roman Empire, he won the chance of decorating the Emperor room in the Rathaus in Aachen, Charlemagne's favourite residence. In the frescoes depicting his story, the German myth of the Emperor who would return to glory was powerfully presented. Between 1847 and 1853 Rethel completed the first four frescoes; after he went insane, his assistant Joseph Kehren completed the remaining pictures according to sketches left by the master. The highpoint of the action, which Rethel as a chronicler of fact was concerned to show, is sometimes displaced from the centre of the picture, as in *Otto III's* Plate 82 *Visit to Charlemagne's Vault*. Having caused the grave of his mighty predecessor to be opened, the young Otto III finds his ancestor's corpse sitting upright in all his princely finery on a stone throne. In the *Battle of Cordoba* (1849) the principal impression is one of forceful movement. Historical fact is conveyed by means of heightened realism, and the spirit of the nation is depicted as a striving for unity. Rethel's genius contains subdued notes of the demonic: a melancholy pathos moulds Cornelius's beautiful arabesque line into a powerfully angular monumental form. Although the brush-work sometimes betrays a certain nervousness, it always retains a fine tense rhythm. Rethel relied on simple, subdued colours to produce a heavy oppressive effect and to make history painting a personal vision. Individual forms are boldly isolated from their natural surroundings and dramatized ruthlessly and violently till they become almost symbolically elemental. Rethel's art is an attempt to formulate in elemental terms a deeply-felt vision of historical reality, haunted by the spectres of death and madness.

Apart from the Charlemagne frescoes, Rethel's fame is based on his six woodcuts *Another Dance of Death* (1848–49) and the two woodcuts, *Death the Destroyer* (1847) and *Death the Friend* (1851). In 1840 he produced his illustrations of the *Nibelungenlied*; in 1843–47 there followed his sketches for *Hannibal's Crossing of the Alps*—all these woodcut illustrations are a kind of prelude to his *Dance of Death* plates, which Baudelaire described in his article 'L'Art philosophique' (1859), as an 'early example of philosophic art'. The illustrations to which accompanying verses by Robert Reinick are appended, were for Baudelaire 'a poem of reaction whose subject is the usurpation of all powers and the seduction of the people by the fatal goddess of death'. It was the fatal, morbid and mysterious aspects of the figure of death which struck a

vital chord in Baudelaire. Rethel's *Another Dance of Death* is primarily a personal avowal of his constant preoccupation with death. Wilhelm Reinhold Valentiner was the first to point out that an article by Heine, 'On the Outbreak of Cholera in Paris', published in the *Augsburger Zeitung*, may have provided the stimulus for Rethel's plate *Death the Destroyer* (1847). In any case, Rethel must have seen Holbein's woodcuts on the same theme; and a personal experience one evening at Dr. Carus's house in Dresden, when a guest suddenly succumbed to a heart attack, no doubt reinforced his intention to treat this subject. Rethel's woodcuts are like large and dramatic handbills; in this they resemble Dürer's and Holbein's works, where the description of the figure of Death and the devastation it causes is both epic and expressionistic. These plates are intended not as a reaction but as a warning to those who will lead the people astray, and were conceived before the 1848 Revolution. Death embodies the idea of anarchy and the dissolution of the stable world. The victim is not the individual human being, but the anonymous mass, who cannot be shown as standing in opposition to death. One plate in the series *Plate 84* shows the *Triumph of Death*, in which death, riding a lean hack, clambers on to the barricades. The plate may have been based on Dürer's drawing of death on horseback; it certainly influenced Stuck's *War*. A dying youth raises himself up for the last time—the same motif appeared in Delacroix' *Liberty on the Barricades* (1830, Paris)—in dramatic contrast to the allegory of freedom. Death is at once skeleton and demon. This vision of death as a sinister, highly emotive figure lurking in the depths of the subconscious, pitiless in its inevitable victory, had accompanied Rethel from his youth, and is heightened into a symbolic archetype. Reinick wrote the following verses to the plate *Triumph of Death*:

> The leader of this band was death!
> He kept his promise all too well.
> His followers lie pale and still
> In equal, free fraternity—
> And see! Now he's removed the mask;
> The scornful victor on his steed,
> Hero of the Red Republic,
> In his train he brings decay.

In the individual plate *Death the Friend*, death appears as a pilgrim in the bell-ringer's room, ringing in the evening. In all these 'poems', reality and vision are merged; the fundamental preoccupations of Rethel's subconscious arise and are expressed in a symbolic manner. Romanticism and revolution are intimately connected and permeated by a tragic vision of life. These grandiose plates were assimilated into the national consciousness like popular airs, but their creator was forgotten all too soon. They stand as a final and worthy conclusion to Romanticism. There is a great similarity between Rethel's *Death the Friend* and Franz Schubert's song 'Death and the Maiden'.

III From Realism to Impressionism

Adolph von Menzel

Adolph von Menzel (1815–1905) is one of the greatest 19th-century German artists. He had genius, but because he was physically stunted, he was distrustful, bitter and solitary. His sense of duty and strength of will occasionally frustrated the full blossoming of his talent. His work reflects the conscious struggle between reason and emotion, duty and desire. As a young man he had to look after his family when his father died in 1832. His thirst for knowledge and his passionate desire to dominate and subdue the reality of his external appearance, as though it were a matter of mastering his own destiny, helped him to produce works unique in 19th-century art, but which contain all kinds of contradictions and anachronisms. Where Menzel followed his senses without the intervention of cerebration, and simply put on paper his visual experience direct from nature, as in his early sketches in pencil and oils in the 1840s, his works have an air of modernity; but where he felt the need to 'reason out' his impressions—as he put it—he often stifled his ability to experience directly. When, at the beginning of the 20th century, Menzel's early oil sketches were discovered (he himself had not allowed them to become known to the public), the critics Meier-Graefe and von Tschudi judged them by the yardstick of French Impressionism. The young Menzel of the impressionistic sketches was played off against the Menzel of the Prussian history paintings. But one must see Menzel's work as a whole in order to understand his achievement and do justice to his importance.

In his *Entwicklungsgeschichte* (History of Modern Painting), Meier-Graefe said: 'Menzel is chaos. Like naturalistic writers, he depends on chance to govern, in as clear a manner as possible, the choice of the selected piece of nature he wants to reproduce.' Menzel is not chaos, but rather the artist who orders, who encounters the chaos of the innumerable phenomena of reality, and makes it obey his pencil, thereby giving lasting form to the physical constituents of the phenomenon. His 'writing with abbreviations', as he described his style of drawing, gave artistic form to the visual. Menzel is primarily a draughtsman and in this he is very close to that other great German artist, Albrecht Dürer. When he turned to painting he had already mastered the technique of close-up, the epigrammatic quality combined with wit, the ability to bring out the painterly quality of line. Menzel's art is determined by reality, and the artistic process is always controlled by the eye. For Menzel and his generation the study was never an end in itself, but a means to achieve the finished picture. In his view there was no contradiction between the open painterly form of his sketches and the 'finished' quality of his pictures. Historically his impressionistic sketches, made directly from nature, are in no way contradictory to the finished painted pictures which were completed in the studio. The problem for him was not artistic form, but the artistic transformation of the subject. The subject is more important than the form, even

though he does invest artistic form with qualities which, in view of the coming generation of Impressionists, can be regarded as modern. Menzel saw history painting as the artist's noblest subject, and his pictures illustrating the story of Frederick the Great, which he worked on in the 1850s, give a clear indication of what art meant to him. But in contrast to his contemporaries, he did not consider history painting as a means of historicizing the present, but of bringing history alive.

Daniel Chodowiecki (1726–1801) had been the first Berlin realist; behind the apparently rococo world of his pictures lurks a strong sense of reality. Nature not imagination, was his mentor. In his work he depicted bourgeois *Plate 87* life, as in *Company at Table* (1760, Hamburg); he robbed the playful, brilliant, erotic elements of their force.

Johann Gottfried Schadow (1764–1850), whose importance to 19th-century art has already been mentioned, took as the starting-point of the Neoclassical style of his sculptures observation of reality direct from life; in the numerous sketches which for the most part served him as preparatory studies to his sculptures, elements of realistic painting techniques can be seen, which arose *Plate 85* solely from direct experience of reality. His watercolour *Self-portrait* (1838, Berlin) is reminiscent of portraits by Chardin and Graff in old age, and invokes associations with impressionistic works. The specifically Berlin mixture of sensitivity and intellect or 'wit' that can be seen in Schadow's caricatures of Napoleon is also evident in Menzel's ironic comments in his Prussian society-pictures. It is a form of wit which certainly draws inspiration from reality, but in no way destroys it, as sarcasm does. Even where Berlin artists were confronted by the art-forms of French Neoclassicism, as in the case of Karl Begas (1794–1854), a sure sense of the realistic remained dominant, *Plate 86* e.g. *Portrait of the Artist's Wife* (1828, Berlin), whose delicate characterization of the human features leads directly to Menzel's early portraits.

Franz Krüger (1797–1857) painted in a sober bourgeois manner, and the tone is set by his clinically precise observation of reality. In his book on Menzel, Karl Scheffler accurately describes Krüger's art: 'an infinitely light and graceful hand, an ever sure eye, cultured taste and absolutely no soul at all.' These qualities, however, made him an excellent observer of contemporary events, *Plates 88* as in the picture *Parade in the Opernplatz, Berlin, 1822* (1824–29, Berlin), *and 89* where he was concerned to achieve freshness and immediacy; the parade-type picture may derive from Horace Vernet's *Parade on the Champ de Mars in Paris* of 1822, which was part of the inventory of Charlottenburg Castle in Berlin. Krüger's favourite subject was horses, and he was popularly dubbed 'Pferde-Krüger' (Horsey Krüger). In 1846 he had travelled to France and even watched Delacroix painting, although this had no direct consequences.

The basis of Krüger's art was not painting but drawing, and in this too he is very similar to Menzel. One of Krüger's pupils was Karl Steffeck (1819–1890), who specialized in drawing horses and in military pictures. Krüger's essentially objective painting was continued by Eduard Gärtner (1801–77), whose topographical views often expand into full-scale panoramas,

like his *Panorama of Berlin*, painted in 1834–35, which carried 18th-century *veduta*-painting to a final high-point. His smaller views of Berlin buildings and streets are some of the most precious examples of late Romantic painting.

Thus when Menzel came to Berlin in 1830 he found an indigenous school of painting there, distinguished by its objectivity. But by enlarging and surpassing its quality he became the greatest personality in 19th-century art in Berlin, both summing up tradition and pointing forward to new developments.

The sketch is fundamental to Menzel's work, even where his painting is concerned. At the beginning of the 1840s a notable discrepancy appeared between Menzel the polished draughtsman, whose woodcut illustrations to *The History of Frederick the Great* had been praised by Degas as 'one of the most extraordinary things in modern art', and the as yet immature painter. In an unobtrusive way the sketches already possess the kind of wash-technique more common to painting, which renders the material quality of objects, space and mood, as different degrees of black and white. From such sketches it is not far to Menzel's first attempts at painting in the middle of the 1840s.

With his illustrations to Franz Kugler's *History of Frederick the Great*—which began to come out in 1840 at the publishing house of J. J. Weber in Leipzig and are undisputedly the summit of his achievement as an illustrator—Menzel produced a worthy counterpart to Vernet's illustrations to *The History of Napoleon* (1839, Paris). In preparing his illustrations, Menzel had carefully studied everything available on the history and character of Frederick the Great. Disappointed by the schematic reproduction method of the French woodcutters, he entrusted the making of a facsimile of his sketches to the Berlin cutters. The illustrations are independent interpretations of the text; they embellish it as vignettes; they are epigrammatic, and the style contains qualities of both painting and drawing, and is both illustrative and decorative. Menzel wanted to be as faithful as possible to 'historical truth', but wanted also to bring history up to date and strip it of its aura of mythology and its idealistic aspects. He therefore presented Frederick not as a superhuman hero, but as a great man whose keen wit (in his relations with Voltaire), strict sense of duty and lack of affinity with women, were close to Menzel's own character —a similarity which can also be explained in psychological terms.

The illustrations to the *History of Frederick the Great* already express Menzel's whole artistic attitude, as it is expressed later in his painting. For him the study of nature was the exclusive prerequisite for his art. Such concepts as 'writing with abbreviations'—with respect to his drawing—or 'reasoning out'— with respect to his work on composition—are also fundamental to his artistic purpose. In close-up the presence, the impact, of an object must not be lost. To be optically 'intelligible' each transient phenomenon must be made both comprehensible and visible. Where a work of art aims at only one of these components, as in Impressionism, where comprehensibility in Menzel's sense is neglected, it is for him not art, but only a kind of half-way house on the path to being understandable. The fact that art must be intelligible (in his words *raisonnable*) means that his use of form is complete in the sense that it renders both the optical and the intellectual dimensions of the subject.

From all this it is easy to see that Menzel viewed his oil studies only as a preparatory stage to his pictures; the subject appears first in a sort of note form, without its intellectual associations, which are restored to it with expanded significance in the finished work. Along with his generation Menzel held fast to the conception of the finished painting. To be complete meant for him to be exhaustive. Not until the Impressionists was completion of the work no longer to be seen as implying an exhaustive treatment of the subject.

In Menzel's early oil sketches one finds a conception of form which characterizes the optical element of his visual experience; but his own ideal conception of art form was a long way from such studies. He did not exhibit his studies publicly, and in the index of his works which he drew up for Friedrich Pecht in 1872, none of these studies is mentioned, although they figure among the crucial achievements of the German 19th century. Menzel may have been stimulated to his first attempts at painting by the Berlin style of Krüger, with its emphasis on objectivity, by the Düsseldorf history painters, by the works of Constable, which were exhibited in Berlin in 1839, and by his visits to picture galleries and graphic collections, where he admired Rembrandt's engravings.

Menzel painted his landscape studies either from pencil studies or directly from the window of his studio. A particular cloud-formation may have Plate 92 inspired the study *View of Prince Albrecht's Park* (1846, West Berlin) which he repeated in a smaller, more compact picture of 1846 (East Berlin). The study is reminiscent of Constable in the combination of colours—the yellow castle buildings with the red roof, the bright closed blinds above the lush green of the trees in the park. Later, in 1876, Menzel revised the study, and among other things he added the workmen resting in the foreground. The *Building Site with Willows* (1846, Berlin) follows a sketch in pencil and falls into several self-contained parts. The oil sketch *The Berlin-Potsdam Railway* (1847, Berlin) is based on a sketch of 1845, and its smudge effect makes one think of Rembrandt and Constable. It seems important here that the first version from nature was a sketch, and Menzel converts its light/shade values into colour. The addition of visual elements containing narrative associations, like the workers in the *View of Prince Albrecht's Park* or the train in *The Berlin-Potsdam Railway*, is typical of Menzel, and in this way the directness of the first impression is considerably affected. He wanted to be sure that the picture did not gain its effect simply from observation of the phenomenon but also from its 'intellectual' content, by introducing elements of narrative, anecdote, poetry or wit. This very tendency to stress the importance of narrative prevented him from fully developing his pictorial form, which had been acquired in the first place from pure observation.

Plate VI The study *Room with Balcony* (1845, Berlin) is the first of the series of interiors which display Menzel's great talent for coloration and his ability to reduce formal qualities to expressive essentials. He does not, like the late Plate 53 Romantic Schwind in his *Morning Hour* (Munich), emphasize the associative or subjective qualities of the interior, but rather its external visible appearance, which is here transformed into a composition of light and colour, ranging from brown to red, from greenish grey to white. The picture takes its structure

from a coalescence of subtle harmonious parts, which are integrated by means of horizontal, vertical and diagonal lines arising naturally from the form of the objects depicted. The individual objects are indicated only in a general way, not reproduced in their specific but momentary state, yet the use of shades of black is altogether avoided; the curtain in front of the open door to the balcony swings gently to and fro, and the whole room is pervaded by a particular atmosphere. Visible reality, and the laws of light and colour basic to it, are the real subject of this study. *The Artist's Bedroom* (1847, Berlin) shows a narrow *Plate 90* room with one window, viewed in depth. It is extraordinary the way the eye is led past the bed, the writing desk and the incomplete bust up to the window, and there directed to a prospect of houses—the same view by Menzel in another study, *View of the Houses at the Back* (1847, Berlin). This 'picture within a picture', with its red roofs and a patch of blue sky, stands in contrast to the modulated reddish-violet twilight of the room. Menzel always heightened the object in its quality as object and its pictorial appeal by means of this startling directing of the gaze, and at the same time he isolates it from its natural surroundings and places it in a new relationship to everyday experience by means of colour and light. The study *Living Room with Menzel's Sister* (1847, Munich) has an unusually compact compositional structure, *Plate 91* which is further stressed by the way he places his monogram and the date in the left-hand bottom corner. By means of a slight elevation of the angle of vision, foreground and background, instead of being sharply differentiated, fuse into a single surface over which the eye travels with ease. Menzel used only two colours, a brown and a grey, which he varied and with which he mixed a pink. The artist was here principally interested in the artificial light which illuminates and models the figures and the interior.

The oil study *The Studio Wall* (1852, Berlin) is a bravura piece. The *Plate 93* artist wrote to his friend Albert Hertel: 'The numerous life-size studies from beneath, consisting of illuminated plaster limbs and shapes—all by lamplight— that you can still see today on my studio walls, owe their origin to the attempt to exercise my hand and my great wide brush in large brush-strokes, and in the unusual light effects of the naked flames all around.' The plaster shapes are arranged as if they belonged to an invisible figure, and show a tendency to the wittily grotesque, which is a salient feature of Menzel's art. In the study *Medieval Armour* (1868, Hamburg), for instance, he conjures up associations with a procession of medieval knights. *The Studio Wall* leads one inevitably to think of Géricault; the French painter was extremely exact in the depiction of human limbs, but Menzel extracts from these plaster limbs an impression of grotesque hidden significance, which gives objective material an additional magic dimension. This is heightened by Menzel's frequently startling perspective which makes space appear foreshortened and thus alienates it. It was not until later, at the beginning of the 1860s, when they became acquainted with Far Eastern art, that the French Impressionists adopted this procedure.

The study *The Friedrichsgracht in Old Berlin* (c. 1856, Berlin) is an extension *Plate 96* in painterly terms of the Romantic mood-landscape, in which Menzel was trying out his technique of using large brush-strokes. The dominant tone

is a bluish grey, covered by brush strokes giving an impressionistic effect.

Menzel was acquainted with contemporary history painting in Düsseldorf;
Plate 79 but Lessing's *Hussite Sermon* (1836, Düsseldorf) showed him clearly 'how little sense the Düsseldorf painters have developed for arranging the lighting and the different degrees of detail in accordance with the greater or lesser degree of importance the object has', as he wrote to his friend Carl Arnold on 29 December 1836, although Lessing's picture seemed to him the most complete of all the Düsseldorf works.

Menzel turned to contemporary history in 1848. His uncompleted picture,
Plate 94 *The Lying-in-state of Those who Fell in March* (1848, Hamburg), was painted under the influence of the 1848 Revolution and shows the lying-in-state of the freedom fighters on the front steps of the Neue Kirche in the Gendarmenmarkt in Berlin, which the artist witnessed. On a bright ground the figures stand out in dark grey and black local colours. The type of picture derives directly from Krüger's parade pictures, and here one finds a similar tendency to compress the crowd into a small area in front of a piece of architecture which encircles the events and serves as a frame. The fact that the picture was not completed is a result of Menzel's growing disillusionment about the outcome of the Revolution. Resignedly he stated in September 1848: 'Once again we hoped too much of humanity; the (justified) indignation about those at the top has now merely been superseded by indignation about those at the bottom. It's just the swing of the pendulum from one side to the other.'

Having turned away from contemporary history, Menzel became interested once again in national history. While working on the Frederick the Great woodcuts he had the idea of treating this theme in painting. 'Frederick above all. Nothing is more fascinating. The material is so rich, so interesting, so grandiose, indeed, although you will no doubt shake your head about this, when one gets to know it better, so fit for painting, that I would just like to be fortunate enough to be able to paint a cycle of great history paintings from this period.' Menzel's *Latin Poems*—as he called his pictures of Frederick—followed directly from the woodcut illustrations, transposed into full-scale pictures. The figure of the Prussian King serves as the central theme and unites the pictures into a cycle in which the world of rococo received a final noble and sympathetic evaluation. Menzel was not concerned with history painting as a genre heavy with pathos and theatricality, aiming to reproduce the tension of a great moment in history; he wanted to bring to contemporary experience an epoch which directly preceded the 19th century and which had in Frederick the Great a leader who incorporated all the Prussian virtues.

In 1849 he began the first picture, *Letter of Supplication* or *Frederick the Great taking a Promenade*. During the 1850s he completed the rest of the eight pictures, among them *The Round Table* and *The Flute Concert* which are the most popular of the series. In *The Round Table* Menzel depicts the conversation between Frederick and Voltaire, who was a frequent guest at the Prussian
Plate 97 Court in Sans Souci Castle in Potsdam; *The Flute Concert* (1852, Berlin) shows a concert in the music room in this castle which the King gave on the occasion of the visit of his sister, the Countess Wilhelmina of Bayreuth, and when he

himself played the flute solo. Menzel characterizes the most diverse reactions in the poses and gestures of those present with brilliant psychological insight. He further recreates the extraordinary atmosphere in the candle-lit rococo hall, by using a more or less uniform reddish brown base, against which the golden yellow of the burning candles shines out. This candle light is reflected in the mirror and models the faces of those present, and yet it does not change the physical substances it illuminates: Menzel's art touches here on the kind of realistic painting whose supreme aim is to bring to life the spiritual in the material. It is therefore not surprising that he saw his main problem as that of the depiction of light. 'I can certainly say I have never approached my subject-matter lightly, but I have never set myself a task like this before, and principally (apart from everything else) because of the kind of lighting: candle light from all sides and from above.'

In the uncompleted picture *Frederick the Great in Lissa Castle* (1858, Hamburg) Menzel took up again a subject which he had already treated in his woodcuts. The King had come unawares into the camp of the enemy, the Austrian Army led by Prince Karl of Lorraine, and was only able to avoid being taken prisoner due to his presence of mind: he greeted the astonished enemies with the words 'Bon soir Messieurs' and asked to be introduced to the officers, in order to create the impression that his army was following him. In the dramatic disposition of contrasting movements, in the interplay of light and shadow, in the definitive lines of the pictorial area and finally in the animation given to the whole situation, Menzel has taken over and developed Baroque elements. This picture seems to achieve a synthesis of Velasquez' *The Surrender of Breda* and Rembrandt's *Night Watch*. *Plate 95*

In *Frederick and His Followers at Hochkirch* (1856) the battle picture acquires monumental form due to its inherent intellectual content, which is not unlike that of Emanuel Leutze's (1816–68) famous history painting *Washington Crossing the Delaware* (1850, Bremen). Menzel's last work in the cycle, *Frederick's Address to his Generals before the Battle of Leuthen* (1858), gains its effect solely from its success as a psychological study.

The official commission to paint the *Coronation of Wilhelm I in the Castle Church of Königsberg on 18 October 1861* (1863–65) was the external signal for Menzel to break off his work on the cycle of pictures about Frederick. Menzel completed the picture with difficulty, and while working on this representational history painting of a contemporary event it became clear to him that contemporary history was incapable of providing him with suitable material for monumental history painting—his previous attempt to monumentalize the 1848 Revolution had been a failure from his point of view. Genuine interest in history and in history painting declined after the 1848 bourgeois revolution had been put down and the second German Reich founded. A mediocre painter, Anton von Werner (1843–1915), managed to establish himself as official Prussian pictorial historian and painted the heroes of the Franco-German War of 1870/71, endowing them with the pathos of great historical figures, and not infrequently achieving in place of history a kind of sentimental anecdote.

Menzel visited the French capital three times, in 1855, 1867 and 1868. As early as 1851 the French art dealer Goupil had ordered from him two small pictures from the *History of Frederick the Great*. After his first stay in Paris in 1855 he painted several pictures from sketches or from memory, in which the coloration already present in the oil sketches of the 1840s was made more systematic. *Théâtre Gymnase* (1856, Berlin) is similar in theme and composition to certain French painting, although the predominant use of the brownish red with which yellow, blue and red are harmonized, is typical of Menzel. *Peasant Theatre* (1859, Hamburg) has a similar subject, and here the artist was concerned with the representation of the most diverse light effects, which give the interior a poetic quality while at the same time bringing it to life in a realistic manner. A picture like *Policeman and Lady in the Tuileries Gardens* (1856, Berlin) is related at least thematically to the French Impressionists' open-air paintings of the 1860s, and Menzel himself developed the

Plate 98 subject in the style of these paintings in *A Walk in the Garden* (1867, Bremen).

In the 1860s Menzel began a series of sketches in body colours for his children's album, in which scenes from the zoo are depicted in colourful, abbreviated impressionistic style. In his oils Menzel rarely got away from the brownish red of studio paintings; nevertheless he differed from his colleagues in applying the colours to the canvas without glazing, which gives them a striking luminosity.

In his painting, he devoted considerable attention to the problem of light, and this meant for him primarily illumination. Since Menzel worked from nature, but did not in fact paint his pictures in the open, the problem of impressionistic open-air painting did not at first seem to exist, and he did not occupy himself with it until his second stay in Paris in 1867. In open-air painting, figures and open space had to be fused into a pictorial harmony by means of light. In France it was the masters from Barbizon (Daubigny, Rousseau, Millet, etc.), in Germany similarly Blechen, Wasmann, Gensler, Rottmann or Schirmer, among others, who took the first hesitant step from the studio to nature, and especially in the 1830s and 1840s produced impressionistic sketches in oils from nature; however, they lost their immediacy as soon as they were transferred to the studio and subjected to the restrictions of studio light and conscious compositional arrangement, as for example the addition of accessories. This had the effect of making open-air painting appear to be just another subject treated by a painter in his studio. That was true for Menzel as well as for the early French impressionistic open-air painters; Manet's *Lunch on the Grass* (1863, Paris), for example, was prepared in the open air, but painted in the studio. In the 1860s artists began to use open-air light as a means of welding separate pictorial elements into a single optical

Plate 98 experience. Menzel's *Walk in the Garden* (1867, Bremen) is one of the first German attempts at open-air painting, done at the same time as Renoir's *Lise with the Sunshade* (1867, Essen). The picture appears to have originated during one of Menzel's many visits to Meissonier at his country house in Poissy. In spite of certain similarities with contemporary French painting, both in theme and technique, *Walk in the Garden* is an individual development

of Menzel's oil sketches of the 1840s and of the pictures in his children's album of the 1860s. The choice of two visual perspectives, indicating that the painter is observing from an elevated position, the fact that the relationship between figure and space is seen more from the point of view of the figure's motivation than as a formal concern, and the tendency to paint in small areas, all differentiate Menzel from contemporary French painting, whose principal representatives belonged to a younger generation. A later gouache, *Plans for a Journey* (1875, Essen), is like a paraphrased sketch of Impressionism. Menzel has taken from the French the elements that appealed to him, the ability to harmonize colours and to grade them chromatically, and also to see light not just as illumination from one quarter but also as open-air light.

Reciprocally, the French painters and critics much appreciated Menzel's art. On the occasion of the 1855 International Exhibition in Paris his *Flute Concert* (1852, Berlin) was displayed among others; at the graphic exhibition in the Paris *Salon* of 1869 French critics discovered how good his sketches were. In the following years Menzel worked on the pictures of court balls which brought him great recognition in France. *The Interlude* (1870, Munich) is the precursor of *Ball Supper* (1878, Berlin), in which the intimacy of the *Plate 99* former gives way to the impression that people have been put on show: the figures are more strongly typical and the framework has become monumental and decorative. The impression of depth is accentuated by the pillars, candle light streams down on to the figures from great candelabra. The golden yellow light is reflected many times over in the mirrors. If one compares the *Ball Supper* with the younger Manet's *Bar of the Folies-Bergère* (1881–82, London), one finds in the French picture the tendency to transfer the physical reality of the scene into a kind of purely artistic existence, thus casting doubt on the illusion of uniformly constructed pictorial dimensions; for Menzel, on the other hand, mirrors are a welcome means to further emphasize material objective reality by the candle light, as well as to heighten the illusion of depth. The picture takes its unity in painterly terms from a synthesis of sketch work and application of colour, where the techniques of drawing and painting are interchangeable.

In 1878 Menzel was represented at the Paris exhibition by a series of pictures, among them *Rolling Mill* (1872–75, Berlin) and *The Interlude* (1870, Munich). In the *Gazette des Beaux-Arts*, in 1880, Louis-Emile-Edmond Duranty devoted an amazingly long commentary to Menzel's work, which no doubt played a part in preparing the great Menzel exhibition of 1885 in Paris, inaugurated by F. G. Dumas. Duranty characterized Menzel's work as follows: 'Moreover, Menzel has a great temperament; he is a little brutal and wild like Hogarth; he goes directly to nature . . . like Holbein, like Daumier, with whom he has certain things in common, like all artists who are governed by the spirit of reality, even as a young man he displays great intelligence . . . he is passionately concerned to give the strongest expression to details, which he multiplies, without ever depicting them exactly, and he is obsessed by light in all its forms and in its effects according to the source: whether it be the light of day or of night, the light from a window, from an open fire or from a lamp, from

candelabra, blast furnaces, etc. Gradually Menzel has become a painter; this has less to do with the dominance which the magic of colour exerts upon the emotions of certain artists, than with the strength of his intellect. Everything which one has so far seen of Menzel develops in a light, gracious, unforced manner, culminating in the *Ball Supper*, in which one observes the greatest animation in everything. This work is a combination of intellectual reflection and a quick and skilful hand.'

Degas shared his friend Duranty's enthusiasm for Menzel; when *Ball Supper* was shown at Goupil's in Paris in 1883, Degas made a free copy (Strasbourg) which reproduces the basic features fairly accurately, but simplifies the details and retains the original choice and arrangement of colours in a strikingly superficial manner. What may be described as Menzel's luminosity has been transformed by Degas into mere flat planes of colour. Degas sees as a unity of colour what Menzel divides into objects being illuminated on the one hand and colourful objects on the other.

Camille Pissarro took the opposite view of Menzel's art, occasioned to some degree, no doubt, by Menzel's criticism of the French Impressionists which Durand Ruel had exhibited at Gurlitt's in Berlin in 1883. Menzel had described Impressionism as 'lazy art'. This is referred to in Pissarro's letter to his son on 10 November 1883: 'I am not surprised by Menzel's opinion; he is obviously a man of talent, but ponderous and a confounded bourgeois. Degas was crazy about him and dragged us off to Goupil's to look at a picture *Ball Supper*. I went along, very pleased to be able to admire a masterpiece— went quite unbiasedly with Miss Cassatt. We found a dirty-looking dark picture, executed with care, it is true, but lacking totally in art and delicacy.... We were able to make a most interesting comparison between Degas and this wretched painter. When Degas came back from Goupil's exhibition, he dashed off a sketch of Menzel's *Ball Supper* for us. On the way back we were amazed at the superiority of Degas' sketch. Naturally a sketch exercises a greater attraction, but that's beside the point: we had Degas' work before our eyes and compared the one with the other.'

In spite of this criticism of Menzel's realism—understandable from the point of view of the French Impressionists, especially because Menzel, born in 1815, and Pissarro, born in 1830, belonged to different generations—French criticism as a whole considered Menzel to be the greatest German painter of the 19th century.

Anselm Feuerbach

Anselm Feuerbach (1829–80) was brought up in an atmosphere of classical antiquity which preoccupied him in his work throughout his life. His father was Professor of Archaeology and author of the book *Apollo of Belvedere*; his uncle was the famous philosopher Ludwig Feuerbach. At the age of six, Anselm already had a good knowledge of Homer's poetry and of Flaxman's

illustrations to the *Iliad* and the *Odyssey*. At the age of sixteen, on the advice of Wilhelm von Schadow, he attended the Academy in Düsseldorf, which he left in 1848, in order to continue his studies in Munich under Karl Rahl, who directed his attention to the Flemish and Venetian painters. It was therefore advisable for Feuerbach to go to Antwerp, where he studied under Gustav Wappers in 1850, and then ended his wanderings by spending the years from 1851 to 1853 in Paris. In Thomas Couture he found a teacher who encouraged his yearnings for the classical and whose figures possessed for him 'as great a plastic nobility and beauty as did the Ancients'. From Couture he also inherited the prevalent epigonic trend to interpret everything from the standpoint of classical antiquity: a form of eclecticism from which he rid himself only with difficulty in later years. Before studying under Couture he was influenced by the Barbizon painters and by Courbet and Delacroix, whose famous picture *Dante's Barque* he copied. His first large picture, *Hafiz outside the Tavern* (1852, Mannheim), still reflects the internal conflict between Romantic and realistic conceptions of art: the subject is Romantic and the softness of modelling is reminiscent of pictures by Courbet like *Women Bathing* or *Women Sifting Corn*. Finally, however, Feuerbach decided in favour of Couture whose *Romans of the Age of Decline* he copied: 'I cannot sufficiently thank the master [Couture] who led me from German brush-tip daubing to generous broad brush treatment, from academic mechanical composition to breadth of vision and conception.'

After a short stay in Karlsruhe in 1855 he received a travelling scholarship to Venice, where he copied Titian's *Assumption* and painted *Musical Poetry* (1856, Karlsruhe), in which he strove, somewhat awkwardly, to imitate his model, Raphael's *Saint Cecilia* in Bologna. For him the picture personified old Italy in a similar way to Overbeck's *Italy and Germany*. Later, on another occasion, he praised Raphael's picture: 'The form and heart-felt expression of the picture is inexpressively beautiful. . . . In this age of trips, railways, spiked helmets and ragged ulsters, art can no longer be found. Who nowadays has time to immerse his soul in the All-Holy in this way? How this master puts to shame our erudite snippers of coupons and the sterile poetry of sentimental hack writers' (1873). The essential nature of Feuerbach's art is already to be found in such comments: the classical inheritance—of antiquity as well as of the Renaissance—must be rescued from oblivion. This conscious historical return to past epochs makes his own work rather problematical, since his relationship to antiquity, to Raphael, Correggio, Andrea del Sarto or Michelangelo, influences his originally realistically-oriented views on form in favour of an ever-increasing tendency to idealize reality on the basis of given examples.

Feuerbach's choice of subjects for his pictures was no doubt literary in nature. In classical themes, such as *Dante with the Noble Ladies of Ravenna* (1858, Karlsruhe), *Iphigenia* (first version of 1862 in Darmstadt, second version of 1871 in Stuttgart), *Medea* (1870, Munich), *Orpheus and Eurydice* (1869, Vienna), *The Judgment of Paris* (1870, Hamburg), *Platonic Banquet* (first version of 1869 in Karlsruhe, second version of 1873 in Berlin), the subject required, in his view, a pictorial form which was at variance with the principles of

classical art. His preference for grey was a means of intensifying the plasticity of the figures, which in fact often gave rather an academic impression, for beauty is being sought after rather than found and the overall effect is somewhat over-serious and slightly stiff. In his numerous portraits of Roman models, the artist hoped to elevate the natural grace of southern races into an ideal by grafting on historical allusions: thus Nana Risi, a cobbler's wife, became Iphigenia, Bianca Capella or even Lucrezia Borgia. It is true that his pictures 'arise from the fusion of some inward prompting and some chance sight', as Feuerbach wrote in his *Testimony*. What he called 'the slumbering of poetic impulses' was the ideal classical conception which he projected onto reality and which, typifying as it did his personal conception of form, should have burst into life on contact with reality.

Like other German artists in Rome, he found acquaintance with art on Italian soil a very profound experience. On 7 October 1856, he reported, 'Today the Sistine, then Raphael in the Vatican, stood in front of the Apollo of Belvedere; felt a revolution in me and the sure knowledge that I am becoming a different person.' But this revolution in fact produced a kind of restoration, a re-introduction of classical pictorial subjects and classical formal language. In many of his history paintings Feuerbach was not able to overcome the grandiose decorative gestures of his revered teacher Couture. In contrast, a few of his portraits reveal amazingly good observation and plasticity in the *Plate 100* construction of form, as in the *Portrait of Julius Allgeyer* (1857, Munich), his friend and biographer. The portrait, completed in two sittings, still adheres to the late Baroque type of representative portrait, but the way the paint is applied, particularly in the gradations of browns against a greyish-green background, and the forceful movement of Allgeyer, free of all posing, testify to Feuerbach's ability to paint most expressively. The landscape studies from Castel Togliono or from the Baths of Caracalla in Rome are likewise unique in his work, as for example the *Study of a Terrain* (1858, Hamburg), which the artist made use of again in his picture *Spring* (1867–68, Berlin), which Hugo von Tschudi compared with Manet's pictures.

During the period when he lived in Italy, Feuerbach took his pictures from exhibition to exhibition in Germany, but was unable to find a buyer; this, plus constant difficulties, considerably worsened his financial situation and, since he was somewhat depressive by nature, led him to the verge of a breakdown, when the attention of the art-lover, the Count Adolf Friedrich von Schack was drawn to him.

Von Schack was anxious to encourage talented young artists, and filled his gallery in Munich with works by Böcklin, Feuerbach, Marées, Schwind, Genelli, etc. He ordered numerous pictures, mostly of poetic content, from Feuerbach in the years between 1862 and 1866, thus freeing him for a time from his financial difficulties. When Feuerbach requested his patron to commission a life-size version of the picture he had long desired to paint, the *Platonic Banquet*, von Schack refused and relations were severed. This could have been foreseeable, since they had previously not seen eye to eye on all matters, and von Schack did not regard Feuerbach as a monumental painter

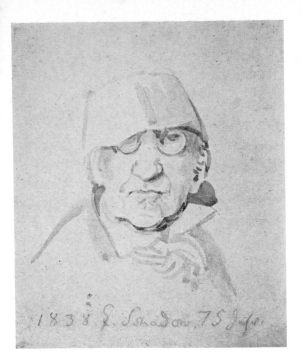

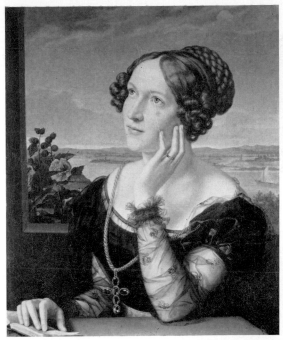

85 JOHANN GOTTFRIED SCHADOW
Self-portrait 1838

86 KARL JOSEPH BEGAS
Wilhelmine Begas, the Artist's Wife 1828

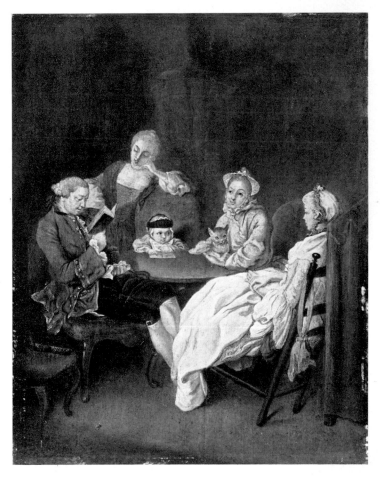

87 DANIEL NIKOLAUS CHODWIECKI
Company at Table c. 1758-62

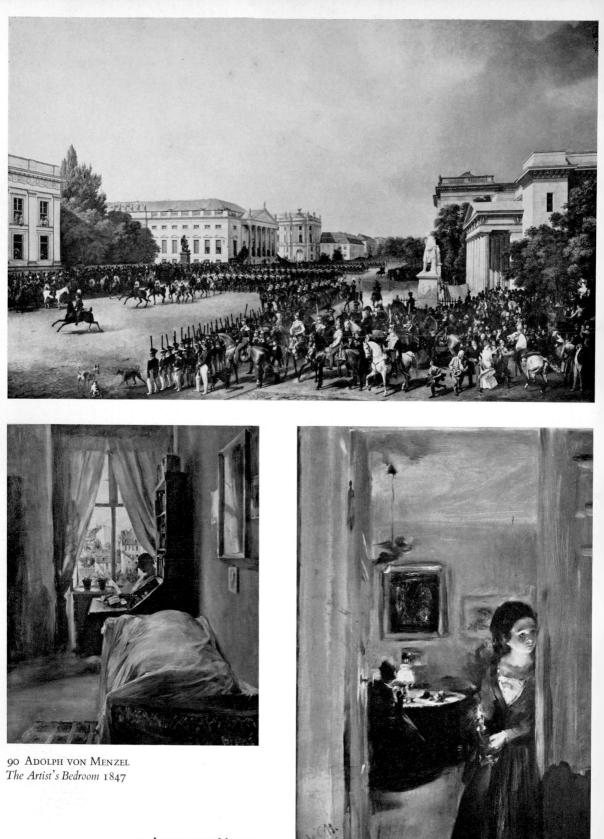

90 ADOLPH VON MENZEL
The Artist's Bedroom 1847

91 ADOLPH VON MENZEL
Living Room with Menzel's Sister 1847

88-89 Franz Kruger
Parade in the Opernplatz, Berlin, 1822, 1824-29
with detail at right

92 Adolph von Menzel
Garden of Prince Albrecht's Palace 1846

93 ADOLPH VON MENZEL *Studio Wall* 1852

94 ADOLPH VON MENZEL *The Lying-in-state of Those who Fell in March* 1848

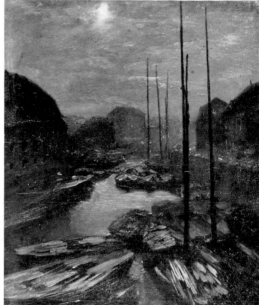

95 ADOLPH VON MENZEL
Frederick the Great in Lissa Castle—
Bon Soir, Messieurs! 1858

96 ADOLPH VON MENZEL
The Friedrichsgracht in Old Berlin c. 1856

97 ADOLPH VON MENZEL *The Flute Concert* 1852

98 ADOLPH VON MENZEL *A Walk in the Garden* 1867

99 ADOLPH VON MENZEL *The Ball Supper* 1878

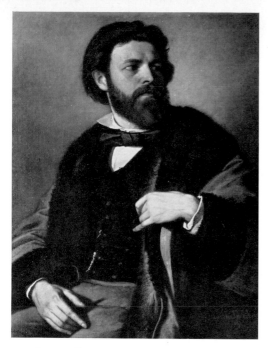

100 ANSELM FEUERBACH
The Engraver Julius Allgeyer 1857

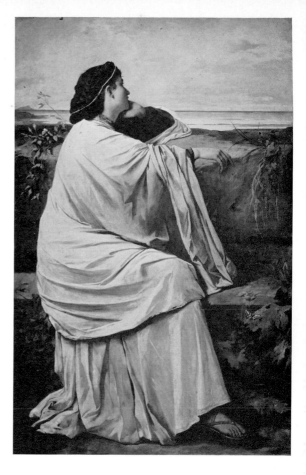

101 ANSELM FEUERBACH *Iphigenia* 1871

102 ANSELM FEUERBACH *Medea in her fury c.* 1872

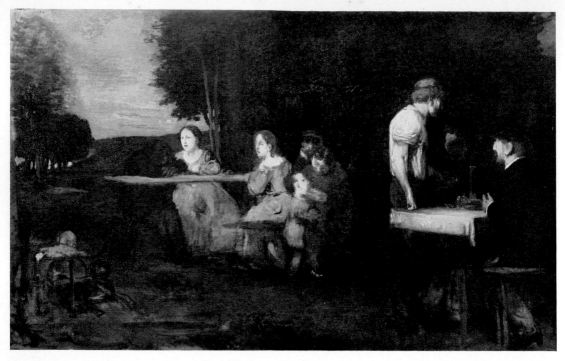

109 HANS VON MARÉES *Roman Vineyard c.* 1871

110 HANS VON MARÉES *Halt for Rest on the Edge of the Wood* 1863

111 HANS VON MARÉES *The Pergola* 1873

112 HANS VON MARÉES *The Oarsmen* 1873

113 HANS VON MARÉES
Self-portrait c. 1870

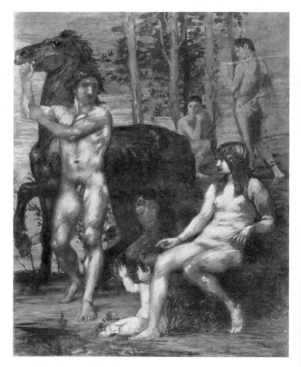

114 HANS VON MARÉES
Horse-handler and Nymph 1881–83

115 HANS VON MARÉES
The Hesperides 1884–85

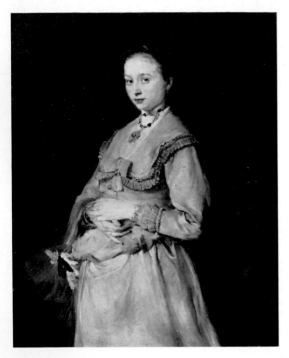

116 WILHELM LEIBL
Portrait of Frau Gedow 1869

117 WILHELM LEIBL
The old Parisienne 1869

118 WILHELM LEIBL
Concert Study 1870

119 FRITZ SCHIDER
Landscape Study c. 1872

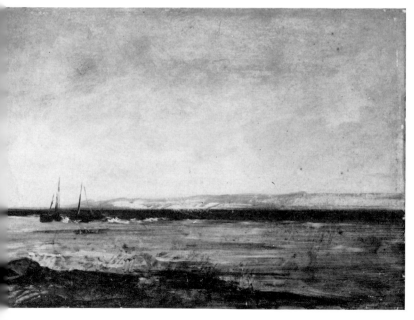

120 EDUARD SCHLEICH the Elder
Seashore c. 1851

121 WILHELM LEIBL
Veterinary Surgeon Reindl in the Arbour c. 1890

122 WILHELM LEIBL
Three Women in Church 1882

123 WILHELM LEIBL *Women spinning* 1892

but as the creator of pretty poetic idylls. In the following years, which were extremely difficult for him, he was supported both morally and financially, as far as her modest means allowed, by his step-mother, Henriette Feuerbach.

Ever since 1858, Feuerbach had been interested in the figure of Iphigenia. Goethe had treated her as the symbol of the longing for higher things: 'das Land der Griechen mit der Seele suchend' (seeking in spirit the land of the Greeks). At the same time he had taken this expression as a metaphor for the desire to acquire the culture of the classical age. Feuerbach found his model in Nana Risi—and when she was dressed in a Grecian robe specially tailored for her, it seemed to him that he saw a 'statue of Phidias move before his very eyes'. The first version of *Iphigenia* (1862, Darmstadt) was followed by the *Plate 101* second version of 1871, with Lucia Brunacci as model (Stuttgart). 'For the emotional state we call yearning it is necessary for the body to be in repose. This state requires a degree of going deep within oneself, of letting oneself go,' the artist wrote in June 1861 with reference to his *Iphigenia*, who is sitting on the seashore resting her head on her left hand and gazing out longingly over the sea. This motif of Iphigenia sitting—completely original to Feuerbach— in which yearning, contemplation and also melancholy are expressed, is prefigured—leaving aside the archetype, Dürer's Melancholy—in Overbeck's *Italy and Germany* (Munich), in Philipp Veit's *Italy* (Frankfurt) and in Eberhard Wächter's *Cornelia* (Neuss). From the interplay of subject and form, i.e. the motif of yearning and the use of classical form, there arises an opposition which did not escape Julius Allgeyer, and which allowed him to define the way the picture moves the observer as essentially un-Greek: 'in which the elegiac emotional state of yearning, which we call homesickness, is exhausted in the figure and heightened to become thoroughly typical, displaying a kind of depth and intimacy of feeling which may indeed be found in the religious art of the Middle Ages, but does not exist to the same degree in the art of classical antiquity'. That, however, testifies to the Romantic heritage in Feuerbach's art, which is to a large extent literary. Feuerbach was concerned to express the content of an idea, intended, for instance in his *Platonic Banquet*, to sum up the contrast between the life of the senses and that of the intellect. While the Greek philosophers are celebrating the recipient of the prize, the tragic poet Agathan, Alcibiades enters the hall flushed with wine. Feuerbach had taken the idea for his composition from the Baroque painter Pietro Testa, a fact first indicated by A. Vischer in 1887. The format of the picture is based on classical wall-painting as seen by the artist on his frequent excursions to Naples, Herculaneum and Pompeii; the figures are arranged in the form of a relief and the dominant grey tone is a further conscious attempt to conjure up the spirit of antiquity. The failings Feuerbach criticized in contemporary Viennese history painting in an article entitled 'Makartism' crop up, if in a slightly different form, in his own work. 'True history painting should never descend to pictures of a particular archaeological epoch or social period but must first and foremost portray the greatness of the humanitarian ideal of all societies, no matter how they dress.' But the mere intention to display the

ideal conception of what is most typically human was not enough to give Feuerbach's works directness of vision, since the intellectual idea behind the picture always dominated the form. Feuerbach's large-scale history paintings, *The Battle of the Amazons* (1873, Nuremberg) and *The Fall of the Titans* (1879, Vienna), failed because of the lack of impact of movement and space, vision and idea—qualities which were so characteristic of Rubens and Delacroix. The dull coloration of his pictures, another element inherited from German Neoclassicism since the days of Mengs, also contributed to making this kind of painting cold and academic.

Plate 102 In *Medea in Her Fury* (c. 1872, formerly in Frankfurt), a sketch which has the compactness of a painting, the artist was, by contrast, successful in attaining a form closely allied to that of Delacroix's Medea pictures. This is one of the few examples where Feuerbach abandoned reflection in favour of direct observation, producing an almost Baroque pomposity of form, which, though very appropriate to his cast of mind, was constantly suppressed by intellectual reflection in an effort 'to produce a classical effect'.

In 1873 Feuerbach was appointed Professor of History Painting at the Academy in Vienna. This was an ill-starred position from the beginning, for he could do nothing in face of the theatrical flamboyance of Hans Makart, who was adulated by the Viennese. Before finally emigrating to Venice in 1876, Feuerbach began work on his *Testimony* in Heidelberg, with the clear intention of explaining and justifying his work in literary terms, since it had seldom achieved recognition and was often misinterpreted. In Italy he completed another of his most beautiful pictures, *A Concert* (1878, Berlin), in which Raphael's *Saint Cecilia* is once again transformed into poetic terms; and he also completed a sketch *The Burial of a Court Jester* (1877, formerly Berlin), in which, referring to himself, he parodies the tragic element in his life as an artist.

Bonaventura Genelli and Karl Heinrich Dreber

Two other artists should be mentioned who, although older than Feuerbach, likewise turned to Neoclassicism with an essentially Romantic cast of mind. Bonaventura Genelli (1798–1868), the nephew of an artist who had come to Berlin from Rome, was surrounded in his parental home by enthusiasm for Carstens. During his stay in Rome (1822–32) he made friends with Cornelius, Koch, Karl Rahl and Friedrich Preller. His works lack the plastic sensitivity of Carstens but in their delicate but firm outlines are reminiscent of Greek painting. His caricatures of the Munich artist Wilhelm Kaulbach, the official history painter of his age, are extremely witty and drawn with a sarcastic pen, revealing a great talent, which was nevertheless wasted in inconsequential figure painting. Not till late in life did Genelli begin oil painting and he did so as a result of commissions from von Schack from 1856 onwards. These large-scale paintings, mostly on classical mythological themes, which are not without technical failings in execution, represent the swan-song of Neo-

classicism; the writer Paul Heyse preserved Genelli's memory in literature in his novella, *The Last Centaur*. The incomplete picture *Bacchus among the Muses* (1868, Munich), originally planned as a ceiling painting for the garden room in Dr Hermann Härtel's 'Römisches Haus' in Leipzig, has the effect of a last paraphrase of Mengs' *Parnassus* in the Villa Albani in Rome.

Plate 103

Genelli concentrated on figure painting with classical themes, whereas Karl Heinrich Dreber, known as Franz-Dreber (1822–75) continued the tradition of classical landscape painting in Rome and provided vital inspiration to the painters of the next generation. After studying under Richter in Dresden, he settled permanently in Rome in 1843, and formed a friendship with the landscape painter Johann Christian Reinhart. His first Roman landscapes were conceived while still under Richter's influence, but his later landscapes, such as *Campagna Landscape* (1850–60, Hamburg), take up the tradition of Poussin and Claude Lorrain, and are reminiscent in some parts, particularly in the treatment of individual objects, of Corot. He took the motifs for his ideal landscapes mainly from the Roman Campagna, the Alban and Sabine hills, and animated them with classical accessories or with folk scenes. The sketch *Sappho* (1859, Munich)—after seeing this von Schack ordered in 1864 the large picture *Sappho* (1870, Munich)—shows the Greek poetess from Lesbos, who has thrown herself from a cliff into the sea out of unhappy love for Phaon. The picture is similar in theme to the works of Feuerbach or Böcklin in which classical heroines turn the landscape into the reflection of an emotional experience.

Plate 104

Arnold Böcklin

'Arnold Böcklin was of a different race from Feuerbach, not from a family with a long history of intellectual activity entering on a period of physical decline, but from sturdy Swiss stock, full of youthful vigour. In contrast to Feuerbach's delicate, fine-boned stature, he was of sturdy build. Feuerbach painted himself with a cigarette in his hand, Böcklin with a glass of red wine. In spite of poverty he married a poor wife as a young man and fathered many children, whereas Feuerbach merely worked out plans for marriage on paper, with an eye to lightening his serious financial difficulties. Böcklin's character is a mixture of delicate sensitivity and robustness, along with broad humour, and the most fragile form goes along with hardness and even crudeness.' Thus Ludwig Justi in his book *German Painting in the 19th Century*.

Like Feuerbach, Arnold Böcklin (1827–1901) began his studies in Düsseldorf in 1845 under the landscape painter Johann Wilhelm Schirmer and came in on the late phase of Romantic realism. A picture painted during a summer stay in Switzerland, *A View of the Village of Tenniken* (1846, Hamburg), has directness in the observation of nature, clarity in the compositional arrangement of the individual spatial planes and intensity of colour. He spent the years from 1847 to 1850 in Geneva under the landscape painter Alexandre Calame, then went to Brussels and Antwerp and finally to Paris, where he studied the

135

works of Couture and Corot. At this time he painted mainly landscapes and portraits, which are distinguished for exactness in the observation of nature and clarity and simplicity of composition. His first period in Rome, from 1850 to 1857, brought a decisive change of style: in his early works a richness of colours and forms is noticeable, resulting from the influence of the southern landscape pictures. He peopled them with fabulous beings from antiquity, in order to make the experience of southern landscape and art still more intense and poetic. Thus a satyr rapes a nymph (1856, Berlin), or Diana is seen resting by the stream under shady trees (1855–56, Munich), and Pan, the god of nature, appears in burlesque and humorous situations. While Feuerbach spoke of the 'slumbering of poetic impulses', meaning by that the great ideal figures of classical antiquity, Böcklin's capacity for experience when confronted by southern landscape increased his powers of imagination, so that he saw nature as a direct expression of life in its basic and original form. The idea for *Pan in the Reeds* (1855–56, Winterthur, second version 1857–58, Munich) came to the artist during his daily walk alongside the reed-thickets on the bank of the Tiber to the Ponte Molle where he used to work from nature. In *Pan Frightens a*

Plate 105

Shepherd (post-1858, Basle, second version 1860–61, Munich) it was, according to Angela Böcklin, his wife, 'the dry rocks thrusting majestically upwards and glowing hot in the sun' which led him to visualize Pan. Böcklin concerned himself with the lower strata of mythical beings, as it were, who people nature and express the elementary emotions. He worked from direct observation of nature; this he had in common with the Impressionists, who for their part had freed colour from subdued tones and were exclusively guided by what they could see. In *Pan Frightens a Shepherd* Böcklin uses pure and richly harmonious colours, such as clear and intensive blue and a delicate gradation of ochre and brown which possess a glowing luminosity and give the effect of self-contained planes of light: to produce this he sacrificed the charm of individual brush-strokes and applied his colours onto a thin, often transparent, base. He ground his colours himself and made his own adhesive agent. He studied old recipes and reconstructed old techniques of painting, making this conscientiousness in practical matters one of the maxims of his art.

Böcklin had his first public success with *Pan in the Reeds* at the Munich Art Exhibition of 1858; there followed a commission to paint the dining-room of Consul Carl Wedekind in Hanover with four great landscapes, which illustrate the saga of Prometheus and the discovery of fire. In 1859, Böcklin was introduced to von Schack by Paul Heyse, and during the 1860s he painted his most beautiful works for Schack's gallery in Munich. After teaching for a short period at the art school in Weimar (1860–62), he went back to Rome, where he lived until 1866.

In the works painted during these years—e.g. *Ancient Roman Tavern* (1865, Munich), whose bucolic character is taken from the motif on the Porta del

Plate 106

Popolo in Rome; *Villa by the Sea*, of which there are numerous versions, where the emotional mood predominates; *Daphne and Amaryllis* (1865–66, Munich), in which Theocritus' idyll provided the subject-matter for a lyrical work—the Romantic heritage is combined with a psychological naturalism.

If it was the aim of Romanticism to transform the experience of reality into a vision of the transcendental in the Christian sense, Böcklin uses atmospheric, emotional moods or associations to give reality an air of mystification.

The sequence of several versions of the theme *Villa by the Sea* is in the tradition of Romanticism. As in the pictures painted in the 1850s, here too the experience of reality—the Fort of Fusano near Ostia—was the principal impulse towards a poetic treatment of the motif; in the first picture of the series, *The Murder in the Castle Garden* (1859, Essen), he united natural happenings with the dramatic event of a murder. The motif occupied Böcklin's imagination constantly: in the sketch *Villa by the Sea* (1858–63, Munich) a pair of lovers are leaning on a garden wall in melancholy fashion. On seeing this sketch von Schack commissioned a larger version (1863–64, Munich) *Plate 106* which he described in his book *My Art Collection*: 'There is a "Villa by the Sea" on which the rays of the setting sun still linger. In front of the building huge cypresses sway in the wind, air and sky are filled with grey mists, as is usually the case when the sirocco is blowing. As a personification of the melancholy mood which hangs over the whole scene, a figure swathed in a black veil is striding towards the sea shore.' The description 'melancholy mood' also fits the title Böcklin gave to this picture: *Iphigenia*. The composition thus takes its place among the Romantic variations on the theme of yearning which include Feuerbach's *Iphigenia*, painted about the same time as Böcklin's *Villa by the Sea*. In a lecture on Böcklin (1897), Wölfflin pinpointed the importance of the *Villa by the Sea* in the history of ideas: 'It is a picture which we can no longer imagine ourselves without, and from which we attach links to all sides. Wherever one comes to speak of the way people of our country feel things, the *Villa by the Sea* will inevitably be mentioned.' In fact, links can be drawn back to Romanticism and forward to the 20th century. One cannot help thinking of Caspar David Friedrich's emotionally charged landscapes with ruins, like the *Abbey in the Oak Forest*, in which a *Plate 21* similar melancholy and mournfulness hold sway. And yet there is a fundamental difference between Friedrich's *Abbey in the Oak Forest* and Böcklin's picture: Friedrich makes his subject harmonize with the rhythm of the seasons and chooses the theme of winter, death and mourning to lead up to the certainty of Christian salvation, whereas Böcklin frees the subject of its connections with the Romantic world-view and makes the expression of an emotional mood the exclusive function of the picture. Friedrich's symbols, like the Gothic ruins, the cross, the grave, the lonely individual, are components of a total view of life which for him is still viable. The analogy between what can be said and what can be seen arises from the act of seeing: the Gothic ruin is primarily a pictorial motif with all its possible mental associations, as well as possessing its own inherent meaning.

Böcklin's later nature allegories suffer from the discrepancy between the external experience of reality and the internal attribution of poetic overtones, which cannot be experienced externally. In pictures like *The Play of the Waves* (c. 1880, Munich), *Triton and Water-Nymph* (1873, Munich) or *Foaming Sea* (1879, Berlin), mythical creatures are intended to express the forces of

nature; they are symbolic responses to visual experience, a somewhat excessive use of poetic licence to transform the classical into a wild southern dream. Böcklin's success consisted in the representation of this dream-like experience, though in formal terms the disparate elements of reality and fantasy are reconciled with some difficulty by his own particular brand of naturalism.

When he saw Böcklin's pictures in the Neue Pinakothek and in the Schack Gallery in Munich in 1906, De Chirico found in his use of the fantastic a poetic capacity for experience which he himself characterized in his pictures of titans and centaurs about 1909; and in the 1920s he painted a series of Roman villas which owe their existence directly to Böcklin's *Villa by the Sea*. On De Chirico's instigation, even Salvador Dali found valuable inspiration in Böcklin's work.

As long as subject and form interact equally and the mood produced is a result of the form employed, as in the *Villa by the Sea*, Böcklin's art is not problematic. But it became so when, instead of making the experience of nature the basis of his art, he started from the poetic experience and presented it in the guise of naturalism. In his *Triton and Water-Nymph* (1873, Munich) in which a triton is sitting on a storm-swept rock and blowing his conch, while a water-nymph lies turned away from him and flirts with a sea-serpent, the mysterious quality of the sea, its ambivalent nature of restlessness and sullenness, is expressed in pictorial terms. Böcklin wrote of this painting on 25 August 1877 to Max Jordan, the Director of the Berlin National Gallery: 'One of the main problems in composing the picture would . . . be to harmonize the expression of the figures and that of the surroundings so completely that each seems to be the expression of the other.' However, the desired harmonization of the 'music of the sea' has become merely literary by the use of allegory. It was this that caused art critics, like Meier-Graefe in his book *The Case of Böcklin* (1904), to reject Böcklin's late works as creations which were indeed poetic, but did not satisfy the requirements of art, whereas poets, like Hofmannsthal in his *Commemoration of Arnold Böcklin* (1901), praised these very poetic qualities with reference to Böcklin's *The Elysian Fields* (1878, Berlin):

> And of this goodness I have had much need,
> For in this age great darkness doth abound,
> And as the swan, while swimming blissfully,
> Takes from the Naiad's streaming wet white hands
> Sustenance with a kiss, I in dark hours,
> Head bent above his hands, would likewise seek
> Nourishment for my soul: deepest of dreams . . .

In the literary work, as in the case of Hofmannsthal, allegorical and literal sense can be expressed via the same medium, namely language—the image of the swan, wanting to take its nourishment from the hands of the Naiad as the poet takes his from the works of the painter Böcklin; but in the work of art the whole conception is appreciated simultaneously as artistic form, and not as a

logical sequence of separate ideas. Yet this is what Böcklin wanted, and therefore his nature allegories inevitably give rise to controversy. Böcklin painted many versions of *The Island of the Dead*, which, during his life, was much admired as the symbol of the *fin-de-siècle* mood; he also produced an 'inspiration-picture' (*i.e.*, the painter and his muse) in his *Self-portrait with Death the Fiddler* (1872, Berlin). Although poets and painters were more usually inspired by Venus or the Muses, Böcklin shows the figure of Death, which has strong personal associations for him. It is noticeable, too, that the artist and death theme, used frequently since the Renaissance and particularly in Romanticism—for example, Rethel's intensive preoccupation with the theme of death in his frescoes and in his series of woodcuts *Another Dance of Death*—has been deliberately given psychological overtones. Yet the compactness and simplicity of composition and the feeling of tension in the painting have a powerful effect.

Plate 107

It was predictable that Böcklin, because of his preference for mythology and allegory, would end up producing figure painting in which the poetic element predominated. In *Sleeping Diana Spied on by Two Fauns* (1877, Düsseldorf) he took as his example Poussin's *Sleeping Venus* in Dresden. Hofmannsthal considered Böcklin's version 'Poussin coarsened and sentimentalized'. Ariosto's *Orlando Furioso*, which was among his favourite books, inspired *Ruggiero and Angelica* (1879, formerly Düsseldorf), and late in life he painted the grandiose allegories—*Adventure* (1882, Bremen), *War* (1896, Zürich) and *Plague* (1898, Basle)—in which the colours are often variegated or more suited to posters, and the draughtsmanship appears clumsy or stylized; but they do show Böcklin's gift for the fantastic and the gloomy, bordering on the surrealistic.

Although Böcklin is no longer accorded the exaggerated praise his contemporaries gave his art, it is none the less a late form of German Romanticism, in which surrealistic, fantastic and mythical elements familiar to the 20th century can already be seen, although in his case these were just part of his naturalistic form.

Hans von Marées

Hans von Marées (1837–87) sought to resolve the deficiencies common to both rival streams in German painting—realism, which upheld the primacy of the sensuously perceptible, and idealism, which considered it more important to impose external significance upon a work. What Schiller required of the artist in his famous letter to Goethe of 14 September 1797, applies equally to Marées' programme: 'To rise above reality yet remain within the realm of what is sensuously perceptible.' The art philosopher Conrad Fiedler, a friend and patron of Marées, carried on an intellectual exchange with the artist as a result of which the latter's theories were given more order and clarity, and he put Schiller's aesthetic maxim in similar words. 'The so-called realists are not to be criticized because they place the prime importance on

139

material phenomena, but because they are commonly incapable of perceiving in that physical substance more than the least perceptive of men would gain from it. They remain on a very low imaginative plane, and because of this the nature they recreate may deservedly be described as mundane and mean, because it is what mundane, mean minds see. . . . But the idealists, who neither feel satisfied by nature as they understand it, nor possess the ability to develop their vision of nature to ever higher levels, seek to compensate for the artistic poverty of their creations by the addition of external matter. As art, the works of both groups are insignificant.'

The goal of Romanticism, as seen in the works of the North Germans Runge and Friedrich or the Nazarenes Cornelius and Overbeck, was the restoration of the myth of the Godhead, as it appeared either in the phenomena of nature or in Christian history. The next generation replaced the myth of God, which had lost currency, by the myth of nature as the means of salvation.

Although Böcklin, Feuerbach and Marées shared a feeling of nostalgia for 'native Italy', Marées's longing was not for the stuff of poetry but for concrete objective experience, for autonomous form which imposed its own laws and which he wanted to derive from perception of nature. The figures of the classical tradition, the beautiful people and the Italian landscape, were not for him component parts of a 'poetic theme'; instead, they were to merge completely with the overall conception of the picture. Form, not content, was to be the symbol of an existence closely allied to the classical way of life, and was to achieve a harmonious accord of feeling and intellect; Cézanne also dreamed of this and wanted to return to the classical manner purely through perception of nature.

Marées began his studies at the Berlin Academy and in the studio of Karl Steffeck, the painter of horse pictures and military scenes, in 1853, then he worked in Munich from 1857 onwards. Here he painted *Rest on the Edge of the Wood* (1863, Karlsruhe), which aroused great interest at the exhibition of the Munich Art Society. Friedrich Pecht, an art critic open to new ideas, commented: 'The picture excites much controversy, like every new tendency which is associated with great talent and fearless innovation', and he praised it for 'having no pretensions, not trying to be anything else but a beautiful picture, but achieving this aim in the most eminent manner.' What is new about this picture, when compared to the run-of-the-mill realistic and naturalistic genre-pieces of the time, is the way the subject is distanced so that it gains an almost idyllic objectivity. It is of the same type as pictures of rests on the flight to Egypt or the idylls of the Venetian painter Giorgione. The pictorial area is clearly defined, and light is indicated by dots, using a gentle, fluid technique, all of which is reminiscent of the works of Corot or Courbet. Its idyllic character links it with the paintings, *Diana Resting* (1863, Munich) or *Horse Pond* (1864, Munich), in which restrained Venetian luminosity of colour is steeped in mysterious darkness. Meier-Graefe described these precisely: 'The pictures are all quite unfinished, they consist of colourful shadow, in which the figures move', with an 'indescribable spatial effect, colour indicates outline shape as in the case of Manet'. In *Diana Resting* Marées uses for the first

Plate 110

time a theme that means so much to him—that of the nude human figure surrounded by nature.

In Munich Marées became friendly with Franz Lenbach, with whom he painted himself in the *Twin Portraits of Marées and Lenbach* (1863, Munich) which, though externally true to the Romantic tradition of friends being portrayed together, transforms the tender intimacy of, for example, the dual portrait of *Overbeck and Cornelius* (1812, Munich) into an almost embarrass- *Plate 108* ingly intense character study. Von Schack commissioned Lenbach to make copies of old Italian masters for his Gallery in Munich, thus giving him the opportunity to spend some time in Italy. It was through Lenbach that von Schack also became interested in Marées, and he sent both artists to Italy in 1864. Lenbach was adaptable enough to take easily to the task of making the required copies—he was able in this way to perfect his technique, which helped him to become one of the most popular portrait painters in Germany— but Marées found the work more and more restricting to his own individual development, especially as von Schack was impatient to receive the finished articles. The artist wrote to his patron on 12 May 1865: 'On arriving in Rome, everything I saw disturbed me so much that I almost despaired of my calling as a painter.' He soon left Rome and settled in Florence, where the style of life and the kind of art he found were much more propitious. He was not content merely with copying, and finally requested von Schack to allow him to send his own work instead; permission was granted, if somewhat un- willingly. Thus arose two paintings entitled *Roman Landscape* (1868, one version in Munich), which are idyllic landscapes along the lines of *Diana Resting*; but neither the themes nor their treatment pleased von Schack, whose traditional attitude to classical culture caused him to prefer the noble and poetic qualities of Feuerbach's *Hafiz at the Well* (Munich) or the lyrical element in Böcklin's *Daphne and Amaryllis* (Munich).

In 1868, when von Schack withdrew his support from Marées, who had in fact received little in the way of understanding, Conrad Fiedler, whom Marées had previously met in Florence in 1866, was quick to replace him. In 1869 the two travelled together to Spain, France, Belgium and Holland, and then Marées was invited to stay with Fiedler at his residence in Crostewitz. Here, under the influence of the art of Delacroix, which he had seen during the journey in Paris, Marées painted one of his most beautiful works, *Philip and the Chamberlain* (1869, Berlin), in which colour is applied to the figures on the canvas in broad brush-strokes. One sees here the glowing colours of the French artist, who, like Marées, modelled himself on the Venetians; and in the *Self-portrait* (c. 1870, Bremen) Marées reproduces the impressions he *Plate 113* gained in Holland of Rembrandt's painting. In later self-portraits, such as *Self-portrait with Yellow Hat* (1874, Berlin) or *Self-portrait* (1883, Munich), the same coloration has been retained but the sitter, like an echo of the southern landscape, has no trace of the Romantic about him—he is classical, severe, intellectual, almost ascetic.

In 1870 Marées was again in Rome for a short while, but the outbreak of the Franco-German War (1870/71) caused him to hurry back to Germany and

Plate 109

make a halt in Berlin. But he still longed for the south: from sketches made in Rome he painted the complementary pieces *Roman Vineyard* (1871, Hamburg) and *Villa Borghese* (1870/71, Hamburg). In contrast to *Rest on the Edge of the Wood* (1863, Karlsruhe) the *Roman Vineyard* has a greater degree of compositional rigour, but the paint-work is less accomplished. At this time Marées usually stopped painting as soon as it seemed to him that the problem of depicting the subject had been solved. In this case the problem consisted of arranging the groups of figures not within a clearly defined area but in a number of interacting planes arising from the position of the groups, each of which preserves an internal balance of plasticity and colour. Hence the figure, as plastic form and as an area of colour, becomes the means of defining the spatial limits of the picture. In the right-hand group, Marées can be seen in profile at the table with Fiedler opposite him; the red on the headdress of the approaching landlord—repeated in the group of women sitting on the left-hand side of the table—serves to delineate both space in depth and surface area. This kind of fusion of figure and space by means of shape and colour is an attempt at rhythmical organization of the picture surface, in which every conjunction of figure and space has a particular quality—what could be defined as its 'classical' or 'normative' function. A whole chain of motifs can be followed from the *Twin Portrait of Marées and Lenbach* (1863, Munich), taking in the right-hand group in the *Roman Vineyard*, up to the fresco *Pergola* (1873, Naples), for which Bernhard Degenhart reproduced a lost preparatory sketch which again contains the right-hand group from *Roman Vineyard*. In such cases Marées would have spoken of an 'observed series' which served 'to condense typical experience'. About 1870 he discovered in such pictures the 'idyll without action', where the Arcadian element is not a literary addition but results directly from the interaction of an inner conception of classical form and the visual perception of reality.

The grandiose form already present in embryo in these works inevitably led on to the need to exploit wall surfaces for artistic expression. It is fortunate for German art in the 19th century that Marées was at this point in time given the opportunity to realize his classical conception of form in the frescoes in the Library of the Zoological Institute in Naples (1873). Following Mengs' fresco *Parnassus* in the Villa Albani and Cornelius's and Overbeck's frescoes in the Casa Bartholdy, another German painter was now to leave behind in Italy a work which caused Meier-Graefe, among others, to comment 'that for the first time a German has come to terms with antiquity'. The German zoologist Anton Dohrn, whom Marées got to know in Dresden, had founded a Zoological Institute in Naples with the intention of establishing by experiments the doctrines of Darwin, of whom Dohrn was a disciple. The library afforded ample wall space for decoration. When financial difficulties arose, Marées and Adolf von Hildebrand (1847–1921), whom Marées had met in Florence in 1867 and had taken on as a like-minded pupil, were even prepared to complete the decoration of the library without payment—it was that important to them to be finally in possession of a wall space they could paint. Surrounded by classical art and the southern landscape, they were inspired to

complete the frescoes, stuccoes and sculptures within a year. They quickly agreed on the subject: no historical or Biblical scenes, no allegories or myths, as were usual in monumental enterprises. This renunciation of history painting was revolutionary in itself, and it further implied a rejection of Cornelius's Neoclassical style, which had become degraded and robbed of all animation in the works of Wilhelm Kaulbach. In order to give unity to the decoration of the elongated library, Marées decided to divide it up by means of painted pieces of architecture. The four walls, including the south wall which has a balcony looking out over the sea, show representations of the sea with the shores of Capri and Ischia in the background, with rocky beaches, ruined palaces, and the orange groves of Sorrento. At first Fiedler expressed a negative opinion about the frescoes, 'The whole thing gives the impression of a clever piece of improvisation'. But later he said: 'With great artistic skill the un-boundedness of natural life, the whole glorious world of earth and sea, of light and splendour, of ripeness and solemn tranquility, of primeval natural activity and contemplative inactivity, is brought together in one precise, internally structured and compact expression.'

The fresco with the *Pergola* on the east wall shows the palace of Donna *Plate 111* Anna at Posillipo, where the artists and naturalists were accustomed to drink wine after the day's work. The dark brown open stone arcades of a pergola, into which the sun sends its last rays, tower up into the cloudy evening sky. On the stone balustrade a young servant girl is sitting wearing a green dress with a white apron; Dohrn, Kleinberg, Grant, Hildebrand and Marées are grouped from left to right round a table; in the right foreground an old oyster-seller is cowering. The strong straight lines, reflected also in the immobility of the figures, give the scene a monumental quality which has a distancing, radiant effect. Each area of the picture has its own focal point; the different zones—i.e. the oyster-seller, the servant girl, the men round the table, the arches of the pergola—are welded into a unified whole, not by any use of a central perspective, but by the 'classical-normative' disposition of the figures, which divide the picture into rectangular areas.

While the *Pergola* fresco is characterized by clarity of structure, the earlier north wall painting, *The Oarsmen*, is notable chiefly for its fluid coloration. *Plate 112* The colours are applied to the wall in strong contours and the whole composition is even more sharply divided by the pieces of painted architecture. Space and movement, far and near distance are graduated so as to organize the surface area in a rhythmical manner, yet the individual elements retain their autonomy. The group of men in the fresco on the south wall, *The Orange Grove* and *Women Seated*—these being two parts of one composition span- *Plate VII* ning the dividing door-opening—contains the later Hesperides-motif and possibly also a symbolic representation of the ages of man.

In his subsequent works, Marées only occasionally attained this monumental greatness in his easel paintings, because the achievement was too often marred by intellectual reflection, posing, frequent repainting and amending, and not least by inadequate technique. In his sketches, however, especially those in red chalk, one can follow the realization of his conception of pictures

as expressed so fluently and brilliantly in the frescoes at Naples. Marées's conception of the picture may be compared with Cézanne's: Cézanne's art is *réalisation*, that is to say, the emergence into visibility of the individual object from the overall basic structure, where basic structure means the ground of all reality. In his letters about Cézanne (1907), Rilke said that the painter was concerned to present 'the convincing fact of things becoming things, reality made so real that it becomes indestructible' and translated Cézanne's term *réalisation* as *Dingwerdung*. Marées's art is 'idealization' in so far as he approaches the phenomena of reality according to their 'classical-normative' function. Both artists share the renunciation of the kind of art which claimed to reproduce naturé, as the Impressionists did. Cézanne strove 'to make something stable out of Impressionism', and this was closely allied to Marées' antagonism to Impressionism. Cézanne's saying 'art is a harmony parallel with nature' is complemented by Marées's demand that 'the work of art must replace nature'.

Marées's inherent tendency to think in terms of large-scale structures was naturally most suitable to wall surfaces. But in the lack of further commissions of this kind he found a substitute in large-scale triptychs, which had a similar structure. He thought he discovered the answer by painting on wood, but he lacked the new technique to adapt to the new form of art. Things that had been resolved in the frescoes of Naples now became problems, because his attempts to find a new technique led to unfortunate results; what emerged was a kind of painting which was all surface veneer, where not only were the original outlines eclipsed by being painted over several times, but the colours were darkened and partly spoiled by swollen coagulations of paint. From 1873 Marées was again in Florence, where he set up a studio with Hildebrand in the monastery of San Francesco de Paola, and worked behind closed doors, suspicious even of his best friends. The tragic element in his character is reminiscent of the painter Claude Lentier in Zola's novel *L'Œuvre*.

Plate 114 The style of the painting *Horse-handler and Nymph* (1881–83, Munich), is largely classical. In the Roman landscapes and in the fresco, *The Orange Grove*, he had already dealt with the theme of the idyll, attempting to make the nude the basis of the monumental form, 'amid beautiful landscapes in which people just loiter about with no particular purpose in view' (Meier-Graefe). In these works the idyllic quality in the landscape was not altogether free of a merely illustrative function; but Marées was now striving to develop pictorial form solely from the human figure, and instead of reflecting the mental state of the figures as a kind of objective correlative, the form was to be the expression of the classical way of seeing things. In using the posture of the nude man and the horse to link the transient and the eternal, the individual and the general, the qualities of the relief with those of the enclosed surface, Marées gives the picture classical dimensions.

Plate 115 Marées's critics saw the *Hesperides* (1884–85, Munich) as the most perfect example of his formal invention. Along with the other large triptychs— *The Golden Age, The Three Riders, The Courtship* (all in Munich)—it comprises the last great works of the artist. The triptych form introduced a kind of

'formula of pathos' to easel-painting as it was at the time, and the *putto* frieze is supposed to represent an imaginary wall painting. Here Marées had in mind the fusion of wall- and easel-painting. In ancient mythology the Hesperides, the daughters of Night, guarded the golden apples which Gaia, the goddess of Earth, had given to Hera as a wedding present on her marriage with Zeus. On the left-hand wing, men are harvesting the oranges; on the right-hand wing there is an old man with some children, who are playing with the oranges. Marées described his first version of the *Hesperides* (1879, destroyed) as his 'landscape of longing'. But the theme of the Hesperides is not used as classical subject-matter, as in Neoclassicism; it is a 'pretence for the process of pictorial composition' (Marées), which becomes the real theme of the picture.

In Marées's *Hesperides* and in Cézanne's *Large Bathers* (1898–1905, Philadelphia), the artists were interested in renewing the classical tradition just by making natural phenomena visible as form rather than as subject. Marées used the human figure and the way it is constructed to bring out the solid and the statuesque; Cézanne used a chromatic scale to modulate the appearance of figure and landscape in a subtle way, and brought the material world to life as spots of colour. Both share the common aim of a pleasing synthesis of existence and appearance, taking nature thematically as it appears at first sight and also as its material components are revealed in their physical reality. The idea of Arcadia is thus no longer *a priori* external subject-matter, but the result of the 'process of pictorial composition'.

As Fiedler wrote, 'Marées's need to express himself as an artist led him to seek a form which was not limited by the subject-matter, and in the process he became an innovator; he overcame the inherited condition of subservience of artists to all possible areas of human feeling, thought and action, he made art an entirely unequivocal expression of visible reality, and thus placed it on a level with the other great forms of activity of the human spirit as something autonomous and sufficient unto itself.'

Marées's works and his vision of art had an important influence on Fiedler's theory of art and on Hildebrand's book, *The Problem of Form in Art* (1893), and were most sympathetically interpreted from the point of view of art philosophy and art history by Benedetto Croce and Heinrich Wölfflin. The early work of the painter Carl Hofer and the sculptor Wilhelm Lehmbruck derives from Marées's classical style. Forgotten and misunderstood in his life, Marées's *Kunstwollen* (artistic intent)—to use Alois Riegl's concept—did not receive its due until the 20th century.

Wilhelm Leibl and his Circle

A knowledge of French painting, in particular the Barbizon School and Gustave Courbet, helped the generation of German painters born in the 1840s, like Hans Thoma, Wilhelm Leibl and Max Liebermann, to systematize their

means of expression, thus enabling them to reflect the age they lived in. Leibl and his circle wanted to achieve a definitive formulation of the picture according to the old rules of art. The relationship between subject and form, between pictorial means and expression had to be completely re-thought. The main question was the degree of artistry involved in the execution of the picture, and here it was not simply a case of equating accomplishment with fulness of detail; old and new painting diverge at the point of differentiation between the finished painting in the traditional sense and the picture which, although complete, gives a sketch-like appearance. The desire for artistic spontaneity implies the retention, as far as possible, of the first impression made by the phenomenon, but also aims to imbue this impression with a kind of simultaneous existence of its own, limited on the one hand by the stamp of the artist's own subjective vision, and on the other by the need to remain objectively faithful to the phenomenon. The pictorial form was thus the result of an enhanced method of perception. Whereas the Romantics questioned the autonomy of the objective world and used it as the correlative of their subjective processes, the realists and the Impressionists were more concerned with the visualization of phenomena. Courbet's 'realism' was an artistic revelation to Leibl and his circle because it reproduced nature in a generous open manner in all its colourful beauty.

The Frankfurt painters Victor Müller (1829–71) and Otto Scholderer (1834–1902) were in Paris at the end of the 1850s and were among the first German artists to experience Courbet's art as a liberating influence on their painting. In 1858/59 Courbet came to Frankfurt at their invitation. The *Plate 124* 1860s saw the creation of works like Thoma's *In the Sunshine* (1867, Karlsruhe) *Plate 116* and Leibl's *Portrait of Frau Gedon* (1869, Munich), which were very close to Courbet in their intention. When Thoma went to Paris with his friend Scholderer in 1868, the works of the Barbizon masters and Courbet had a profound effect on him. 'Seeing his pictures I had the impression that I might have painted them myself; I felt myself free of the shackles of the Academy,' he wrote later to his friend Gerland, 'and I was filled with confidence that I too could do something worthwhile. I dared now to devote myself to nature as I saw it, without the fear of falling into abysses of ugliness and so on, in the way they used to threaten art students. With a feeling of liberation I painted in Bernau in the summer of 1868.'

While official painting in Munich stylized history painting into the depiction of sensational events, or degraded genre painting into trite sentimentality, new trends were stirring outside the Academy or in protest against it, and were beginning to dispute the leadership of art. Foremost in this movement was Eduard Schleich the elder, who travelled with Carl Spitzweg to Paris, *Plate 120* Brussels and London in 1851, and whose landscape paintings (e.g. *Beach*, c. 1851, Munich) were distinguished by free forms and the refusal to produce 'composed' scenes smacking of the studio. Schleich was one of the prime movers in arranging the first international art exhibition of 1869 in Munich, in which—in the face of considerable opposition—the new French painting could be seen alongside official painting. This became a great attraction for the

146

younger German painters. Among others, works by Corot, Courbet, Daubigny, Diaz, Isabey, Manet, Meissonier, Millet and Rousseau were displayed. Faced by such pictures as Courbet's *The Stone-breakers* (formerly in Dresden) and *Halali* (Besançon), official criticism found itself in a great state of perplexity: was 'German idealism' in danger? In the works exhibited by Courbet, who was awarded a medal of honour by the exhibition committee, one of the leading conservative critics, Karl von Lützow, saw 'a colossal success on the part of this most impudent assassin of nature, in the bosom of German idealism.' In the *Zeitschrift für bildende Kunst* of 1869/70 he announced: 'the social question sweeps in through the wide-open gates of art.'

Leibl made his debut among others at the same exhibition with the *Portrait of Frau Gedon* (1869, Munich), which was not awarded a gold medal, because *Plate 116* he was still a pupil of the Academy teacher, Arthur Georg von Ramberg; but it did bring him a gold medal at the Paris *Salon* of 1870. This picture moved Courbet to declare his cultural affinity with Leibl. 'The famous painter Courbet praises me, and I am the only person in Munich who can say this,' the artist wrote to his parents in 1869.

The Barbizon painters and Courbet had prepared the ground for the direct examination of nature and human action, and the French Impressionists took up the story there and developed it in so far as they saw the task of painting as making pure phenomena visible. In Germany the situation was more complex, because the development from realism via naturalism to Impressionism did not take place in successive generations, but in the same generation. Thoma, Leibl, Liebermann and Trübner tried in their early works to clarify the terms 'realistic' and 'naturalistic' with reference to both subject and form; in their later works they were partly successful in achieving a breakthrough to Impressionism. Thoma sums up the artistic concerns of his generation in his memoirs. 'After a few dull rainy days I am so appreciative of the poetry of sunlight that I believe that a picture in which, without great thought being given to the choice of subject or to the action, merely life in its essence and colours and light are portrayed, is sufficiently poetic, and thus contains enough intellectual meaning, to lay full and justified claim as a beautiful product to be considered a work of art.'

Wilhelm Leibl (1844–1900) was exclusively preoccupied with portraying man in his simplicity, and allowing landscape and nature to speak through him. This made Leibl primarily a naturalist. To the charge that his portraits had no psychological depth, he answered: 'If you paint the man as he is, the soul must be there too.'

Leibl's art, which depicts simple, peasant-like people and their surroundings, seems to be a meditation on man as he appears to the artist. Many of his figures are characterized by a tranquillity almost akin to that of still-life, and this also pervades the artistic form, which remains free of any literary pathos. Leibl's painting has not unjustly been compared with early German painting, especially the portraits of Hans Holbein the younger and Albrecht Dürer, in which a similar exact observation of reality is found together with the ability

to make the scene appear characteristic and thus generally valid. Although Leibl did have links with the early German tradition, his art was also influenced decisively by that of the Baroque. The Dutch and Flemish painters, above all, were responsible for an element of animation in his treatment of line, colour and light. In copying the pictures of Frans Hals, Cornelis de Vos and Rubens, Leibl learned the technique of delicate and gradual progression towards perfection of individual forms. Dutch and Flemish Baroque painting had a similar significance for the French painters Delacroix, Courbet and Manet.

In his early works, Leibl continued the tradition of realistic painting in the portrait art of late Romanticism. In the study *Man with White Beard* (1866, Cologne) or in the portrait *The Artist's Father* (1866, Cologne), he uses a technique of short broad brush-strokes which give the layer of paint considerable animation, since every brush-stroke contains a different mixture of colours. Leibl probably realized the rich possibilities of grading colours when he copied the Dutch old masters. At an early stage he stopped trying to produce the usual smooth, glazed, uniform surface and achieved the optical effect of mixed colours by using colour pigments which he tore off when dry. Courbet used a similar technique, although with a palette knife, whereas Leibl nearly always worked with the brush. The tendency in Leibl's later works towards the almost still-life representation of human activity can also be seen in the early portrait, *The Artist's Father*, in which the motif of the hands, which are resting on a book, afforded the possibility, artistically and intellectually, of seeing beyond the material. It was Leibl's greatest gift to extract 'animated' form from exact observation of nature, and not to impose an idealized form on nature.

Plate 116 After these early portrait studies, Leibl achieved his first masterpiece with the *Portrait of Frau Gedon* (1869, Munich). The sitter is Mina Gedon, in whose apartment the artist and his friends spent much time and (for lack of a studio of their own) even worked. On one of these visits Leibl expressed the wish to paint the portrait of his friend's wife, who was expecting a child. The great achievement of the portrait is the way the artist directs the eye to the sitter, while merely suggesting the background, and establishing an intense relationship in the position of the hands and the expression of the face, which
Plate 4 is basically very similar to Graff's *Portrait of Henry XIII* (1775, Munich). The brush movement can be deduced from the surface of the picture; and making the painting technique so clear doubtless intensifies the visual attraction.

The portrait earned Leibl enthusiastic praise from Courbet and an invitation to go to France, which he took up in the same year. The stay in Paris, which was short because of the outbreak of war in 1870, gave him the opportunity to acquaint himself with contemporary trends in French painting, and particularly to work in the company of Courbet and Alfred Stevens. Manet's works also had a great effect on the young German, whose application of colour became lighter and the pigment fluffier. In Paris he painted, among others, *The Coquette* (or *The Young Parisienne*, 1869, Cologne) and *The Old*
Plate 117 *Parisienne* (1869, Cologne), which were complementary pictures according to Emil Waldmann. In any case it is particularly interesting that in these

148

pictures Leibl followed up the Dutch elements already present in his early work. Thus *The Coquette*, in which Meier-Graefe saw the 'German modern Olympia', is reminiscent of Vermeer in its enamel-like, firm style of painting; moreover, such things as the blue vase, the oriental carpet, the white ruff, the outspread fingers and the overall formal balance between the young woman's backward leaning posture and the enormously long pipe in her right hand, make the whole picture seem more Dutch than French. In contrast, *The Old Parisienne* shows much more use of broad brush-work. In its use of paint in the construction of the face, the variations of browns and ochres, the contrast between the black cap and the white collar, the picture seems almost a paraphrase of Frans Hals. .

Fritz Novotny cites Courbet's picture of 1849, *After the Meal*, as the possible inspiration for Leibl's sketch, *Company at Table* (1870, Cologne). A tension between depth and surface area is created by the way the figures are isolated both thematically and spatially, a process not dissimilar to that in Marées's mural, *Pergola* (1873, Naples). But in the finished picture (1872/73, Cologne) *Plate 111* the action, the narrative conjunction of the figures, becomes the artist's main concern. Frequently in Leibl's genre pictures these narrative or literary and illustrative elements determine the choice of subject-matter. These remnants, however small, of a specific narrative attitude required a representational form which was to some extent still in accord with that of traditional pictures. This may be one of the reasons why Leibl did not consider the manner of painting, in the sense of his early works and of the French painters, as the final goal of his art, but merely as one stage on the way.

The pictorial sketch, *The Concert Study* (1870, Cologne), which is related *Plate 118* thematically and stylistically to *Company at Table*, is distinctive for its impressionistic technique. But the fact that Leibl restricts himself to brown, ochre and grey, with occasional splashes of yellow and red, shows how strongly he was still attached to the Munich studio atmosphere; only in a few later works did he manage to make the transition from Courbet's style to that of Manet. Leibl allowed the movement of the brush on the canvas to be seen; every variation in the luminosity of the colours was of equal importance to the gradations in their degree of lightness and darkness; and the colours made up a unity of paint work, thanks to the triple function of the brush-strokes which simultaneously indicated surface alignment, refraction of light and density of colour.

When Leibl returned from Paris to Munich in 1870, a circle of like-minded friends and pupils formed round him, with the common motto of 'realism', but all of them developed according to their own personalities. Leibl himself viewed his achievements as an intermediary stage, although he continued in his portraits to work principally from the painterly approach rather than from that of drawing or plasticity of form. The brush technique and the composition of colours in the portraits *The Painter Carl Schuch* (1870–72, Munich) and *Miss Lina Kirchdorffer* (1871, Munich) are magnificent. The latter is of the *Plate VIII* same type as the portrait of Frau Gedon, but it appears to be indebted to Manet for the dominant grey of the dress, with the white notes in the hat, in

the frill at the neck and in the cuffs, and with the red necklace set against a neutral background. Emil Waldmann considered that in the portrait of Miss Lina Kirchdorffer and in a further version (1871–72, Winterthur) Leibl came much nearer to Manet than to Courbet.

In his genre paintings Leibl was concerned to render the typical aspects of figures treated in portrait style; along with this depiction of type, or characterization, went a condensation of material and of intellectual content. Leibl was not interested in depicting any subject but human beings. The fact that he settled early on in the rural surroundings of Grasslfing, Unterschöndorf, and then Berbling, in order to find the themes of his pictures among simple people, is to some extent still Romantic and shows his close affinity to the Barbizon painters. Leibl wanted to restore the shattered relationship between art and moral values; hence his interest in reality incorporated an ideal which revealed itself in his choice of themes. Millet, too, had extended the peasant ethos into a kind of Romantic naturalism in which the artist found his subjective experience confirmed. Julius Mayr has quoted Leibl as saying: 'I want to paint what is true, and people consider that ugly, because they are no longer accustomed to seeing the truth.' Leibl's art is a kind of subjective naturalism to the extent that the works are justified in his eyes not merely by the imitative principle of copying reality, but also by the principle of the ethos. *Three* Plate 122 *Women in Church* (1882, Hamburg), which Leibl worked on from 1878, differs from the impressionistic form of the early works in its careful sketch structure. 'Seeing is everything, but very few people can see. . . . To enter as exactly as possible into the intricacy of nature is my sole inspiration.' By means of this penetration of the phenomena of nature, the artist immerses himself in the material structure of man and objects, and thus spirit and intellect animate the material. The delicate characterization of the three women's different ages and the poses they adopt, in which the religious experience is powerfully reflected, is reminiscent of early German art. A close relationship between Dürer's famous sketch, *Praying Hands*, and Leibl's picture is evident; yet the latter work seems to speak of the loss of inner sincerity in man, which Leibl tried to restore by his attitude to life and by his art.

In a number of letters to his mother, Leibl reported on the various difficulties he encountered in completing this picture. On 18 March 1879, he wrote from Berbling: 'Here, in the open country and among those who live close to nature, one can paint naturally. My stay in Munich served to confirm my belief that painting in that city is simply habit, carried on with a shrewd eye to expediency, but quite without original feeling or any independent outlook. Whether it be called historical painting, genre, or landscape, that kind of thing is not art; it is merely a superficial copying of things familiar to the point of satiety.' And on 20 May 1879, he wrote, 'It really takes great staying-power to bring such a difficult, detailed picture to completion in the circumstances. Most of the time I have literally taken my life in my hands in order to paint it. For up to now the church has been as cold as the grave, so that one's fingers get completely stiff. Sometimes, too, it is so dark that I have the greatest difficulty in getting a clear enough view of the part on which I am

working. I need hardly say that work like this can be completely upset by even the faintest idea of finishing it by a particular date. So you must begin to accustom yourself to the thought that you will not find me represented at the Munich exhibition. But do not feel uneasy. Even if the picture is not exhibited, it will have its effect. Several peasants came to look at it just lately, and they instinctively folded their hands in front of it. One man said, "That is the work of a master." I have always set greater store by the opinion of simple peasants than by that of so-called painters, so I take that peasant's remark as a good omen.'

Although painted with great directness and in close-up, the figures seem to be at a distance. The light falling from all sides, highlighting particularly the figure on the left against the whitewashed wall, both illuminates and radiates: this clarity is appropriate to the depth of religious feeling.

The picture belongs to the type of representation which may indeed be described as genre, but this needs more detailed explanation. In addition to his portraits, Leibl was interested in depicting rural people, showing their inner calm and making the genre-scene display a typical way of life. In pictures like *Village Politicians* (1877, Winterthur), *The Return of the Peasant Hunter* (1893, Cologne) or *Kitchen in Kutterling* (1898, Cologne), he sought to present truth as a balance of inner and outer values, since art, in his view, also had a moral function to fulfil. *Woman spinning* (1892, Leipzig) is related to Max Liebermann's *Flax Barn in Laren* (1887, Berlin), but Liebermann adds to the 'genre' a conscious note of social criticism, which is also to be found, for example, in Gerhart Hauptmann's play *Die Weber* (*The Weavers*, 1892).

This tendency seems to have found its appropriate form in a style of painting developing from the basic sketch and carried to the utmost perfection. The way in which the colour is localized around the actual object gives a very smooth pigmentation similar to the technique of the Dutch old masters. *The Poachers* (1882–86), which Leibl cut up after it had been accounted a failure at the Paris exhibition of 1888, was the highpoint of this very intricate, old-master style of painting.

In the 1890s, Leibl transferred from the bright even surfaces of the 1880s to a style of painting in which flickering light and shadow effects were major constructional elements. This is evident in several of his open-air pictures— *Girl Reading on a Bench in the Open Air* (1893–94, Cologne) and *Veterinary Surgeon Reindl in the Arbour* (c. 1890, Munich)—in which figures and space are *Plate 121* united by means of outdoor light. But such works seem to reflect principally Leibl's technical interest in the contemporary impressionistic attempts of Max Liebermann and Fritz von Uhde, whereas he himself was mainly concerned with interior painting.

Hans Thoma

Hans Thoma (1839–1924) had already achieved great stability of form in his early work, before going to Paris in 1868 with his friend Otto Scholderer. In

Mother and Sister Reading the Bible (1866, Karlsruhe) and *Feeding the Hens* (1867, Karlsruhe), the forms have gained plastic or sculptural quality by the balanced combination of paint and graphic structure. The directness of observation of everyday events from Thoma's peasant milieu is associated with a solid proficiency. In the picture *In the Sunshine* (1867, Karlsruhe) Thoma was trying to establish a connection between a figure and open space under conditions of outdoor light. One can tell, however, that although the picture was prepared in the open air, it was painted in the studio. A certain inconsistency can be observed between the depiction of nature and the upright motif of the standing girl – frequently encountered at this period, as in *The Young Man in the Wood* (*c.* 1868, Bremen)—which was ascribed to Courbet's circle.

Plate 124

The experience of French art was a decisive one for Thoma in 1868. Pictures like *Woman Driving Donkey* (1869, Düsseldorf), which was painted in the open air and whose lightness of atmosphere is close to Corot, or *Girl Sewing* (1868, Karlsruhe) were direct results of this new experience. Thoma used a very objective style to encompass the phenomenal world.

On his return to Karlsruhe he failed to obtain the success he hoped for. In a letter of 7 March 1880, he reported: 'In Karlsruhe, where I first exhibited these pictures, the Academy professors admitted their importance, but warned me of the rash path, the false path, on which I had set out. This soon proved to be the case. The public were outraged at these somewhat blackish-green pictures, in which nature dared to show itself in its ugliness. I have found that in general the public finds nature ugly and does not want anything to do with it.' In fact, Thoma had chosen landscape subjects which aimed neither to reproduce any kind of 'beauty' in the academy sense, nor to invest nature with higher significance, in the manner of Poussin or Claude Lorrain, but which were valuable merely by virtue of their spontaneous, everyday quality. Since his pictures were rejected so abruptly, he decided to go to Munich in 1870, where he formed a friendship with Wilhelm Leibl and Arnold Böcklin. It was the latter's *Self-Portrait with Death the Fiddler* (1872, Berlin) which inspired Thoma to paint his *Self-Portrait with Cupid and Death* (1875, Karlsruhe). Böcklin's influence was responsible for the poetic intensity of Thoma's later works, which transformed the fresh and spontaneous observation of nature into late Romantic mood-landscapes—a development which was hardly to Thoma's advantage as an artist, but which fitted in with public taste at the time. At first, in his landscapes, Thoma continued the late Romantic tradition. *Oed Holzhausen Park in Frankfurt* (1876, Frankfurt), which shows the view from the window of Thoma's studio in Frankfurt, is no doubt Romantic in its choice of motif, but there is a striking discrepancy between an illusionistic foreground and an impressionistic 'picture within a picture', i.e. the landscape outside. The idea was to make the landscape seen from the window the real subject of the picture, hence passing from the studio in the open-air landscape. Thoma in fact accomplished this in a later version of the same subject (1880, Frankfurt); here he used a more graphic manner, and a narrative motif—a horse-drawn carriage driving by—

was added to the landscape. This is another specifically late Romantic note. *Main Landscape* (1875, Munich) is one of the few works in which Thoma *Plate 126* worked principally with the palette-knife. Vibrant greys are set against white and brown colours, and light breaks through the white and grey clouds. Colour and light, subject and form, are fused by means of the palette-knife technique; the colours have been applied quickly to the green preparatory sketch, whereas in the *Taunus Landscapes* of the 1890s a thin glazed layer of paint allows the structure of the canvas to show through. Thoma's *Forest Meadow* (1876, Hamburg) shows genuine sensitivity to spatial depth and atmosphere, to colour and light, and to rhythmical surface construction; its general appearance reminds one of the contemporary landscapes of Camille Pissarro.

After this interlude of impressionistic painting techniques, which was only of short duration, Thoma came more and more under the influence of Böcklin, and believed he was approaching the ideals of the Old Masters by careful graphic treatment of the subject forms and by the addition of typically Romantic accessory figures. His contemporaries were even more willing to support him in this obvious misunderstanding; the art historian Henry Thode saw Thoma as the 'greatest German painter'. Sentimental painting aimed at the emotions found favour because of what it was trying to do; the way in which it did this was for the most part ignored by the critics.

In his portraits, Thoma developed realistic elements, and in *The Artist's Mother* (1886, Berlin), *Self-Portrait* (1880, Dresden) and *Portrait with Wife* *Plate 125* (1887, Hamburg) he arrived at a synthesis of plastic form and decorative partition of the surface, emphasized by painting the picture frame in the Renaissance style. It is possible that Thoma had in mind the 'classical-normative' style of Hans von Marées, with whom he had become acquainted during a stay in Florence in 1874; but if so, he gave it a new interpretation by adding decorative elements. *Portrait with Wife* has an intensity in the moulding of the heads reminiscent of early German painting; it is one of Thoma's masterpieces. His interest in the decorative and floral, particularly on the picture frame, looks forward to the *Jugendstil* of around 1900.

In his late landscapes, Thoma further extended the late Romantic heritage; now, however, he adulterated it into a kind of poetic sentimentality. One of these landscapes is characteristically entitled *Depart from My Heart and Seek Joy* (1903, Cologne), and is based on a study of 1873. Thoma never got beyond the first stage visible in the works of the 1870s, towards conceiving things purely in paint. He either came to interpret subject forms in a graphic or plastic manner, as in the portraits, or succumbed to a sentimental Romantic landscape painting, in which the accessory figures produce narrative effects.

Wilhelm Trübner and Carl Schuch

Wilhelm Trübner (1851–1917) developed what Leibl had instigated as the principle of the predominance of painting over plastic or graphic elements, but in the course of time this had in fact become inverted. Whereas Leibl was

153

the expert on tone, Trübner was the colourist. In the years 1871 to 1872 he was very close to Leibl, and devoted himself to landscape painting, while Leibl turned exclusively to the depiction of man. 'Every subject is interesting, and even the least important provides enough interest for painting; indeed the simpler the subject the more I can depict it in an interesting and complete way by the use of paint techniques and coloration,' wrote Trübner in his autobiography, *Personalities and Principles*. *Female Nude* (Dresden), painted at the beginning of the 1870s, is a bravura piece using broad brushwork, and is in some ways a predecessor of Lovis Corinth's *Bathsheba* (1908, Dresden). *Plate 127* In *Moor Reading a Newspaper* (1872, Frankfurt), Trübner places a greenish blue sofa against a blue ground, gives the Moor yellow gloves and a newspaper to read, and emphasizes the orange-coloured lining of the bowler hat. His talent for coloration is seen in the way the colours are balanced.

In landscapes like *Outbuildings on the Herreninsel* (1874, Frankfurt) or *Monastery Buildings on the Herreninsel in the Chiemsee* (1874, Berlin), Trübner constructs a harmony of greyish-green, greyish-blue and greyish-white, and his brightness of colour, his softness and delicacy of application show him to be close to Corot. The subject of the picture is not interpreted for its own sake —for example, architecture is not seen from the topographical point of view as a *veduta*—but always serves as a pretext for treating the theme as a problem of painterly technique, and thus to reach beyond its meaning. In the still-life *Silver and Roses* (1873, Düsseldorf) colour is no longer purely descriptive, but creates a new kind of pictorial subject-matter: it is true that the Baroque way the objects are superimposed one upon the other seems to imply that Dutch influence is still strong, but Trübner comes close to Cézanne in the way subject forms are broken up by colour and reduced to partly geometrical component shapes.

The subject becomes the pretext for pure painting in the excellent portrait *Boy with Hound* (1878, Düsseldorf), which is also a paraphrase of Velasquez, *Plate 129* and in *Beech Wood with Pair of Lovers* (1876, Vienna), in which the forms of objects are converted into the language of painting by a lively combination of brush-strokes rich in colour, light, relief, width and smoothness.

Since the artist did not achieve public success, he turned to literary and mythological painting. The influence of Böcklin and Thoma became evident at the same time as the Leibl circle was beginning to break up. Trübner's works of this type suffer from the contradiction between poetic intention and painterly form—a discord not infrequent also in Böcklin. Not until Max Liebermann began the new painting in Berlin did Trübner rediscover his own true talent: his palette became brighter, and in his old age he painted radiant landscapes in beautiful colours, fine horse pictures and strong portraits. In his late landscapes, like *Monastery Garden at Neuburg* (1913, Berlin), Trübner again achieved a crystalline form. He began to develop a new sense of spatial depth, applying colour in great swathes and squares and leading the eye smoothly from the foreground into the depth. The recurrent novelistic element, however, prevented Trübner's last works from being truly impressionistic.

The Viennese painter Carl Schuch (1846–1903) was a friend of Trübner's and joined the Leibl circle in 1871. He was one of the artists who actually succeed in making the step from realism to Impressionism, particularly in his works after 1876, in which he obtained richness of tone and a fine luminosity of colour. Schuch's early still-lifes, e.g. *Apple Still-life with Wine Glass and Pewter Mug* (prior to 1876, Munich), are between Courbet and Cézanne: his palette-knife technique is close to Courbet, the way he breaks up subject forms and constructs surface patterns from them is similar to Cézanne. His friend and biographer, Karl Hagemeister (1848–1933), who was influenced in his works by Trübner and Schuch, collected Schuch's statements about art theory, among them: 'A new relationship: we have learned how to see and represent air, meadow, tree and bush and much more, thanks to Courbet, Daubigny, Corot . . . we use much more colour, particularly in skies, and instead of mixing the colours too much we put them down on the canvas next to one another and let them mix themselves on the retina.' This impressionistic means of dissolving objects came to Schuch during the period he spent in Paris as a mature painter. This was when he painted his still-life *Peonies* (c. 1885, Munich), in which the colours are applied thickly with broad *Plate 130* brush-strokes, and detail is neglected in favour of pure coloration. The surface seems to vibrate and in places can be said to consist merely of colour— in contrast to the crystalline surfaces of contemporary works by Trübner. In such pictures Schuch reached a point at which he surpasses the realism of the Leibl circle, and achieves a degree of expression which is closely related to the works of Corinth. Emil Waldmann has spoken of the still-life treatment of landscape and of the landscape treatment of still-life in Schuch's mature works. Schuch's indifference to subject-matter in order to make colour autonomous and visible for itself enabled him, alone among the Leibl circle, to go beyond objectivity in the sense of realism.

Wilhelm Busch (1832–1908), though not one of the Leibl circle, is an important figure in 19th-century realism. He was the greatest humorous illustrator of the century in Germany, and produced successful pictorial stories of a grotesque nature by the interpolation of irrational elements (i.e. *Max and Moritz*, 1865), thus extending realism almost to the absurd. As a painter he was self-taught. The basically sketch-like *Portrait of an Artist with* *Plate 128* *Palette* (c. 1875, Munich) shows that he was acquainted with the work of Frans Hals, at a time when Leibl also took the Dutch and Flemish painters as his model.

Franz Lenbach (1836–1904), another Munich artist, was by far the most highly-favoured portrait painter of the *Gründerzeit* (the period of industrial expansion in the last quarter of the 19th century). Bismarck, Wagner, Count von Moltke and Pope Leo XIII sat for him. But in his early works, he linked up with the tradition of late Romantic and realistic painting and, during his first period in Rome, in 1858 to 1859, accompanied by his teacher Karl von Piloty, he painted *Titus' Triumphal Arch with Country Shepherds Passing through in Bright Morning Sunshine* (Munich), which was praised by Friedrich

Pecht as the 'most gripping naturalism'. One of Lenbach's principal works in this realistic style of open-air painting is *The Shepherd Boy* (1860, Munich); the Städtische Galerie in Munich and the Kunsthalle in Hamburg possess

Plate 131 similar pictures, for example, *The Red Umbrella* (1860, Hamburg). Whereas Böcklin turned from realistic landscapes to Romantic mythological nature idylls, Lenbach soon gave up this early disposition to open-air painting and concentrated exclusively on portrait painting in the style of the Old Masters.

Impressionism: the German Contribution

The French Impressionists considered pure colours, a spontaneous technique of painting, and open-air light as the means of depicting the true appearance of things; they translated physical substance into chromatic terms by using evocative masses of glowing, sparkling, luminous colour. To produce this effect, they applied colour as blobs. While the pictures of Hals, Velasquez, Delacroix and Courbet already show this use of paint, the Impressionists were the first to make the technique their exclusive method of composition. The Impressionists' basic tenet was to express the rich optical possibilities of the world, limited to the momentary impression and the fleeting nature of phenomena. They regarded Delacroix as their predecessor; and since he had taken Rubens and the Venetian 16th-century painters as his models, French Impressionism can claim a certain continuity in the history of its development.

The situation was different in Germany. Here the Impressionists could not look back to a continuous tradition of painting as in France. It is true that in Germany there were a number of independent attempts to develop an impressionistic style in the works of the late Romantics and Menzel, but these promising beginnings were, as a rule, overshadowed by drawing techniques or belief in the importance of subject-matter. Whereas the French Impressionists made a visual experience out of the phenomenon, German Impressionists took the pure optical experience, in Monet's sense, not as the aim of their art but as a means of intensifying the expression of the content or literary component of their pictures. This dualism between the expression of content and pure visual experience is one of the unique characteristics of German Impressionism and serves to differentiate it quite sharply from French Impressionism.

Four centres figured in the development of German Impressionism: Munich, Paris, Holland and Berlin. In Munich, Leibl and his circle, particularly Schuch and Trübner, had already paved the way for the use of impressionistic means of expression, and had themselves to some extent produced genuinely impressionist works. As a result of Courbet's impact at the international Art Exhibition in Munich in 1869, it was not surprising that the young German painters should look to France for inspiration, particularly to the Barbizon painters, and that they studied for the most part at the Académie Julian, which had a good reputation among foreign students, and

VIII WILHELM LEIBL *Portrait of Lina Kirchdorffer* 1871/72
IX MAX LIEBERMANN *The Parrot Man* 1902

VIII

IX

XII

informed themselves about French art in the official *Salon* without taking much note of the real impressionist painting that was going on at the time.

German Impressionism experienced its real flowcring in Berlin, the capital city of the new Reich, which was natural since the ground had been prepared by the tradition, principally Menzel's, of realistic painting in Berlin. The city also had a cosmopolitan atmosphere which was favourable to Impressionism. Even in the 1880s French Impressionist works were exhibited there. Lesser Ury (1861–1931) painted impressionistic pictures, like *Lady and Gentleman in Unter den Linden in Berlin 1889* (Munich), in which the palette-knife technique betrays its origins in realism.

In contrast, official criticism sharply rejected works in this new style. Hugo von Tschudi, Director of the National Gallery, who enthusiastically supported the newer German and French painters, was forced to leave and moved to Munich, where he experienced further difficulties. Since the state was not willing to finance the purchase of French Impressionist works, he acquired them himself and with the help of friends, and later presented the collection to the Bayerische Staatsgemäldesammlungen, where it now forms the nucleus of the modern French section. When official permission was withheld to send works to the Paris World Exhibition of 1889, the centenary of the French Revolution, Max Liebermann and Walter Leistikow (1865–1908) persuaded the Berlin artists to send their works to Paris privately. Corinth, Trübner, Uhde, Segantini and Israels founded the *Secession* in Munich in 1892; and in the same year the progressive artists broke up the traditional *Verein Berliner Künstler* (Berlin artists' club), an opportunity provided by the first-ever exhibition of Edvard Munch's works, put on by the Club. After the fifty pictures on display had caused a great stir among the opponents of the new style, a majority of the Club approved a motion by the painter Anton von Werner to close the exhibition prematurely. Thereupon the progressive elements, led by Max Liebermann and Ludwig von Hofmann, formed the *Gruppe XI*, which made up the core of the Berlin *Secession* founded in 1898. At the end of 1894 appeared the first annual issue of the satirical periodical *Pan*—a complementary publication to *Jugend* and *Simplicissimus* in Munich, starting from 1896. Maximilian Harden and Julius Meier-Graefe were among the critics who set its tone, being accustomed to express their views through the medium of journalism as well as in books. The art dealer and publisher Paul Cassirer, well known for his interest in modern art in Berlin, looked after the business side. He may also have coined the apt slogan, 'Triumvirate of German Impressionists' (Liebermann, Corinth, Slevogt). Recently attempts have been made to exclude Corinth and Slevogt from this trio. If one measures the works of these artists by the standards of French Impressionism, it is true that one can only call a part of Liebermann's work (from approximately 1900 on) impressionistic in the true sense, and that only to a limited degree. Since the critics, however, can suggest no viable alternative to the linking of Liebermann, Corinth and Slevogt, there seems to be little cause to refrain from bracketing their works together under the title of Impressionism, particularly if one bears in mind the different determining

X PAULA MODERSOHN-BECKER *Self-portrait with Camellia Branch c.* 1907
XI ALEXEJ GEORGEWITSCH VON JAWLENSKY *The White Feather* 1909
XII WASSILY KANDINSKY *Improvisation 9* 1910

factors, the differences of generations and—for example with regard to the retention of figure painting—the different aims of German and French artists.

Max Liebermann

From the point of view of age, Max Liebermann (1847–1935) was a contemporary of Wilhelm Leibl and his circle in Munich. He was a well-loved figure, both as a man and as the representative of the artistic community in his status as President of the *Secession* and later of the Academy. He combined the virtues of a liberal-minded Prussian and a cosmopolitan European. He also wrote most intelligently about art—on Manet, Degas, Menzel, etc. His art marked a summit and refinement of the 19th-century tradition of painting.

Plate 132 In the winter of 1871/72, after studying under Karl Steffeck in Berlin, he painted in Weimar his first large oil, *Women plucking Geese* (1872, Berlin). Although the dark overall tone of the realistic subject resembles Millet or Jozef Israels, it has none of the pathos of the Frenchman's work. The fluid brush technique and painterly treatment of individual areas anticipate his later impressionistic style. There are traces of Menzel's influence in this realistic representation. Menzel saw the picture at the art dealer Lepke's in Berlin and commented to Liebermann, 'Your talent comes from the good Lord, I can only praise the artist's industry.' Menzel criticized the sketch-like way the paint was applied, for this was in conflict with his principle of 'finished painting'. The official publication, *Kunstchronik*, castigated the picture as 'horrifyingly ugly'. Meier-Graefe said of it: 'Leibl could *paint* finished pictures, Liebermann has to *sketch* them to completion!'

Liebermann's stay in Paris (1873–78) helped him in many ways to determine the course of his further development. He took his cue not, as one might have expected, from the Impressionists, but from the older generation: the Barbizon painters and especially Courbet. In 1875 he went to Holland for the first time, and subsequently spent the summer there frequently, indeed regularly after 1880. In Jozef Israels (1824–1911) he found a like-minded tutor and friend, and described his work as 'a poem turned into colour'. Contemporary Dutch painting afforded him important hints on how to solve the problems of transposing pictorial space and figures into an evocative surface alignment, which was of vital importance for open-air painting. He found Frans Hals's painting technique of inestimable value in making his brushwork more assured, as Courbet and Manet had also done before him. In the Louvre he copied Hals's *Bohémienne* (1875, Karlsruhe), and later in Haarlem he copied individual figures from Hals's large Guild pictures. In *At the Smithy* (1874, Karlsruhe) and *Market Scene* (1874, Cologne), painted in Paris, the construction of the figures has something of Millet's statuary quality. The fragment *Mother and Child* (1878, Winterthur), from the painting *Commérage*, executed in 1876 and then cut up, is an excellent example of monumentality

resulting from form and content, which can stand independently alongside Courbet's realistic painting.

Liebermann lived in Munich from 1878 to 1884 and became friendly with Fritz von Uhde, giving him advice on open-air painting. He also got to know Leibl's art better, and this not only helped him to consolidate his sketching technique, but also supported his efforts to clarify his primarily spatial approach to nature. Light meant for him both the illumination of spatial depth and the accentuation of the surface area of the picture by means of colour. In pictures like *Orphanage in Amsterdam* (1881, Frankfurt), *Bleaching Ground* (1882, Cologne) and *Pig Market in Haarlem* (1886, Mannheim), the structure is determined by the three-dimensional treatment of space, which restricts the colours to relatively stable areas defining different objects. In *Eva* (1883, *Plate 134* Hamburg), which depicts a little Dutch peasant girl in a brown dress with a violet apron and a dark cap, Liebermann adds a landscape element to the figure as a kind of 'painted stage set'. The girl is isolated on the picture plane and in depth, and this brings a note of concentration on the individual which is encountered earlier in Runge's *Hülsenbeck Children* and later in the works of Paula Modersohn-Becker. Through the use of the palette-knife for many parts of the picture, the bright colour, composed of dots, becomes the means of depicting light, and links figure and space. Furthermore, light, whether open-air or interior, is also channelled by the use of carefully constructed three-dimensional perspective, as in the interior *Women spinning Flax* (1886–7, Berlin), in which the first impression is that of space or perspective in depth, into which light streams.

In contrast, the composition *Potato Harvest* (1875, Düsseldorf) is the first of the open-air pictures in which the figures at work occupy the whole of the depth of the picture, emphasizing the intensity of its alignment, and are silhouetted in the background against a kind of spatial barrier. In *Women mending Nets* (1889, Hamburg) there is no such barrier, since space is more *Plate 133* closely related to the construction of the pictorial surface: here the figures form a pattern on the surface, and the way they are arranged serves to define and limit the spatial depth. The old woman sitting on the left-hand edge of the picture is reminiscent of the motif of the oyster-seller in Marées's *Pergola* *Plate 111* (1873, Naples); but whereas Marées uses figures (the motif of the picture) to divide the surface area, especially since in his fresco there is no unified constructed spatial depth in terms of central perspective, Liebermann places the motif on the surface in such a way as to enable spatial depth to be appreciated as a unity. Marées sacrifices the illusion of depth to a relief-like surface pattern, whereas Liebermann attempts to co-ordinate figure and space by means of a surface construction which serves to indicate both. In *Old Woman with Goat* (1890, Munich), the figure of an old woman seen from the back, laboriously dragging her goat behind her along an uphill track, attains a degree of monumentality which marks a first highpoint of the series of open-air pictures.

During the 1880s there was an increase in the number of pastels in Liebermann's work; coloured chalk provides a means of uniting colour and light. This was probably also what attracted him to the French Impressionists.

163

Along with Manet, on whose work he wrote a fairly long essay, he found in the art of Degas 'the novelistic element overcome', and Degas's compositional methods, particularly with reference to the reproduction of spatial depth, seem to have confirmed his interest in Japanese woodcuts, of which he possessed a large collection. From the early 1860s the French Impressionists had found much of value in Japanese woodcuts, since they contained important compositional elements with regard to a formulation of pictorial space no longer entirely dependent on the rules of the central perspective. As for the French painters, from the Impressionists to the Nabis, so too for Liebermann, Japanese art had a beneficial liberating influence.

Plate IX In *The Parrot Man* (1902, Essen), whose subject and impressionistic technique are similar to Slevogt's numerous oil studies for the same subject (a version of 1901 in Hanover), colour becomes an optical experience. In the painterly treatment of individual forms and in the multiplicity of colour relationships, particularly in the figure of the parrot man himself, in the contrast between the colourful main subject and the almost neutral background which is like a framework, Liebermann comes close to Manet. And yet in the German's picture one can observe a dualism between spatial depth and surface plane, between light and colour, between a sketch-like delineation of objects and a dissolving of objects into masses of colour. The eye simultaneously follows the diagonal movement of the spatial layers into depth, and the colourful surface movement of the dots of light. The forms thus act as ingredients of both surface area and spatial depth, and as values of both light and colour. During a stay in Hamburg, Liebermann made some pastels,

Plate 135 among them *Rainy Atmosphere on the Elbe* (1902, Hamburg), in which the coloured chalk delicately reproduces the atmospheric mood, and the breadth of space is suggested. In pictures like *Horseman and Horsewoman on the Beach* (1903, Cologne) and *Polo Players* (1903, Hamburg), the momentary nature of movement is captured by the distribution of the figures on the surface, to such a degree that the once-and-for-all quality of movement, the awareness of spatial depth and the outdoor light which links figures and space, are all rendered by an immediately perceptible surface pattern. In later works, such as *Jews' Alley in Amsterdam* (1905, Cologne) and *Garden in Wannsee* (1906–7, Bremen), the surface of the picture becomes a vibrating layer of particles of broadly applied colour, which in addition to their descriptive function are also important for their mere presence as colour. Colour is first of all a material substance, which only when seen in conjunction with other particles of colour on the canvas becomes a means of indicating objective forms, without ever exactly reproducing them, as the naturalists did. Liebermann thus completed the transition from naturalism to Impressionism. The phenomenal world is partly dissolved in colour substance, in pigment. Although in many of his later pictures colour begins to take on an expressive note, Liebermann remained essentially an Impressionist, for whom nature in its colourful external image was the starting point and goal of his art. 'They must never distort the original image of nature to the point of unrecognizability,' he wrote in his manifesto, *Ein Credo*, published in 1922.

The contribution of Fritz von Uhde (1848–1911) to German Impressionism is appropriately mentioned in connection with Max Liebermann. A stay in Holland in 1882 taught Uhde a great deal about open-air painting, which he used in pictures like *At the Holiday Resort* (1883, Munich) and *Bavarian Drummers* (1883, Dresden). He chose pure bright colours and used them almost without shadow. Most of his works show a pleasure in telling stories, which is not always advantageous. In the study—composed with the care of a painting—*Three Models* for the picture *Suffer the Little Children to Come unto Me* (1884, Leipzig), Uhde follows the early realistic style of Thoma, by stressing the exact reproduction of every detail and treating light merely as illumination. Towards 1890, he came under Liebermann's influence and progressed from his early style, which consisted of uniformly bright surfaces, to a kind of painting which made use of flickering light and shadow effects. Although these appear almost totally impressionistic, similar effects can be seen in Leibl's works of this period, for example the portrait *Veterinary Surgeon Reindl in the Arbour* (c. 1890, Munich). Uhde's *The Conversation* (1891, Hamburg) takes up realistic interior painting again, and in *Mother and Child* (1892, Munich) the foreshortening of the setting, the reproduction of a casual unposed posture and the modelling are all reminiscent of French Impressionists, although Uhde uses darker colours. In the open-air pictures, as for example *The Daughters in the Garden* (1906, Mannheim), Uhde did not succeed in the critical task of liberating light from its function as illumination and thereby creating a purely visual experience. By clinging to the naturalistic idea of the three-dimensional picture, he found himself unable to transform light into colour.

Plate 121
Plate 136

Lovis Corinth and Max Slevogt

Lovis Corinth (1858–1925), an East Prussian, attended the Academies in Königsberg, Munich, and Antwerp; then lived in Paris from 1884 to 1887, studying principally at the Académie Julian under Bouguereau and Robert-Fleury. Though his years of study in Paris did not result in any direct influence from the French Impressionists, there is a marked preoccupation in his early work with French Romanticism, particularly Delacroix. This introduced him to a transformation of Flemish baroque art and helped him to achieve a freer, more fluid style. An early picture, *Susannah in the Bath* (1890, Essen), contains the essence of much of his later work. The theme was all-important, since it inspired the imagination to take up the story. There is a distant echo of Delacroix' palette in the interaction of wine-red, yellow, violet and blue; colour is applied in broad strokes, in a manner reminiscent of Courbet and Trübner. But Corinth started with a bright surface and made it darker where it seemed suitable, in order to increase the luminosity. In this early picture the baroque element is already present, comparable in close-up to Rubens' application of colour and his delight in depicting flesh. Some intimate affinity seems to link Corinth and Rubens, though Corinth is less polished, more

elemental and, one might say, more 'breathless' in the way he transforms the objective world into its colourful appearance.

At the beginning of his stay in Munich (1891–1900) he was working out the impressions he had brought back from Paris. In *View from the Studio in Munich* (1891, Karlsruhe) the familiar Romantic motif comes up again, linked with traces of Menzel's style in the 1840s. The gloomy violet mood and the crows in *Ploughed Field in Late Autumn* (1893, Frankfurt) recall Millet's lonely, melancholy landscapes. *Reclining Nude* (1906, Bremen) has none of Delacroix's richness of colour, but the skilful combination of whites, greys and greyish-browns applied with broad strokes, which permits only the female body to be distinguished with certainty as a coherent mass, testifies to a feeling for baroque nuance which is otherwise achieved only by Trübner in a few of his nudes. A series of depictions of butchers' shops, in which mostly wine-red and pinkish tones merge into one another in an animated way, calls to mind Rembrandt's *Slaughtered Ox* (Paris), though here the inimitable yellow has a transfiguring effect.

Corinth's choice of themes around 1900 was not unaffected by *Jugendstil*; having tested his pictorial methods he allowed himself the luxury of some exotic themes. Pictures like *Harem* (1900, Darmstadt) and *Salome* (1900, Leipzig) are not only typical of the age, but also characteristic of Corinth. One finds neither Beardsley's ethereal women (*cf.* his illustrations to Oscar Wilde's *Salome*), nor the exaggeratedly erotic type, as in Stuck's *Sin*, but a completely elemental grasp of the vitality of the naked female body, which comes over in a quite unaffected, powerful way. Corinth never treated his material merely from the illustrative, imitative or superficially erotic angle, but always with the dominant intention of transforming the subject into its appropriate amalgam of rich colours. The artist may appear outwardly headstrong, but he possessed a great sensitivity, reflected not least in his tender depiction of his wife Charlotte Berend-Corinth. As he became more and more in command of his forceful brushwork and was able to use it to transform phenomena into colours so intense that they seem almost to consume themselves, the material was welded by his hand into something quite new. His appreciation of classical myths is hardly surprising in view of his truly classical delight in the senses, which he shared with Rubens. From 1900 he worked on large figure paintings: *The Childhood of Zeus* (1905–06, Bremen), *The Judgment of Paris* (1907, Dresden), *Orpheus* (sketch of 1908, Dresden), *Homeric Laughter* (1909, Munich). In his 'interpretations of antiquity' Corinth combined two elements, which are also common to Delacroix's numerous depictions of classical myths and Daumier's series of lithographs to the *Histoire Ancienne*: the feeling for the fundamentally sensuous quality of colour and its corresponding psychological effect, and the use of humour to distance the subject. Thus, for example, his *Homeric Laughter* is a wonderful farce about the discovery of the love-struck Vulcan by the other gods of Olympus. It should be noted that Corinth's pupil Max Beckmann (1884–1950) not only continued the tradition of these figure paintings in his expressionistic style, but also achieved credible interpretations of classical myths.

In the open-air studies painted at the same time, Corinth confronted the style of French Impressionism. The picture *After the Swim* (1906, Hamburg), *Plate 137* painted from a boat at Lychen in Mark Brandenburg, seems like a paraphrase of Renoir, but harder, more masculine. (The French Impressionists had begun to transform their boats into 'floating studios': one of the best-known examples is Manet's *Bark* (1874, Munich), in which the painter Monet is shown painting on his boat.) Corinth was interested in the effects of light, the bulk of the female body, the broad application of colour, in which gradations of red, grey and blue in the striped stocking are particularly striking, the contrast between the red cloth the artist's wife is sitting on and the greenish-grey and violet shades in the background. In the following years Corinth's brushwork became more spontaneous, as in *Morning Sunlight* (1910, Darmstadt), which *Plate 138* also depicts the artist's wife. Corinth has applied colour to the canvas in great swift strokes; the brushwork both indicates and dissolves the subject. This vitality of handiwork, together with the choice of subject and the juxtaposition of bright white, brown and pink, means not merely that voluptuousness is the theme, but that it is physically present as colour. This picture bears comparison with Friedrich's *Morning Light*, Schwind's *Morning* *Plate 22* *Hour*, and Menzel's *Room with Balcony*—and one becomes aware how much *Plates 53* the means of painting had gained in expressive power during the century, so *and VI* that finally, with Corinth, the application of paint is enough to convey meaning.

In the landscapes painted about 1910, for example *Inn Valley Landscape* (1910, Berlin), Corinth comes close to Slevogt's sketch-like structure, which itself owes much to late Romanticism, as did the landscapes of Thoma and Trübner. The sketch-like structure, particularly in the construction of space, is always present, even though it is overshadowed by colour in all its autonomy. From 1910 the signs of a strong 'baroque' penetration of material substance become more frequent, which implies a breaking-away from the strict tenets of Impressionism; for Corinth's painting was no longer concerned with the surface of the phenomenal world, but also left ripples on the surface that indicate the internal tension of the things he painted.

Corinth took up the theme of a Dutch or Flemish baroque still-life in *Birthday Still-life* (1911, Cologne), and, by incorporating with it the figure of a woman (probably his wife) nude to the waist, achieved an ultimate effect in the purely optical rendering of the visual appearance of things. In *Self-portrait with Panama Hat* (1912, Luzern) or in *Bordighera* (1912, Essen), the colours are worked on in the form of relatively stable contours, and thus, instead of tending almost to dissolve as previously, they gain in richness and luminosity, and acquire a plasticity brought about by the combination of sketch and colour techniques. In these works the experience of Southern landscape had a similar effect on Corinth as on Marées when he painted his frescoes in Naples.

In the 1920s Corinth's palette became heavier. In one of the most powerful portraits by him or indeed by any German painter, the *Portrait of Grönvold* (1923, Bremen), Impressionism has given way to the visionary and expressive

aspects of the external colourful appearance of objects. The subject forms, like the face of the sitter, are dissolved in planes of colour, which give only the merest hint of its ability to express objective reality; material substance is devoured by colour and born anew. The eyes are in deep shadow: Nordic artists have a notable predilection for leaving the eyes in shadow, so that brightness is seen from out of that shadow, as in the self-portraits of Dürer, Rembrandt and Beckmann. In one of Corinth's last self-portraits (1925, Zürich), the face is tinged with melancholy regret at having to take leave of a world the painter loved and reconstructed with such elemental vigour. In *The Red Christ* (1922, Munich) or in the numerous landscapes of Walchensee, in the still-lifes and the portraits of his final creative period, the external material touches off a highly personal chord in the artist, and, broken into fragments by the mirror of his consciousness, emerges enriched by a new dimension which extends to the deepest areas of human existence.

The South German Max Slevogt (1868–1932), the youngest of the three best-known German Impressionists, likewise began his career, following early training at the Munich Academy under Wilhelm von Diez and a stay in Paris (1889), in the wake of Leibl's circle, by meeting Wilhelm Trübner on a journey to Italy. Like Liebermann and Corinth he also had a leaning towards figure painting. He took his material from the stage, the ballet and the cabaret, and reproduced it mostly in the form of rapid visual impressions.

His journey to Holland in 1898 was in order to study the work of Rembrandt. His triptych of the following year, *The Prodigal Son* (1899, Stuttgart), is a kind of reflex response to the undogmatic and deeply religious painting of the Dutch master. Like Uhde in his triptych *Holy Night* (1889, Dresden), Slevogt wanted to revive Christian painting by removing the idealistic gloss from traditional religious painting and the related concept of Christ, and he tried to do this by using straightforward realistic depiction. But this met with violent opposition from the representatives of the orthodox Church. Liebermann had also used religious themes, as for example a representation of *Christ among the Doctors* (1897), but Corinth, in *The Red Christ*, was among the first to shake off the shackles of naturalistic representation and achieve a new personal interpretation.

Slevogt's move to Berlin, the centre of impressionistic painting, resulted in an intensification of his bright impressionistic style. In 1901 he painted many studies and pictures of animals in the Zoological Gardens in Frankfurt, some of which bear a superficial resemblance to Delacroix's animal pictures. But Slevogt was really most at home on the stage. At the beginning of the 20th century he produced a series of portraits of the famous Mozart singer, Francisco d'Andrade, in his most brilliant role as Don Giovanni. In 1894 Slevogt had seen the Portuguese singer in a performance of this role in Munich; when he lived in Berlin he found more opportunities to portray him. While in the *Champagne Song* (1902, Stuttgart) importance is still laid on the archi-
Plate 140 tectural framework, in the Hamburg version, *The 'Black d'Andrade'* (1903), Slevogt is concerned only with bringing to life the moment in the final scene

168

124 HANS THOMA *In the Sunshine* 1867

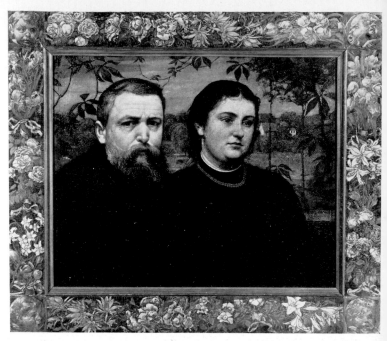

125 HANS THOMA *Self-portrait with Wife* 1887

126 HANS THOMA *Main (River) Landscape* 1875

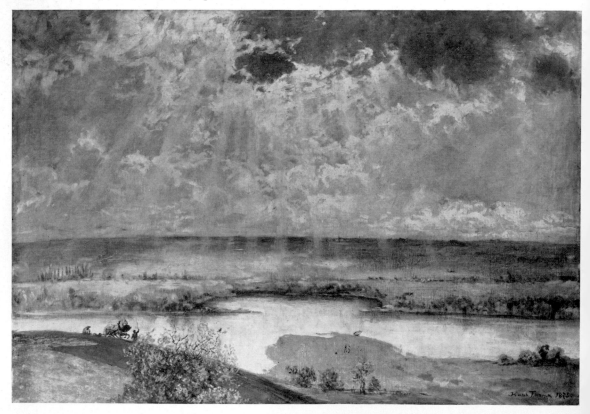

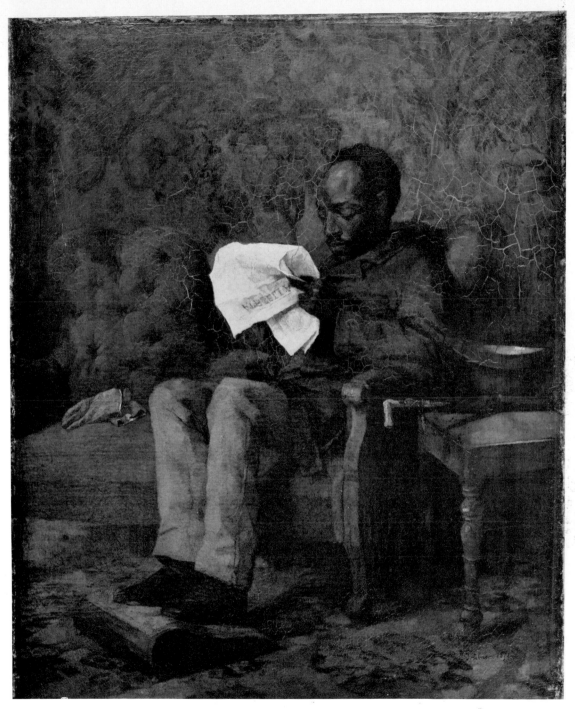

127 WILHELM TRÜBNER *Negro reading a Newspaper* 1872

128 WILHELM BUSCH
Half-portrait of Painter with Palette c. 1875

129 WILHELM TRÜBNER
Beechwood with Pair of lovers 1876

130 KARL SCHUCH
Peonies c. 1885

131 FRANZ VON LENBACH
The Red Umbrella c. 1860

132 MAX LIEBERMANN *Women plucking Geese* 1871-72

133 MAX LIEBERMANN *Women mending Nets* 1889

134 Max Liebermann *Eva* 1883

137 LOVIS CORINTH
After the Swim 1906

138 LOVIS CORINTH
Morning Sun 1910

139 MAX SLEVOGT *Portrait of the
Dancer Marietta di Rigardo* 1904

140 MAX SLEVOGT
The 'Black D'Andrade' 1903

141 MAX SLEVOGT
Achilles Frightens the Trojans 1907

142 Christian Rohlfs *Woodland Path in Winter* 1889

143 Otto Modersohn *Autumn on the Moor* 1895

144 LUDWIG VON HOFMANN *Spring Dance c.* 1900

145 EGON SCHIELE
Tree in Autumn c. 1909

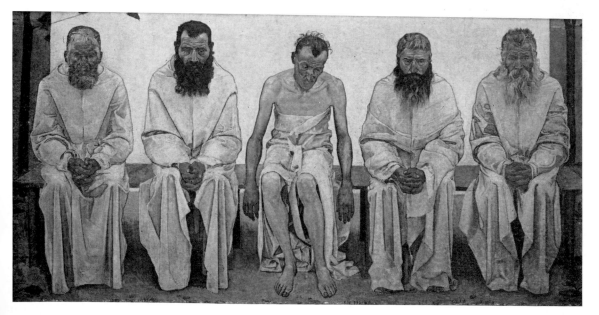

146 FERDINAND HODLER *The World Weary* 1892

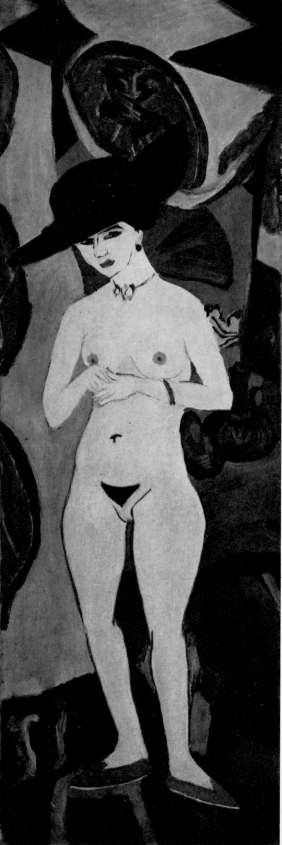

147 ERNST LUDWIG KIRCHNER *Nude with Hat* 1907

148 MAX PECHSTEIN *Portrait in Red* 1909

149 KARL SCHMIDT-ROTTLUFF *Estate in Dangast* c. 1910

150 FRANZ MARC *Horse in Landscape* c. 1910

151 ALFRED KUBIN *Storm* 1906

of the opera when Don Giovanni is seized by the white marble hand of the statue of the Commendatore which can be seen on the left of the picture. The dramatic moment is intensified by the contrast of black and yellow in Don Giovanni's clothing. It is known that Slevogt studied Manet's painting in detail about 1900, and one is reminded here of Manet's depiction of the singer Faure in the role of Hamlet (sketch in Hamburg, picture of 1877 in Essen), which may have inspired Slevogt.

Whereas Corinth had a stronger affinity with the baroque, Slevogt was closer to late baroque: to the light, decorative extravagance of colour of rococo, to the dazzling lights of the stage, to the conscious pose of the dancer— as in the *Portrait of the Dancer Marietta di Rigardo* (1904, Dresden)—and to the music of Mozart, whose *Magic Flute* he embellished with arabesques in the form of etchings, which have the same grace and lightness as Mozart's work. In Slevogt's painting, colour often has a touch of the decorative. But not until his journey to Egypt in 1914 did his feeling for pure colour in the Impressionists' sense make itself plain. The landscapes he painted in Egypt are the purest impressionist painting. Later Slevogt returned to a kind of 'coloured sketching' and in his *Vine Arbour in Neukastel* (1917, Cologne), one can see that he was born a sketcher, not in fact unlike Menzel who was also very attracted by the rococo. *Plate 139*

Slevogt's great gift as draughtsman, illustrator and graphic artist was undoubtedly that of light and graceful sketching, the pencil reacting quickly to the visual experience and transferring it on to paper. It is noteworthy that this sensitivity and speed of reaction are maintained in his painting. His first attempts at etching appeared in 1905 under the title *Black Scenes*, published by Bruno Cassirer in Berlin. There followed his lithographs to the *Iliad* (1909), which display a fine balance of graphic qualities, and heighten the 'supernatural' attributes of the Greek heroes into something rather humorous—as in the plate *Achilles Frightens the Trojans*. In this way they become rather like *Plate 141* caricatures, in the manner of Corinth's classical figures.

IV The Transition to the Twentieth Century

From Representation to Suggestion

Wassily Kandinsky (1866–1944) described in his *Rückblicke* (Retrospections) the two experiences which influenced the development of his art and gave him the signal to move forward into the 20th century. They were a performance of Wagner's *Lohengrin* at the Court Theatre in Moscow, and an exhibition of impressionist paintings in the same city. Kandinsky said of the exhibition: 'Suddenly for the first time I saw a PICTURE. The catalogue informed me that it was a haystack [by Claude Monet]. It was painful not to be able to recognize it. I also considered that the painter had no right to paint in such an unclear fashion. I felt dimly that this picture had no real subject. . . . But unconsciously the idea that a picture must contain a subject was also discredited.' Wagner's music gave him an inkling: 'I saw all my colours, they were standing before my eyes. Wild, almost crazy lines appeared to me. . . . It became clear to me that art in general is much more powerful than I thought, and on the other hand that painting could develop those same forces that music possessed.'

Early German Romanticism, in the writings of Novalis, Schelling, Arnim, Tieck and the brothers Schlegel, and in the painting of Runge and Friedrich, had demanded that art should not depict reality, but rather interpret or decipher it, in order to bring to light the ideas or laws behind the external appearance of phenomena. A letter from Schiller to Goethe (29 December 1797) is one of the earliest documents in which the discrepancy between depiction and interpretation in art is discussed. In connection with necessary reforms in the field of drama, Schiller refuted 'common imitation of nature' and wanted to see it replaced with 'symbolic aids, which, as regards everything not directly germane to the poet's artistic world and thus not requiring portrayal, stand in place of such objects'.

Almost at the same time Novalis had further developed the concept of the symbolic in poetry: 'What use to us are lifeless descriptions which leave the heart and mind cold, lifeless descriptions of lifeless nature—they must at least be symbolic, like nature itself. . . . The artist's every representation must be symbolic or moving. Moving here means affecting. The symbolic does not affect directly, it creates a kind of autonomy.' Whereas Novalis rejected naturalism in the sense of 'common imitation of nature', he required of the artist a degree of independence enabling him to create symbols from the raw material of observed reality. The artist, by 'unravelling' objective reality, made its secret, vital essence the real content of his art and hence too of his symbols. In Runge's *The Nightingale's Lesson*, in his *Four Times of Day*, and in Friedrich's *Cross in the Mountains*, the fundamental common religious experience which gave rise to the symbols is still appreciable. Since the Romantics accepted neither Greek nature mythology nor the Christian mythos unquestioningly, they turned the myth into poetry and made its

substance symbol. Such symbols thus depended firstly on one's perception and conception of what is real, and secondly on expressing the myth in secular and poetic terms, with the result that the symbols are not 'pure abstractions' or 'arbitrary secret signs', but interpretations of reality arising from the myth. 'What else is every beautiful mythology', asked Friedrich Schlegel in his *Rede über die Mythologie* (Lectures on Mythology, 1800) 'but a hieroglyphic expression of nature surrounding us, transfigured by fantasy and love?'

German Romanticism and German idealism saw art not as imitating nature, but as creating forms taken from nature and using the form as symbols to express ideas. Hence Schopenhauer saw in objects merely an 'ostensible' reality, whereas the ideas contained what was truly real. We cannot go into detail here regarding the very great influence of German idealism on Romanticism and Symbolism in France, but a few points must be mentioned. In his *Salon of 1846*, Baudelaire expressly quoted Heine's ideas on symbolism and used them to explain Delacroix's works. Delacroix wrote in his diary, on 20 October 1853, of figures in his painting, which 'seem like a solid bridge on which the imagination can rest before penetrating to the mysterious and profound sensation whose forms are to some extent hieroglyphs.' In his poem 'Correspondances' Baudelaire speaks of nature as a temple. Curiously enough, similar or identical observations can be found in Wackenroder's essay *Von zwei wunderbaren Sprachen*, in his *Outpourings of an Art-Loving Monk*, and in Novalis's story *Apprentices in Sais*. In all these cases art is seen not as a representation of nature, but as a transcription of it. Delacroix said: 'The impression transmitted by nature to the artist is the most important thing to translate'. It is also useful to recall Stéphane Mallarmé's distinction between *nommer* and *suggérer*, which extends Schiller's ideas: 'To NAME an object means to suppress three-quarters of the delight of the poem, which consists of the pleasure of guessing little by little; the dream lies in SUGGESTING. What makes up a symbol is perfect dexterity in manipulating this secret miracle: gradually to conjure up an object in order to reveal a state of mind, or alternatively to choose an object and from it lay bare a state of mind by means of a series of decipherings.'

The connection between music and painting, that experience of synaesthesia which characterizes Runge's *The Nightingale's Lesson* and *Four Times of Day* goes back to Plato's *Republic*, in which it is stated that 'painting finds its fulfilment in the same laws as musical rhythm.' Wagner's musical *leitmotif*, whose structure is comparable to that of the Romantic system of symbols, acted as a stimulus on both French and German Symbolists; it moved them to endow the work of art with symbols serving to reveal the central theme, mutually reinforcing one another, replacing description by a new pattern of symbolic connections. Hence words were used for their quality of musicality, each syllable having a particular tone or shade, which produced corresponding emotional and mental responses by their harmonic interaction.

As the Wagnerian *leitmotif* opened the way to 'suggestion', so other Romantic elements were carefully screened by the moderns to decide upon their utility. The Romantics had viewed the symbolic 'journey within' as a 'return

home' to the transcendental field which was the basis of their belief, whereas the moderns located this attachment to nature, this belief in the wonder of the transcendental, within their own consciousness. The Romantic intoxication with nature was replaced by a feeling of alienation. Art took on the aspect of an existential response to the danger threatening the artist. Painting was seen as the answer to external pressure, a state of affairs which could only exist by reason of the fact that subject-matter was no longer objective, but derived from the subjective consciousness. By assimilating the material—or objective phenomenon—in his consciousness, the artist made it a part of his personal make-up. Kant was the first to point this out, and it is interesting that his categories of mind, particularly those of his Aesthetic (*Kritik der Urteilskraft*, 1970), were revived at the end of the 19th century, in Germany by the New Kantians, especially Hermann Cohen, and in France by Cézanne and later in French Cubism through D. H. Kahnweiler's intermediary function. For Kant, art is a means of confirming the individual consciousness; thus the artistic process can be considered to belong to the categories of the structure and development of consciousness, since it is 'the way of generating the contents of the consciousness'. Cézanne said once in his conversations with Gasquet: 'Landscape is reflected, made human and endowed with the power of thought in me. I objectify it, transmit it, fix it on my canvas . . . Recently you talked about Kant to me. Maybe I am talking nonsense, but it seems to me that I am the subjective consciousness of the landscape and my canvas is my objective consciousness.' Although Cézanne is known to have said, 'Monet is only an eye, but my God what an eye!', this first statement denies the very essence of Impressionism, which is to present the purely optical appearance of things to the eye, not to the consciousness. Conrad Fiedler summed up the impressionist view concisely: 'The consciousness has to give shape to what the eye transmits to it.' Since, however, landscape becomes human for Cézanne and is reflected in his awareness, the picture resulting from it is the objective correlative of the artist's subjective experience.

In this way, under the substantial influence of German idealism, the relationship of the artist to his subject altered during the course of the 19th century: the imitative principle was replaced by the suggestive principle, which took up the Romantic concept of the symbol (or hieroglyph) and made use of it—apart from Symbolism—in Expressionism. Moreover, due to the artist's attitude of mind, subject-matter became a factor of the consciousness, and was no longer the manifestation of the external, purely visual aspect of reality.

Beyond Impressionism

Dissatisfaction with Impressionism manifested itself in the generation born in the 1860s, who were disenchanted with the idea of totality as a result of the teachings of empiricism and materialism. 'I believe that the concept of totality in art has been lost for ever,' said Hugo von Hofmannsthal resignedly.

The first signs of change can be seen in Impressionism itself. In his late series *Water Lilies*, Monet reproduced the autonomous visual aspects of objects in such a way that their individual characteristics were partly surrendered. This process was described by Conrad Fiedler—without his having seen Monet's pictures—as follows: 'The visual aspect of an object breaks free from the object and appears as a free, independent creation.' This hiving off of the visual aspect from objects entailed a loss of individuality on the part of objects. A similar tendency can be seen in Corinth's work. The process began in the type of painting known as 'divisionist'. This implied a crisis in the attitude towards the pictorial surface, and the form it took in the paintings of Seurat and Signac was of the greatest consequence for the future. The Nabis adopted Seurat's silhouette figures together with the Japanese woodcut style, and arrived at a 'surface style', which enabled them to formulate the interconnection between objects as a total unity. Maurice Denis's famous remark of 1890; 'One should remember that a picture—before being a war horse, a nude woman, or some anecdote—is essentially a flat surface covered with colours assembled in a certain order', pinpoints the intention of making this flatness of surface a formal rule, and ensuring that pictorial subjects are seen as being entirely relative. For that generation the object was not something individual, but a configuration, a poetic symbol of the one omnipresent 'life energy' of unseen forces, manifested in objects. In his book *On the Spiritual in Art* (1912) Kandinsky, like the Nabis, regarded Cézanne's art as the best example of this dematerialization of the material world. 'Cézanne does not reproduce a human being, an apple, or a tree, but he uses all that to construct an internally harmonious thing called a picture.'

A small group of painters who had studied landscape painting in Weimar under Theodor Hagen (1842–90) used this divisionist technique of painting—and it is probable that they would have hit upon it independently without the inspiration of Signac and Seurat. They were Ludwig Gleichen-Russwurm (1836–1901), Paul Baum (1859–1932) and Christian Rohlfs (1849–1938). In 1891 at Gurlitt's showrooms in Berlin, Baum exhibited for the first time his pictures composed according to the principle of dividing up the surface. He met Signac and Theo van Rysselberghe for the first time in 1894 and took part in the exhibition of the group *Libre Esthétique*, at the same time making the acquaintance of Pissarro in Knocke; the art dealer Gustave Kahn introduced him to Seurat's painting.

Rohlfs, in one of his early pictures, *Woodland Path in Winter* (1889, Cologne), conferred a lyrical note on the landscape in the play of the gracefully arching trees, the snow and the sunlight. The Romantic feeling of universality of Caspar David Friedrich, where nature symbolically expressed man's metaphysical bondage to the cycle of death and rebirth, is here refined by a naturalistic approach, which lends the picture an air of Pissarro's and Sisley's impressionistic landscapes. In 1898 Rohlfs met Munch who was exhibiting in Berlin. In the following years Rohlf's work began to display a greater degree of surface organization: in *Willows* (1899, Essen), arrangements of shapes are cut into the paint surface; and in the picture *In the Heart of the*

Plate 142

Woods (1907, Essen) he is already influenced by the late Impressionism of Monet and the divisionism of Signac and Seurat. Individual phenomena dissolve into their visual colourful equivalent; in all cases, even the shapely trees, three-dimensional form and shape and colourful surface form are so interwoven that the object is represented by colour, and colour by the object.

Nature Lyricism: the Worpswede Painters

Far away from the main artistic centres, permeated by a rural atmosphere and a feeling of great intimacy with nature, there developed at the end of the 19th century artists' colonies, where the spirit of Romanticism was renewed, if in a different form, which may be called nature lyricism. Among these colonies were the Scottish painters of Cockburnspath near Glasgow, who gave an exhibition in Munich in 1890, and created a real sensation by their simple, straightforward presentation of nature; and the Breton painters of Cottet and Simon. The most prominent German representatives—apart from a community of painters in Dachau—were the young painters in Worpswede, near Bremen, whom Rainer Maria Rilke commemorated in his book *Worpswede* (1903).

There were varying degrees of naturalism in 19th-century German painting, but the artists were in every case captivated by nature, which unlocked in them the feelings they expressed in their works. The Romantic Fohr spoke of the 'externalization of emotion', which was infinitely enriched by contact with nature: 'My emotional response is always the same. It can only be developed when I gaze in wonder at nature.' But for the younger painters the wonder of nature was something different. Rilke expressed it as follows: 'Landscape is something alien for us and one is terribly alone among trees which blossom, and among streams which pass by.' In contrast to Romanticism, the dialogue with nature became much more direct, powerful, disturbing and full of longing, since it was dominated by tragic feelings of this kind.

Worpswede, a little village in moorland scenery, where the peasants laboriously earned a living from turf-cutting and the landscape was melancholy and lyrical, was the place where the young painters Mackensen, Modersohn, Vogeler and others could devote themselves in seclusion to their peaceful painting. In his book, Rilke speaks particularly of Runge, then of Millet, whose lonely pathetic figures had considerable influence on the young painters, and finally of Böcklin, the painter of emotionally charged mood landscapes.

Fritz Mackensen (1866–1953) and Otto Modersohn (1865–1943) were the first to settle in Worpswede in 1889. Mackensen's pictures, *Babe in Arms* (Bremen) or *Divine Worship in the Open Air*, are related to the mood pictures of Millet and even those of Uhde. Modersohn's landscapes, on the other hand, are characterized by a profound intimacy and peace very appropriate to nature lyricism. His early landscapes, *Village Street of Delbrück near Paderborn*

(1888, Bremen) and *Country Road near Münster* (Bremen), reflect his know-
ledge of French impressionist painting, especially Pissarro and Sisley. In a
picture like *Autumn on the Moor* (1895, Bremen), the simplicity with which
the moor landscape, in which man and nature meet in silence, is composed,
evokes a lyrical mood which transforms the impression of nature into poetry.
Rilke spoke of Modersohn as a 'poet-painter', the 'painter of half lights',
whose forms seemed to be organic growths which radiated peace and intimacy
to the heart and rich decorative colourfulness to the eye. To Rilke, the objects
in Modersohn's pictures seemed to be 'full of colour within', testifying to the
'Nordic mysterious worship of colour'.

Plate 143

Heinrich Vogeler (1872–1942), who illustrated Hofmannsthal's play *Der
Kaiser und die Hexe* (The Emperor and the Witch), used a linear style which
strikingly resembles the English Pre-Raphaelites and hence points forward
to *Jugendstil*.

All these painters were distinguished by the powerful effect nature had on
them, but in spite of such strong feelings, their art remained rather decorative
or failed to free itself from post-Romantic mood painting. The picture did
indeed become the means of expressing a poetic mood, but it did not acquire
any degree of formal strength. Artists were still skating over the surface of
objects; they had the experience of being frighteningly alone in nature, they
had an intimation of inner richness of colour, they saw colours as 'lasting
occurrences on the surface of objects' (Rilke)—but they lacked the strength
to release themselves from such feelings by expressing them in an almost
elemental formal language, to transform those profoundly affecting experi-
ences into appropriate signs, hieroglyphs and symbols.

Paula Modersohn-Becker (1876–1907), the wife of Otto Modersohn, did
in fact accomplish this. She successfully managed the transition from nature
lyricism to early Expressionism. In 1898 she wrote in her diary that she was
attempting 'to express my unconscious feelings in shapes.' Her feeling for
nature reveals itself in her early works as an awareness of the interpenetration
of human and vegetable life—as is still the case in the later picture, *Girl Playing
a Flute in Birch-Wood* (1905, Bremen)—and she soon found the means to give
it pictorial expression. In 1900, while in Paris, she met Emil Nolde. She was
also profoundly stirred by the Barbizon masters. The dialogue she carried on
with nature became more profound, until she finally found her path marked
by the art of Cézanne and Gauguin. The Worpswede painters' lyricism
vanished, to be replaced by powerful, simple forms, reflecting the inherent
grandeur of objects. Art is no longer representation, but the reflection of the
personal experience of objects, expressed in great elemental symbols. In 1906
and 1907 Rilke wrote in his letters about the effect Cézanne's art had on him,
and probably exchanged ideas on the subject with the artist. The figure in
Woman Pauper (1906, Darmstadt) has an air of universality reminiscent of
Cézanne, and is expressed in terms of monumental simplicity and calm. In
the *Self-portrait with Camellia Branch* (1907, Essen), painted in the year of
Modersohn-Becker's death, the brown face with the large eyes is sorrowful
yet loving. The dark head in red and violet colours is set against a turquoise

Plate X

curtain; there is a simple grandeur about the gently smiling mouth, which seems to express a quiet sadness, and in the camellia branch held in the hands, like a sign. A lyricism infused with sorrow at the world is expressed in firm forms which produce an icon-like effect. The Worpswede painters' late Romantic 'gazing in wonder at nature', which Modersohn-Becker also subscribed to at first, has been transformed into a highly personal expressional relationship to nature: nature poetry has grown into early Expressionism.

Decoration as a Form of Expression: Jugendstil

In remarking of Gauguin's work, 'We see in it the peremptory example of expression by means of "décor"', and requiring of the work of art, 'To be at once decoration and expression, ornament and poetry; to shun illusion and untruth', Maurice Denis might have been referring to the kind of painting at the turn of the century in which decoration became a means of expression. In other words, his definition applies to the German type of painting called Jugendstil, in which the fundamental element was the decorative and symbolic picture. In Jugendstil, artistic means, such as line, colour, and plane, were released from their exclusive descriptive function, and hence appeared as an alternative to the imitative principle of naturalistic reproduction.

English Art Nouveau found inspiration in the works not only of William Blake but also of the Nazarenes, who had influenced the Pre-Raphaelites; and Burne-Jones and the Morris circle reciprocally influenced German art and craftsmanship at the turn of the century. In book illustration Melchior Lechter (1865–1936) took elements from William Morris, whose influence was also responsible for Henry van de Velde (1863–1956) turning away from painting in 1890 and taking up architecture and handicrafts. Along with his painter friends in the village of Wechel der Zande near Antwerp, van de Velde had previously associated himself with the older 'luminists', who took Nietzsche's *Thus Spake Zarathustra* and its affirmation of the joys of this life as their own philosophy of life. This seems to have proved the basis for van de Velde's later Jugendstil aesthetic. In a lecture in 1894 he said that 'easel painting is a sign of very great age, the ebbing away of strength in an old man, the last moments before death'; and in fact the supremacy of easel painting, undisputed since the Renaissance, became questionable at the time of Jugendstil. The younger artists were not only concerned to reintegrate painting and handicrafts into an artistic totality, but also to lead art out of the idyllic aesthetic zone of 'art for art's sake'.

From 1902 van de Velde was artistic adviser to Grand Duke Wilhelm Ernst in Weimar, and from 1906 to 1914 he organized the arts-and-crafts schools there and became director of them. Both his practical work and his theoretical writings, among which the *Kunstgewerbliche Laienpredigten* (Lay Sermon on Handicrafts, 1902), *Vom neuen Stil* (On the new Style, 1906) and *Die Belebung des Stoffes als Prinzip der Schönheit* (The Animation of Material as a Principle

of Beauty, 1910) are outstanding, make van de Velde one of the pathfinders of the new art. The titles of many other books, like Hermann Bahr's *Überwindung des Naturalismus* (Beyond Naturalism, 1891) and Arthur Moeller-Bruck's *Stilismus* (1901), reflect the nostalgic longing of the age for the virtues of style, in reaction to naturalism, Impressionism and all kinds of historicism, in order to encompass life as a total phenomenon. The concept of 'style', so forcefully expressed by Alois Riegl in his theory of 'Stilwollen' (that is, the deliberate creation of Style), is the synonym for art. The Romantic Novalis had demanded the transformation of the world in poetry; in 1900 the cry was for art as an autonomous world founded on life. The vacuum in the consciousness left by the disappearance of the transcendental was to be filled by life itself.

Munich was the German centre in which the most varied trends, particularly in the field of handicrafts, became established. The illustrators Otto Eckmann, August Endell, Richard Riemerschmid, Bruno Paul, Olaf Gulbransson, Thomas Theodor Heine and others, collaborated in the popular satirical periodicals *Jugend* and *Simplicissimus*, founded in 1896, and thus their ornamental, witty drawings, which contained many elements of the new style, characterized chiefly by its adoption of the flat two-dimensional surface as a formal rule, became widely known. The fact that it was periodicals which popularized the new ideas on form and theories of art, no doubt assisted in making Jugendstil a kind of folk art.

The façade of the Elvira studio (1896) in Munich, by August Endell (1871–1925), is recognized as one of the classic examples of Munich Jugendstil. The decoration, in the form of a gigantic ornament with ridged vaulting in turquoise, green and violet, swamps the original architectural organization of the wall. As an art theorist, Endell characterized the situation of his age perceptively, when he stated in his essay of 1898, *Formschönheit und dekorative Kunst* (Beauty of form and decorative art): 'We stand at the beginning of the development of a completely new art, of art with forms which signify nothing and represent nothing and are reminiscent of nothing, and which stir us deeply and powerfully as only musical notes can do.' And in another essay, *Um die Schönheit* (On Beauty, 1896), he described the formal beauty which is the 'secret of life': 'He who has never been entranced by the graceful bending of blades of grass, the marvellous inflexibility of the thistle leaf, the severe youthfulness of springing leaf-buds, and who has never been moved to the depths of his soul by the massive formation of a tree root, the unflinching strength of split bark, the slim elegance of the birch trunk, the great calm of masses of white leaves, knows nothing of the beauty of forms.' One is reminded of Runge's experience of nature, which speaks of the wonder of nature in similar ecstatic language; but whereas for the Romantic Runge the experience of the transcendental penetrates the whole of life and testifies to the existence of God, Endell sensed in nature the omnipresent stream of life in all organic forms. This spiritual relationship between nature and man is not unlike Romanticism, but the transcendental element has vanished.

193

The Jugendstil painting of the Munich artists is interesting from a historical point of view because, beneath the rather decorative surface, it displays elements which anticipate future developments. In his *Composition* (*c.* 1900, artist's collection), Hans Schmithals (*b.* 1878) chooses glacier-like ripples and spirals which suggest natural forms but are at the same time purely formal. Adolf Hoelzel (1856–1934), who was painting pictures with an abstract effect prior to 1910, defined the aims of the new art: 'The picture poses demands which cannot be satisfied from nature in the commonly accepted sense of the word. Thus the question of the concept of the picture is raised.'

Franz von Stuck (1863–1928) was one of the most striking artistic person-alities of Munich Jugendstil; his villa in Munich, which has now been turned into a museum, is a gem of the age. His works are calculated to stimulate sensual appetites: that, too, is typical of the years around 1900, when the *fin-de-siècle* sense of the loss of paradise gave rise to the creation of an artificial paradise. Stuck had studied under Böcklin, who transformed each impression of nature into a poetic figuration; Stuck, on the other hand, probably started from his own somewhat over-active imagination and concocted a sensual intoxicant for himself and his contemporaries.

Ludwig von Hofmann (1861–1941), one of the better known Jugendstil painters, owed his inspiration to Puvis de Chavannes, Maurice Denis, Böcklin and Marées. In his painting, nature lyricism was extended in symbolic terms.

Plate 144 In *Spring Dance* (*c.* 1900, Bremen), decoration and symbol are pleasingly balanced. It is possible that Hofmann took the motif of the nude human figure in landscape from Marées's idylls. But in contrast to Marées's classical means of expression resulting from the structure of the human figure, Hofmann decoratively interweaves vegetable and human existence, landscape and dance motifs, to form a visual unity, supported by the finely blended, not clearly separable combination of greens, pinks and violets. The picture consciously attempts to invoke a particular mood typifying the artist's feeling for life. The way the individual objects are woven together is remi-niscent of a favourite symbol of the age—the tapestry. In this connection it is interesting that Stefan George addressed two poems in his cycle *Teppich des Lebens* (The tapestry of life, 1899) to Hofmann: the tapestry as a symbol of the 'frozen dance' of phenomena came, around 1900, to apply to art as a whole. The artificially created structure served to explain symbolically the course of life: in *Die Frau ohne Schatten* (The woman without a shadow, 1919) Hugo von Hofmannsthal gave the best literary description of symbolic art as a whole. In the story, the Emperor sees a marvellously beautiful tapestry, on which flowers and animals are woven around each other, and hunters and lovers extricate themselves from among graceful tendrils. When the Emperor asks the girl who made the tapestry to explain how she did so, she replies: 'When weaving I adopt the same procedure as does your blessed eye when seeing. I do not see what is, and nor do I see what is not, but that which is always, and according to that I weave.' Thus the subject of her art is neither dream nor reality, but what is externally valid, the fulness of life which is woven into all external forms.

The Berlin *Secession* put on an extensive exhibition in 1905, with works by Hofmann, Gustav Klimt, Max Klinger and Ferdinand Hodler, thus bringing together the great masters of decorative expressive form. For the Nabis in France, especially Maurice Denis, decoration was a means of achieving expression; for Gustav Klimt (1862–1918), the leading representative of Vienna Jugendstil, decoration was both a means and an end. In his many female portraits, colour and line are used to heighten the sensual appeal, producing eloquent examples of the decadent and lascivious undertones of the *fin-de-siècle* mood. Equally important in Viennese Jugendstil was Egon Schiele (1890–1918), who met Klimt in 1907. In his *Tree in Autumn* (1909, Darmstadt), the forms of the trees are set against a white ground and transformed into two-dimensional ornamental arabesques; the painstaking reproduction of the tracery of the branches seems to be a microcosm of its own. Any association with spatial depth is excluded in favour of the two-dimensional surface.

Plate 145

Max Klinger (1857–1920) worked in Leipzig from 1893 and made an early reputation for himself through his graphic cycles. Like Leibl and Liebermann, Klinger adopted a committed social attitude in his early work. In his cycle *Dramas* (1883) he was inspired by French naturalist literature, and depicted tragic, strife-ridden situations against the bleak background of the metropolis of Berlin—as the Expressionists similarly did not much later. Käthe Kollwitz (1867–1945) continued this tradition in Berlin: in her *Weavers' Rebellion* (1895–98) and *Peasant War* (1903–09) cycles she did, however, free social protest from its naturalistic accessories. In 1884 Klinger began his cycle of fourteen large murals and friezes for the Villa Albers in Berlin, and then painted his triptych *The Judgment of Paris* (1885–87, Vienna), in which easel painting is stylized into a kind of illusionistic architecture by means of an exceedingly decorative frame with carved masks. The deities appear rather plump to the modern eye, but Klinger's contemporaries probably did not notice them at all, because they were fascinated by the imaginary stage on which the actors played their roles. When the picture was first exhibited in public, a special room was decorated with flowers and palm trees and bathed in a kind of mysterious stillness, producing in the observer an empathy with the drama of the classical saga. Klinger's monuments, both planned and executed, such as the one to Beethoven in Leipzig (1899–1902) and to Richard Wagner, also in Leipzig (1912–13) but never executed, are full of exaggerated theatricalism providing a typical conclusion to the 19th century's excessive delight in monuments.

In the mature works of Ferdinand Hodler (1853–1918) the intellectual element is of great importance. In such large figure paintings as *Night* (post 1890), produced under the influence of Puvis de Chavannes, the expressive element, e.g. the figures' gestures of pathos, became dominant. In 1892 Hodler completed a large picture *The World-weary* (Munich), about which he wrote: 'Hopeless resignation to an inevitable, cheerless destiny characterized them all, and this uniformity of attitude was also seen externally in their behaviour. That attracted me and for that reason I painted them.' The outline

Plate 146

is open and stylized, and there is a rhythmical reiteration of the same gesture in the case of all the sitting men, set against a light wall. The figure in the middle is distinguished from the others by his posture and the fact that he is only partly clothed, inducing an association with Christ being laid in the grave. Thus the picture expresses the bleakness of human existence, isolated and forsaken. Hodler deals with typical expressions of certain dominant human conditions—hope, sorrow, love, death—themes communicated by large symbolic figures inscribed on monumental surfaces, which are rhythmically and decoratively articulated.

Some Thoughts on German Expressionism

This book does not aim to describe German Expressionism, since it deals with the history of German 19th-century painting. But it seems fitting to conclude with a few thoughts indicating certain connections between Romanticism and Expressionism.

The 19th century was the last to acknowledge the designation of easel painting as being essentially concerned with naturalistic reproduction. The renewal of painting, which was equivalent to a completely new start, was not regarded by the artists themselves as a deliberate reaction to Impressionism, but rather as the expression of a 'rebirth of thinking' (Marc), which brought about the use of new forms intended to make 'inner music' visible. This new artistic consciousness began in Romanticism, and during the course of the 19th century started to disrupt the belief in a materialistic view of the world. Conscious of the loss of the concept of totality, art at the turn of the century seemed at first to offer an alternative that could be described as 'life': the secret of life manifesting itself to the artists in the richness of forms. Floral forms symbolized the phenomenon 'life': in Symbolism the Romantic desire for all-embracing universal experience was prolonged.

Even the Blaue Reiter painters were affected by this longing. In 1911, Wassily Kandinsky, Franz Marc, Alfred Kubin and Gabriele Münter left the *Neue Künstlervereinigung* in Munich, which had broken away from the Munich *Secession* in 1909, and founded a new community. Kandinsky and Marc published an almanac under the title *Der Blaue Reiter* in 1912 and also mounted their first large exhibition under this title, in which foreign artists like Robert Delaunay and Henri Rousseau represented the opposite poles of extreme abstraction and extreme primitive realism. The name *Blaue Reiter* (blue rider), about whose origins opinions differ, itself includes at least one motif associated with German Romanticism: the blue flower in Novalis' novel, *Heinrich von Ofterdingen*, where it appears as a symbol of longing. Franz Marc (1880–1916) dreamed of some kind of basic poetry and wished to achieve the harmony of man and the world, which is projected in mystic fashion on to the vegetable and animal world. In the act of painting he was able to soothe his anguish at the disastrous state of the world. Painting meant

salvation to him, immersion in eternal Being: 'I saw the picture that comes into the eyes of the duck as it dives: the thousand circles which enclose every tiny living thing, the blue of the whispering sky which is drunk by the lake, the delighted surfacing in a different spot—know, my friends, what pictures are: surfacing in a different spot.'

'Form is a secret for us, because it is the expression of secret forces,' wrote August Macke (1887–1914) in *Der Blaue Reiter*; and Kandinsky expressed this similarly in his contribution, 'Über die Formfrage' (On the question of form). In so far as form expressed secret forces, for Macke and his circle the 'creative forms [meant] life'. Such an attitude to art can be traced back to Jugendstil and Romanticism. The Jugendstil artists took the floral form as symbolizing life itself, which it embodied; now form became the result of de-formation of the model from nature, as in the works of the Brücke painters, or the result of an abstract process of composition, as in some of the works of the Blaue Reiter group. In each case the relationship between natural form and artistic form altered: 'under the veil of appearance we are today seeking hidden things in nature. Nature blossoms in our pictures as in every art. . . . Nature is everywhere, within us and outside of us; there is only something that is not completely nature, but rather surpasses and interprets it. Art was, and is, in its essence at all times the boldest departure from nature and natural-ness', wrote Marc in the periodical *Pan* in 1912. This implied that there was no such thing as a heightening of nature, in the sense of intensifying natural forms, but only an alternative, which itself was also, however, 'nature'—in so far as the forces which went to produce it were those of *natura naturans*. But these forces were the artistic means which contained the 'latent law of nature'. Paul Klee (1879–1940) noted in his diary in 1908: 'I am getting clear of the dead end of ornamentation . . . strengthened by my naturalistic studies, I dare once again return to my original realm of psychic improvisation. Here, restricted only quite indirectly by the nature impression, I dare again to try to formulate what burdens the soul. To note down experiences, which could transform themselves into lines in the dark.' Two years later he reported: 'And now another completely revolutionary discovery: more important than nature and the study of it is the attitude to the contents of the paint box. I must some day be able to improvise at will on the colour keyboard of water-colours lined up side by side.' In 1914, on his journey to North Africa, he managed for the first time to realize his intention in his watercolour studies, and he cried: 'I and colour are one, I am a painter.'

Even where artists apparently still clung to the external attributes of objective reality, as in the works of Marc, it can be seen on closer inspection that they subjected the phenomenal world to a metamorphosis by simplifying its forms and by no longer remaining dependent on nature for colour. From 1908, Marc worked on the motif of the horse: e.g. *Horse in Landscape* (1910, Essen). In freeing colour from nature, simplifying the forms of animals and landscape, and equating colourful appearance and linear structure, Marc creates expressive forms which symbolically present the state of being in its totality. Kandinsky may have been speaking of Marc's horse compositions

Plate 150

197

when he said in his book *On the Spiritual in Art*: 'A red horse. The mere sound of these words removes us into a different atmosphere. The natural impossibility of a red horse demands a correspondingly unnatural milieu in which this horse is placed. Otherwise the total effect can either be that of an oddity . . . or a clumsily conceived fairy tale.' Since, however, one is prevented from imagining animal and landscape in a naturalistic way by the autonomous nature of pure colour and by the use of two-dimensional surface presentation rather than three-dimensional shape in depth, Marc fully understood the problem of his generation, namely that of a 'mystical inner construction', as he expressed it in his contribution to *Der Blaue Reiter*. And in his later pictures, *Animal Destinies*, *Forms in Combat*, *The Play of Forms*, etc., he came close to a solution, for the crystalline forms and refined colours impart mythical and intellectual overtones to the world, and are thus symbols intended to embellish the 'altars of the coming intellectual religion'.

In contrast to this abstract Expressionism of the painters of the Blaue Reiter, the Brücke painters were more concerned with rendering the phenomenal world in concrete terms by breaking objects up violently, and dramatically inscribing their fervent response to this powerful pull on the part of the objects of the world in the form of 'psycho-graphical signs with symbolic force' (Kirchner). In 1905 the four students of architecture, Ernst Ludwig Kirchner, Erich Heckel, Karl Schmidt-Rottluff and Fritz Bleyl, formed the community *Die Brücke* (The bridge) in Dresden, which Emil Nolde and Max Pechstein joined in 1906, followed by O. Müller in 1910. In 1906 the young Oskar Kokoschka came to terms with the art of van Gogh, which assisted him to create great Expressionistic works, like *Still-life with Pineapple* (1907, Berlin).

Plate 147 Ernst Ludwig Kirchner (1880–1938) was the intellectual leader of the Brücke. In his *Nude with Hat* (1907, Frankfurt), he sought to confront traditional art and its formal rules: one cannot help thinking of a representation of Venus by Cranach, which Kirchner may have seen in the Dresden Gallery or during his period of study in Munich. What Kirchner said about his woodcut of the same subject, but reversed (*c.* 1911), is also true of the painting: 'The proportions reflect the feeling which gave rise to the work, in order to depict this feeling in the most forceful manner possible. The *Nude Woman* is very significant in this respect. If one investigates all the measurements according to the laws of nature, one will find all the forms distorted. But precisely these forms give rise to the slim and yet so soft female body.' Against a background of yellow, green and blue serrated and rounded forms, which resembles a flat plane rather than a three-dimensional structure, stands the long, delicate, almost fragile white body, adorned with an overwhelming bluish-black hat. The pictorial surface is used to convey powerful symbols composed of strongly contoured unbroken colours, with which Kirchner renders the subject in an angular, almost deformed way. In his later pictures of coquettes, painted in Berlin between 1911 and 1915, he unmasked the deceitfulness of big-city life by distorting the surface violently and giving expression free reign in the form of psycho-graphical signs or hieroglyphs.

Portrait in Red (1909, Darmstadt) by Max Pechstein (1881–1955) reflects *Plate 148* certain impressions possibly derived from Fauvism, although here the impressionistic open-air theme seems to have been transferred to the interior. In a picture with a similar motif, *Red Girl at Table* (1910, Essen), he has made the step towards Expressionism. In contrast, Karl Schmidt-Rottluff (*b.* 1884) transformed in his *Estate in Dangast* (1910, Berlin) the impression made by the land- *Plate 149* scape into a vibrating mass of surface colour, in which red, blue, green, yellow, and orange form an internal two-dimensional contrast to visible reality.

By such objectivization of the pictorial means, the picture constitutes its own reality: 'thus when in the picture a line is released from the aim of describing a thing—is allowed to function as a thing in itself—its inner music is not adulterated by any subsidiary role' (Kandinsky in *Der Blaue Reiter*). In the Blaue Reiter circle, subject-matter was increasingly determined by the symbolic and affective quality of the colours, until visible reality was understood only through man's ability to perceive. In the portrait *The White Feather* (1909, *Plate XI* Stuttgart) by Alexej von Jawlensky (1864–1941), of Alexander Sacharoff, elements of Jugendstil are indeed still in evidence, like the decorative construction of the head with white feather and black locks. That the affective quality of colour is also envisaged is clear from its partly autonomous nature. Colour sensuously conveys a mood, a particular emotional state.

The Romantics had begun to incorporate the unconscious, and the qualities of mind and heart, into the artistic process of expressing consciousness; they were followed by the Symbolists and the Expressionists. In his novel, *Die andere Seite* (The other side, 1909), Alfred Kubin (1877–1959), of the Blaue Reiter, described completely abstract colour experiences: 'I saw the world as a wonderful tapestry of colour, the startled objects all dissolved into a harmony. In the darkness a colour symphony of tones swirled about me, in which pathetic and delicate natural noises formed meaningful chords.' In his illustrative drawings and compositions Kubin took up the fantastic tradition of Brueghel, Bosch, Redon, and Munch; and in his composition *Storm* (1906, *Plate 151* Munich), not meant to be seen as a concrete objective representation, the bizarre, tumultuous, and crystalline structures reflect an emotional stimulus. 'I don't see the world like that', he wrote, 'but in strange, semi-conscious moments I am amazed to espy these metamorphoses, which are often almost unnoticeable, so that they can seldom be perceived clearly at first sight but have to be nosed out gradually. . . . My realms are those neither of nature nor of my head, and yet they do exist, in the borderlands of twilight.'

Kandinsky's *Improvisation 9* (1910, Stuttgart), painted in the same year as *Plate XII* his first abstract watercolour, stands at the dividing line where the last remnants of a demonstrable direct impression of a part of 'external nature' gives way to the representation of principally unconscious occurrences, that is to say, impressions of 'internal nature'. But for Kandinsky, pure abstraction was only one pole, complemented by the opposite pole of extreme primitive realism. The dualism between realism and idealism, characteristic of the German 19th century, seems to have been overcome here, since for Kandinsky 'the greatest external differences become the greatest internal similarities'.

Catalogue of Artists and Illustrations

AMERLING, Friedrich von
b. Vienna 1803—d. Vienna 1887

1816 study at Academy in Vienna. In 1820s journey to London, to work under Sir Thomas Lawrence; then in Paris under Horace Vernet. 1831 study trip to Italy, then return to Vienna, where he was a favourite portrait painter of high society. 1841 further stay in Italy: 1844 return to Vienna.
Lit.: L. A. Frankl, *Friedrich von Amerling*, Vienna-Pest-Leipzig 1889; G. Probszt, *Friedrich von Amerling*, Zürich-Leipzig-Vienna 1927 (with index of works).

72. Bildnis Carl Christian Vogel von Vogelstein. 1837
Portrait of Carl Christian Vogel von Vogelstein.
Paper on canvas with pasteboard backing. 42 (46.5) × 34.5 (38.5) cm.
Staatliche Museen zu Berlin, National-Galerie, Berlin (East).
Inv. No. A III 541
Lit.: Cat. Berlin (East) p. 206.

BEGAS, Karl Joseph
b. Hainsberg nr. Aachen 1794—d. Berlin 1854

Pupil of Gros in Paris; brought to Berlin by Friedrich Wilhelm III, who gave him a stipend for many years; 1821 return to Berlin, appointed court painter to the King. History, portrait, and genre painter. Father of Oscar Begas (1828–83), portrait painter of Berlin society.
Lit.: F. Eggers, 'Karl Joseph Begas', in *Deutsches Kunstblatt*, Yr. 6, Berlin, pp. 336, 339ff; K. Gläser, *Das Bildnis im Berliner Biedermeier*, Berlin 1932; V.-M. Ruthenberg, 'Carl Begas der Ältere, Zeichnungen seiner Frau und seiner Kinder', in *Forschungen und Berichte*, Vol. I, Berlin 1957, pp. 139ff.

86. Wilhelmine Begas, Die Frau des Künstlers. 1828.
Wilhelmine Begas, the artist's wife.
Oil on canvas. 66 × 56 cm.
Sig. bottom l.: C. Begas F. 1828.
Staatliche Museen zu Berlin, National-Galerie, Berlin (East).
Inv. No. A II 1037
Lit.: Cat. Berlin (East), p. 210f.

BLECHEN, Carl
b. Cottbus 1798—d. Berlin 1840

At first clerk in Berlin bank, self-taught painter. 1822 period at Berlin Academy, 1823 in studio of landscape painter P. L. Lütke. In same year became acquainted with C. D. Friedrich and J. C. Dahl in Dresden. In Berlin Schinkel got him a post as scenery painter at Königstadt Theatre 1824–27. 1828/29 journey to Italy, very important experience for him. 1833 Professor, 1835 full member of Berlin Academy. 1833 trip through Harz Mts. and 1835 in Paris for a few weeks. Suffered from nervous disease from 1836.
Lit.: G. J. Kern, *Karl Blechen, Sein Leben und seine Werke*, Berlin 1911; P. O. Rave, *Karl Blechen, Leben, Würdigung und Werk*, Berlin 1940; P. O. Rave, 'Blechens italienische Skizzenbücher', in *Deutschland-Italien, Festschrift W. Waetzoldt*, Berlin 1941, pp. 315–326; G. Heider, *Carl Blechen*, Leipzig 1970.

V. Blick auf Dächer und Gärten. *c.* 1828.
View of Roofs and gardens.
Oil on pasteboard. 20 × 26 cm.
Stittung Preussischer Kuiturbesitz, Nationalgalerie, Berlin (West).
Inv. No. 765
Lit.: Cat. Berlin (West) 1968, p. 28f.

73. Werkstatt des Bildhauers Ridolfo Schadow in Rom. *c.*
1829
Studio of the Sculptor Ridolfo
Schadow in Rome.
Oil on pasteboard. 21.4 × 30 cm.
Kunsthalle, Bremen. Inv. No. 343
The studio of the sculptor Ridolfo
Schadow (1786–1822), son of J. G.
Schadow.

76. Walzwerk bei Neustadt-Eberswalde. *c.* 1834
Rolling mill near Neustadt-
Eberswalde
Oil on wood. 25.5 × 33 cm.
Stiftung Preussischer Kulterbesitz,
Nationalgalerie, Berlin (West).
Inv. No. 763
Lit.: Cat. Berlin (West) 1968, p. 31

BÖCKLIN, Arnold
b. Basle 1827—d. San Domenico nr.
Fiesole 1901

1845 Düsseldorf Academy, studied
under J. W. Schirmer; further
study in Brussels and Antwerp
(1847), 1847/48 to Switzerland, to
Geneva, working temporarily
under the landscape painter Calame,
and to Basle, making short trips
from there to Paris (1848) and
Rome (1850). 1852 settled in
Rome, friendly with Feuerbach,
Franz-Dreber and Begas. 1858 re-
turn to Munich via Basle, Hanover.
1860 appointed to Art School in
Weimar, taught with Begas and
Lenbach. 1862 second stay in
Rome. 1866 in Basle, 1871–74 in
Munich, friendly with Thoma.
1874–75 in Florence, 1885–92 in
Zürich, knew writer Gottfried
Keller. From 1893 permanently in
or near Florence.
Lit.: H. A. Schmid, *Arnold Böcklin,
Eine Auswahl der hervorragendsten
Werke des Künstlers,* Munich 1892–
1901; R. Schick, *Tagebuchaufzeich-
nungen aus den Jahren 1866, 1868
und 1869,* Berlin 1901; J. Meier-
Graefe, *Der Fall Böcklin und die
Lehre von den Einheiten,* Stuttgart
1911; Exhib. *Arnold Böcklin,*
National-Galerie, Berlin 1927 (in-
troduction by L. Justi); R. Andree,
*Arnold Böcklin, Beiträge zur Analyse
seiner Bildgestaltung,* Düsseldorf
1962; Exhib.: *Arnold Böcklin,* Frank-
furt, Kunstverein 1964.

105. Pan Erschreckt einen Hirten.
c. 1860/61
Pan frightens a Shepherd
Oil on canvas. 134.5 × 110 cm.
Sig. bottom r.: A. Böcklin p.
Bayerische Staatsgemäldesamm-
lungen, Schack-Galerie, Munich
Inv. No. 11533
First version (post 1858) in Basle
(Kunstmuseum); preparatory
drawings of 1853 in Basle and
Munich (Stadtmuseum)
Lit.: Cat. Schack-Galerie, Munich
1969, pp. 44–46.

106. Villa am Meer (first version).
1864
Villa by the Sea
Resin tempera and wax on canvas.
80.7 × 102.7 cm.
Sig. bottom l.: A. Böcklin p.
Bayerische Staatsgemäldesamm-
lungen, Schack-Galerie, Munich
Inv. No. 11528
The motif from Castell Fusano nr.
Ostia. Original form of the com-
position, handed down in 8 versions
altogether (mentioned in Cat.
Schack-Galerie, Munich 1969), is a
colour sketch of 1859 in Düsseldorf
(Kunstmuseum).
Lit.: Cat. Schack-Galerie, Munich,
1969, pp. 53–60

**107. Selbstbildnis mit Fiedelndem
Tod.** 1872
Self-portrait with Death the Fiddler
Oil on canvas. 75 × 61 cm.
Sig. top l.: A. Böcklin pin. 1872
Stiftung Preussischer Kulturbesitz,
National-Galerie, Berlin (West).
Inv. No. 772
Lit.: Cat. Berlin (West) 1968, p. 41.

BUSCH, Wilhelm
b. Wiedensahl nr. Hanover 1832—d.
Mechtshausen nr. Hanover 1908

After study at Technische Hoch-
schule Hannover pupil at Düssel-
dorf Academy from 1851; stay in

Antwerp important for study of works of Rubens, Brouwer, Hals, and Teniers. 1854 at Munich Academy; until settling in Mechtshausen 1898 worked mostly in Munich and Wiedensahl. Painted work consisted of sketchlike pictures, strongly influenced by Dutch painting. Busch famous as writer and illustrator of humorous popular and childrens' books (*Max und Moritz*), in which humour sometimes grotesque.

Lit.: A. Vanselow, *Die Erstdrucke und Erstausgaben der Werke von Wilhelm Busch*, Leipzig 1913; R. Dangers, *Wilhelm Busch, Sein Leben und sein Werk*, Berlin 1930; O. Nöldeke, *Wilhelm Busch, Sämtliche Werke*, Munich 1943; F. Novotny, *Wilhelm Busch als Zeichner und Maler*, Vienna 1949; F. Bohne, *Wilhelm Busch, Leben-Werk-Schicksal*, Zürich-Stuttgart 1958.

128. Brustbild eines Malers mit Palette. *c.* 1875
Portrait of an Artist with palette.
Oil on canvas. 33 × 28 cm.
Sig. top r.: Wilh. Busch.
Bayerische Staatsgemäldesammlungen, Munich
Inv. No. 10739
Possibly a self-portrait, since close relationship to his *Self-portrait* in Munich (Bayerische Staatsgemäldesammlungen).

CARSTENS, Asmus Jakob
b. Schleswig 1754—d. Rome 1798

Early training as merchant, 1776 to Academy in Copenhagen, then earned living by portrait sketches in Lübeck, settled 1788 Berlin, appointed Professor at Academy. 1792 to Rome on grant, lived there till death. In Rome freed himself from late baroque style and created Neoclassical style, based mainly on antiquity and Michelangelo.
Lit.: K. L. Fernow, *Leben des Künstlers Asmus Jacob Carstens, ein Beitrag zur Kunstgeschichte des 18. Jahrhunderts*, Leipzig 1806 (New ed.

entitled: *Carstens, Leben und Werke*, ed. H. Riegel, Hannover 1867); A. Kamphausen, 'Asmus Jakob Carstens', in *Studien zur Schleswig-Holsteinschen Kunstgeschichte*, V, Neumünster in Holstein 1941; A.-F. Heine, *Asmus Jakob Carstens*, Strasbourg 1928.

2. Die Nacht mit ihren Kindern. 1794
Night with Her Children
Charcoal sketch on brown card, outlined in white. 145 × 985 mm.
Sig. bottom l.: Asmus Jacob Carstens. ex Chersonesu Cimbria inv. (On the back: 'Entstd in Rom 1794').
Staatliche Kunstsammlungen, Schlossmuseum, Weimar.
Inv. No. KK 568

CARUS, Carl Gustav
b. Leipzig 1789—d. Dresden 1869

Doctor and nature philosopher, self-taught painter. From 1814 in Dresden, influenced by C. D. Friedrich and J. C. Dahl. Friendly with Tieck, Friedrich, Kersting, Dahl and Rietschel. First public works 1816. Close to Goethe, extended his ideas on morphology. Founded Romantic conception of landscape in *Neun Briefe über Landschaftsmalerei*, published 1831. Undertook several journeys, to Rügen (1819), into Riesengebirge and to Bohemia (1820), to Switzerland (1821), Italy (1828 and 1841), France (1835), England and Scotland (1844).
Lit.: C. G. Carus, *Lebenserinnerungen und Denkwürdigkeiten*, Leipzig 1865 (4 vols.—5th vol. Dresden 1931 by R. Zaunick); C. G. Carus, *Neun Briefe über Landschaftsmalerei*, Leipzig 1831 (New ed. by K. Gerstenberg, 2nd ed. Dresden 1955); W. Goldschmidt, *Die Landschaftsbriefe des Carl Gustav Carus, ihre Bedeutung für die Theorie der romantischen Landschaftsmalerei*, Breslau 1935; M. Prause, *Carl Gustav Carus, Leben und Werk*, Berlin 1968.

28. Kahnfahrt auf der Elbe bei Dresden. 1827
Boat trip on the Elbe near Dresden.
Oil on canvas. 29 × 22 cm.
Sig. bottom l.: Carus 1827
Kunstmuseum, Düsseldorf
Inv. No. 130
Lit.: Cat. Düsseldorf 1968, p. 22.

CHODOWIECKI, Daniel Nikolaus
b. Danzig 1726—d. Berlin 1801

Began as merchant apprentice, self-taught in watercolour miniatures and enamel painting, from 1758 attempts at etching, illustrations to works by Lessing, Gellert and Goethe, and to Lavater's *Studies in Physiognomy*. Member of Berlin Academy from 1764, Director 1797. Produced variation of European rococo at same time as Chardin in France and Hogarth in England. Noticeable for bourgeois sense of reality which characterized Berlin artists from Chodowiecki to Liebermann, including Schadow, Krüger and Menzel.
Lit.: W. Engelmann, *Daniel Chodowieckis sämtliche Kupferstiche*, Leipzig 1857; W. von Oettingen, *Daniel Chodowiecki, Ein Berliner Künstlerleben im achtzehnten Jahrhundert*, Berlin 1895; G. Chr. Lichtenberg, *Chodowiecki, Handlungen des Lebens*, Stuttgart 1971.

87. Gesellschaft am Tisch. *c.* 1758–62
Company at Table.
Oil on pine-wood. 23.8 × 18.8 cm.
Sig. bottom l.: D. Chodowiecki invt.
Kunsthalle, Hamburg
Inv. No. 738.
Lit.: Cat. Hamburg 1966, p. 41.

CORINTH, Lovis
b. Tapiau (E. Prussia) 1858—d. Zandvoort (Holland) 1925

1876–80 study at Königsberg. From 1880 in Munich, in summer in Defregger's class, in autumn to Academy under Löfftz. 1884 to Paris via Antwerp, till 1887 in Académie Julian under Bouguereau

and Robert Fleury. 1891–1900 settled in Munich, after short stays in Berlin (1887–88) and Königsberg (1888). From 1901 in Berlin, one of founders of Berlin *Secession*, President in 1915. 1903 m. painter Charlotte Berend (b. Berlin 1880—d. New York 1967). From 1918 every summer in Urfeld on the Walchensee. 1923 and 1924 in Switzerland, 1925 in Holland.
Lit.: L. Corinth, *Gesammelte Schriften*, Berlin 1920; L. Corinth, *Selbstbiographie*, Leipzig 1926; K. Schwarz, *Das graphische Werke von Lovis Corinth*, 2nd extended ed. Berlin 1922; Ch. Berend-Corinth and H. Röthel, *Die Gemälde von Lovis Corinth*, Cat. of works, Munich 1958.

137. Nach dem Bade. 1906
After the Swim.
Oil on canvas. 80 × 60 cm.
Sig. bottom l.: Lovis Corinth.
Kunsthalle, Hamburg
Inv. No. 2375
Prep. sketch under title *Lychen 1906* reproduced in G. Pauli, *L. Corinth*, in *Kunst und Künstler*, 16, 1918, p. 337.
Lit.: Cat. Hamburg 1969 (20th-century Masters), p. 22.

138. Morgensonne. 1910
Morning Sunlight.
Oil on canvas. 62 × 70 cm.
Sig. top r.: Lovis Corinth 1910
Hessisches Landesmuseum, Darmstadt
Inv. No. GK 1144

CORNELIUS, Peter von
b. Düsseldorf 1783—d. Berlin 1867

From 1795 at Düsseldorf Academy under Peter Langer. On death of father worked first as illustrator; allegorical paintings in Frankfurt 1809. 1811/16 sketches to Goethe's *Faust* Pt. I, publ. 1816 as etchings. 1811 with Christian Xeller to Italy via Heidelberg and Switzerland. In Rome close to Overbeck and Pforr, but did not live with Brotherhood of St Luke in San Isidoro

monastery in order to remain independent. 6 sketches to Nibelungen cycle publ. by Reimer in Berlin. In Rome worked on frescoes in Casa Bartholdy, then helped with Dante frescoes in Villa Massimo. 1818 with Crown Prince Ludwig in Munich, appointed Professor 1819; from 1821 taught at Düsseldorf Academy. Frescoes for Glyptothek in Munich painted up to 1830. 1825 Director of Munich Academy, large circle of pupils. 1836–39 worked on frescoes for Ludwigskirche Munich. 1839 split with Bavarian King. To Berlin 1841 after invitation from King Wilhelm IV of Prussia 1840. Last great commission was Campo Santo frescoes in Berlin: presented cartoons, but never completed work. In 1840s and 1853–61 in Rome.
Lit.: H. Riegel, *Cornelius, der Meister der deutschen Malerei*, Hanover 1866; E. Förster, *Peter von Cornelius*, Berlin 1874; D. Koch, *Peter Cornelius, ein deutscher Maler*, Stuttgart 1905; Ch. Eckert, *Peter Cornelius*, Bielefeld and Leipzig 1906; A. Kuhn, *Die Faustillustrationen des Peter Cornelius in ihrer Beziehung zur deutschen Nationalliteratur der Romantik*, Berlin 1916; A. Kuhn, *Peter Cornelius und die geistigen Strömungen seiner Zeit*, Berlin 1921; H. von Einem, 'Peter Cornelius', in *Wallraf-Richartz-Jahrbuch*, *XVI*, 1954, pp. 106 ff.; K. Andrews, *The Nazarenes, a Brotherhood of German Painters in Rome*, Oxford 1964.

34. **Faust und Mephistopheles am Rabenstein.** 1811
Faust and Mephistopheles at the Rabenstein.
Ink sketch on paper. 348 × 519 mm.
Sig. bottom r.: P. Cornelius invt. 1811
Staatliche Museen zu Berlin, Kupferstichkabinett und Sammlung der Zeichnungen, Berlin (East)
Inv. No. 68
Along with remaining 11 illustra-

tions to Goethe's *Faust* produced in Frankfurt and Rome, engraved by Ruscheweyh in 1816 and published in Weimar.

108. **Doppelbildnis von Friedrich Overbeck und Peter Cornelius.** 1812
Twin portrait of Friedrich Overbeck and Peter Cornelius.
Pencil on brownish paper. 424 × 370 mm.
Sig. bottom r.: 'Zur Erinnerung an unsern Freund C. F. Schlosser von F. Overbeck und J. P. Cornelius in Rom d. 16. März 1815.' Inscription later wrongly altered, instead of 1815 should read 1812.
Coll. Dr A. Winterstein, Munich
This double portrait mentioned in letter of Overbeck to Sutter of 20 March 1812 and inscription reproduced with date 1812. This later wrongly altered to 1815, probably by Baron Bernus, who owned the drawing.
Lit.: Exhib. *Deutsche Zeichnungen 1800–1850 aus der Sammlung Winterstein*, Museen für Kunst und Kulturgeschichte der Hansestadt Lübeck, Lübeck 1969, pp. 18ff.

IV. **Joseph gibt sich seinen Brüdern zu Erkennen.** 1816–17
Joseph is Recognized by His Brothers.
Fresco. 236 × 290 cm.
Sig.: P. Cornelius
Staatliche Museen zu Berlin, National-Galerie, Berlin (East)
Inv. No. A I 419
Kuhn, 1921, mentions series of prep. sketches, among them one in Vienna (Albertina).
Lit.: K. Andrews, *The Nazarenes*, Oxford 1964, p. 93 (with notes and bibliography)

75. **Die Apokalyptischen Reiter.** 1846
The Four Horsemen of the Apocalypse.
Charcoal drawing on card. 472 × 588 cm.
Staatliche Museen zu Berlin,

National-Galerie, Berlin (Destroyed in war).
Commissioned by King Friedrich Wilhelm IV of Prussia for planned Campo Santo in Berlin. Executed Rome 1846.
Lit.: K. Andrews, *The Nazarenes*, Oxford 1964, p. 123 (with notes)

DAHL, Johann Christian Clausen
b. Bergen (Norway) 1788—d. Dresden 1857

From 1811 training in landscape painting under C. A. Lorentzen at Copenhagen Academy. At first influenced by Dutch landscape painters Hobbema, Ruysdael and Everdingen, then by classical southern compositions of Jan Both and Claude Lorrain. 1816 got to know Danish painter Eckersberg. 1818 to Dresden, friend and pupil of C. D. Friedrich. 1820–21 journey to Italy, some time in Naples; 1826 journey to Norway. After return from Italy to Dresden met C. Blechen. From 1820 member, 1824 Professor of Dresden Academy, also member of Academies in Copenhagen (1827), Stockholm (1832) and Berlin (1835). With T. Fearnley considered founder of Norwegian landscape painting.
Lit.: A. Aubert, *Professor Dahl*, Kristiania 1893; A. Aubert, *Den nordiske Naturfölelse og Professor Dahl*, Kristiania 1894 (cf. *Die norddeutsche Landschaftsmalerei und Joh. Chr. Dahl*, Berlin 1947); J. H. Langaard, *J. C. Dahl's Verk*, Oslo 1937; G. Zöllner, *J. Ch. Cl. Dahl*, Würzburg 1945; L. Østby, *Johann Christian Clausen Dahl, Tegninger og Akvareller*, Oslo 1957.

30. Landschaftsstudie (View of Dresden). 1819
Landscape study.
Oil on canvas, backed with card. 11.5 × 20.3 cm.
Sig. on back of canvas: 'd. 12 Septbr. 1819'
Gemäldegalerie Neue Meister, Staatliche Kunstsammlungen, Dresden

Inv. No. 2206 C
Lit. Cat. Dresden 1960, p. 28.

29. Wolkenstudie. 1832
Cloud study.
Oil on paper, backed with card. 20.3 × 20 cm.
Sig. bottom r.: D. 1832
Kunsthalle, Hamburg
Inv. No. 2165
Lit.: Cat. Hamburg 1969, p. 43.

DILLIS, Johann Georg von
b. Grüngiebing 1759—d. Munich 1856

1777–81 studied philosophy and theology at Ingolstadt University, consecrated priest in 1782. 1782 at Academy of Drawing, Munich, under J. J. Dorner the Elder. 1786 dispensation from ecclesiastical duties, worked as drawing master to noblemen's children. Acquaintance with Count Rumford led to journeys to Switzerland and Upper Rhine accompanying Munich families. 1790 Inspector of Prince's picture gallery in Munich, 1822 Central Director; under his direction Boisserée collection acquired (1827) and Pinakothek opened in 1836. Also made many journeys after 1794, to Italy (1817) in company of Crown Prince Ludwig of Bavaria, to Rome and southern Italy, where his 'Views from Rome, Naples and Sicily' were produced.
Lit: W. Lessing, *Johann Georg Dillis als Künstler und Museumsmann*, Munich 1951; Exhib.: *J. G. Dillis*, Munich 1959; R. Messerer, 'Georg von Dillis, Leben und Werk', in *Oberbayerisches Archiv 84*, Munich 1961.

60. Grotta Ferrata bei Rom. c. 1794/95
Grotta Ferrata near Rome.
Oil on wood. 34 × 44 cm.
Bayerische Staatsgemäldesammlungen, Munich
Inv. No. H.G. 211

61. Das Trivaschlösschen. 1797
Triva Castle.
Oil on wood. 19 × 26.3 cm.

Sig. bottom r.: G. v. Dillis, f. 1797.
Bayerische Staatsgemäldesammlungen, Munich
Inv. No. 9392
The house built by von Ostwaldt c. 1705 stood near the Theatinerkirche and the Schwabing Gate in Munich, pulled down in 1802. Called after its owner von Triva.
Lit.: Cat. Munich 1967, pp. 16 ff.

62. Ausblick von der Villa Malta in Rom auf St Peter. 1818
View of St Peter's from the Villa Malta in Rome.
Oil on paper, backed with canvas. 29.2 × 43.4 cm.
Bayerische Staatsgemäldesammlungen, Schack-Galerie, Munich
Inv. No. 11468
One of series of 3 views from Villa Malta in Rome, all in Munich (Schack-Galerie).
Lit.: Cat. Schack-Galerie, Munich 1969, pp. 91–95.

DREBER, Heinrich (known as Franz-Dreber)
b. Dresden 1822—d. Anticoli di Campagna, near Rome 1875

1836 to Dresden Academy, influenced by L. Richter. Short stay in Munich 1841, then settled in Rome 1843. Close to C. Reinhart, F. Preller and A. Böcklin. Journeys to Germany 1855 and 1856. In Rome became member of S. Luca Academy, freed himself of Richter's influence and developed own landscape style along with Preller and J. A. Koch. His work passed on to German painters in Italy, like Böcklin and Marées, the heritage of Koch and the Romantics Fohr and Friedrich Olivier.
Lit.: R. Schöne, *Heinrich Dreber*, Berlin 1940.

104. Sappho. 1859
Sappho.
Oil on canvas. 60 × 41 cm.
Sig. bottom r.: H.D.
Bayerische Staatsgemäldesammlungen, Munich
Inv. No. 9278

According to legend the Greek poetess Sappho threw herself into the sea out of unhappy love for Phaon, about 600 BC on the isle of Lesbos. On seeing this painting in 1864 Schack ordered the large picture *Sappho*, finished in 1870 (Bayerische Staatsgemäldesammlungen, Schack-Galerie, Munich). Numerous prep. studies in Berlin (East) (Kupferstichkabinett und Sammlung der Zeichnungen) and Munich (Staatliche Graphische Sammlung).
Lit.: Cat. Schack-Galerie, Munich 1969, cf. pp. 97–99.

FEUERBACH, Anselm
b. Speyer 1829—d. Venice 1880

Early study under W. Schadow, C. F. Sohn and J. W. Schirmer at Düsseldorf Academy (1845–48), continued in Munich under K. Rahl 1848–50. Interest in contemporary European history painting took him to G. Wappers in Antwerp (1850–51) and T. Couture in Paris (1851–53). After interlude in Heidelberg to Venice 1855 with J. V. von Scheffel. 1856 to Rome via Florence. 1860 turned down appointment to Weimar Academy. Serious financial difficulties helped by commissions to make copies for A. F. von Schack. Differences in regard to monumental painting led to rift. 1873 accepted post as history painter at Vienna Academy, unsuccessful opposition to Makart's flamboyance caused him to leave Vienna 1876. After short stay in Nuremberg finally settled in Venice.
Lit.: J. Allgeyer, *Anselm Feuerbach*, 2nd ed., Berlin-Stuttgart 1904; H. Uhde-Bernays, *Feuerbach, Beschreibender Katalog seiner sämtlichen Gemälde*, Munich 1929; H. Feuerbach, *Ein Vermächtnis von Anselm Feuerbach*, Munich 1926; E. Kühnemann, *Zu Anselm Feuerbachs reifem Stil* (Thesis), Cologne 1948; H. von Einem, 'Gedanken zu Anselm Feuerbach und seiner "Iphigenie"', in *Zeitschrift des deutschen Vereins*

für Kunstwissenschaft, XVIII, 1964, p. 127 ff.; M. Arndt, *Die Zeichnungen Anselm Feuerbachs—Studien zur Bildentwicklung* (Thesis), Bonn 1967.

100. Der Kupferstecher Julius Allgeyer. 1857
The engraver Julius Allgeyer.
Oil on canvas. 99.2 × 74.4 cm.
Sig. bottom r.: Anselm Feuerbach 1857.
Bayerische Staatsgemäldesammlungen, Munich
Inv. No. 9496
Friend and biographer of Feuerbach, Julius Allgeyer (1829–1900). 2nd version of 1858 in Basle (Kunstmuseum).
Lit.: Cat. Munich 1967, pp. 18–19.

101. Iphigenie. 1871
Iphigenia.
Oil on canvas. 192.5 × 126.5 cm.
Sig. bottom l.: A. Feuerbach/71
Staatsgalerie, Stuttgart
Inv. No. 770
First version 1862 with Nana Risi in Darmstadt (Hessisches Landesmuseum), this version with Lucia Brunacci as model. Bust dated 1870 in Winterthur (Stiftung O. Reinhart).
Lit.: Cat. Stuttgart 1968, p. 63.

102. Die Rasende Medea. c. 1872
Medea in her Fury.
Pen and ink sketch on red blotting paper. 173 × 300 mm.
Sig. bottom l.: AF
Part of cycle of Medea pictures: *Medea auf der Flucht* (Medea Fleeing) of 1866 (formerly Berlin and Breslau), *Medea vor der Tat* (Medea before the Act) of 1870 (Bayerische Staatsgemäldesammlungen, Munich), *Medea mit dem Dolche* (Medea with the Dagger) of 1871 (Kunsthalle, Mannheim) and *Medea an der Urne* (Medea at the Urn) of 1873 (Neue Galerie des Kunsthistorischen Museums, Vienna), in which this composition appears on the urn.
Lit.: formerly F. A. C. Prestel, Versteigerung vom 12. und 13.

November 1918 [Auction catalogue, 12–13 Nov. 1918], Frankfurt/Main, p. 45, with reproduction.

FOHR, Karl Philipp
b. Heidelberg 1795—d. Rome 1818

Early instruction in sketching from Friedrich Rottmann in Heidelberg, along with Ernst Fries and Carl Rottmann. 1810 in Darmstadt under G. W. Issel, but mainly self-taught. 1812 Issel introduced him to Princess of Hessen, to whom he dedicated sketch-books of rambles through Neckar valley (1813/14) and Baden (1814–15). From 1815–16 at Munich Academy under Peter von Langer; learned oil painting from L. Ruhl, with whom he illustrated Tieck's *Melusine*. Short stay in Heidelberg, then to Rome 1816. To studio of J. A. Koch who taught him landscape painting. Close to Brotherhood of St Luke. 1817 began preparatory work on group portrait of German artists in Caffè Greco. Drowned in Tiber.
Lit.: P. Dieffenbach, *Das Leben des Künstlers Karl Fohr*, Darmstadt 1823 (new ed. by R. Schrey and P. F. Schmidt, Frankfurt 1918); A. von Schneider, *Carl Philipp Fohrs Skizzenbuch*, Berlin 1952; G. Poensgen, *C. Ph. Fohr und das Café Greco*, Heidelberg 1957; J. Ch. Jensen, *Carl Philipp Fohr in Heidelberg und im Neckartal*, Karlsruhe 1968; Exhib. *Karl Philipp Fohr*, Städelsches Kunstinstitut, Frankfurt 1968; Exhib. *Carl Philipp Fohr, Skizzenbuch der Neckargegend, Badisches Skizzenbuch*, Kurpfälzisches Museum, Heidelberg 1968.

46. Hornberg am Neckar. 1814
Hornberg on the Neckar.
Brush sketch, grey wash, on paper. 324 × 484 mm.
Hessisches Landesmuseum, Graphische Sammlung, Darmstadt
Inv. No. AE 36
Two further watercolour views in Darmstadt (Hessisches Landes-

museum), also 1814, like Fohr's sketch-book of Neckar region.
Lit.: Exhib. *K. Ph. Fohr*, Frankfurt 1968, No. 15. Exhib. *C. Ph. Fohr*, Heidelberg 1968, No. 4.

41. Selbstbildnis. 1816
Self-portrait.
Pen with bluish ink, wash, on light brown paper. 235 × 187 mm.
Kurpfälzisches Museum, Heidelberg
Inv. No. Z 271
Lit.: Exhib. *K. Ph. Fohr*, Frankfurt 1968, p. 52.

45. Landschaft bei Rocca Canterano im Sabinergebirge. 1818
Landscape near Rocca Canterano in the Sabine Hills.
Oil on canvas. 98.4 × 135.5 cm.
Coll. S. K. H. Ludwig Prinz von Hessen und bei Rhein, Schloss, Darmstadt
Preparatory studies in Berlin/East (Staatliche Museen zu Berlin, Kupferstichkabinett und Sammlung der Zeichnungen), Dresden (Kupferstichkabinett), Frankfurt (Städelsches Kunstinstitut). Motif is near Subiaco.
Lit.: Exhib. *K. Ph. Fohr*, Frankfurt 1968, pp. 14 f.

FRIEDRICH; Caspar David
b. Greifswald 1774—d. Dresden 1840

First studies under University drawing instructor J. F. Quistorp in Greifswald, at Copenhagen Academy 1794–98, influenced mainly by N. A. Abilgaard, a pupil of A. R. Mengs. From 1798 in Dresden, worked as scenery painter with Zingg. 1801 and 1802 in Greifswald, many landscape studies of rambles in Rügen district. Settled Dresden 1802, closely associated with Dresden circle of Romantics esp. L. Tieck, Ph. O. Runge, G. F. Kersting, C. G. Carus, and J. C. Dahl; from 1820 lived in same house as Dahl. 1805 participated in Weimar Art Society's exhibition, won 1/2 share of prize with two landscape water-colours praised by Goethe. Visited Goethe 1810 and 1811. Met writer H. von Kleist, philosopher A. Müller. 1807 started oil painting, 1808 controversial picture *Cross in the Mountains* for private chapel in Tetschen. 1808/09 completed oil painting *Monk by the Sea*, 1809 *Abbey in the Oak Forest*, both caused stir at Berlin Academy Exhibition in 1810. Made member of Berlin Academy 1810. 1816 member, 1824 Professor of Dresden Academy, 1822 and 1824 with Kersting in Meissen. Carl Blechen a pupil of his. 1835 suffered stroke, last years passed in illness and then insanity.

Lit.: C. D. Friedrich, *Bekenntnisse*, publ. K. K. Eberlein, Berlin 1924; C. G. Carus, *C. D. Friedrich, der Landschaftsmaler, zu einem Gedächtnis nebst Fragmenten nach seinen hinterlassenen Papieren*, Dresden 1841 (new ed. Berlin 1944): O. Schmitt, 'C. D. Friedrich und die Klosterruine Eldena' in *Von der Antike zum Christentum, Festschrift Victor Schulze*, Stettin 1931, pp. 167–191; F. Niemitz, *C. D. Friedrich, Die unendliche Landschaft*, Munich 1938; H. Beenken, 'C. D. Friedrich', in *Burlington Magazine* 72, 1938, pp. 171–175; H. von Einem, *C. D. Friedrich*, 3rd ed., Berlin 1950; H. Börsch-Supan, *Die Bildgestaltung bei C. D. Friedrich* (Thesis), Munich 1960; R. Rosenblum, 'Caspar David Friedrich and Modern Painting', in *Art and Literature*, 1966, p. 134 ff.; W. Sumowski, 'Gotische Dome bei C. D. Friedrich', in *Klassizismus und Romantik in Deutschland*; Exhib. Germanisches Nationalmuseum, Nuremberg 1966; L. D. Ettlinger, *C. D. Friedrich*, London 1967; S. Hinz, *Caspar David Friedrich in Briefen und Bekenntnissen*, Berlin 1968; W. Sumowski, *Caspar David Friedrich*, Wiesbaden 1970; *Caspar David Friedrich, 1774–1840. Romantic Landscape Painting in Dresden*. With contributions by W. Vaughan, H. Börsch-Supan, H. J.

Neidhardt. The Tate Gallery, London 1972.

22. Morgenlicht. 1806–07
Morning light.
Oil on canvas. 22 × 30 cm.
Folkwang Museum, Essen
Inv. No. G. 45
Lit.: Cat. Essen 1963, p. 20.

24. Der Sommer. 1808
Summer
Oil on canvas. 71.4 × 103.6 cm.
Bayerische Staatsgemäldesammlungen, Munich
Inv. No. 9702
Based on sepia drawing of 1803, part of four-season cycle. *Winter* (1808, formerly Bayerische Staatsgemäldesammlungen, Munich, destroyed 1931) probably intended with *Summer* to form part of cycle. Sequence of sketches of four seasons (1826) in Hamburg (Kunsthalle, Kupferstichkabinett).
Lit.: Cat. Munich 1967, pp. 20–21.

19. Das Kreuz im Gebirge. 1808
Cross in the Mountains.
Oil on canvas. 115 × 110 cm.
Gemäldegalerie Neue Meister, Staatliche Kunstsammlungen, Dresden
Inv. No. 2197 D
Known as the 'Tetschener Altar', for after seeing watercolour of 1808 (Berlin/East, Staatliche Museen zu Berlin, Kupferstichkabinett und Sammlung der Zeichnungen), Countess of Thun commissioned it for her private chapel in Tetschen. Carved frame executed by Kühne to Friedrich's design. Reformulations in paintings *Cross in the 'Riesen' Mountains* (Verwaltung der Staatlichen Schlösser und Gärten, Berlin/West) and *Cross in the Mountains* (Kunstmuseum, Düsseldorf), both of 1811.
Lit.: Cat. Dresden 1960, p. 36.

21. Abtei im Eichenwald. 1809
Abbey in the Oak Forest.
Oil on canvas. 110.4 × 171 cm.
Verwaltung der Staatlichen Schlösser und Gärten, Schloss Charlottenburg, Berlin (West)

Inv. No. GK I 6917
Architectural motif is the ruins of Eldena, 13th-century Danish Cistercian settlement near Greifswald, often used by Friedrich in studies and paintings.

20. Kreuz im Riesengebirge. 1811
Cross in the 'Riesen' Mountains.
Oil on canvas. 108 × 170 cm.
Verwaltung der Staatlichen Schlösser und Gärten, Schloss Charlottenburg, Berlin (West)
Inv. No. GK I 6911

II. Wiesen bei Greifswald. *c.* 1818
Meadows near Greifswald.
Oil on canvas. 34.5 × 48.3 cm.
Kunsthalle, Hamburg
Inv. No. 1047
Another version, *Greifswald in the Moonlight*, Greifswald seen from the harbour, in Oslo (Nasjonalgalleriet).
Lit.: Cat. Hamburg 1969, p. 71.

23. Zwei Männer in Betrachtung des Mondes. 1819
Two Men gazing at the Moon.
Oil on canvas. 35 × 44.5 cm.
Gemäldegalerie Neue Meister, Staatliche Kunstsammlungen, Dresden
Inv. No. 2194
Based on landscape motif from Rügen. Friedrich's brother-in-law Ch. W. Bommer and the painter A. Heinrich are shown. The picture repeated many times, with slight changes in accessory figures, e.g. *Man and Woman gazing at the Moon* (1824, Stiftung Preussischer Kulturbesitz, Nationalgalerie, Berlin/West).
Lit.: Cat. Dresden 1960, p. 60.

25. Eismeer. 1824
Arctic Shipwreck.
Oil on canvas. 96.7 × 126.9 cm.
Kunsthalle, Hamburg
Inv. No. 1051
1824 version after lost 1822 version. Three studies in oils with ice-floes of 1821 in Hamburg (Kunsthalle). Theme apparently prefigured in *Ship in Frozen Sea*, 1798 (Hamburg, Kunsthalle).

Lit.: Cat. Hamburg 1969, pp. 73–74.

26. Eichbaum im Schnee. 1829
Oak Tree in Snow.
Oil on canvas. 71 × 48 cm.
Stiftung Preussischer Kulturbesitz,
Nationalgalerie, Berlin (West)
Inv. No. 1380
Variant of 1822 in Cologne
(Wallraf-Richartz-Museum).From
study of 1806 (Dresden, Kupfer-
stichkabinett). Same motif in *Pre-
historic Grave in the Snow* (Dresden,
Gemäldegalerie Neue Meister) and
in *Winter* (formerly Munich,
Bayerische Staatsgemäldesamm-
lungen).
Lit.: Cat. Berlin (West) 1968, p. 69.

27. Flussufer im Nebel. *c.* 1822
River Bank in the Fog.
Oil on canvas. 22.5 × 33.5 cm.
Wallraf-Richartz-Museum,
Cologne
Inv. No. 2667
Lit.: Cat. Cologne 1964, p. 42.

GENELLI, Bonaventura
b. Berlin 1798—d. Weimar 1868

Of Italian family living in Berlin.
After death of father, the painter
Janus Genelli, studied under J. E.
Hummel and H. Ch. Genelli, atten-
tion directed to works of A. J.
Carstens. 1822–32 in Rome,
friendly with Müller, Koch and
later K. Rahl. 1832 commission
with F. Preller to paint Hertel's
Römische Haus in Leipzig, broke
with Hertel 1836 due to differences
of opinion. From 1836 lived in
poverty in Munich, helped in 1856
by many commissions from A. F.
von Schack. 1859 appointed to
Weimar Academy by Grand Duke
Karl Alexander.
Lit.: H. Marshall, *Bonaventura
Genelli*, Leipzig 1912; U. Christof-
fel, *Aus dem Leben eines Künstlers,
Originalzeichnungen im Kupferstich-
kabinett des Leipziger Museums*,
Berlin 1922; M. Jordan, 'Bona-
ventura Genelli', in *Zeitschrift für
bildende Kunst*, V, pp. 1–19; L. von

Donop, 'Briefe von Bonaventura
Genelli und Karl Rahl', in *Zeit-
schrift für bildende Kunst*, XII, pp.
25 ff, XIII, pp. 115ff; H. Ebert,
'Über Bonaventura Genelli und
seine künstlerische Gestaltungs-
weise', in *Wissenschaftliche Zeit-
schrift der Karl-Marx-Universität*, Jr.
12, Leipzig 1963; H. Ebert, *Bona-
ventura Genelli, Leben und Werk*,
Graz 1972.

103. Bacchus unter den Musen. 1868
Bacchus among the Muses.
Oil on canvas. 192.5 × 295 cm.
Sig. bottom r.: B: Genelli fect.
Bayerische Staatsgemäldesamm-
lungen, Schack-Galerie, Munich.
Inv. No. 11548
Numerous preparatory studies
from 1857 onwards in Vienna
(Academy and Albertina), Munich
(Staatliche Graphische Sammlung),
and Darmstadt (Hessisches Landes-
museum) mentioned in Cat.
Munich 1969.
Lit.: Cat. Schack-Galerie, Munich
1969, pp. 178–183.

GENSLER, Johann Jacob
b. Hamburg 1808—d. Hamburg 1845

Early study under Gerdt Hardorff
the Elder in Hamburg, 1824–26
under painter Wilhelm Tischbein
(1751–1829) in Eutin, led by Tisch-
bein's landscape idylls—described
by Goethe in 1822—to take up
landscape painting. 1828–30
Munich Academy, 1830–31 Vienna
Academy. From 1831 worked in
Hamburg, journey to Holland
1841.
Lit.: F. Bürger, *Die Gensler*, Stras-
bourg 1916.

67. Elbstrand, Verdeckte Sonne.
1840
Shore of the Elbe with Sun Hidden.
Oil on paper, backed. 33.7 × 47.5
cm.
Sig. bottom centre: Sbr. 12 1840 JG
Kunsthalle, Hamburg
Inv. No. 3338
Used sketch again in finished paint-
ings *Life on Shore near Blankenese
with Willows* and *Cable Railway on*

Shore at Blankenese of 1842 (Hamburg, Private Collection).
Lit.: Cat. Hamburg 1969, p. 86.

GRAFF, Anton
b. Winterthur 1736—d. Dresden 1813
1753 to Johann Ulrich Schellenberg's drawing and painting school in Winterthur until 1756. 1756–7 in Augsburg, following study assistant to court painter Leonhard Schneider in Ansbach 1757–8, settled Augsburg 1759 and started on his own. Friendly with Johann Friedrich Bause from Halle and Salomon Gessner from Zürich. On introduction of Christian Ludwig von Hagedorn appointed member of Dresden Academy 1766. 1769–71 journeys to Leipzig and Berlin. Met Daniel Chodowiecki, 1783 honorary member of Berlin Academy, 1788 Professor at Dresden Academy, encouraged young artists like Karl Ludwig Kaaz and Philipp Otto Runge. Between 1788 and 1801 journeys to Leipzig, Berlin, Karlsbad, and repeatedly to Switzerland.
Lit.: O. Waser, *Anton Graff 1736–1813*, Frauenfeld-Leipzig 1926; B. Becker, *Zur Porträtkunst Anton Graff's, Stil und Gehalt* (Thesis), Göttingen 1949; Exhib. *Anton Graff*, Staatliche Museen zu Berlin, National-Galerie, East Berlin 1963; E. Berckenhagen, *Anton Graff, Leben und Werk*, Berlin 1967.

4. **Bildnis Graf Heinrich XIII. Reuss.** 1775
Portrait of Count Henry XIII of Reuss.
Oil on canvas. 112.6 × 84 cm.
Sig. bottom l.: Graff pinx. Dresden 1775.
Bayerische Staatsgemäldesammlungen, Munich
Inv. No. 9954
Count Henry XIII of Reuss-Greitz (1747–1817), wearing uniform of Austrian General. Another portrait of Count, in landscape, by Graff, 1804 (Private Collection, Ortenberg, Upper Hessen).
Lit.: Cat. Munich 1967, pp. 24–5.

5. **Bildnis des Malers Karl Ludwig Kaaz.** 1808
Portrait of the painter Karl Ludwig Kaaz.
Oil on canvas. 76 × 62.5 cm.
Kunsthalle, Hamburg
Inv. No. 65
Karl Ludwig Kaaz (1773–1810) was Graff's son-in-law (*cf.* H. Geller, *Carl Ludwig Kaaz, Landschaftsmaler und Freund Goethes*, Berlin 1961). Preparatory sketch of 1808 in Dresden (Kupferstichkabinett), bust on back of clothing study post-1808 in Leipzig (Museum der bildenden Künste).
Lit.: Cat. Hamburg 1966, p. 73.

HILDEBRANDT, Ferdinand Theodor
b. Stettin 1804—d. Düsseldorf 1874
Began study at Berlin Academy 1820, from 1823 pupil of Wilhelm von Schadow, followed him to Düsseldorf 1826. Study trips with Schadow 1829, to Belgium (and Paris?), 1830–31 in Rome. Taught at Düsseldorf Academy 1832–54. 1844 journey to St Petersburg, 1849 to Antwerp. During early study acquired from Ludwig Devrient interest in poetry and drama, used subjects in his history painting.
Lit.: A. Rosenberg, *Aus der Düsseldorfer Malerschule, Studien und Skizzen*, 1890; W. Hütt, *Die Düsseldorfer Malerschule, 1819–1869*, Leipzig 1964; I. Markowitz, *Die Düsseldorfer Malerschule*, Bildhefte des Kunstmuseums Düsseldorf, Düsseldorf 1967.

78. **Ermordung der Söhne Eduards IV.** 1835
The Murder of Edward IV's Sons.
Oil on canvas. 150 × 175 cm.
Sig. bottom r.: Theodor Hildebrandt 1835
Kunstmuseum, Düsseldorf
Inv. No. 5493
Theme taken from Shakespeare's *Richard III* (Act IV, Scene 3). Forrest and Dighton murdered Edward's sons in the Tower of London in 1483, at the instigation

of Richard III. Hildebrandt repeated composition in smaller versions of 1835–6 and 1837.
Lit.: I. Markowitz, Düsseldorf 1967, p. 61.

HODLER, Ferdinand
b. Bern 1853—d. Geneva 1918

Early training under *veduta* painter F. Sommer in Thun, then under landscape painter B. Menn in Geneva. Autumn 1878 journey to Spain, where Spanish painting stimulated him to greater freedom of coloration. 1889 took part in World Exhibition in Paris, in 1892 in Salon de la Rose-Croix; inspired by Gauguin and Post-Impressionists. The pictures *Die Lebensmüden* (The World Weary) (1892), *Die Enttäuschten* (The Disappointed Ones) (1892), *Der Auserwählte* (The Elect) and *Eurhythmie* (1895) followed, combining mystical elements with Pre-Raphaelite dogma about the Elect. In 1894 spent four weeks in Antwerp; from 1896 painted Swiss historical scenes, like *Tell* or *Schlacht bei Marignano* (Battle of Marignano), in Zürich (Landesmuseum). Summit of achievement was monumental history painting for Jena University in 1908 *Auszug der Jenenser Studenten zum Freiheitskampf von 1813* (Jena Students leaving to Fight in War of Liberation, 1813).
Lit.: F. Bürger, *Cézanne und Hodler*, Munich 1913; C. A. Loosli, *Hodler, Leben, Werk und Nachlass*, Bern 1921–24; E. Bender and W. Y. Müller, *Die Kunst Ferdinand Hodlers, Gesamtdarstellung*, Zürich 1923–41; W. Hugelshofer, *Ferdinand Hodler*, Zürich 1952; P. Portmann, *Kompositionsgesetze in der Malerei von Ferdinand Hodler, nachgewiesen an den Figurengruppen von 1890–1918*, Winterthur 1956; P. Dietschi, *Der Parallelismus Ferdinand Hodlers. Ein Beitrag zur Stilpsychologie der neuen Kunst*, Basel 1957; G. Steiger, '*Fall Hodler*', *Jena 1914–19. Der Kampf um ein Gemälde*, Jena 1970; Exhib. *Ferdinand Hodler*, Vereinigung bildender Künstler, Wiener Sezession, Vienna 1962.

146. Die Lebensmüden. 1892
The World Weary.
Combination technique on canvas. 150 × 294.5 cm.
Sig. bottom r.: Ferd. Hodler 1892.
Bayerische Staatsgemäldesammlungen, Munich
Inv. No. 9446
Preparatory studies mentioned by Loosli, 1921–24. Two smaller versions, same date, in private collections.
Lit.: Cat. Munich 1966, p. 46.

HOFMANN, Ludwig von
b. Darmstadt 1861—d. Dresden 1941

First studied Dresden Academy 1883, then under F. Keller in Karlsruhe 1888 and at Académie Julian in Paris 1890, where influenced by Puvis de Chavannes. From 1890 friendly with Klinger, Leistikow and Liebermann in Berlin, lived mostly in Rome till 1900. Influenced by works of H. von Marées. 1903 invited to Weimar Art School, 1916–28 taught at Dresden Academy.
Lit.: O. Fischel, *Ludwig von Hofmann*, Leipzig 1903; E. Redslob, *Ludwig von Hofmanns Handzeichnungen*, Weimar 1918.

144. Frühlingsreigen. *c.* 1900
Spring dance.
Oil on canvas. 63.5 × 75.8 cm.
Sig. bottom r.: L. v. Hofmann.
Kunsthalle, Bremen
Inv. No. 801

HORNY, Franz
b. Weimar 1798—d. Olevano 1824

Early training 1806–16 under Heinrich Meyer at Weimar Art School. Noticed in 1816 by C. F. von Rumohr who decided to send him to Rome to study under J. A. Koch. Lived with Koch in Rome, became his pupil and assistant. Friendly with Friedrich Olivier

and Schnorr von Carolsfeld, from 1817 worked with Cornelius on ceiling frescoes in Casino Massimo. Lived in Olevano from 1819, producing many sketches and watercolours from nature. Died from tuberculosis after 2 years serious illness.

Lit.: E. L. Schellenberg, *Der Maler Franz Horny, Briefe und Zeugnisse*, Berlin 1925; M. Goltermann, *Franz Horny, Ein Beitrag zur Künstler- und Kunstgeschichte der Romantik* (Thesis), Frankfurt 1927; K. Z. von Manteuffel, 'Die Zeichnungen von Franz Horny', in *Cicerone*, 16, 1924, pp. 272–280; W. Scheidig, *Franz Horny*, Berlin 1954.

47. Blick auf Olevano. *c.* 1822
View of Olevano.
Pen with black wash over graphite on yellowish paper. 529 × 429 mm.
Staatliche Museen zu Berlin, Kupferstichkabinett und Sammlung der Zeichnungen, Berlin (East)
Inv. No. 2
Lit.: Cat. *Zeichnungen Deutscher Romantiker*, Berlin/East 1964, p. 26.

JANSSEN, Victor Emil
b. Hamburg 1807—d. Hamburg 1845

Study under S. Bendixen in Hamburg, then at Munich Academy 1818–32 under Cornelius and Schnorr von Carolsfeld. To Italy on grant in 1833, met friend Friedrich Wassman in Rome. Left Rome 1835 for Munich, assisted in decoration of Bonifatiuskirche. Returned to Hamburg 1843, died from osteomalitis.

Lit.: A. Lichtwark, 'V. E. Janssen', in *Jahrbuch der Gesellschaft Hamburg. Kunstfreunde*, 1906, pp. 14 ff.; G. Pauli, *Die Hamburger Meister der guten alten Zeit*, Munich 1925; R. Klee-Gobert, *V. E. Janssen* (Thesis) Berlin 1943.

65. Selbstbildnis vor der Staffelei. *c.* 1828
Self-portrait in Front of Easel.
Oil on paper on canvas. 56.6 × 32.7 cm.
Kunsthalle, Hamburg

Inv. No. 2488
Sketch with hand studies dated 1828 in Munich (Collection A. Winterstein).
Lit.: Cat. Hamburg 1969, p. 134.

JAWLENSKY, Alexej Georgewitsch von
b. Torschok, Russia 1864—d. Wiesbaden 1941

While lieutenant in Alexander-Nevsky Regiment began painting at evening classes at St Petersburg Academy in 1889. Met painter I. Repin in 1890, woman painter Marianne von Werefkin in 1891, emigrated with her to Munich in 1896, studied at A. Azbé's private school of painting, where he met Kandinsky in 1897. Exhibited with Munich painters in 1903, with Berlin *Secession* in 1904. During stays in Brittany and Provence in 1905 influenced by works of Cézanne, van Gogh and Matisse. In 1907 worked in Matisse's studio in Paris, and in 1909 founded Neue Künstlervereinigung with Kandinsky, G. Münter, M. von Werefkin, A. Erbslöh, A. Kanoldt, A. Kubin, H. Schnabel and O. Witten. Met Marc 1910, friendly with dancer Nijinsky and with Nolde 1912. Last journey to Russia in 1914; settled in St Prex on Lake Geneva with M. von Werefkin. To Wiesbaden in 1921, after stays in Zürich (1917) and Ascona (1918). In 1924 founded 'Die Blauen Vier' with Klee, Kandinsky and Feininger.
Lit.: C. Weiler, *A. Jawlensky*, Cologne 1959.

XI. Die Weisse Feder. 1909
The White Feather.
Oil on card. 101 × 69 cm.
Sig. bottom half-l.: A. Jawlensky 09
Staatsgalerie, Stuttgart
Inv. No. 2402
Shows dancer Alexander Sacharoff, whom Jawlensky knew from 1908, in female role. On back, sketch to similar picture.
Lit.: Cat. Stuttgart 1968, pp. 86f.

JUEL, Jens
b. Balslev on Fünen 1745—d. Copen-
hagen 1802

First studies under Michael Gehr-
mann in Hamburg, from 1765 at
Copenhagen Academy. 1772–80
travel in Italy, studied under A. R.
Mengs; also went to Paris and
Geneva. In later life Director of
Copenhagen Academy.
Lit.: Exhib. *Jens Juel*, Copenhagen
1909.

7. Binnenalster. 1764
Inner Alster.
Oil on oak. 29.9 × 38.5 cm.
Sig. bottom r.: J. Juel pinxit.
Hamburg 1764.
Kunsthalle, Hamburg
Inv. No. 453
Lit.: Cat. Hamburg 1966, p. 89.

KANDINSKY, Wassily
b. Moscow 1866—d. Paris 1944

After studying law at Moscow
University began painting at 30.
Emigrated to Munich 1896, studied
under Azbé and Stuck. 1900–03
taught in private art School of
Artists' Club 'Phalanx', of which
he was President. Friendly with
G. Münter 1902, member of Berlin
Secession. 1903–08 journeys to
France (in Paris for nearly a year),
Tunis, Italy and Switzerland. Re-
turned to Munich 1908, lived partly
in Murnau. Large part in founding
Neue Künstlervereinigung in 1909,
left it with G. Münter and F. Marc
in 1911; one of prime movers in
exhibition of Blaue Reiter group,
published almanac *Der Blaue Reiter*
in 1912 with Marc. Returned to
Russia 1914, Professor at Moscow
University 1920; invited by
Gropius to Bauhaus in Weimar in
1922. Taught there 1922–33, and
went to Paris after it was dissolved
by the Nazis.
Lit.: Own writings: *Über das
Geistige in der Kunst*, Munich 1912;
with F. Marc, *Der Blaue Reiter*,

Munich 1912; *Rückblicke*, in *Sturm*,
Berlin 1913; *Klänge*, Munich 1913;
Punkt und Linie zu Fläche, Bauhaus
Public. 1926; *Essays über Kunst und
Künstler*, ed. M. Bill, Stuttgart
1955.
M. Bill and others, *Wassily
Kandinsky*, Boston 1951; W.
Grohmann, *Wassily Kandinsky*,
Cologne 1958 (Eng. ed. New York
1959); *W. Kandinsky, Das graph-
ische Werk. A complete catalogue*, by
H. K. Röthel, Cologne 1970; S.
Ringbom, *The Sounding Cosmos.
A study in the spiritualism of Kan-
dinsky and the genesis of abstract
painting*, Åbo 1970; Exhib. *Wassily
Kandinsky, 1866–1944, a retrospec-
tive exhibition*, The Solomon R.
Guggenheim Museum, New York
1962.

XII. Improvisation 9. 1910
Oil on canvas. 110 × 110 cm.
Sig. bottom r.: Kandinsky 1910
Staatsgalerie, Stuttgart
Inv. No. 2723
Based on motif from Murnau.
Lit.: Cat. Stuttgart 1968, p. 89.

KIRCHNER, Ernst Ludwig
b. Aschaffenburg 1880—d. Davos 1938

Began study of architecture at
Technische Hochschule Dresden
1901, obtained Diploma 1905. At
same time often in Munich, began
to study painting. In 1904 met E.
Heckel and F. Bleyl in Dresden,
met K. Schmidt-Rottluff in 1905
and with them founded artists'
group *Brücke*, which held first
exhibition in Dresden in 1906.
1908 in Fehmarn. 1909 worked
with Heckel at Moritzburger Lake.
First traces of influence of African
sculpture appeared in his painting
in 1910. In 1911 moved to Berlin.
In 1912 *Brücke* took part in Blaue
Reiter's 2nd exhibition in Munich.
Called up in 1915, suffered nervous
breakdown 1917. Went to Davos,
settled near there in Frauenkirch-
Wildboden. First Kirchner exhibi-
tion in America under auspices of
Detroit Art Institute 1937.

Lit.: W. Grohmann, *Das Werk Ernst Ludwig Kirchners*, Munich 1926; Ibid., *Kirchner's Zeichnungen*, Dresden 1925; G. Schiefler, *Das graphische Werk E. L. Kirchners*, Vol. I, Berlin 1920, Vol. II, Berlin 1926; W. Grohmann, *Ernst Ludwig Kirchner*, Stuttgart 1958 (Engl. ed.: London 1961); A. Dube-Heynig, *E. L. Kirchner Graphik*, Munich 1961; A. and W. D. Dube, *Ernst Ludwig Kirchner, Das graphische Werk*, Munich 1967; D. E. Gordon, *Ernst Ludwig Kirchner, Mit einem kritischen Katalog sämtlicher Gemälde*, Munich 1968.

147. Nackte Frau mit Hut. 1907
Nude with Hat.
Oil on canvas. 195.5 × 64.5 cm.
Sig. bottom r.: E L Kirchner 07
Städelsches Kunstinstitut, Frankfurt
Inv. No. SG 1168
Kirchner repeated the composition in a woodcut (not earlier than 1911).

KOBELL, Wilhelm von
b. Mannheim 1766—d. Munich 1853

First training in sketching in Mannheim, then from father Ferdinand Kobell. First achieved recognition in 1790 with aquatint copies of Dutch masters. 1792 invited to Munich as Court painter, settled there 1793. Commissioned 1808 by Crown Prince Ludwig of Bavaria to depict Napoleonic War in large-scale battle pictures. 1809 visited battlefields of Aspern and Wagram near Vienna. Much inspiration from Paris stay 1809–10. Appointed Professor of landscape painting at Munich Academy 1814. Journey to Italy (Rome) 1818.
Lit.: W. Lessing, *Wilhelm von Kobell*, Munich 1923; S. Wichmann, *Wilhelm von Kobell*, Munich 1970; Exhib. *Wilhelm von Kobell, 1766–1853*, Munich 1966.

58. Belagerung von Kosel. 1808
Siege of Kosel.
Oil on canvas. 207 × 302 cm.
Sig. bottom r.: Wilhelm Kobell 1808

Bayerische Staatsgemäldesammlungen, Munich
Inv. No. 3822
First in a series of 12 battle paintings of Napoleonic War for Munich Residence of Crown Prince Ludwig of Bavaria, painted 1808–15. Preparatory sketch of 1808 in Paris (Bibliothèque Nationale, Cabinet des Estampes).
Lit.: Kobell exhib., Munich 1966, p. 70.

KOCH, Joseph Anton
b. Obergiblen (Tyrol) 1768—d. Rome 1839

First studies in Dillingen and Augsburg, then in Stuttgart at Karlsschule 1785, instructed in late baroque-orientated Neo-classicism by landscape painter A. F. Harper and history painter Ph. F. Hetsch. 1791 escaped school's strict discipline, more irksome because he shared French Revolution's ideals of freedom; to Strasbourg, then in Switzerland 1792–94, gathering good stock of motifs from Alps, used later in mountain landscapes painted in Rome. Was indebted to English theologian and art-lover Dr George Frederick Nott for 3 year stipend in Italy where he went in 1794 and settled in Rome in 1795. Friendly with A. J. Carstens, who directed his interest to the human figure and made him aware of new thematic possibilities in antiquity and in poetry. Later friendly with Ch. Reinhart, Thorvaldsen and E. Wächter, and with Nazarenes. Introduced to oil painting by G. Schick. Worked on landscapes again from 1803. 1812–15 in Vienna. Studied Italian landscape on frequent excursions to Olevano and Sabine hills, and on returning to Rome in 1815 became much respected leader of German artists there. 1824–29 painted 4 murals in Dante Room of Villa Massimo in Rome.
Lit.: J. A. Koch, *Briefe zweier Freunde in Rom und der Tartarei über*

das moderne Kunstleben und Treiben, oder die Rumfordsche Suppe gekocht und geschrieben von J. A. Koch in Rom, 1834; E. Jaffé, *Josef Anton Koch, Sein Leben und sein Schaffen*, Innsbruck 1905; W. Stein, *Die Erneuerung der heroischen Landschaft nach 1800*, Strasbourg 1917; A. von Schneider, 'Die Briefe J. A. Kochs an den Freiherrn Karl Friedrich Von Uexküll', in *Jahrbuch der Preussischen Kunstsammlungen*, LIX, 1938; O. R. von Lutterotti, *Josef Anton Koch*, Berlin 1940; D. Frey, 'Die Bildkomposition bei J. A. Koch und ihre Beziehung zur Dichtung. Eine Untersuchung über Kochs geistesgeschichtliche Stellung', in *Wiener Jahrbuch für Kunstgeschichte*, XIV–XVIII, 1950; J. E. von Borries, *Joseph Anton Koch, Heroische Landschaft mit Regenbogen*, Staatliche Kunsthalle Karlsruhe, Karlsruhe 1967.

8. **Heroische Landschaft mit Regenbogen.** 1805
Heroic Landscape with Rainbow.
Oil on canvas. 116.5 × 112.5 cm.
Sig. bottom r.: J.K.
Staatliche Kunsthalle, Karlsruhe
Inv. No. 789
Based on watercolour of 1795 in Vienna (Academy). 2nd version, begun 1804, completed 1815, in Munich (Bayerische Staatsgemäldesammlungen). Pencil sketch of 1806 after Munich version in Nuremberg (Germanisches National-Museum). 3rd version of 1824 in Berlin/East (Märkisches Museum), preparatory sketch for this in Karlsruhe (Staatliche Kunsthalle).
Lit.: J. E. von Borries, *J. A. Koch*, Karlsruhe 1967.

35. **Dante-Zimmer, Ansicht des Raumes.** 1827–29
View of Dante Room.
Fresco.
Villa Massimo, Rome.
Numerous preparatory studies in Berlin/East (Staatliche Museen zu Berlin, Kupferstichkabinett und Sammlung der Zeichnungen),

Innsbruck, Lübeck and Vienna. All mentioned by O. R. von Lutterotti, 1940.
Lit.: K. Andrews, *The Nazarenes*, Oxford 1964.

9. **Italienisches Winzerfest.** *c.* 1830
Italian Vintage Festival.
Oil on wood. 46 × 57 cm.
Sig. bottom r.: J.A.K.
Bayerische Staatsgemäldesammlungen, Munich
Inv. No. WAF 448

KRÜGER, Franz
b. Gross-Badegast nr. Köthen 1797—
d. Berlin 1857

Taught himself sketching from nature, influenced early by C. W. Kolbe the Elder in Dessau, studied 1812–14 at Berlin Academy pursuing own development independently for most part. 1818 1st exhibition of military and hunting scenes in Berlin Academy, whereafter became favourite military and portrait painter of Berlin Court. 1825 appointed Professor and member of Academy. Commissions led to journeys to numerous courts, e.g. 1844 and 1850 to St Petersburg and Moscow on invitation of Nicholas I. In Paris 1846, visited Delacroix's studio, and in Belgium. In Dessau for a few months in 1848.
Lit.: M. Cohn, *Franz Krüger, Sein Leben und Werk* (Thesis), Breslau 1909; M. Osborn, *Franz Krüger*, Bielefeld and Leipzig 1910; W. Weidmann, *Franz Krüger*, Berlin n.d. [1927]

89. **Parade auf dem Opernplatz in Berlin, 1822.** 1824–29
Parade in the Opernplatz, Berlin, 1822
Oil on canvas. 249 × 374 cm.
Staatliche Museen zu Berlin, National-Galerie, Berlin (East)
Inv. No. A II 648
In the Parade of 1822 Prince Nicholas of Russia led his regiment of dragoons past King Friedrich Wilhelm III of Prussia in the Opernplatz in Berlin. Oil study for

Knappe mit dem Apfelschimmel (Page with dapple-grey Horse) in Winterthur (Stiftung O. Reinhart). 10 years later Krüger painted different version. In right foreground in front of Neue Wache well-known Berlin personalities can be seen, including J. G. Schadow, K. F. Schinkel, C. D. Rauch, H. Sonntag, N. Paganini.
Lit.: Cat. East Berlin p. 261.

88. Parade auf dem Opernplatz in Berlin, 1822. 1824–29
Detail.

KUBIN, Alfred
b. Leitmeritz (Bohemia) 1877—d. Zwickledt am Inn 1959

1898 at Munich Academy, 1902, 1st exhibition at Bruno Cassirer's 1st portfolio of sketches published by H. von Weber. 1905 journeys to Paris and Italy, 1907 to Dalmatia and the Balkans. Member of Blaue Reiter in 1910, took part in their exhibitions of 1912 and 1913. Illustrated works by Poe, Nerval, E. Th. A. Hoffmann and others for publisher Georg Müller, published *Blätter mit dem Tod* (Plates with death) in 1914–16. Known also as writer.
Lit.: Own writings: *Die andere Seite*, Munich 1909; *Dämonen und Nachtgesichte*, Dresden 1926; *Mein Werk*, Dresden 1931.—W. Schneditz, *Alfred Kubin*, Vienna 1956; P. Raabe, *Alfred Kubin, Leben, Werk, Wirkung*, Hamburg 1957; *Die Alfred-Kubin-Stiftung* (The Alfred Kubin Foundation), *Graphische Sammlung Albertina*, Vienna 1961; Exhib. *Alfred Kubin*, Kunstverein, Munich 1964; W. Schmied, *Der Zeichner Alfred Kubin*, Salzburg 1967; W. Schmied, *Alfred Kubin*, Catalogue by Alfred Marks, London 1970.

151. Gewitter. 1906
Storm.
Gouache on paper. 33.8 × 36.4 cm.
Sig. bottom r.: Kubin

Städtische Galerie im Lenbachhaus, Munich
Inv. No. G 12415

KÜGELGEN, Franz Gerhard von
b. Bacharach am Rhein 1772—d. Dresden 1820

Pupil of J. Zick in Koblenz and C. H. Fessel in Würzburg, pursued development in Rome from 1791–95, influenced strongly by Raphael. After stay in Riga (1795) became popular portrait-painter in St Petersburg 1798–1803. Settled in Dresden 1805, friendly with C. D. Friedrich. Professor at Academy 1814.
Lit.: W. J. von Kügelgen, *Jugenderinnerungen eines alten Mannes*, publ. J. Werner, Leipzig 1924.

18. Bildnis von Caspar David Friedrich. 1805/10
Portrait of Caspar David Friedrich.
Oil on card. 22 × 19.5 cm.
Stiftung O. Reinhart, Winterthur
Inv. No. 245
Possibly a preparatory study to portrait of C. D. Friedrich in Hamburg (Kunsthalle).
Lit.: Cat. Winterthur 1951, p. 44.

LEIBL, Wilhelm (Maria Hubertus)
b. Cologne 1844—d. Würzburg 1900

Locksmith's apprentice, then pupil of H. Becker in Cologne 1861–64, then at Munich Academy, at first under A. Strähuber and H. Anschütz, later student under A. von Ramberg in 1866 and K. von Piloty in 1869. Occupied studio with Alt, Hirth du Frênes and Sperl. During Munich International Art Exhibition of 1869, where works by Courbet and Leibl's *Portrait of Frau Gedon* were shown, the two met. Leibl's success led to commissions and an invitation to Paris, where he lived till outbreak of war in late summer of 1870. Returned to Munich, met H. Thoma, and in following year Schuch, Trübner and Lang. Became leader, both as man and as artist,

of group of young artists, who worked in close contact till 1873. Th. Alt, K. Hagemeister, K. Haider, R. Hirth du Frênes, A. Lang, E. Sattler, F. Schider, C. Schuch, J. Sperl, H. Thoma and W. Trübner belonged to this 'Leibl circle'. Leibl left Munich in 1873, lived 1873–74 in Grasslfing near Dachau, 1875–77 in Unterschöndorf on the Ammersee. Shared house with Sperl from 1878, till 1881 in Berbling, then till 1892 in Aibling and finally till his death in Kutterling.
Lit.: J. Mayr, *Wilhelm Leibl, sein Leben und Schaffen*, Berlin 1906; E. Waldmann, *Wilhelm Leibl, Eine Darstellung seiner Kunst*, Berlin 1914; E. Waldmann, 'Leibl und die Franzosen', in *Kunst und Künstler*, 12, 1914, pp. 43–54; G. J. Wolf, *Leibl und sein Kreis*, Munich 1923; P. Lufft, *Die Bildnismalerei Wilhelm Leibls* (Thesis), Zürich 1942; E. Waldmann, *Wilhelm Leibl als Zeichner*, Munich 1943; R. Neuhaus, *Die Bildnismalerei des Leibl-Kreises*, Marburg 1953; K. Römpler, *Wilhelm Leibl*, Dresden 1955; A. Langer, *Wilhelm Leibl*, Leipzig 1961.

116. Bildnis der Frau Gedon. 1869
Portrait of Frau Gedon.
Oil on canvas. 119.5 × 95.7 cm.
Bayerische Staatsgemäldesammlungen, Munich
Inv. No. 8708
Lit.: Cat. Munich 1967, pp. 40–41.

117. Die Alte Pariserin. 1869
The old Parisienne.
Oil on mahogany. 81.5 × 64.5 cm.
Sig. bottom l.: Leibl Paris 1869
Wallraf-Richartz-Museum, Cologne
Inv. No. 1169
According to Waldmann this is complementary picture to *Die junge Pariserin* (The young Parisienne), 1869, in Cologne (Wallraf-Richartz Museum).
Lit.: Cat. Cologne 1964, pp. 63–64.

118. Konzertstudie. 1870
Concert Study.

Oil on canvas, backed with pasteboard. 44 × 40 cm.
Sig. bottom r.: W Leibl 1870
(on back: Skizze zu einem Bild von W Leibl in Münch [en] F. Paulsen Paris 1870 Werth 200)
Wallraf-Richartz-Museum, Cologne.
Inv. No. 1154
Preparatory Indian ink sketch in Munich (Städtische Galerie im Lenbachhaus).
Lit.: Cat. Cologne 1964, p. 64.

VIII. Bildnis Lina Kirchdorffer. 1871/72
Portrait of Lina Kirchdorffer.
Oil on canvas. 111.5 × 83.5 cm.
Sig. on back: Portrait der Nichte W. Leibls: Lina Schider, geb. Kirchdorffer, gemalt von Wilhelm Leibl in München 1871. bestätigt von Dr. F. Schider in Basel 1905.
Bayerische Staatsgemäldesammlungen, Munich
Inv. No. 8446
Leibl painted another half-portrait of Lina Kirchdorffer in 1871/72 (Winterthur, Stiftung O. Reinhart).
Lit.: Cat. Munich 1967, pp. 43–44.

122. Drei Frauen in der Kirche. 1882
Three Women in Church.
Oil on mahogany. 113 × 77 cm.
Sig. top l.: W. Leibl 82. Berbling
Kunsthalle, Hamburg
Inv. No. 1534
A sketch Leibl worked on from 1878 is known to have been offered for sale in Switzerland, from the former collection of R. von Mendelssohn in Berlin.
Lit.: Cat. Hamburg 1969, p. 174.

121. Tierarzt Reindl in Der Laube. c. 1890
Veterinary Surgeon Reindl in the Arbour.
Oil on mahogany. 26 × 19.3 cm.
Sig. bottom r.: W. Leibl
Städtische Galerie im Lenbachhaus, Munich
Inv. No. G 307

123. Die Spinnerin. 1892
Woman spinning.

Oil on canvas. 65 × 74 cm.
Sig. bottom r.: W. Leibl. 92
Museum der bildenden Künste, Leipzig
Inv. No. 928
Lit.: Cat. Berlin/East, p. 264.

LENBACH, Franz von
b. Schrobenhausen (Upper Bavaria) 1836—d. Munich 1904

From 1851 apprenticed mason to his father, started painting after his death in 1852 under guidance of J. B. Hofner and 1852–53 made copies of old masters in Augsburg. Then to Munich Academy 1854, pupil of K. von Piloty from 1857. To Rome on state grant with Piloty 1858/9. Appointed teacher in new Weimar Art School in 1860 along with A. Böcklin, R. Begas. 1862 returned to Munich, met Count A. F. von Schack and copied old masters for his gallery 1863–68 in Italy and Spain. Great success with two portraits at Paris Exhibition 1867, turned exclusively to portraits in style of old masters. Became one of most popular portrait-painters, invited to Vienna, Berlin and Munich from 1870 to portray European nobility. Most famous portraits, for which he prepared photographic-type studies from 1885, are those of Moltke, Richard Wagner, Bismarck and Pope Leo XIII. 1875/6 to Egypt with Makart, from 1882 worked in winter in Palazzo Borghese in Rome, where he painted Pope Leo XIII in 1885. Lived permanently in Munich from middle 1880s.
Lit.: A. Rosenberg, *Franz von Lenbach*, Bielefeld and Leipzig 1898; Wyl, *Franz von Lenbach, Gespräche und Erinnerungen*, Stuttgart 1904; Exhib. *Fotografische Bildnisstudien zu Gemälden von Lenbach und Stuck*, Folkwang Museum, Essen 1969.

131. Der Rote Schirm. *c.* 1860
The Red Umbrella.
Oil on paper on pasteboard. 26.9 × 34.6 cm.

Kunsthalle, Hamburg
Inv. No. 1492
Lit.: Cat. Hamburg 1969, p. 175.

LESSING, Carl Friedrich
b. Breslau 1808—d. Karlsruhe 1880

Began studies 1822 at Berlin School of Architecture under Schinkel, taking drawing lessons from H. A. Dähling. Pupil of W. von Schadow at Berlin Academy, followed him to Düsseldorf in 1826, became important history and landscape painter of Düsseldorf school. Created the 'historical landscape', in which the historical event and the depiction of nature are given equal importance. His naturalistic landscape studies laid the basis for the landscape painting of Thoma's generation. 1858 to Karlsruhe Art School as Professor, also Director of Art Gallery.
Lit.: H. W. Hupp, *Carl Friedrich Lessing* (Thesis), Bonn 1919; E. Scheyer, 'C. F. Lessing und die deutsche Landschaft', in *Aurora, Eichendorff Almanach*, Regensburg 1965; I. Markowitz, *Die Düsseldorfer Malerschule*, Kunstmuseum Düsseldorf, Düsseldorf 1967.

79. Hussitenpredigt. 1836
Hussite Sermon.
Oil on canvas. 223 × 293 cm.
Sig. bottom centre: C. F. L. 1836
Kunstmuseum, Düsseldorf
Inv. No. 228
(On loan from Stiftung Preussischer Kulturbesitz, Nationalgalerie, Berlin/West, Inv. No. 208)
Lessing's interest in the subject was aroused by historian Uechtritz. After seeing the cartoon exhibited in Berlin in 1836 King Friedrich Wilhelm IV of Prussia commissioned picture. Lessing painted further scenes from Hussite Wars (1419–36): *Hus in Kostwitz* (1842), *Hus in Front of the Wreckage* (1850).
Lit.: I. Markowitz, *Die Düsseldorfer Malerschule*, Düsseldorf 1967, pp. 63–5.

LIEBERMANN, Max
b. Berlin 1847—d. Berlin 1935

First study under K. Steffeck in Berlin 1866, then under F. Pauwels and P. Thumann at Weimar Art School 1868–72. Thence to Düsseldorf with Th. Hagen, got to know M. Munkàcsy's art, and to Paris and Holland. From 1873 to 1878 lived in Paris, and from 1875 spent summers in Holland. In these years studied French painting (Barbizon painters and Courbet) and Dutch open-air painting (Jongkind and J. Israels), copied works of Frans Hals and made many studies from nature. After short interlude in Berlin settled in Munich 1878–84, finally returned to Berlin in 1884. Turned strongly to French Impressionism at the end of 1890s. Greatest works produced 1900–13. 1899 member of Prussian Academy of Arts, Berlin, and President of Berlin *Secession*. From 1914 chose motifs from the Wannsee district of Berlin.
Lit.: Own writings: *Max Liebermann als Schriftsteller*, ed. Cassirer, Berlin 1922;—H. Rosenhagen, *Max Liebermann*, Bielefeld und Leipzig 1900; G. Pauli, *Max Liebermann*, Stuttgart and Leipzig 1911; J. Elias, *Max Liebermann, die Handzeichnungen*, Berlin 1922; E. Hancke, *Max Liebermann, Sein Leben und sein Werk*, 2nd ed. Berlin 1923; G. Schiefler, *Max Liebermann, Sein graphisches Werk*, 2nd ed. Berlin 1923; K. Scheffler, *Max Liebermann*, Munich 1923 (4th ed. Wiesbaden 1953); Exhib. *Max Liebermann*, Königliche Akademie der Künste, Berlin 1927; M. J. Friedländer, *Max Liebermann*, Berlin 1924; A. Lichtwark, *Briefe an Max Liebermann*, Hamburg 1947; F. Stuttmann, *Max Liebermann*, Hanover 1961; A. Werner, 'The forgotten Art of Max Liebermann', in *The Art Journal*, XXIII, 3, 1964.

132. **Die Gänserupferinnen.** 1871/72
Women plucking Geese.
Oil on canvas. 114.5 × 170.5 cm.

Sig. (reportedly): M. Liebermann (no longer decipherable)
Staatliche Museen zu Berlin, National-Galerie, Berlin (East)
Inv. No. A I 524
Inspired by Thomas Herbst's sketch *Woman plucking Geese* and M. Munkàcsy's *Woman making Lint*, painted in Weimar.
Lit.: Cat. East Berlin, p. 266.

134. **Eva.** 1883
Eva.
Oil on canvas. 95.3 × 67.2 cm.
Sig. bottom r.: Max Liebermann 83.
Kunsthalle, Hamburg
Inv. No. 2350
The motif of the girl is repeated on the right-hand side of the picture dated 1883 'Children playing' (G. Pauli, 1911, note 53.)
Lit.: Cat. Hamburg 1969, p. 180.

133. **Die Netzflickerinnen.** 1889
Women mending Nets.
Oil on canvas. 180.5 × 226 cm.
Sig. bottom r.: M. Liebermann
Kunsthalle, Hamburg
Inv. No. 1580
Liebermann etched the composition in 1894. The Hamburg Catalogue 1969 mentions all preparatory sketches.
Lit.: Cat. Hamburg 1969, pp. 181–2.

IX. **Der Papageienmann.** 1902
The Parrot Man.
Oil on canvas. 109.5 × 72 cm.
Sig. bottom r.: M. Liebermann
Folkwang Museum, Essen
Inv. No. G 104
Watercolour preparatory study in Bremen (Kunsthalle).
Lit.: Cat. Essen 1963, p. 36.

135. **Regenstimmung auf der Elbe.** 1902
Rainy Atmosphere on the Elbe.
Pastel. 32 × 41.5 cm.
Kunsthalle, Hamburg
Inv. No. 1607
One of a series of 3 pastels painted during Liebermann's stay in Hamburg in 1902 (Hamburg, Kunsthalle)

Lit.: Cat. Hamburg 1969, p. 186.

MARC, Franz
b. Munich 1880—killed in action,
Verdun 1916

After studying philosophy and
theology became pupil of G. von
Hackl and W. von Diez at Munich
Academy in 1900. Travelled 1902
and 1903 to Italy, Paris and
Brittany, in 1906 to Greece and
Mount Athos. To Paris again in
1907. Moved to Sindelsdorf in
1910, became friendly with A.
Macke, W. Kandinsky, A. Jaw-
lensky, M. von Werefkin and P.
Klee. One of founder members of
Blaue Reiter in 1911, published its
almanac with Kandinsky in 1912.
With Macke in Paris 1912, visited
Delaunay. Moved to Ried in 1914.
Lit.: Own writings: Aufzeichnungen
und Aphorismen, Berlin 1920 (Vol.
I); with W. Kandinsky, Der Blaue
Reiter, Munich 1912; Briefe aus
dem Felde (1914–1916), Berlin 1940
(5th ed. 1959); Aufzeichnungen und
Aphorismen, Munich 1946; Brief-
wechsel mit August Macke, Cologne
1964;—
E. Weiss, Franz Marc, Ein Versuch
zur Deutung expressionistischer Stil-
phänomene und ihre Voraussetzung
(Thesis), Frankfurt 1933; A. J.
Schardt, Franz Marc, Berlin 1936;
H. Demisch, Franz Marc, Hanover
1948; Bünemann, Franz Marc,
Aquarelle und Zeichnungen, Munich
1948; K. Lankheit, Franz Marc,
Berlin 1950; K. Lankheit, Franz
Marc im Urteil seiner Zeit, Cologne
1960; K. Lankheit, Franz Marc,
Oeuvre-katalog, Cologne 1970;
Franz Marc, Drawings, Water-
colours, London 1960; Exhib.: Franz
Marc, Städtische Galerie im Len-
bachhaus, Munich 1963.

150. **Pferd in Landschaft.** c. 1910
Horse in Landscape.
Oil on canvas. 85 × 112 cm.
Folkwang Museum, Essen
Inv. No. G 239
Motif derives thematically from
pencil study of 1908, which ap-
peared in various versions in oil
from 1908 onwards, e.g. Red Horse,
1911 (Essen, Folkwang Museum),
Blue Horse I, 1911 Munich (Städt-
ische Galerie im Lenbachhaus),
Blue Horses' Tower, 1912 (lost).
Lit.: Cat. Essen 1963, p. 38.

MARÉES, Hans von
b. Elberfeld 1837—d. Rome 1887

1853 entered preparatory class of
Berlin Academy, studied 1854–5
under K. Steffeck. Settled in
Munich 1857, earned living with
military pictures in Steffeck's style.
1864, through Lenbach's media-
tion, to Italy, to make copies of old
masters in Rome for Count A. F.
von Schack. Broke with Schack
1868; C. Fiedler, whom Marées
met in 1866, supported him finan-
cially from 1868. In 1867 got to
know young sculptor A. von
Hildebrand, and worked with him
until 1875. Travelled with Fiedler
to Spain, France and Holland in
1869, gaining much inspiration
(Velasquez, Barbizon School, Dela-
croix, Courbet, Rembrandt). 1871–
73 lived alternately in Berlin and
Dresden. In 1873 painted library
of Zoological Institute in Naples.
1874–5 lived in Florence with
Hildebrand, friendly with A.
Böcklin. In 1875 finally settled in
Rome, worked on his great trip-
tychs. Small circle of pupils formed
around him, among others K. von
Pidoll, who took down Marées's
thoughts on art. Marées died in
Rome. In 1909 Rodin took re-
sponsibility for the Marées Com-
memorative Exhibition in Paris.
Lit.: C. Fiedler, Hans von Marées,
Munich 1889; K. von Pidoll, Aus
der Werkstatt eines Künstlers,
Erinnerungen an den Maler Hans von
Marées, Augsburg 1930 (1st ed.
Luxembourg 1890); H. Wölfflin,
'Hans von Marées', in Zeitschrift
für Bildende Kunst, N.F. III, 1892,
pp. 73 ff; A. von Hildebrand, Die
Gesetze der Form in der bildenden
Kunst, Strasbourg 1893; H. Kon-

nerth, *Die Kunsttheorie Conrad Fiedlers*, Munich 1909; J. Meier-Graefe, *Hans von Marées, Sein Leben und Werk*, Munich-Leipzig 1909/10; C. *Fiedlers Schriften über Kunst*, ed. H. Konnerth, Munich 1913/14; A. von Hildebrand, *Das Problem der Form in der bildenden Kunst*, Strasbourg 1913; H. von Marées, *Briefe*, Munich 1920; J. Meier-Graefe, *Der Zeichner Hans von Marées*, Munich 1925; O. Schürer, 'Der Bildraum in den späten Werken des Marées', in *Zeitschrift für Ästhetik und allgemeine Kunstwissenschaft*, XXVIII, 1934; A. Neumeyer, 'Hans von Marées and the Classical Doctrine in the 19th century', in *The Art Bulletin*, XX, 1938, pp. 291–311; B. Degenhart, *Marées Zeichnungen*, Berlin 1953; B. Degenhart, *Hans von Marées: Die Fresken in Neapel*, Munich 1959.

110. **Die Rast am Waldesrand.** 1863
Rest on the Edge of the Wood.
Oil on canvas. 113 × 147 cm.
Sig. bottom l.: Hans v Marées 1863.
Staatliche Kunsthalle, Karlsruhe
Inv. No. 2243

113. **Selbstbildnis.** *c.* 1870
Self-portrait.
Oil on canvas. 74 × 52.8 cm.
Sig. bottom r.: MM (or HvM-monogram)
Kunsthalle, Bremen
Inv. No. 756
The portrait study to which Meier-Graefe ascribed the date 1870 is also the basis of the self-portrait of 1872 in Magdeburg (Museum) and the *Self-portrait in Japanese Cloak* of 1872 in Dresden (Gemäldegalerie Neuer Meister.)

109. **Römische Vigna.** *c.* 1871
Roman Vineyard.
Oil on canvas. 82.5 × 133.2 cm.
Kunsthalle, Hamburg
Inv. No. 1469
Possibly the complementary picture to the *Villa Borghese* of 1870/71 in Hamburg (Kunsthalle), to which the Folkwang Museum in Essen possesses a preparatory study dated 1871.
Lit.: Cat. Hamburg 1969, p. 207.

111. **Die Pergola.** 1873
The Pergola.
Fresco. 350 × 400 cm.
Library of the Zoological Institute, Naples
Frescoes commissioned by zoologist Anton Dohrn; preparatory studies in oils in Berlin/East (Staatliche Museen zu Berlin. National-Galerie), Berlin/West (Stiftung Preussischer Kulturbesitz, Nationalgalerie) and Wuppertal (Städtisches Museum).

112. **Die Ruderer.** 1873
The Oarsmen.
Fresco. 350 × 500 cm.
Library of the Zoological Institute, Naples
See note to fresco *Pergola*, above.
Lit.: B. Degenhart, *Hans von Marées: Die Fresken in Neapel*, Munich 1959.

VII. **Der Orangenhain.** 1873
The Orange Grove.
Fresco, each panel 470 × 240 cm.

114. **Pferdeführer und Nymphe.** 1881/83
Horse-Handler and Nymph.
Oil on wood. 187.6 × 144.7 cm.
Bayerische Staatsgemäldesammlungen, Munich
Inv. No. 7862
A series of preparatory sketches catalogued by J. Meier-Graefe.
Lit.: Cat. Munich 1967, pp. 55–56.

115. **Die Hesperiden.** 1884/85
The Hesperides.
Oil on wood. 341 × 482 cm. (Incl. frame)
Bayerische Staatsgemäldesammlungen, Munich
Inv. No. 7854
Subject taken from classical mythology, according to which the Hesperides are the daughters of night, who guard in their garden the golden apples which Gaia, the goddess of the Earth, gave Hera as a wedding present on her marriage

to Zeus. Heracles, given the task of stealing the apples from the paradisaical garden, offers them to Athena, who gives them back to the Hesperides. The plan for the series of pictures is in Düsseldorf (Kunstmuseum)—all preparatory drawings and individual studies mentioned by J. Meier-Graefe.
Lit.: Cat. Munich 1967, pp. 57–58.

MENGS, Anton Raphael
b. Aussig 1728—d. Rome 1779

Early training under father, Saxon court painter Ismael Mengs (1688–1764), who named his son after Correggio and Raphael. When only 13 went to Rome to study under Marco Benefiale and Sebastiano Conca. Appointed court painter in Dresden 1745, having returned there in 1744. 1751 to Rome, became Director of Rome Academy on the Capitoline in 1754. Friendly with Winckelmann. Became first painter to King of Spain in 1761 and moved to Madrid.
Lit.: Own writings: *Gedanken über die Schönheit und der Geschmack in der Malerei*, Zürich 1762; *Sämmtliche hinterlassene Schriften*, ed. G. Schilling, Bonn 1843–44. —
K. Gerstenberg, *Johann Joachim Winckelmann und Anton Raphael Mengs*, Berlin 1929; D. Honisch, *Anton Raphael Mengs und die Bildform des Frühklassizismus*, Recklinghausen 1965; Exhib. F. J. Sánchez Cantón, *Antonio Rafael Mengs, Catálogo de la Exposición celebrada en Maya de 1929*, Madrid 1929.

1. **Der Parnass.** 1761
Parnassus.
Fresco (ceiling painting). c. 300 × 680 cm.
Sig. on the scroll: Ant. Raph. Mengs Saxo MDCCLXI
Villa Albani, Rome

MENZEL, Adolph von
b. Breslau 1815—d. Berlin 1905

Trained in the lithographic establishment of his father who died in Berlin in 1832. Took it over to provide for the family. For a short while attended Berlin Academy, then taught himself illustration and drawing. Early influences were early 19th century Berlin painting, J. C. Dahl and Constable, whose works were exhibited in Berlin in 1839. Menzel shared with the contemporary Düsseldorf school of history painting, which reflected the French and Belgian school, an interest in historical subjects. In 1839/42 made a name for himself with his woodcuts to Kugler's *History of Frederick the Great*. Several journeys through Germany in the 1840s. Worked on history paintings of Frederick the Great in 1850s. In Paris in 1855, 1867 and 1868, became acquainted with French art and friendly with Meissonier. Made Professor in 1856 and a member of the hereditary aristocracy in 1898. Several trips to South Germany after 1870, to the Netherlands and Austria in 1870, to World Exhibition in Vienna 1873, and on several occasions between 1880 and 1883 in Italy (Verona).
Lit.: *Adolph Menzels Briefe*, ed. H. Wolff, Berlin 1914; J. Beavington-Atkinson, 'Adolph Menzel', in *Art Journal*, May 1882; L. Gonse, 'Illustrations d'Adolphe Menzel pour les œuvres de Frédéric le Grand', in *Gazette des Beaux-Arts*, 1882, I; J. Beavington-Atkinson, 'Menzel's illustrations to the works of Frederick the Great', in *Art Journal*, Nov. 1883; M. Jordan and R. Dohme, *Das Werk Adolph Menzels*, Munich 1890; P. Meyerheim, *Adolph Menzel, Erinnerungen*, Berlin 1906; J. Meier-Graefe, *Der junge Menzel*, Leipzig 1906; H. von Tschudi, *Adolph von Menzel*, Munich 1906; G. Kirstein, *Das Leben A. Menzel's*, Leipzig 1919; M. Liebermann, *Adolph Menzel, 50 Zeichnungen, Pastelle und Aquarelle aus dem Besitz der Nationalgalerie*, Berlin 1921; E. Bock, *Adolph Menzel, Verzeichnis seines graphischen Werkes*, Berlin 1923; K.

Scheffler, *Adolph Menzel*, Leipzig 1938; E. Waldmann, *Der Maler Adolph Menzel*, Vienna 1941; K. Kaiser, *Adolph Menzel*, Berlin 1956; Exhib. *Drawings and watercolours by Adolph Menzel, 1815–1905*, Arts Council 1965 (London, Bristol, Kingston upon Hull, Leicester.)

VI. Das Balkonzimmer. 1845
Room with Balcony.
Oil on pasteboard. 58 × 47 cm.
Sig. bottom r.: A.M.45
Stiftung Preussischer Kulturbesitz, Nationalgalerie, Berlin (West)
Inv. No. NG 845
Lit.: Cat. Berlin/West 1968, p. 140.

92. Palaisgarten des Prinzen Albrecht. 1846
View of Prince Albrecht's Park.
Oil on canvas. 68 × 86 cm.
Sig. bottom l.: A. Menzel 46
Stiftung Preussischer Kulturbesitz, Nationalgalerie, Berlin (West)
Inv. No. NG 1107
Same motif appears in the oil sketch of 1846 *View of Prince Albrecht's Park*, in Berlin/East (Staatliche Museen zu Berlin, Nationalgalerie) where Menzel took a smaller extract. In 1876 he revised the picture, adding the figures and making alterations to the sky and the palace.
Lit.: Cat. Berlin/West 1968, p. 141.

90. Schlafzimmer des Künstlers. 1847
The Artist's Bedroom.
Oil on pasteboard. 56 × 46 cm.
Sig. bottom r.: AM 47
Stiftung Preussischer Kulturbesitz, Nationalgalerie, Berlin (West)
Inv. No. NG 977
Lit.: Cat. Berlin/West 1968, p. 141.

91. Wohnzimmer mit Menzels Schwester. 1847.
Living Room with Menzel's Sister.
Oil on paper. 46 × 31.6 cm.
Sig. bottom l.: A.M./47
Bayerische Staatsgemäldesammlungen, Munich
Inv. No. 8499
Menzel's sister Emilie (1823–1907) sat as model for many of his paintings, pastels and sketches.
Lit.: Cat. Munich 1964, p. 64.

94. Die Aufbahrung der Märzgefallenen. 1848
The Lying-in-state of Those who Fell in March.
Oil on canvas. 45 × 63 cm.
Sig. bottom l.: Ad. Menzel 1848
Kunsthalle, Hamburg
Inv. No. 1270
The coffins of those who were killed in the March Revolution lay in state on the front steps of the Neue Kirche on the Gendarmenmarkt in Berlin, and Menzel drew his pencil studies (Hamburg, Kunsthalle) *in situ*. There was a small sketch in oils in W. Gurlitt's collection in Munich. Compositional sketch in Berlin/East (Staatliche Museen zu Berlin, Kupferstichkabinett und Sammlung der Zeichnungen). The picture remained uncompleted.
Lit.: Cat. Hamburg 1969, p. 215.

93. Atelierwand. 1852
Studio Wall.
Oil on paper, backed on wood. 61 × 44 cm.
Sig. top. r.: A.M. 20 März 1852
Stiftung Preussischer Kulturbesitz, Nationalgalerie, Berlin (West)
Inv. No. NG 987
A similar study of 1871 in Hamburg (Kunsthalle).
Lit.: Cat. Berlin/West 1968, p. 143.

97. Das Flötenkonzert. 1852
The Flute Concert.
Oil on canvas. 142 × 205 cm.
Sig. bottom r.: Adolf Menzel Berlin 1852
Stiftung Preussischer Kulturbesitz, Nationalgalerie, Berlin (West)
Inv. No. NG 219
The picture (oil sketch in Berlin/East, Staatliche Museen zu Berlin, Nationalgalerie) belongs to the cycle of pictures about Frederick, which Menzel began at the end of the 1840s. Based on Menzel's woodcut illustrations to Kugler's *History of Frederick the Great* (1839/42).

Numerous pencil studies in Berlin/ East (Staatliche Museen zu Berlin, Kupferstichkabinett und Sammlung der Zeichnungen). The picture shows a concert in the music room of Sanssouci Castle in Potsdam given on the occasion of a visit by the King's sister, the Countess Wilhelmine of Bayreuth. The King is playing a flute solo. Among those present are Maupertius, Franz Benda, Joachim Quantz, Philipp Emanuel Bach.
Lit.: Cat. West Berlin 1968, p. 143.

96. **Friedrichsgracht im Alten Berlin.** c. 1856
The Friedrichsgracht in Old Berlin.
Oil on canvas. 39.5 × 53 cm.
Staatliche Museen zu Berlin, National-Galerie, Berlin (East)
Inv. No. A II 156.

95. **Friedrich der Grosse in Lissa— Bon Soir, Messieurs!** 1858
Frederick the Great in Lissa Castle —Bon Soir, Messieurs!
Oil on canvas. 247 × 190.5 cm.
Sig. bottom r.: Ad. Menzel 1858
Kunsthalle, Hamburg
Inv. No. 1271
This unfinished work, likewise part of the Frederick cycle, depicts Frederick's meeting with the Austrians in Lissa Castle, shortly after the victorious battle of Leuthen against the Austrian army under Prince Carl of Lorraine in 1757. Frederick the Great had arrived in the enemy camp without realizing it, and showed great presence of mind in asking to be introduced to the officers, thus giving the impression that his own army was following him, and avoiding being taken prisoner. Apart from the woodcut to Kugler's *History of Frederick the Great* (1839/42), there are several preparatory studies and one sketch in oils, all of which are in Berlin/East (Staatliche Museen zu Berlin).
Lit.: Cat. Hamburg 1969, p. 217.

98. **Spaziergang im Garten.** 1867
A Walk in the Garden.

Oil on canvas. 65.5 × 100 cm.
Sig. bottom centre: Ad. Menzel 1867
Kunsthalle, Bremen
Inv. No. 714
Lit.: G. Busch, *Der Spaziergang im Garten. Adolph Menzel und die Entstehung der Freilichtmalerei*, Vol. I of *Schriften der Kunsthalle Bremen*, Bremen 1959.

99. **Das Ballsouper.** 1878
The Ball Supper.
Oil on canvas. 71 × 90 cm.
Sig. bottom l.: Adolf Menzel Berlin 1878
Stiftung Preussischer Kulturbesitz, Nationalgalerie, Berlin (West)
Inv. No. NG 985
Degas copied the picture at the beginning of the 1880s in Paris (Strasbourg, Musées des Beaux-Arts), which gave rise to the unfavourable criticism of Menzel's work by Camille Pissarro.
Lit.: Cat. Berlin/West 1968, p. 146.

MODERSOHN, Otto
b. Soest 1865—d. Rotenburg (Hanover) 1943

At Düsseldorf Academy 1884–88 under E. Dücker, became acquainted with A. Böcklin's art in Munich, then studied under Baisch at Karlsruhe Academy 1888–89. 1892–94 student of E. Bracht at Berlin Academy. From 1889 most time in Worpswede, a village near Bremen, where he helped to found 'Worpswede Artists Club' in 1895. 1901 married painter Paula Becker; they were in Paris in 1903, 1905 and 1906. In 1908 moved to Fischerhude and made frequent study trips to Berlin and Italy.
Lit.: R. M. Rilke, *Worpswede, Monographie einer Landschaft und ihrer Maler*, Bielefeld-Leipzig 1903 (new ed. Bremen 1952); H. Wohltmann, *Otto Modersohn*, Stade 1941; M. Richter, *Otto Modersohn, Mensch und Werk und seine Bedeutung in der Kunstgeschichte* (Thesis), Münster 1947; L. Schüssler, *Die Worpsweder Malerei um 1900 und*

ihre entwicklungsgeschichtliche Stellung (Thesis), Marburg 1952.

143. Herbst im Moor. 1895
Autumn on the Moor.
Oil on canvas. 80 × 150 cm.
Sig. bottom r.: Otto Modersohn.
Worpswede 95
Kunsthalle, Bremen
Inv. No. 182

MODERSOHN-BECKER, Paula
b. Dresden 1876—d. Worpswede 1907

Her family moved to Bremen in 1888, and in 1892 she became a pupil of B. Wiegandt, then continued studies at London School of Arts. At art school of Berlin women painters in 1896, to Worpswede for first time in 1897, continued to study at Berlin Art School until 1898. Then made journey to Norway, settled in Worpswede on return, became friendly with Clara Westhoff and studied under F. Mackensen. 1st exhibition in Kunsthalle, Bremen, 1899. To Paris with C. Westhoff in 1900, visited Colarossi Academy and École des Beaux-Arts, met E. Nolde. Spent summer in Worpswede, met O. Modersohn, whom she married in 1901, and R. M. Rilke. In Berlin 1901, met writer Gerhart Hauptmann in Agnetendorf. To Paris again 1903, 1905, 1906, admired Cézanne's and Gauguin's work. Returned to Worpswede 1907.
Lit.: G. Pauli, *Paula Modersohn-Becker*, Leipzig 1919; P. Modersohn-Becker, *Briefe und Tagebuchblätter*, Munich 1921 (new ed. Weimar 1966); Exhib. *Paula Modersohn-Becker*, Kunsthalle, Bremen 1947; O. Stelzer, *Paula Modersohn-Becker*, Berlin 1958; Exhib. *Modersohn-Becker*, Behnhaus, Lübeck 1959/60; C. G. Heise, *Paula Becker-Modersohn* (sic), *Mutter und Kind*, Stuttgart 1961; Exhib. *Paula Modersohn-Becker*, Bremen 1968.

X. Selbstbildnis mit Camelienzweig. *c.* 1907

Self-portrait with Camellia Branch.
Oil on wood. 61.7 × 30.5 cm.
Sig. bottom l.: PMB.
Folkwang Museum, Essen
Inv. No. G 269
Lit.: Cat. Essen 1963, p. 41.

MORGENSTERN, Christian Ernst Bernhard
b. Hamburg 1805—d. Munich 1867

Studied under panorama painter C. Suhr in Hamburg, accompanied him on journey to Russia. 1824 under Hamburg painter S. Bendixen. To Copenhagen Academy 1827, then in 1829 to Munich via Hamburg on advice of C. F. von Rumohr, who showed great interest in him. Study trips to Norway, Sweden, Switzerland, Upper Italy and France enriched his knowledge. In Munich became one of the most important representatives of early Realism in landscape painting, was then influenced by the Düsseldorf School from 1835 (A. Achenbach was in Munich in 1835) and by C. Rottmann.
Lit.: H. Uhde-Bernays, *Münchener Landschafter im 19. Jahrhundert*, Munich 1921; G. Pauli, *Die Hamburger Meister der guten alten Zeit*, Munich 1925; M. Mauss, *Christian Morgenstern* (Thesis), Marburg 1968.

64. Starnberger See. *c.* 1840
Starnberger Lake.
Oil on canvas. 34 × 41.5 cm.
Sig. bottom r.: Christ. Morgenstern
Städtische Galerie im Lenbachhaus, Munich
Inv. No. G 75

NERLY, Friedrich (real name Nehrlich)
b. Erfurt 1807—d. Venice 1878

First training under painter J. Herterich in Hamburg, where he learnt lithography. Further training under C. F. von Rumohr. Met L. Richter in Dresden, went to Italy with Rumohr 1828, settled in Rome 1829–35. Found inspiration in landscapes of J. M. Rohden and

J. Ch. Reinhart. 1833 study trip to Terracina, S. Italy and Sicily. From 1837 in Venice, worked for most part on *veduta* painting.
Lit.: F. Meyer, *Friedrich von Nerly*, Erfurt 1908 (Special ed. by Verein für die Geschichte und Altertums-kunde, Erfurt); A. Lichtwark, 'Rumohr und Nerly', in *Jahrbuch d. Ges. Hambg. Kunstfreunde*, 16, 1910, and 17, 1911; L. Martius, 'Aus Friedrich Nerly Lehrzeit bei Carl Fr. v. Rumohr', in *Kunst für Alle*, 59, 1943, pp. 34–39; Exhib. *Friedrich Nerly, Ein deutscher Romantiker in Italien*, Kunsthalle, Bremen 1957.

48. Blick von Olevano auf die Volskerberge. *c.* 1830
View of the Volsker Mountains from Olevano.
Watercolour on lead. 202 × 310 mm.
Sig. bottom r.: Olevanno
Kunsthalle, Bremen
Inv. No. 94

OLDACH, Julius
b. Hamburg 1804—d. Munich 1830

Early training under G. Hardorff the Elder and C. Suhr in Hamburg. 1821–23 to Dresden Academy, 1824–7 pupil of Cornelius in Munich, from 1829 in Hamburg again.
Lit.: A. Lichtwark, *Julius Oldach*, Hamburg 1899.

66. Catharina Maria Oldach, die Mutter des Künstlers. *c.* 1824
Catharina Maria Oldach, the Artist's Mother.
Oil on canvas. 54.5 × 42.5 cm.
Kunsthalle, Hamburg
Inv. no. 1103
Complementary picture is *Portrait of Johann Friedrich Nikolaus Oldach, the Artist's Father* (*c.* 1824, Hamburg, Kunsthalle).
Lit.: Cat. Hamburg 1969, pp. 239–240.

OLIVIER, Johann Heinrich Ferdinand
b. Dessau 1785—d. Munich 1841

First training under K. W. Kolbe and Haldewang in Dessau, went with his brother Heinrich to Dresden in 1804, studied under J. Mechau and also studied landscapes of Claude Lorrain and Ruysdael in Dresden Gallery. Met C. D. Friedrich on introduction of F. A. von Klinkowström. In Paris 1807. 1811 with brother Friedrich to Vienna, met J. A. Koch. 1816 member of Brotherhood of St Luke, friendly with Ludwig Schnorr von Carolsfeld. 1814 trip to Salzburg with Ph. Veit and again in 1817, where he produced numerous landscape studies. In 1822 his lithographs of 'Seven regions from Salzburg and Berchtesgaden, arranged according to the seven days of the week' appeared, which he worked on from 1818. In 1830 followed Schnorr von Carolsfeld to Munich, where he became Professor of Art History at the Academy due to mediation of Cornelius.
Lit.: L. Grote, 'Dokumente romantischer Zeichenkunst, Ferdinand Oliviers Salzburg-Landschaften', in *Pantheon*, 13, 1934, pp. 10–15; L. Grote, *Die Brüder Olivier und die deutsche Romantik*, Berlin 1938; H. Schwarz, *Salzburg und das Salzkammergut, Die künstlerische Entdeckung der Stadt und der Landschaft im 19. Jahrhundert*, 3rd ed. Vienna 1958; F. Novotny, *Ferdinand Oliviers Landschaftszeichnungen von Wien und Umgebung*, Graz 1971.

49. Tongrube in Wien-Matzleindorf. 1814–16
Clay-pit in Vienna-Matzleindorf.
Pencil sketch over lead. 160 × 240 mm.
Albertina, Vienna.
Inv. No. 47112

OLIVIER, Friedrich Woldemar
b. Dessau 1791—d. Dessau 1859

Studied first under sculptor Hunold in Dessau, started painting in 1810. 1811 with brother Ferdinand to Vienna, entered circle of Vienna

Romantics around Schlegel, Eichendorff, J. A. Koch and Ph. Veit, friendly with Ludwig Schnorr von Carolsfeld, Scheffer von Leonhardshoff and H. Reinhold. Journey to Netherlands and England, joined brother Ferdinand on his excursion in Salzburg region about 1817. In 1818 went with Schnorr von Carolsfeld to Rome, met Brotherhood of St Luke, particularly influenced by Cornelius. In 1823 returned to Vienna. 1829 invited by Schnorr von Carolsfeld to Munich, assisted with Nibellungen frescoes for Munich Residenz. Stayed in Munich till 1850, then moved to Dessau.
Lit.: L. Grote, *Die Brüder Olivier und die deutsche Romantik*, Berlin 1938.

50. Campagnalandschaft mit dem Soracte. 1818–23
Campagna Landscape with the Soracte.
Oil on paper, backed on oak. 24.8 × 18.9 cm.
Sig. on the back in ink: Olivier Woldemar Friedrich 1791–1859.
Bayerische Staatsgemäldesammlungen, Munich
Inv. No. 8921
Lit. Cat. Munich 1867, pp. 67–68.

OVERBECK, Friedrich Johann
b. Lübeck—d. Rome 1869

First instruction in painting from portrait painter J. N. Peroux in Lübeck. To Vienna Academy in 1806. Joined up with pupil of Carsten's E. Wächter, and found like-minded friend in F. Pforr. With him and the young Academy pupils J. Wintergerst, J. K. Hottinger, L. Vogel and J. Sutter founded Brotherhood of St Luke in 1809, which wanted to renew religious and moral conscience after manner of early German painters. In 1810 arrived in Rome with his friends, stayed there till death, apart from three journeys to Germany in 1831, 1855 and 1865.
Lit.: J. R. Beavington-Atkinson,

Overbeck, London 1882; M. Howitt, *Friedrich Overbeck*, Freiburg 1886; C. G. Heise and K. K. Eberlein, *Overbeck und sein Kreis*, Munich 1928; J. C. Jensen, *Friedrich Overbeck, Die Werke im Behnhaus*, Lübeck 1963; W. Teupser, *Italia und Germania von Pforr und Overbeck*, Berlin n.d.; K. Andrews, *The Nazarenes*, Oxford 1964.

32. Italia und Germania (Sulamith und Maria—Die Freundschaft). 1828.
Italy and Germany (Sulamite and Maria—Friendship).
Oil on canvas. 94.4 × 104.7 cm.
Bayerische Staatsgemäldesammlungen, Munich
Inv. No. WAF 755
The composition, begun in 1811 as a gift of friendship in return for Pforr's picture *Sulamite and Maria* of 1811 (Coll. Schäfer, Schweinfurt), is based on two sketches by Pforr (Städelsches Kunstinstitut, Frankfurt). A sketch of 1811–12 based on a previous outline drawing is in Lübeck (Behnhaus). Overbeck recommenced work in 1815 after breaking it off due to Pforr's death in 1812, and then completed the picture for F. Wenner in 1828. An oil sketch—critics disagree whether this was a preparatory sketch or a study based on the finished picture —in Schweinfurt (Coll. Schäfer). A copy from another hand in Dresden (Gemäldegalerie Neue Meister).
Lit.: Cat. Munich 1967, pp. 70–72.

37. Joseph wird von seinen Brüdern verkauft. 1816–17
Joseph being sold by His Brothers.
Fresco. 243 × 304 cm.
Staatliche Museen zu Berlin, National-Galerie, Berlin (East)
Inv. No. A III 477
Lit.: K. Andrews, *The Nazarenes*, Oxford 1964, pp. 92–93 (notes).

42. Bildnis des Malers Johann Carl Eggers. 1816–20
Portrait of the Painter Johann Carl Eggers.

Oil on canvas, backed on wood.
25.5 × 19 cm.
Staatliche Kunsthalle, Karlsruhe
Inv. No. 2172
The painter Johann Carl Eggers
(1787–1863) was a friend of Over-
beck and lived in Rome from 1816
to 1830.
Lit.: Cat. Karlsruhe 1964, No. 11.

PECHSTEIN, Max
b. Eckersbach (Zwickau) 1881—d.
Berlin 1955

Studied painting from 1896 to 1900.
Attended arts and crafts school in
Dresden in 1900, became pupil of
Gussmann from 1902 to 1906 at
Dresden Academy. In 1906 met
Kirchner and Heckel and joined
the artists' community *Die Brücke*.
1907–08 travelled to Italy and Paris,
where van Dongen's painting made
a strong impression on him. Moved
to Berlin 1908, became President
in 1910 of the Neue Sezession
founded in that year. Met Macke,
Marc and Kandinsky. In 1911 and
1913 travelled to Florence and
Rome, in 1914 to the South Sea
Islands. After military service re-
turned to Berlin in 1919 and stayed
there till 1933, went to Leba
(Pomerania) and returned to Berlin
in 1945. From 1909 spent the
summer regularly on the Baltic.
Lit.: M. Pechstein, *Erinnerungen*,
Wiesbaden 1960;—P. Fechter, *Das
graphische Werk Max Pechsteins*,
Berlin 1921; M. Osborn, *Max
Pechstein*, Berlin 1922; K. Lemmer,
*Max Pechstein und der Beginn des
Expressionismus*, Berlin 1949;
Exhib. *Der junge Pechstein*, Hoch-
schule für bildende Künste, Berlin
1959; W. Heymann, *Max Pech-
stein*, Munich 1960.

148. Bildnis in Rot. 1909
Portrait in Red.
Oil on canvas. 101 × 101 cm.
Sig. top r.: HMP 09
Hessisches Landesmuseum, Darm-
stadt
Inv. No. GK 1154

PFORR, Franz
b. Frankfurt 1788—d. Albano 1812

First training from his father, then
from 1801 under his uncle J. H.
Tischbein in Cassel. In 1805 in
Frankfurt, met J. D. Passavant and
went to Vienna in the same year,
where he remained at the Academy
under H. Füger till 1810. Founded
Brotherhood of St Luke in 1809
with Overbeck, J. Wintergerst,
L. Vogel, J. Sutter and J. K.
Hottinger. In 1810 went to Rome
with Overbeck, Vogel and Hot-
tinger; they lived in the monastery
of San Isidoro as an artistic and
religious community. In Rome
painted *Sulamith and Maria* as sym-
bolic representation of his friend-
ship with Overbeck, who for his
part began his picture *Italy and
Germany* in 1811 and finished it in
1828. Journey to Naples 1811,
returned to Rome ill. Died of
tuberculosis in Albano.
Lit.: F. H. Lehr, *Die Blütezeit
romantischer Bildkunst, Franz Pforr,
der Meister des Lukasbundes*, Mar-
burg 1924; R. Benz, 'Goethes
Götz von Berlichingen in Zeich-
nungen von Franz Pforr', in
Schriften der Goethe-Gesellschaft,
Vol. 52, Weimar 1941; K.
Andrews, *The Nazarenes*, Oxford
1964.

**33. Einzug Kaiser Rudolfs von
Habsburg in Basel.** 1810
Entry of the Emperor Rudolf of
Habsburg into Basle.
Oil on canvas. 90.5 × 118.9 cm.
Städelsches Kunstinstitut, Frank-
furt (on loan from Historisches
Museum, Frankfurt)
Inv. No. HM 51
Pforr began the painting in Vienna
in 1808 and completed it in Rome
in 1810.
Lit.: K. Andrews, *The Nazarenes*,
Oxford 1964, p. 91.

PILOTY, Karl Theodor von
b. Munich 1826—d. Munich 1886

Early study under father Ferdinand

Piloty, who had specialized in the lithographical reproduction and coloration of paintings in the Munich Pinakothek; then under K. Schorn. In 1834 attended Munich Academy under J. Schnorr von Carolsfeld, very enthusiastic about Rubens and van Dyck. The Belgian history painters Gallait and de Bièfve who exhibited in Munich in 1843 influenced him. Broke off studies due to death of father in 1844 and took over lithographic establishment. Visited Venice 1847, studied under Gallait in Antwerp in 1852 and under P. Delaroche in Paris. Successful with first great history painting *Seni and Wallenstein's Corpse* (1855); appointed Professor at Academy in 1856 and soon collected great number of students, among them Makart, Lenbach, Max, Grützner and Defregger. In 1869 declined invitation to Berlin and received commission from Bavarian State for history painting *Thusnelda in the Triumphal Procession of Germanicus*.
Lit.: K. Stieler, *Die Pilotyschule*, Berlin 1888; F. Pecht, 'Karl von Piloty', in *Die Kunst für Alle*, 11, 1895/96, pp. 321 ff; H. Eckstein, 'Piloty und die Münchener Kunst', in *Die Kunst*, LXXIII, Munich 1936, pp. 365f. and p. 372.

77. Seni an der Leiche Wallensteins.
1855
Seni and Wallenstein's Corpse.
Oil on canvas. 312 × 365 cm.
Bayerische Staatsgemäldesammlungen, Munich
Inv. No. WAF 770.

PRELLER, Friedrich, the Elder
b. Eisenach 1804—d. Weimar 1878

Studied under H. Meyer at drawing school in Weimar and copied Dutch masters in Dresden Gallery. 1822 met Goethe, corrected his cloud-studies. In Dresden in 1822, friendly with C. D. Friedrich and J. Ch. Dahl. To Antwerp on scholarship 1824–26, worked there under van Bree. Went to Munich via Weimar

and then to Rome in 1829, joined the circle of Nazarenes and J. A. Koch and J. Ch. Reinhart. In 1831 returned to Weimar and began in 1832 (till 1836) the frescoes on the Odyssey for Dr Härtel's Römisches Haus in Leipzig. Taught at drawing school in Weimar and 1835–41 worked on the frescoes for the Weiland Room in the Königsbau in the Munich Residenz. Numerous journeys, 1837 and 1839 to Rügen, 1840 to Amsterdam, Hamburg, Copenhagen and Norway, 1850 to the Tyrol and finally 1859–61 to Rome, where he made studies for Penelope cycle for Dr Härtel. 1868–73 director of drawing school in Weimar.
Lit.: M. Jordan, *Friedrich Prellers Figuren-Fries zur Odyssee*, Leipzig 1875; O. Roquette, *Friedrich Preller, Ein Lebensbild*, Frankfurt 1883; J. Vogel, *Das Römische Haus in Leipzig*, Leipzig 1903; J. Gensel, *Friedrich Preller d.Ä.*, Bielefeld und Leipzig 1904; Exhib. *Friedrich Preller d.Ä.*, Heidelberg 1954.

10. Odysseus und Nausikaa. 1869
Odysseus and Nausicaa.
Wall painting in wax colours. 155 × 248 cm.
Sig.: Ausp. Caroli Alexandri mag. d.Sax. F. Preller opus Romae MDCCCLX inchoatum MDCCCLXIX terminativ portium architectat. est J. Zitek. ornam. pinx. Westphal.
Staatliche Kunstsammlungen, Schlossmuseum, Weimar
Inv. No. G 86 f 2
The fresco belongs to a series of 14 Odysseus landscapes which Preller painted for the Grand Duke of Saxony between 1863 and 1869. He had already painted 7 Odysseus frescoes for Dr Härtel's Römisches Haus in Leipzig 1832–36.

RAYSKI, Ferdinand von
b. Pegau 1806—d. Dresden 1890

1823–25 at Dresden Academy under T. Faber, then self-taught. After four years military service

in Ballenstedt returned to Academy. Lived in Paris 1835, made many journeys through Germany and then lived near Würzburg. From 1839 in Dresden again. Travelled to England in 1862.
Lit.: O. Grautoff, *Ferdinand von Rayski*, Berlin 1923; E. Sigismund, *Ferdinand von Rayski*, Dresden 1923; M. Goeritz, *F. von Rayski und die Kunst des 19. Jahrhunderts*, Berlin 1942; M. Walter, *Ferdinand von Rayski, Sein Leben und sein Werk*, Bielefeld und Leipzig 1943; H. Menz, *Ferdinand von Rayski*, Dresden 1954.

74. Graf Haubold von Einsiedel.
1855
Count Haubold von Einsiedel.
Oil on canvas. 73 × 62 cm.
Sig. bottom r.: F.v.R. 1855 (with dog's head).
Stiftung Preussischer Kulturbesitz, Nationalgalerie, Berlin (West)
Inv. No. NG 1005
The sitter is the 11-year-old Count Haubold von Einsiedel (1844–68).
Lit.: Cat. Berlin/West 1968, p. 172.

RETHEL, Alfred
b. Diepenabend nr. Aachen 1816—d. Düsseldorf 1859

First training under J. Bastiné in Aachen. 1829–36 pupil at Düsseldorf Academy under Wilhelm von Schadow. Then until 1847 to Philipp Veit at Städel School in Frankfurt, where he developed a strongly individual style of drawing, free of all trace of his Nazarene training. First well known work is *The Emperor Max on the Martinswand* of 1836. In 1840 his woodcuts to the Nibelungen edition appeared. To the same year belong the first sketches for the later decoration of the Emperor Room in the Rathaus in Aachen, which he worked on from 1847. 1844–45 and 1852–53 in Italy. His series of woodcuts *Another Dance of Death*, made in 1848, appeared in 1849. From 1853 Rethel suffered from nervous illness.

Lit.: J. Ponten, *Alfred Rethel*, Stuttgart and Leipzig 1911; J. Ponten (ed.), *Alfred Rethels Briefe*, Berlin 1912; K. Zoege von Manteuffel, *Alfred Rethel, Sechszehn Bildtafeln, mit einführendem Text und kritischem Verzeichnis der Bilddrucke Rethels*, Hamburg 1926; K. Koetschau, *Alfred Rethels Kunst vor dem Hintergrund der Historienmalerei seiner Zeit*, Düsseldorf 1929; Exhib. A. Rethel —*Auch ein Totentanz*, Kunstmuseum Düsseldorf 1956; Exhib. A. Rethel, Suermondt Museum, Aachen 1958; H. Schmidt, 'Alfred Rethel', in *Rheinischer Verein für Denkmalpflege und Heimatschutz* (1958), Neuss 1958; I. Markowitz, *Die Düsseldorf Malerschule*, Düsseldorf 1967.

83. Mönch an der Leiche Heinrich IV. *c.* 1844
Monk by the Corpse of Henry IV.
Oil on paper on canvas. 54.4 × 58.5 cm.
Kunstmuseum, Düsseldorf
Inv. No. 4460
The picture shows a monk praying by the coffin of Emperor Henry IV, who was excommunicated in Liège in 1106, and was not given Christian burial until 1111 in Speyer Cathedral. Already in 1835 Rethel had used the figure of Henry IV in his works on the *Cycle of Rhenish Legends* of Adelheid von Stolterfoth. Preparatory studies and colour sketches of 1840 and 1843 in Aachen (Suermondt-Museum).

84. Der Triumph des Todes. 1848/49
The Triumph of Death.
Woodcut. 220 × 320 mm.
The woodcut belongs to the series of six plates *Another Dance of Death*, which appeared in 1849 with explanatory text by R. Reinick. The Kupferstichkabinett in Dresden possesses all the pencil sketches.

82. Besuch Otto III in der Gruft Karls des Grossen. 1847–52
Otto III's Visit to Charlemagne's Vault.

Fresco.
Kaisersaal in the Rathaus, Aachen
In 1840 Rethel received the official commission to decorate the Rathaus in Aachen. He worked on the frescoes from 1847. This fresco depicts how, according to the legend, the young Otto caused the grave of his mighty predecessor, Charlemagne, to be opened and saw the Emperor, dressed in all his princely finery, sitting on his stone throne. The theme was part of the 19th-century nationalist credo, which spoke of the 'return of the German Emperor'. A colour study in Düsseldorf (Kunstmuseum), further preparatory studies in Aachen (Suermondt-Museum).

RICHTER, Adrian Ludwig
b. Dresden 1803—d. Loschwitz nr. Dresden 1884

Studied under father Carl August Richter and accompanied Russian prince Narichkin to Southern France in 1820–21 as a draughtsman. In 1820 collaboration on the *Picturesque Views of Dresden*, which his father edited. 1823–26 went to Rome on a grant, became friendly with J. A. Koch and J. Schnorr von Carolsfeld. Made excursions into the Alban and Sabine hills, and to Naples and Sicily. After his return to Dresden he obtained in 1828 a post as drawing master in Meissen, where he remained until 1835. Appointed Professor at Dresden Academy in 1836. From this year dated his connection with the publisher Wiegand in Leipzig, for whom he illustrated fairy tales; made illustrations for a Shakespeare edition which also appeared in England. Richter made altogether more than 2,000 illustrations. After his Italian landscapes he turned to the depiction of his native landscape in Germany.
Lit.: A. L. Richter, *Lebenserinnerungen eines deutschen Malers*, Frankfurt 1885 (new ed. by E. Marx, Leipzig 1950); J. F. Hoff, *Adrian*

Ludwig Richter, Verzeichnis seines gesamten graphischen Werkes, 2nd ed. by K. Budde, Freiburg i.Br. 1922; K. J. Friedrich, *Die Gemälde Ludwig Richters*, Berlin 1937; E. Warm, *Die Entwicklung der Bildkomposition bei L. Richter* (Thesis), Göttingen, Bleicherode 1939; E. Kalkschmidt, *Ludwig Richter, Leben, Werk, Wirkung*, 2nd ed. Munich 1948; W. Balzer, *Ludwig Richter, Frühe Zeichnungen*, 2nd ed. Dresden 1955; K. J. Friedrich, *Ludwig Richter und sein Schülerkreis*, Leipzig 1956.

51. **Überfahrt über die Elbe am Schreckenstein bei Aussig.** 1837
Crossing the Elbe at Schreckenstein near Aussig.
Oil on canvas. 116.5 × 156.5 cm.
Sig. bottom l.: L. Richter 1837.
Gemäldegalerie Neue Meister, Staatliche Kunstsammlungen, Dresden.
Inv. No. 2229
Pencil compositional study in Berlin/East (Staatliche Museen zu Berlin, Kupferstichkabinett und Sammlung der Zeichnungen).
Lit.: Cat. Dresden 1960, p. 87.

52. **Frühlingsabend.** 1844
Spring Evening.
Oil on canvas. 72 × 109 cm.
Sig. bottom l.: L. Richter. 1844.
Kunstmuseum, Düsseldorf
Inv. No. 4270.
Richter treated this theme several times, e.g. in a watercolour of 1871 in Düsseldorf (Kunstmuseum). The Düsseldorf Cat. gives a full list of the preparatory studies.
Lit.: Cat. Düsseldorf 1968, pp. 95–96.

ROHDEN, Johann Martin von
b. Cassel 1778—d. Rome 1868

Attended Cassel Academy, receiving instruction in drawing, then went with K. Du Ry to Rome via Nuremberg, Munich and Innsbruck. Stayed in Rome till 1799, in circle around landscape painters J. A. Koch and J. Ch. Reinhart.

On return to Germany lived in Cassel 1801–02, then in Rome again 1802–11. 1811–12 in Germany, met Goethe, returned to Rome in 1818. Appointed court painter to Prince Wilhelm II of Hessen in Cassel 1827. Finally settled in Rome 1831.
Lit.: H. Mackowsky, 'Die beiden Rohden, Ein vergessenes Kapitel deutsch-römischer Kunstgeschichte', in *Jahrbuch für Kunstwissenschaft*, 1924/25, pp. 47–62; R. J. Pinnau, *Johann Martin von Rohden, Leben und Werk*, Bielefeld 1965.

59. Ruinen der Villa des Hadrian bei Rom. *c.* 1796
Ruins of Hadrian's Villa near Rome.
Oil on paper on canvas. 56 × 73.5 cm.
Kunsthalle, Hamburg
Inv. No. 2505
According to Pinnau the subject is the remains of an aqueduct between Subiaco and Tivoli. A similar picture, *Aqueduct near Tivoli*, in Winterthur (Stiftung O. Reinhart), dated 1796, would seem to indicate the same date for the Hamburg picture.
Lit.: Cat. Hamburg 1969, p. 269.

ROHLFS, Christian
b. Niendorf in Holstein 1849—d. Hagen in Westphalia 1938

From 1870 to 1881 pupil at Art School in Weimar under P. Thumann, F. Schauss and A. Struys. In 1881 obtained own studio there; first exhibition in Weimar 1889. Spent the year 1895 in Berlin. Met E. Munch in 1898 and from 1900 took part in Berlin *Secession*'s exhibitions. In 1901, on recommendation of H. van de Velde and the invitation of K. E. Osthaus moved to Hagen in Westphalia, appointed Professor at Folkwang-Schule in Hagen 1903. Worked in Soest 1905 and 1906, became friendly with E. Nolde there. Made first woodcuts in 1908. Became member of Prussian Art Academy in Berlin in 1924.
Lit.: W. v. d. Briele, *Christian Rohlfs, Der Künstler und sein Werk*, Dortmund 1921; T. Benders-Egens, *Christian Rohlfs Anfänge und die Weimarer Malschule* (Thesis), Marburg 1952; G. Bender, 'Christian Rohlfs, ein Mittler zwischen zwei Jahrhunderten', in *Westfalen*, 30, 1952, pp. 1–30; P. Vogt, *Christian Rohlfs*, Cologne 1956; P. Vogt, *Christian Rohlfs, Aquarelle und Zeichnungen*, Recklinghausen 1958; W. Scheidig, *Christian Rohlfs*, Dresden 1964.

142. Waldweg im Winter (Chaussee nach Tiefurt in Webicht bei Weimar). 1889
Woodland Path in Winter (Track to Tiefurt in Webicht near Weimar).
Oil on canvas. 59.5 × 74.5 cm.
Sig. bottom r.: CR 89
Wallraf-Richartz-Museum, Cologne
Inv. No. 2460
Lit.: Cat. Cologne 1964, p. 104.

ROTTMANN, Carl
b. Handschuhsheim near Heidelberg 1797—d. Munich 1850

First studies under father Christian Friedrich Rottmann, together with E. Fries and C. Ph. Fohr. Made walking tour in Rhine and Moselle valleys in 1818, published views under title 'Picturesque Journey along the Moselle from Coblenz to Trier' as engravings. Pupil at Munich Academy in 1821, influenced by Koch's works and copied his mountain landscapes. Lived in Italy from 1826–7 and walked through Sabine hills, to Tyrol and Olevano, with H. Hess. In 1828 exhibited in Munich pictures painted in Rome; they induced King Ludwig to have the arcades of the court gardens decorated with frescoes by Rottmann. In furtherance of this commission went to Rome 1829–30 to do preparatory work. Worked on

frescoes in Munich 1830–33. In 1834–5 made a journey to Greece, to compose a second cycle of Greek pictures for the Pinakothek, which he worked on 1838–50. Appointed court painter in 1841.
Lit.: F. Krauss, *Carl Rottmann*, Heidelberg 1930; H. Decker, *Carl Rottmann*, Berlin 1957.

63. Ebene von Marathon. *c.* 1834–35
Plain of Marathon.
Oil on canvas. 16.6 × 20.6 cm.
Bayerische Staatsgemäldesammlungen, Munich
Inv. No. 11 140
Probably painted during Rottmann's journey to Greece of 1834–5 as a sketch for the Greek cycle in the court gardens in Munich which was later exhibited in the Neue Pinakothek in Munich.

RUNGE, Philipp Otto
b. Wolgast 1777—d. Hamburg 1810

In 1795 became merchant apprentice to brother Daniel in Hamburg, who later supported him financially and edited his writings. At the same time took instruction in drawing under H. Herterich and H. Hardorff and learned oil painting from D. Eckhardt. In 1798 attended Copenhagen Academy, where J. Juel and N. A. Abildgaard taught according to Neoclassical precepts. In 1801 went to Dresden Academy, studied the works in the Dresden Gallery and joined A. Graff. Became friendly with F. Hartmann, F. A. von Klinkowström, L. Berger and L. Tieck. Took part in Weimar art competition in 1801, visited Goethe in Weimar in 1803, corresponded with him about theories on colour; published his 'Farbkugel' (colour spectrum) in 1810. In Hamburg in 1803, perfected his technique in oils under J. F. Eich. Lived in Wolgast in 1806, returned to Hamburg in 1807.
Lit.: *Hinterlassene Schriften von Philipp Otto Runge, Mahler.* Herausgegeben von dessen ältestem Bruder [Daniel], 2 parts, Hamburg

1840–41; P. F. Schmidt, *Philipp Otto Runge, Sein Leben und Werk*, Leipzig 1923 (2nd ed. Wiesbaden 1956); J. B. C. Grundy, *Tieck und Runge*, Strasbourg 1930; O. Böttcher, *Philipp Otto Runge, Sein Leben, Wirken und Schaffen*, Hamburg 1937; S. Waetzoldt, *Philipp Otto Runges 'Vier Zeiten'* (Thesis), Hamburg 1951; O. G. von Simson, 'Philipp Otto Runge and the mythology of landscape', in *Art Bulletin*, 24, 1942, pp. 335–50; C. Grützmacher, *Über drei Zentralmotive und ihre Bedeutungssphäre bei Novalis und Ph. O. Runge* (Thesis), Munich 1961; G. Berefelt, *Philipp Otto Runge—zwischen Aufbruch und Opposition 1772–1802* (Thesis), Stockholm 1961, Uppsala 1961; J. Langner, *Philipp Otto Runge in der Hamburger Kunsthalle*, Hamburg 1963; R. M. Bisanz, *German Romanticism and Philipp Otto Runge. A Study in 19th Century Art Theory and Iconography*, Dekalb 1970.

12. Selbstbildnis. 1802/03
Self-portrait.
Oil on canvas. 37 × 31.5 cm.
Kunsthalle, Hamburg
Inv. No. 1002
Cat. Hamburg 1969, p. 276.

11. Lehrstunde der Nachtigall. 1801
The Nightingale's Lesson.
Pen drawing on paper, stuck on black hand-made paper, underneath the silhouette of a cupid.
256 × 254 mm.
Sig. bottom r.: 1801 (with lines from Klopstock's 93rd ode in the artist's handwriting).
Kunsthalle, Kupferstichkabinett, Hamburg
Inv. No. 1926/135.
The idea for this composition may have been thought up to send in a letter to Runge's friend Conrad Christian Böhndel, whom he wrote to about the picture on 7 November 1801.
Lit.: Cat. Hamburg 1969, p. 277.

14. Lehrstunde der Nachtigall. 1805
The Nightingale's Lesson.

Oil on canvas. 104.7 × 85.5 cm.
Sig. on the oval frame: Philipp Otto Runge MDCCCV (next to the verses from Klopstock's 93rd ode.)
Kunsthalle, Hamburg
Inv. No. 1009
Repetition by the artist according to first version of 1802–3 (formerly in Hamburg, destroyed in 1931). On the frame of the oval the inscription with the verses from Klopstock's 93rd ode: 'Flöten musst du, bald mit immer stärkerem Laute, bald mit leiserem, bis sich verlieren die Töne; Schmettern dann, dass es die Wipfel des Waldes durchrauscht! Flöten, flöten, bis sich bey den Rosenknospen verlieren die Töne.' ('You must play the flute, now crescendo, now diminuendo, till the notes fade away; then warble so that your song stirs the treetops in the wood. Pipe away until the notes fade into the rosebuds.') Numerous preparatory studies to both painted versions are to be found in Hamburg (Kunsthalle) and are mentioned in the Hamburg Cat. 1969.
Lit.: Cat. Hamburg 1969, pp. 277–8.

16. **Ruhe auf der Flucht nach Ägypten.** 1805/06
Rest on the Flight to Egypt.
Oil on canvas. 96.5 × 129.5 cm.
Unfinished.
Kunsthalle, Hamburg
Inv. No. 1004
All preparatory studies listed in Hamburg Cat. 1969.
Lit.: Cat. Hamburg 1969, pp. 279–80.

I. **Die Hülsenbeckschen Kinder.** 1805/06
The Hülsenbeck Children.
Oil on canvas. 131.5 × 143.5 cm.
Kunsthalle, Hamburg
Inv. No. 1012
The children of F. A. Hülsenbeck (1766–1834), the business partner of Runge's brother Daniel, painted in front of the country house in Elmsbüttel, a suburb of Hamburg, whose towers appear on the left-hand side of the horizon.
Lit.: Cat. Hamburg 1969, pp. 280–81.

13. **Die Eltern des Künstlers.** 1806.
The Artist's Parents.
Oil on canvas. 196 × 131 cm.
Sig. on the back: 'Diese meine lieben Eltern habe ich meinen Geschwistern und mir zum Andenken gemalt und zur Lust mein Söhnlein Otto Sigismund alt 1 1/2 Jahr und meines Bruders Jacob Söhnlein Friedrich 3 1/2 Jahr. Wolgast im Sommer 1806.'
Kunsthalle, Hamburg
Inv. No. 1001
Runge's parents, the corn-dealer and shipowner Daniel Nicolaus Runge (1737–1825) and Magdalena Dorothea née Müller (1737–1818). Preparatory studies and colour sketches mainly in Hamburg (Kunsthalle), some in Berlin/East (Staatliche Museen zu Berlin, Kupferstichkabinett und Sammlung der Zeichnungen) and on the art market or in private collections.
Lit.: Cat. Hamburg 1969, pp. 281–82.

17. **Christus auf dem Meere Wandelnd.** 1806/07
Christ Walking on the Water.
Oil on canvas. 116 × 157 cm.
Preparatory colour only.
Kunsthalle, Hamburg
Inv. No. 1007
The unfinished picture was commissioned by Runge's former teacher, the parson and poet G. L. Rosegarten, for a newly-built chapel near the fishing village of Vitte on the island of Rügen. Numerous preparatory studies in Hamburg (Kunsthalle), mentioned in Hamburg Cat. 1969.
Lit.: Cat. Hamburg 1969, pp. 283–84.

15. **Der Morgen.** 1809.
Morning.
2nd painted version. Unfinished.
Oil on canvas. 152 × 113 cm.
Kunsthalle, Hamburg

Inv. No. 1022
Depicts the bringer of light, Aurora, surrounded by flower spirits, with the new-born child at her feet as the Saviour. Runge made sketches for the cycle *Four Times of Day* in 1802 (Hamburg, Kunsthalle), which were etched by Dresden craftsmen until 1805 and appeared in two editions in 1806 and 1807. After 1804 Runge undertook an unsuccessful attempt (Hamburg, Kunsthalle) to paint the central portion of *Day* as an oil painting on a gold ground. In 1806 he continued work on *Morning*, of which the first, smaller, version was produced in 1807 (Hamburg, Kunsthalle) and the second, larger, version in 1809; this was cut up in 1870 and restored in 1927. Numerous preparatory studies for the painted versions in Hamburg (Kunsthalle) and Berlin/East (Staatliche Museen zu Berlin, Kupferstichkabinett und Sammlung der Zeichnungen). The Hamburg Cat. 1969 includes all preparatory studies.
Lit.: Cat. Hamburg 1969, pp. 285–86.

SCHADOW, Johann Gottfried
b. Berlin 1764—d. Berlin 1850

After first studies with J. P. A. Tassaert to Berlin Academy. 1785–87 in Rome where he sketched from antique statues. Friendship with A. Canova. 1787 returned to Berlin and 1788 elected Director of court studio of sculpture. 1790–1800 produced many monuments, also the carved decorations for the suite of King Friedrich Wilhelm II of Prussia in Berlin Castle. In 1793 produced monument to Frederick the Great in Stettin, after which he produced many busts. 1815–19 worked on bronze statue of Blücher in Rostock, 1821 finished the Luther monument in Wittenberg, 1823 the marble bust of Goethe. 1815 elected Director of Berlin Academy.

Lit.: G. Schadow, *Kunstwerke und Kunstansichten*, Berlin 1840; H. Mackowsky, *Johann Gottfried Schadows Jugend und Aufstieg, 1764–97*, Berlin 1927; H. Mackowsky, 'Schadows Graphik', in *Forschungen zur deutschen Kunstgeschichte*, XIX, Berlin 1936; H. Mackowsky, *Die Bildwerke Gottfried Schadows*, Berlin 1951; H. Ragaller, 'Skizzen und Zeichnungen von Johann Gottfried Schadow im Berliner Kupferstichkabinett', in *Jahrbuch der Berliner Museen* (*Jahrbuch der Kunstsammlungen*, Neue Folge), II, Berlin 1960, p. 121 ff.; Exhib. *Johann Gottfried Schadow, 1764–1850, Bildwerke und Zeichnungen*, Staatliche Museen zu Berlin, National-Galerie, Berlin (East) 1964–65.

85. **Selbstbildnis.** 1838
Self-portrait.
Brush, watercolour on paper. 203 × 170 mm.
Sig. bottom: 1838 G. Schadow 75 Jahr.
Staatliche Museen, Kupferstichkabinett und Sammlung der Zeichnungen, Berlin (East)
Inv. No. 91
The water colour is taken from Schadow's 'Familienalbum'.
Lit.: Exhib. *J. G. Schadow*, East Berlin 1964/65, p. 219.

SCHICK, Gottlieb
b. Stuttgart 1776—d. Stuttgart 1812

First studied under G. F. Hetsch 1787–94 Stuttgart, then influenced by J. H. Dannecker. 1798–1802 worked in studio of J. L. David in Paris. 1802 went via Stuttgart to Rome, where stayed till 1811. Friendship with Wilhelm von Humboldt; influenced by E. Wächter and J. A. Koch. 1808 exhibited his pictures in Rome, achieved great success. 1811 returned to Stuttgart, worked principally as portrait-painter.
Lit.: K. Simon, *Gottlieb Schick, Ein Beitrag zur Geschichte der deutschen Malerei um 1800*, Leipzig 1914; Th. Musper, 'Neues zu

Schick', in *Festschrift J. Baum*, Stuttgart 1952.

III. Bildnis der Frau von Cotta.
1802
Portrait of Frau von Cotta.
Oil on canvas. 132 × 140 cm.
Sig. r.: Schick faciebat 1802.
Staatsgalerie, Stuttgart
Inv. No. GVL 87
Portrait of Ernestine Philippine Wilhelmine, née Haas (1771–1821), from 1794 first wife of publisher Joh. Friedrich von Cotta. Preparatory study in Schick's sketchbook (Staatsgalerie, Stuttgart).
Lit.: Cat. Stuttgart 1962, p. 182.

SCHIDER, Fritz
b. Salzburg 1846—d. Basle 1907

Began studies at Academy in Vienna. Continued studies 1868–73 at Munich Academy under A. von Wagner and Ramberg. In Munich joined the circle of Leibl, his friend and brother-in-law. From 1876 teacher at Art and Crafts school in Basle. 1886–7 and 1898 journeys to Italy and South Tyrol.
Lit.: E. Waldmann, 'Aus Fritz Schiders Münchener Zeit', in *Kunst und Künstler*, 14, 1916; H. Uhde-Bernays, *Münchener Landschafter im 19. Jahrhundert*, Munich 1921; G. J. Wolf, *Leibl und sein Kreis*, Munich 1923; E. Diem, 'Fritz Schider, Ein vergessener Vorläufer des deutschen Impressionismus', in *Die Kunst*, 55, 1957.

119. Landschaftsstudie. *c.* 1872.
Landscape study.
Oil on canvas. 32.5 × 25.5 cm.
Collection A. Winterstein, Munich
The study is a preparatory study for Schider's picture *Chinesischer Turm im Englischen Garten in München* (Chinese Tower in the English Garden, Munich) of 1872 in Basle (Öffentliche Kunstsammlung). Several preparatory studies in Basle (Öffentliche Kunstsammlung), Winterthur (Stiftung O. Reinhart) and Munich (Städtische Galerie im Lenbachhaus). An in-

dependent variation of 1873 in Düsseldorf (Kunstmuseum).

SCHIELE, Egon
b. Tulln an der Donau 1890—d. Vienna 1918

1906–09 studied at Academy in Vienna. 1907 met Gustav Klimt. 1909 left Academy and became a founder of the 'Neukunstgruppe Wien'. From 1913 wrote for Berlin periodical *Aktion*.
Lit.: O. Nierenstein, *Egon Schiele*, Berlin-Vienna-Leipzig 1930; O. Benesch, *Egon Schiele as a Draughtsman*, Vienna 1951; Exhib. *Viennese Expressionism, 1910–1914, The work of Egon Schiele with the work of Gustav Klimt and Oskar Kokoschka*, Berkeley, University of California, Art Gallery, 1963; O. Kallir, *Egon Schiele. The Graphic Work*, a catalogue raisonné, Vienna 1970; Exhib. *Egon Schiele*, Marlborough Gallery, London 1964; O. Kallir, *Egon Schiele*, Vienna 1966; R. Leopold, *Egon Schiele, Paintings, Watercolours, Drawings*, London 1972.

145. Herbstbaum. *c.* 1909
Tree in Autumn.
Oil on canvas. 89 × 89 cm.
Hessisches Landesmuseum, Darmstadt
Inv. No. G.K. 1178

SCHINKEL, Karl Friedrich
b. Neuruppin 1781—d. Berlin 1841

Early training with Friedrich Gilly in Berlin. In Paris till 1789. From 1799 studied at Academy of Architecture in Berlin. 1803 travelled to Rome, Naples and Sicily. 1804 in Paris and returned to Berlin in 1805. Until 1810 active primarily as landscape painter. After 1816 stage designer. Subsequently devoted all his attention to buildings. Built the Neue Wache in Berlin (1817–18), the Theatre (1819–20), the Cathedral (1816–21). 1822–24 built Tegel Castle for Wilhelm von

Humboldt. Journeyed again to Italy (1824), Paris and London (1826).
Lit.: K. F. Schinkel, *Briefe, Tagebücher, Gedanken*, ed. H. Mackowsky, Berlin 1922; P. O. Rave, *Schinkelbibliographie*, Berlin 1935; P. O. Rave, *Karl Friedrich Schinkel*, Munich 1953.

31. Dom über einer Stadt. 1813
Cathedral above a Town.
Oil on canvas. 93.8 × 125.7 cm.
Bayerische Staatsgemäldesammlungen, Munich
Inv. No. 13422
Probably first version, repeated 1813 (formerly Berlin, National-Galerie, destroyed 1931). An accurate copy of Berlin version by Wilhelm Ahlborn, 1823 in Berlin/West (Stiftung Preussischer Kulturbesitz, Nationalgalerie), preparatory studies in Berlin/East (Schinkel-Museum der National Galerie).
Lit.: Cat. Munich 1967, pp. 83–84.

SCHIRMER, Johann Wilhelm
b. Jülich 1807—d. Karlsruhe 1863

From 1825 studied at Academy in Düsseldorf. Together with C. F. Lessing worked on landscape studies. 1835 and 1837 travelled to Normandy and Switzerland. 1839–40 travelled to Italy. 1840–54 taught at Düsseldorf Academy. An influential landscape painter. 1854 became Director of newly-founded Academy in Karlsruhe.
Lit.: K. Zimmermann, *Johann Wilhelm Schirmer* (Thesis), Kiel 1920; Saalfeld 1920; H. Curjel, *Landschaftsstudien Johann Wilhelm Schirmers*, Düsseldorf 1925; J. W. Schirmer, *Lebenserinnerungen*, ed. P. Kauhausen, Krefeld 1956; I. Markowitz, *Die Düsseldorfer Malerschule*, Düsseldorf 1967.

81. Morgen. *c.* 1839/40
Morning.
Oil on paper, on pasteboard. 17.5 × 23 cm.
Wallraf-Richartz-Museum, Cologne

Inv. No. 1122
The landscape sketch belongs to a series of four sketches, depicting the times of day (Cologne, Wallraf-Richartz-Museum); one (Inv. No. 1123) used for picture *Landscape with Good Samaritan* 1856/57 (Wallraf-Richartz-Museum). The landscape sketch was probably produced during Schirmer's stay in Italy.
Lit.: Cat. Cologne 1964, p. 108 (mentioned under Inv. No. 1120).

80. Aufziehendes Gewitter in der Campagna. 1858
Storm rising in the Campagna.
Oil on canvas. 90 × 138 cm.
Sig. bottom l.: J. W. Schirmer
Staatliche Kunsthalle, Karlsruhe
Inv. No. 612
Preparatory oil studies in Basle (Öffentliche Kunstsammlung) and in Düren (Leopold-Hösch-Museum).
Lit.: Exhib. *Hans Thoma und sein Kreis*, Gemälde aus der Staatlichen Kunsthalle Karlsruhe, Stuttgart (Staatsgalerie) 1961/62, No. 21.

SCHLEICH, Eduard, the Elder
b. Haarbach 1812—d. Munich 1874

1824–27 studied at Munich Academy where he was influenced by C. Rottmann and Ch. Morgenstern. 1843 journey to Venice with Morgenstern, 1851 to France and Belgium with C. Spitzweg. Organized the first International Art Exhibition in Munich 1869, where the works of Courbet were very well received. Apart from a journey to Italy in 1871, he stayed in Munich.
Lit.: S. Wichmann, *Eduard Schleich d.Ä. 1812–1874* (Thesis), Munich 1951.

120. Strand. *c.* 1851
Seashore.
Oil on wood. 14.5 × 41 cm.
Bayerische Staatsgemäldesammlungen, Munich
Inv. No. 7690
Probably produced from Schleich's

journey to France with Spitzweg (1851).

SCHMIDT-ROTTLUFF, Karl
b. Rottluff near Chemnitz 1884—lives in Berlin

1905 studied architecture in Dresden, founded artists' group *Die Brücke* together with E. L. Kirchner, F. Bleyl and E. Heckel. 1906 stayed at Alsen with E. Nolde. 1910 in Berlin, where he met Feininger and O. Müller. Interim summer stays in Dangast. 1911 travelled to Norway. 1923 to Italy with Kolbe and Scheibe, 1924 with Kolbe to Paris and 1925 to Dalmatia. 1931 he was elected a member of the Prussian Academy of Art in Berlin. Stay in Rottluff until 1946. Has been living in Berlin since.
Lit.: W. R. Valentiner, *Karl Schmidt-Rottluff*, Leipzig 1920; K. Scheffler, 'Karl Schmidt-Rottluff', in *Kunst und Künstler*, 18, 1920, pp. 274–80; W. R. Valentiner, 'Karl Schmidt-Rottluff', in *Cicerone*, 12, 1920, pp. 454–76; R. Schapire, *Karl Schmidt-Rottluffs Graphisches Werk bis 1923*, Berlin 1924; E. Rathenau, *Karl Schmidt-Rottluff, Das graphische Werk seit 1923*, Stuttgart 1964; A. Dorner, *Karl Schmidt-Rottluff*, New Haven 1950; W. Grohmann, *Karl Schmidt-Rottluff*, Stuttgart 1956; G. Thiem, *Karl Schmidt-Rottluff, Aquarelle und Zeichnungen*, Munich 1959; Exhib. *Karl Schmidt-Rottluff*, Museum Folkwang, Essen 1964 (and in Frankfurt, Hanover, Berlin); K. Brix, *Karl Schmidt-Rottluff*, Vienna/Munich 1972.

149. Gutshof in Dangast (Grambergsche Häuser). *c.* 1910
Estate in Dangast (Gramberg Houses).
Oil on canvas. 86.6 × 94.5 cm.
Sig. bottom l.: S. Rottluff (on back: Schmidt-Rottluff Gutshof in Dangast).
Stiftung Preussischer Kulturbesitz, Nationalgalerie, Berlin (West)

Inv. No. Berlin B 86a.
Lit.: Cat. West Berlin 1968, pp. 185–86.

SCHNORR VON CAROLSFELD, Julius
b. Leipzig 1794—d. Dresden 1872

From 1811 studied at Academy in Vienna; met J. A. Koch during his stay there. Became pupil of Ferdinand Olivier, with whom he lived 1814–17. 1817 went to Italy where settled in Rome in 1818. Mixed with the Nazarenes. Friendship with Friedrich Olivier and Th. Rehbenitz. 1818–27 decorated the Ariosto Room in the Villa Massimo in Rome. At the same time produced landscape studies in the Alban and Sabine hillsides. 1825 King Ludwig I invited him to Munich to carry out the Odyssey frescoes in his Residence. To Sicily in 1826 to work on preparatory studies for these frescoes. Returned via Vienna to Munich and from 1827 worked on the Nibelungen frescoes in the Munich Residence, as the King had changed his plan. 1835–42 produced the frescoes of the History of the German Kings. 1846 elected Professor and Director of the Dresden picture gallery. Nibelungen illustrations appeared 1843, Bible illustrations 1860.
Lit.: *Briefe aus Italien von Julius Schnorr von Carolsfeld, geschrieben in den Jahren 1817–27*, publ. F. Schnorr von Carolsfeld, Gotha 1886; A. Trost, *Das römische Porträtbuch Julius Schnorrs von Carolsfeld*, Leipzig 1909; H. W. Singer, *Julius Schnorr von Carolsfeld*, Bielefeld and Leipzig 1911; K. Gerstenberg and P. O. Rave, *Die Wandgemälde im Casino Massimo zu Rom*, Berlin 1934; A. Schahl, *Geschichte der Bilderbibel von Julius Schnorr von Carolsfeld* (Thesis), Leipzig 1936; H. E. May, 'Zu Schnorr von Carolsfelds künstlerischer Entwicklung', in *Wallraf-Richartz-Jahrbuch*, 12/13, 1941/42; K. Andrews, *The Nazarenes*, Oxford 1964.

44. Weiblicher Akt. 1820
Female Nude.
Pencil, wash on paper. 334 × 263
mm.
Sig. bottom l.: d. 13 Julij 1820.
Staatliche Kunstsammlungen,
Kupferstich-Kabinett, Dresden
Inv. No. C 1908—760.

**43. Bildnis der Frau Bianca von
Quandt.** 1819–20
Portrait of Frau Bianca von
Quandt.
Oil on wood. 37 × 26 cm.
Unfinished.
Stiftung Preussischer Kulturbesitz,
Nationalgalerie, Berlin (West)
Inv. No. NG 1411
Frau Clara Bianca von Quandt
was the wife of the Dresden art
connoisseur Johann Gottlob von
Quandt (1787–1859). The portrait
was produced during the von
Quandts' stay in Rome (winter
1819/20). A preparatory water-
colour in Berlin/East (Staatliche
Museen zu Berlin, Kupferstich-
kabinett und Sammlung der Zeich-
nungen) and a sketch in ink in
Munich (Städtische Galerie im
Lenbachhaus).
Lit.: Cat. West Berlin 1968, pp.
187–88.

**36. Ariost Zimmer. Ansicht des
Raumes.** 1818–27
Ariosto Room. View of the room.
Frescoes.
Villa Massimo, Rome
Lit.: K. Andrews, *The Nazarenes*,
Oxford 1964.

39. Flucht nach Ägypten. 1828.
Flight to Egypt.
Oil on canvas. 120.5 × 114 cm.
Sig. bottom l.: 18 JS 28
Kunstmuseum, Düsseldorf
Inv. No. 4263.
Lit.: Cat. Düsseldorf 1968, pp.
105–06.

SCHUCH, Carl
b. Vienna 1846—d. Vienna 1903

1866–68 pupil of Vienna landscape
painter L. Halauska. From 1868
with painter A. Lang in Italy,
settled in Munich 1869/70, friendly
with W. Trübner and W. Leibl.
1872–3 again in Italy, especially
Olevano. In 1873 made studies on
the Hintersee near Berchtesgaden
with friend, pupil and biographer
K. Hagemeister. In 1873/4 spent
six months in Belgium and
Holland, went back to Olevano in
1875. 1874–6 more frequently in
Munich, then 1874–82 in Venice,
partly with Hagemeister, and in
summer in Frech and Kähnsdorf
near Berlin. 1882–94 lived in Paris.
Returned to Vienna in 1894 and
died after years of insanity.
Lit.: K. Hagemeister, *Karl Schuch,
Sein Leben und seine Werke*, Berlin
1913; C. Schuch, *Briefe*, mit einem
Vorwort von H. Roessler, Vienna
and Leipzig 1922; G. J. Wolf, *Leibl
und sein Kreis*, Munich 1923; E.
Ruhmer, 'Karl Schuch in Olevano',
in *Deutschland–Italien, Festschrift W.
Waetzoldt*, Berlin 1941, pp. 340–52.

130. Päonien. *c.* 1885
Peonies.
Oil on canvas. 63.7 × 56.3 cm.
(On the upper moulding of the
frame in blue chalk in W. Trübner's
handwriting: C. Schuch pxt quod
testat W. Trübner).
Bayerische Staatsgemäldesamm-
lungen, Munich
Inv. No. 8599
Lit.: Cat. Munich 1967, pp. 85–86.

SCHWIND, Moritz von
b. Vienna 1804—d. Munich 1871

At first studied philosophy at
Vienna University. From 1821
earned living with occasional draw-
ing while studying under Schnorr
von Carolsfeld. Member of Vienna
circle of Romantics with Schubert,
Lenau, Grillparzer, Kupelwieser
and the Olivier brothers. Worked
on book illustration 1821–25, e.g.
to the *Freischütz* and to Rossini's
operas. To Munich 1828, painted
ceiling frescoes in library in Königs-
bau in Munich Residenz until 1834.
Schnorr von Carolsfeld obtained
for him the job of doing the

frescoes for the Habsburg Room in the Residenz. To Italy 1835. In 1840 decorated staircase area in Karlsruhe Gallery. Appointed Professor at Munich Academy in 1847. 1854–55 painted frescoes in the Wartburg, 1863–67 frescoes in the loggia of the Vienna Opera House. At the same time he produced his cycles of illustrations to fairy tales, like *Cinderella* (finished in 1854), *Seven Ravens* (1857/8) and *The Tale of Fair Melusine* (from 1867). In Munich Schwind became a popular illustrator in the *Fliegende Blätter* pamphlets, in Munich *Bilderbögen* and of the *Gestiefelte Kater* (Puss in boots).

Lit.: M. von Schwind, *Briefe*, ed. O. Stoessl, Leipzig 1924; H. W. Rath, ed., *Briefwechsel zwischen Eduard Mörike und Moritz von Schwind*, Stuttgart 1919;—O. Weigmann, *Moritz von Schwind*, Stuttgart-Leipzig 1907; Fr. v. Ostini, *Moritz von Schwind*, Barmen 1925; P. Halm, *Moritz von Schwinds Zeichnungen und Aquarelle*, Exhib. Karlsruhe 1937; E. Hanfstaengl, *Moritz von Schwind*, Munich 1953; Commemorative exhib. *Moritz von Schwind*, Weimar 1954; J. Busse, *Die Bilderzählung des Moritz von Schwind* (Thesis), Cologne 1955.

55. Die Symphonie. 1852
The Symphony.
Oil on canvas. 169.3 × 99.5 cm.
Sig. in middle picture, bottom l.: 'Schwind inv.', inscription on architrave on left of sculpted frame: 'OTTO. I. GRAEC. REX'—on right: 'ORD. MDCCCLII'.
Bayerische Staatsgemäldesammlungen, Munich
Inv. No. WAF 1017
The idea for a 'Beethoven wall for a music room' derives from 1849. King Otto I of Greece, son of King Ludwig I of Bavaria, commissioned the picture in 1852 after seeing the cartoon (Leipzig, Museum für bildende Künste), and Schwind painted it in the same year. It depicts the love story of the

court singer Karoline Hetzenecker, who was a member of the Munich court opera 1839–49, and Privy Counsellor von Mangstle; the story is paraphrased by Beethoven's *Fantasia in C for Piano, Orchestra and Chorus* (Op. 80), divided into the sections allegro, andante, scherzo and allegro. Schwind also made sketches for a Mozart wall (*The Magic Flute*) and a Schubert wall, but the work was never executed. The Munich Cat. 1967 mentions all the preparatory studies.
Lit.: Cat. Munich 1967, pp. 87–89.

54. Die Hochzeitsreise. *c.* 1855
The Honeymoon Journey.
Oil on wood. 53.6 × 42.2 cm.
Bayerische Staatsgemäldesammlungen, Schack-Galerie, Munich
Inv. No. 11 577
A pencil study of the bride sitting in Munich (Staatliche Graphische Sammlung).
Lit.: Cat. Schack-Galerie, Munich 1969, pp. 355–57.

53. Morgenstunde. *c.* 1858
Morning Hour.
Oil on canvas. 34.8 × 41.9 cm.
Bayerische Staatsgemäldesammlungen, Schack-Galerie, Munich
Inv. No. 11 559.
An earlier version of 1852 in Darmstadt (Hessisches Landesmuseum).
Lit.: Cat. Schack-Galerie, Munich 1969, pp. 360–62.

SLEVOGT, Max
b. Landshut 1868—d. Neukastel 1932

Studied under J. Herterich and W. von Diez at Munich Academy 1885–89, friendly with W. Trübner. Made study trip to Paris 1889, worked at Académie Julian; 1880 first study trip to Italy with painter R. Breyer. In Holland in 1898, principally studying Rembrandt's paintings. From 1896 collaborated on *Jugend* and *Simplicissimus*, moved to Berlin in 1901. Travelled to Egypt in 1914, and became director of a master's studio at Berlin Academy of Arts in 1917,

and was also made a member of the Academies of Berlin, Munich and Dresden. In 1924 painted murals in Berlin and Neukastel, and others for the Hauff Room in the Bremen Ratskeller in 1927. Painted Golgotha fresco in Friedenskirche in Ludwigshafen am Rhein in 1931/2 (destroyed in the war).
Lit.: E. Waldmann, *Max Slevogt, Graphische Kunst*, Dresden 1921; E. Waldmann, *Max Slevogt*, Berlin 1923; W. v. Alten, *Max Slevogt*, Bielefeld and Leipzig 1926; K. Scheffler, *Max Slevogt*, Berlin 1940; Commemorative Exhib. *Max Slevogt*, Mannheim 1948; J. Sievers and E. Waldmann, *Max Slevogt, Das druckgraphische Werk*, ed. H. J. Imiela, Heidelberg and Berlin 1962; H. J. Imiela, *Max Slevogt*, Karlsruhe 1968.

140. Der 'Schwarze d'Andrade'. 1903
The 'Black d'Andrade'.
Oil on canvas. 150 × 109 cm.
Sig. bottom l.: Slevogt 1903.
Kunsthalle, Hamburg
Inv. No. 5149
Slevogt depicted the Portuguese singer Francisco d'Andrade (1856–1921) in his most outstanding role as Don Giovanni in Mozart's opera performed in the Champagnerie (*The White d'Andrade*, 1902, Staatsgalerie, Stuttgart); and then as *The Black d'Andrade* in the death scene, when Don Giovanni is seized by the white marble hand of the Commendatore—the Hamburg picture; and finally as *The Red d'Andrade* (1912, National-Galerie, East Berlin). Some preparatory studies for the Hamburg picture are mentioned by Imiela, 1968.
Lit.: Cat. Hamburg 1969, p. 120.

139. Bildnis der Tänzerin Marietta di Rigardo. 1904
Portrait of the Dancer Marietta di Rigardo.
Oil on canvas. 229 × 180 cm.
Sig. bottom r.: Slevogt 1904.
Gemäldegalerie Neue Meister, Staatliche Kunstsammlungen, Dresden

Inv. No. 2549
A preparatory study dated 1904 in oil on pasteboard in Dresden (Gemäldegalerie Neue Meister). Slevogt etched the composition in 1904 under the title *The Dancer*, and repeated it in the series *Black Scenes*, 1923 (plate 6).
Lit.: Cat. Dresden 1960, p. 95.

141. Achill schreckt die Trojaner.
1907
Achilles Frightens the Trojans.
Lithograph. 272 × 420 mm.
A plate from the series 'Achilles, 15 lithographs to the Iliad by Max Slevogt, A. Langen, Munich' of 1907 (original title: 'Achill, 15 Lithographien zur Ilias von Max Slevogt, Verlag A. Langen, München').
Wallraf-Richartz-Museum, Kupferstichkabinett, Cologne
Inv. No. 9129/3

SPITZWEG, Carl
b. Munich 1808—d. Munich 1885

Began as apothecary in Munich and Straubing. Trained as draughtsman and painter under Ch. H. Hanson in Munich from 1833, also self-taught. Copied early Dutch paintings in Alte Pinakothek in Munich. Friendly with B. Stange, D. Langko, Ch. Morgenstern and E. Schleich, with whom he shared a distaste for the Academy. In the 1840s made several trips to Italy. In 1844 produced illustrations for *Fliegende Blätter* in Munich. To Prague in 1849, influenced by J. Návratil and J. Mánes. In 1851 went to Paris and London with E. Schleich, studying the works of the Barbizon painters and Constable. Made study trips in vicinity of Munich with E. Schleich and D. Langko 1852–62. Friendly with H. Bürkel, M. von Schwind, F. Pecht, E. Grützner and F. Lachner.
Lit.: H. Uhde-Bernays, *Carl Spitzweg, Des Meisters Werk und seine Bedeutung in der Geschichte der Münchener Kunst*, Munich 1913;

M. von Boehn, *Karl Spitzweg*, 4th ed. Bielefeld and Leipzig 1937; A. Elsen, *Carl Spitzweg*, Vienna 1948; E. Kalkschmidt, *Karl Spitzweg und seine Welt*, 2nd ed. Munich 1949; G. Roennefahrt, *Carl Spitzweg, Beschreibendes Verzeichnis seiner Gemälde, Ölstudien und Aquarelle*, Munich 1960; E. Höhne, *Carl Spitzweg*, Leipzig 1961; E. Hanfstaengl, *Bilder von Carl Spitzweg*, Zürich 1965; Exhib. *Carl Spitzweg und sein Freundeskreis*, Haus der Kunst, Munich 1967; S. Wichmann, *Carl Spitzweg—Der Maler, der Zeichner, Ein Corpus der Vorzeichnungen zu den Gamälden*, Stuttgart 1968.

56. Der Liebesbrief. 1845/46
The Love Letter.
Oil on canvas. 24 × 21 cm.
Stiftung Preussischer Kulturbesitz, Nationalgalerie, Berlin (West)
Inv. No. NG 1298
Lit.: Cat. West Berlin 1968, p. 206.

57. Der Witwer. *c.* 1850
The Widower.
Oil on canvas. 42.7 × 49.6 cm.
Sig. bottom r.: S (in the rhombus) Spitzweg.
Bayerische Staatsgemäldesammlungen, Munich
Inv. No. 8899
A variant of the picture dated 1844 in Frankfurt (Städelsches Kunstinstitut). A tree study for the picture in private collection in Germany.
Lit.: Cat. Munich 1967, p. 92.

THOMA, Hans
b. Bernau 1839—d. Karlsruhe 1924

After short study as lithographer and painter began studies at Karlsruhe Art School in 1859 under L. Descoudres, J. W. Schirmer and H. Canon. In 1867 to Düsseldorf Academy, where he met O. Scholderer, with whom he went to Paris. Courbet and Barbizon painters influenced him strongly. After a short stay in Karlsruhe went to Munich 1870, established con-nection with the Leibl circle and made friends with V. Müller, A. Böcklin and A. Bayersdorfer. In 1874 made first journey to Italy with A. Lang, and stayed in Frankfurt on several occasions, finally settling there 1877–99. Travelled to Italy again in 1880 and 1887, met A. von Hildebrand in Florence. Had great success in 1890 exhibition of Munich Art Club. In 1899 appointed Professor and Director of the Gallery in Karlsruhe, moved there in same year.
Lit.: H. Thoma, *Im Herbste des Lebens, Gesammelte Erinnerungsblätter*, Munich 1909; H. Thoma, *Im Winter des Lebens, Aus acht Jahrzehnten gesammelte Erinnerungen*, Jena 1919;—H. Thode, *Hans Thoma*, Stuttgart 1909; E. Würtenberger, *Hans Thoma*, Erlenbach-Zürich 1924; Exhib. *Hans Thoma, 1839–1924*, Karlsruhe 1939; Exhib. *Hans Thoma und sein Kreis, Gemälde aus der Staatlichen Kunsthalle Karlsruhe*, Staatsgalerie Stuttgart 1962.

124. Im Sonnenschein. 1867
In the Sunshine.
Oil on canvas. 108 × 85 cm.
Staatliche Kunsthalle, Karlsruhe
Inv. No. 1285
The picture, which Thoma himself testified to have painted in 1867, possesses a variant in *Singing Children* in Hanover (Landesmuseum), which depicts the same landscape.
Lit.: Exhib. *Hans Thoma und sein Kreis*, Stuttgart 1962, No. 5.

126. Mainlandschaft. 1875
Main (River) Landscape.
Oil on canvas. 85.5 × 124.4 cm.
Sig. bottom r.: Hans Thoma. 1875.
Bayerische Staatsgemäldesammlungen, Munich
Inv. No. 8878
The same motif, seen from a different angle, appears in the picture *Main Landscape* of 1875 in Vienna (Neue Galerie des Kunsthistorischen Museums). Also about 1875 Thoma painted a slightly different mural for the Ullmann house in Frankfurt. In 1900 he took

up the theme again in a sketch (formerly in private collection, Dresden) and in an etching.
Lit. Cat. Munich 1967, p. 102.

125. Selbstbildnis mit Frau. 1887
Self-portrait with Wife.
Oil on canvas. 62 × 76 cm.
Sig. on the wall on the right: H Th (intertwined) 87.
Kunsthalle, Hamburg
Inv. No. 1540
The artist's wife is Bonicella Thoma, née Berteneder (1858–1901).
Lit.: Cat. Hamburg 1969, p. 337.

TISCHBEIN, Johann Heinrich Wilhelm
b. Haina 1751—d. Eutin 1829

From 1766 pupil of his uncle Johann Jacob Tischbein in Hamburg. Travelled through Switzerland, Holland and Italy, where he lived in Naples from 1787 and became Director of the Academy in 1789. Settled in Hamburg in 1800 and moved to Eutin in 1809.
Lit.: Tischbein, *Aus meinem Leben*, ed. G. G. W. Schiller, Leipzig 1861;—Luthmer, *Die hessische Malerfamilie Tischbein*, Cassel n.d.; F. Landsberger, *Wilhelm Tischbein*, 1908; A. Stoll, *Der Maler Johann Friedrich August Tischbein und seine Familie*, Stuttgart 1923; J. W. Goethe, *Wilhelm Tischbeins Idyllen*, new ed. Munich 1970; Exhib. *J. H. W. Tischbein*, Landesmuseum Oldenburg, Oldenburg 1930.

3. Goethe in der Römischen Campagna. 1786/88
Goethe in the Roman Campagna.
Oil on canvas. 164 × 206 cm.
Städelsches Kunstinstitut, Frankfurt
Inv. No. 1157
Portrays the poet and scholar Johann Wolfgang von Goethe (1749–1832) during his Italian journey (1786–88), on which Tischbein accompanied him. The first sketch for the portrait, mentioned by Goethe, has been lost; there is a watercolour bust study of about

1793 in Weimar (Nationale Forschungsstätten), and a free copy made at the same time by H. Meyer, F. Bury and J. G. Schütz in Weimar (Schlossmuseum). The scenes from the story of Iphigenia depicted on the ancient sarcophagus refer to the fact that Goethe had completed his play *Iphigenie* in Italy.

TRÜBNER, Wilhelm
b. Heidelberg 1851—d. Karlsruhe 1917

On the advice of A. Feuerbach attended Karlsruhe Art School under R. Schick and H. Gude 1867–68, and was also strongly influenced by H. Canon. At Munich Academy 1869, got to know Courbet's and Leibl's art at 1st International Art Exhibition in Munich in 1869. Worked in Canon's studio in Stuttgart in the winter of 1869/70, then returned to Munich and joined Leibl circle. After various journeys, mostly in the company of C. Schuch (Italy, Holland), settled in Munich in 1875, stayed till 1896, apart from journeys to Paris (1879 and 1889), and to London (1884/5). Moved to Frankfurt in 1896, taught at Städelsches Kunstinstitut. Professor at Karlsruhe Academy 1903–17.
Lit.: W. Trübner, *Personalien und Prinzipien*, introduction by E. Waldmann, Berlin 1918 (2nd and 3rd ed.);—G. Fuchs, *Wilhelm Trübner und sein Werk*, Munich-Leipzig 1908; J. A. Beringer, *Trübner*, Stuttgart-Berlin 1917; G. J. Wolf, *Leibl und sein Kreis*, Munich 1923; K. Martin, *Wilhelm Trübner und sein Kreis*, Karlsruhe 1951 (exhib.).

127. Ein Zeitung Lesender Mohr. 1872
Moor reading a Newspaper.
Oil on canvas. 63 × 51 cm.
Sig. bottom r.: W. Trübner 1872.
Städelsches Kunstinstitut, Frankfurt
Inv. No. 1352
Two further versions privately

244

owned. In Waldmann's book (*Die Kunst des Realismus und des Impressionismus*, 1927) a work is reproduced on p. 313 which purports to be the Frankfurt picture, but is signed at top right: W. Trübner. The reproduction is, however, clearly not identical with the Frankfurt picture.

129. Buchenwald mit Liebespaar.
1876
Beechwood with Pair of Lovers.
Oil on canvas. 55 × 46 cm.
Sig. bottom r.: W. Trübner. 1876.
Neue Galerie des Kunsthistorischen Museums, Vienna
Inv. No. MG 294
Lit.: Cat. Vienna 1966, p. 57.

UHDE, Fritz von
b. Wolkenburg in Saxony 1848 – d. Munich 1911

At Dresden Academy 1866, then began 10-year military career in Saxon cavalry and taught himself painting. Went to Vienna in 1876 to become a pupil of Makart, but Makart refused to accept him. He was likewise refused in Munich by K. von Piloty, W. von Diez and W. von Lindenschmidt. On the advice of F. von Lenbach continued to study on his own, copying the Dutch masters in the Alte Pinakothek. 1879–80 pupil of M. v. Munkácsy in Paris. Returned to Munich at end of 1880 and earned friendship of M. Liebermann, who greatly helped his progress as an artist. Was one of founders of *Secession* in Munich.
Lit.: F. von Ostini, *Uhde*, Bielefeld and Leipzig 1902; H. Rosenhagen, *Fritz von Uhde*, Stuttgart and Berlin 1908; O. J. Bierbaum, *Fritz von Uhde*, Munich and Leipzig 1908.

136. Mutter und Kind. *c.* 1892
Mother and Child.
Oil on wood. 133 × 63.5 cm.
Sig. bottom l.: F. Uhde
Städtische Galerie im Lenbachhaus, Munich
Inv. No. 1784

VEIT, Philipp
b. Berlin 1793 – d. Mainz 1877

With brother Johannes at Dresden Academy 1809–11. Lived in Vienna from 1811. In the house of his stepfather Friedrich Schlegel he met J. v. Eichendorff, Th. Körner and J. A. Koch. Went to Rome in 1815, allied himself with Overbeck and Cornelius, helping the latter with the frescoes in the Casa Bartholdy. After Cornelius's departure to Munich, took over decoration of Dante Room in Villa Massimo (1819–24). Took inspiration from Führich and Steinle. In 1830 invited to become Director of Städelsches Institut in Frankfurt; in 1854 to Mainz Museum as Director. In later years mostly painted religious painting in style of Nazarenes.
Lit.: M. Spahn, *Philipp Veit*, Bielefeld 1901; K. Andrews, *The Nazarenes*, Oxford 1964.

40. Bildnis der Freifrau von Bernus.
1838
Portrait of Baroness von Bernus.
Oil on canvas. 128.6 × 97.2 cm.
Sig. bottom l.: 18 PVS (Monogram: Philipp Veit—Schlegel) 38.
Städelsches Kunstinstitut, Frankfurt
Inv. No. 1798

WALDMÜLLER, Ferdinand Georg
b. Vienna 1793 – d. Helmstreitmühle near Baden (Austria) 1865

In 1807 began training under Viennese flower-painter Zintler. Then attended Vienna Academy under H. Maurer and J. B. Lampi. From 1811 drawing master in House of Count Gyulay in Agram, subsequently worked as theatre painter, e.g. 1815 at Stadttheater in Baden near Vienna. Returned to Vienna in 1817 and studied further. From 1825 for two decades made summer study trips to Italy. In 1827 in Dresden and Leipzig, became Keeper of Vienna picture gallery in 1829 and Professor of the Aca-

demy in Vienna. From the 1840s opposed traditional academic studies and advocated study of nature. In 1830 and 1855 in Paris, in 1856 in London. After the continuation of his dispute in Vienna, pensioned in 1857 as a punishment, but reinstated by Emperor Franz Joseph in 1864.
Lit.: F. G. Waldmüller, *Das Bedürfnis eines zweckmässigen Unterrichts in der Malerei und plastischen Kunst, Angedeutet nach eigenen Erfahrungen*, Vienna 1846; F. G. Waldmüller, *Andeutungen zur Belebung der vaterländischen bildenden Kunst*, Vienna 1857; F. G. Waldmüller, 'Imitation, Reminiszenz, Plagiat. Bemerkungen über krankhafte Zustände der bildenden Kunst', in *Frankfurter Museum*, 1857;—K. K. Eberlein, *F. G. Waldmüller*, Berlin 1938; A. Roessler—G. Pisko, *F. G. Waldmüller*, Vienna 1907; B. Grimschitz, *Ferdinand Georg Waldmüller*, Salzburg 1957.

70. **Blick auf Ischl.** 1838
View of Ischl.
Oil on wood. 45 × 57.5 cm.
Sig. in the middle at the bottom: Waldmüller 1838
Stiftung Preussischer Kulturbesitz, Nationalgalerie, Berlin (West)
Inv. No. NG 1040
Lit.: Cat. Berlin/West 1968, pp. 221–222.

71. **Mutter und Kind.** 1835
Mother and Child.
Oil on canvas. 94 × 74 cm.
Sig. bottom r.: Waldmüller 1835.
Stiftung Preussischer Kulturbesitz, Nationalgalerie, Berlin (West)
Inv. No. NG 1039
Lit.: Cat. Berlin/West 1968, p. 221.

WASMANN, Friedrich
b. Hamburg 1805—d. Meran 1886

Attended Dresden Academy 1824–28 under G. H. Naeke. Went to Munich on Hamburg scholarship in 1829 to study at Academy under P. von Cornelius and H. M. von Hess. In 1830 settled in Meran. Travelled to Rome in 1832 and joined Overbeck and his friends. Returned to Munich in 1835. In 1839 again lived in Meran, then in Bozen, working mainly as a portrait-sketcher. From 1843 portrait-painter in Hamburg, lived continuously in Meran from 1846.
Lit.: F. Wasmann, *Ein deutsches Künstlerleben, von ihm selbst geschildert*, ed. B. Grönvold, Leipzig 1915;—P. Nathan, *Friedrich Wasmann, sein Leben und sein Werk*, Munich 1954.

68. **Durchblick im Bergwald.** *c.* 1833
View through Wooded Hillside.
Oil on paper on pasteboard. 30.5 × 22.2 cm.
Kunsthalle, Kupferstichkabinett, Hamburg
Inv. No. 35123

69. **Meraner Blumengarten.** *c.* 1840
Flower Garden in Meran.
Oil on pasteboard. 40.3 × 34 cm.
Kunsthalle, Hamburg
Inv. No. 1399
The picture, painted in 1840, is based on a similar composition of 1831 in Winterthur (Stiftung O. Reinhart), on the back of which is inscribed: Ottmansgut unter dem Berge.
Lit.: Cat. Hamburg 1969, p. 359.

WINTERGERST, Josef
b. Wallerstein near Ellwangen 1783—
d. Düsseldorf 1867

From 1804 at Munich Academy, then in Vienna, where joined F. Overbeck and helped to found Brotherhood of St Luke. Went to Rome in 1811, became member of the community in the Monastery of San Isidoro. In Heidelberg for a short time in 1813, then drawing-master in Aarau. Became drawing-master in Ellwangen in 1815 and was on several occasions in Heidel-

berg. On recommendation of P. von Cornelius became teacher in 1822, Inspector in 1824 at Düsseldorf Academy.
Lit.: J. Ch. Jensen, 'Das Werk des Malers Josef Wintergerst', in *Zeitschrift des Deutschen Vereins für Kunstwissenschaft*, XXI, 1967, pp. 21–58.

38. Sarah führt Abraham die Hagar zu. 1809
Sarah leading Hagar to Abraham.
Oil on canvas. 87 × 68 cm.
Sig. bottom l.: Wintergerst inv. et pinx. 1809.
Staatliche Museen zu Berlin, National-Galerie, Berlin (East)
Inv. No. A III 477

Bibliography

1. General Books

*Books written in English.

A. ANDRESEN, *Die deutschen Maler-Radirer des neunzehnten Jahrhunderts nach ihren Leben und Werken*, Leipzig 1878.

*K. ANDREWS, *The Nazarenes, A Brotherhood of German Painters in Rome*, Oxford 1964.

H. BEENKEN, *Das neunzehnte Jahrhundert in der deutschen Kunst*, Munich 1944.

R. BENZ, *Der Geist der romantischen Malerei*, Dresden 1934.

R. BENZ and A. VON SCHNEIDER, *Die Kunst der deutschen Romantik*, Munich 1939.

H. BÖRSCH-SUPAN, *Deutsche Romantiker. Deutsche Maler zwischen 1800 und 1850*, Munich 1972.

F. BOETTICHER, *Malerwerke des 19. Jahrhunderts*, Leipzig 1891–1901, new ed. 1941.

P. BRIEGER, *Die deutsche Geschichtsmalerei des. 19. Jahrhunderts*, Berlin 1930.

*M. BRION, *Art of the Romantic Era: Romanticism, Classicism, Realism*, London 1966.

L. G. BUCHHEIM, *Die Künstlergemeinschaft Brücke. Gemälde, Zeichnungen, Graphik, Plastik, Dokumente*, Feldafing 1956.

L. G. BUCHHEIM, *Der Blaue Reiter und die "Neue Künstlervereinigung München"*, Feldafing 1959.

*L. G. BUCHHEIM, *The Graphic Art of German Expressionism*, New York 1960.

E. BÜLAU, *Der englische Einfluss auf die deutsche Landschaftsmalerei im frühen 19. Jahrhundert*, (Thesis) Freiburg i.B. 1955.

E. CASSIRER, *Künstlerbriefe aus dem neunzehnten Jahrhundert*, Berlin 1923.

*J. CASSOU, E. LANGUI, N. PEVSNER, *The Sources of Modern Art*, London 1962.

*K. and K. CHAMPA, *German Painting of the Nineteenth Century*, New Haven 1970.

U. CHRISTOFFEL, *Die romantische Zeichnung von Runge bis Schwind*, Munich 1920.

U. CHRISTOFFEL, *Deutsche Malerei des 19. Jahrhunderts*, Leipzig 1925.

*P. COURTHION, *Romanticism*, Lausanne 1961.

C. Denecke, *Die Farbe im Expressionismus bei Franz Marc und Emil Nolde*, Düsseldorf 1950.

L. von Donop, *Die Wandgemälde der Casa Bartholdy in der Nationalgalerie*, Berlin 1888.

B. Dörries, *Zeichnungen der Frühromantik*, Munich 1950.

*O. Edwards, G. Martin and A. Scharf, *Romanticism*, Bletchley 1972.

A. Feulner, *Skulptur und Malerei des 18. Jahrhunderts in Deutschland*, Wildpark-Potsdam 1929.

R. Feuchtmüller and W. Mrazek, *Biedermeier in Österreich*, Vienna 1963.

H. Fuchs, *Die österreichischen Maler des 19. Jahrhunderts*, Vienna 1972.

W. Geismeier, *Deutsche Malerei des 19. Jahrhunderts*, Leipzig 1966.

H. Geller, *Die Bildnisse der deutschen Künstler in Rom 1800–1830; mit einer Einführung in die Kunst der Deutschrömer von H. von Einem*, Berlin 1952.

K. Gerstenberg, *Die ideale Landschaftsmalerei, Ihre Begründung und Vollendung in Rom*, Halle 1923.

K. Gerstenberg and O. P. Rave, *Die Wandgemälder der deutschen Romantiker im Casino Massimo zu Rom*, Berlin 1934.

C. Gurlitt, *Die deutsche Kunst seit 1800*, 4th ed. Berlin 1924.

F. Haack, *Die Kunst des XIX. Jahrhunderts*, Stuttgart 1905.

*W. Haftmann, *Painting in the Twentieth Century*, London 1965.

R. Hamann, *Die deutsche Malerei im 19. Jahrhundert*, Leipzig-Berlin 1914.

R. Hamann, *Die deutsche Malerei vom Rokoko bis zum Expressionismus*, Leipzig-Berlin 1925.

R. Hamann, J. Hermand, *Deutsche Kunst und Kultur von der Grunderzeit bis zum Expressionismus*, Berlin 1965.

*G. H. Hamilton, *Painting and Sculpture in Europe, 1880–1940*, Harmondsworth 1967.

C. G. Heise, *Grosse Zeichner des 19. Jahrhunderts*, Berlin 1959.

W. Hess, *Dokumente zum Verständnis der modernen Malerei*, Hamburg 1956.

H. Hildebrandt, *Die Kunst des XIX. und XX. Jahrhunderts*, Wildpark-Potsdam 1924.

Historismus und bildende Kunst, Studien zur Kunst des neunzehnten Jahrhunderts, Vol. 1, Munich 1965.

*W. Hofmann, *Art in the Nineteenth Century*, London 1961.

*W. Hofmann, *Turning Points in Twentieth-Century Art, 1890–1917*, London 1969.

H. H. Hofstatter, *Geschichte der europäischen Jugendstilmalerei, ein Entwurf*, Cologne 1963.

*E. G. Holt, ed., *From the Classicists to the Impressionists, A Documentary History of Art and Architecture in the 19th Century*, London and New York 1966.

*H. Honour, *Neo-classicism*, Harmondsworth 1969.

H. Jerchel, *Malerei der Romantik*, Munich 1932.

L. Justi, *Deutsche Zeichenkunst im neunzehnten Jahrhundert, Ein Führer zur Sammlung der Handzeichnungen in der Nationalgalerie Berlin*, Berlin 1919.

L. Justi, *Deutsche Malkunst im neunzehnten Jahrhundert, Ein Führer durch die Nationalgalerie Berlin*, Berlin 1921.

L. Justi, *Von Runge bis Thoma, Deutsche Malkunst im 19. und 20. Jahrhundert, Ein Gang durch die Nationalgalerie*, Berlin 1932.

L. Justi and H. Weissgärber, *Zeichnungen deutscher Meister vom Klassizismus bis zum Impressionismus*, Berlin 1954.

K. Kaiser, *Deutsche Malerei um 1800*, Leipzig 1959.

H. Karlinger, *München und die deutsche Kunst des XIX. Jahrhunderts*, Munich 1933.

B. Knaus, *Das Künstlerideal des Klassizismus und der Romantik*, Reutlingen 1925.

*C. L. Kuhn, *German Expressionism and Abstract Art*, Cambridge Mass. 1957.

K. Lankheit, *Das Freundschaftsbild der Romantik*, Heidelberg 1952.

K. Lankheit, *Revolution und Restauration*, Baden-Baden 1965.

* G. Lindemann, *History of German Art, Painting, Sculpture, Prints and Architecture*, London 1970.

K. Lohmeyer, *Heidelberger Maler der Romantik*, Heidelberg 1935.

J. Meier-Graefe, *Entwicklungsgeschichte der modernen Kunst*, 3 vols, 4th ed. Munich 1924.

*J. Meier-Graefe, *Modern Art. Being a Contribution to a new system of aesthetics*, 2 vols, London 1908.

R. Muther, *Geschichte der Malerei im 19. Jahrhundert*, 3 vols, Munich 1893–94.

*R. Muther, *The History of Modern Painting, in Three Volumes*, London 1895.

*B. S. Myers, *The German Expressionists, A Generation in Revolt*, New York 1957 (concise ed. 1963).

F. Noack, *Das Deutschtum in Rom, seit dem Ausgang des Mittelalters*, 2 vols, Berlin-Leipzig 1927.

*L. Nochlin, ed., *Realism and Tradition in Art, 1848–1900, Sources and Documents*, Englewood Cliffs, New Jersey 1966.

* F. Novotny, *Painting and Sculpture in Europe, 1780–1880*, Harmondsworth 1960.

R. Oldenbourg and H. Uhde-Bernays, *Die Münchener Malerei im neunzehnten Jahrhundert*, 2 vols, Munich 1922.

M. Osborn, *Die deutsche Kunst im neunzehnten Jahrhundert*, Berlin 1901.

G. Pauli, *Die Kunst des Klassizismus und der Romantik*, Berlin 1925.

G. Pauli, *Das neunzehnte Jahrhundert*, 2 vols, Berlin 1934.

F. Pecht, *Deutsche Künstler des 19. Jahrhunderts, Studien und Erinnerungen*, Nördlingen 1877–81.

F. Pecht, *Geschichte der Münchener Kunst*, Munich 1889.

P. O. Rave, *Deutsche Malerei des 19. Jahrhunderts*, Berlin n.d.

H. Riegel, *Geschichte der deutschen Kunst seit Carstens und Gottfried Schadow. Vol. 1: Geschichte des Wiederauflebens der deutschen Kunst zu Ende des 18. und Anfang des 19. Jahrhunderts*, Hanover 1876.

*F. Roh, *German Art in the Twentieth Century, Painting — Sculpture — Architecture*, London 1968.

A. Rosenberg, *Geschichte der modernen Kunst*, 2nd ed. vols 2 and 3, Leipzig 1894.

A. Rümann, *Die illustrierten deutschen Bücher des 19. Jahrhunderts*, Stuttgart 1926.

*R. Samuel and R. H. Thomas, *Expressionism in German Life, Literature, and the Theatre (1901–1924)*, Cambridge 1939.

A. F. von Schack, *Meine Gemäldesammlung*, Stuttgart 1881.

K. Scheffler, *Deutsche Maler und Zeichner im neunzehnten Jahrhundert*, 2nd ed. Leipzig 1920.

K. Scheffler, *Die europäische Kunst im neunzehnten Jahrhundert*, 2 vols, Berlin 1927.

K. Scheffler, *Verwandlungen des Barocks in der Kunst des 19. Jahrhunderts*, Vienna 1947.

K. Scheffler, *Das Phänomen der Kunst: Grundsätzliche Betrachtungen zum 19. Jahrhundert*, Munich 1952.

W. Scheidig, *Goethes Preisaufgaben für bildende Künstler 1799–1805*, Weimar 1958.

E. L. Schellenberg, *Das Buch der deutschen Romantik. Die Sehnsucht nach*

249

dem Unendlichen, Berlin-Lichterfelde 1924.

E. SCHILLING, Deutsche Romantiker-Zeichnungen, Frankfurt 1935.

P. F. SCHMIDT, Die deutsche Landschaftsmalerei von 1750–1830, Munich 1922.

P. F. SCHMIDT, Biedermeier-Malerei: Zur Geschichte und Geistigkeit der deutschen Malerei in der ersten Hälfte des neunzehnten Jahrhunderts, Munich 1922.

P. F. SCHMIDT, Deutsche Malerei um 1800. Vol. I: Die Landschaft, Vol. II: Bildnis und Komposition, Munich 1922 and 1928.

P. F. SCHMIDT, Geschichte der modernen Malerei, 8th ed. Stuttgart 1957.

*R. SCHMUTZLER, Art Nouveau, New York and London 1964.

A. VON SCHNEIDER, Deutsche Romantiker —Zeichnungen, Munich 1942.

H. SCHRADE, Deutsche Maler der Romantik, Cologne 1967.

C. W. SCHÜMANN, Deutsche Malerei des 19. Jahrhunderts, Cologne 1971.

*P. SELZ, German Expressionist Painting, Berkeley, Calif. 1957.

U. THIEME and F. BECKER, Allgemeines Lexikon der bildenden Künstler, vols. 1–37, Leipzig 1907–1950.

H. UHDE-BERNAYS, Münchener Landschafter im 19. Jahrhundert, Munich 1921.

H. UHDE-BERNAYS, Die Münchener Malerei im neunzehnten Jahrhundert, Munich 1925.

E. WALDMANN, Das Bildnis im 19. Jahrhundert, Berlin 1921.

E. WALDMANN, Die Kunst des Realismus und des Impressionismus im 19. Jahrhundert, Berlin 1927.

H. WENTZEL, Bildnisse der Brücke-Künstler voneinander, Stuttgart 1961.

S. WICHMANN, Realismus und Impressionismus in Deutschland, Stuttgart 1964.

R. ZEITLER, Klassizismus und Utopia, Stockholm 1954.

R. ZEITLER, Die Kunst des 19. Jahrhunderts, Berlin 1966.

*C. ZIGROSSER, The Expressionists, A Survey of their Graphic Art, New York 1957.

2. Exhibition Catalogues

Berlin 1906. Ausstellung deutscher Kunst aus der Zeit von 1775–1875, Gemälde und Skulpturen, Königliche Nationalgalerie Berlin, 2nd ed. Munich 1906.

Berlin 1906 I. H. v. Tschudi, Ausstellung deutscher Kunst aus der Zeit von 1775–1875, in der Königlichen Nationalgalerie Berlin 1906, Auswahl der hervorragendsten Bilder mit einleitendem Text, Munich 1906.

Berlin 1906 II. Ausstellung deutscher Kunst aus der Zeit von 1775–1875, in der Königlichen Nationalgalerie Berlin 1906, Katalog der Gemälde mit 1137 Abbildungen, Munich 1906.

Berlin 1957. Deutsche Landschaftsmalerei 1800–1914, Nationalgalerie Berlin 1957.

Berlin 1968. Le salon imaginaire, Bilder aus den grossen Kunstausstellungen der zweiten Hälfte des XIX. Jahrhunderts, Ausstellung der Deutschen Gesellschaft für Bildende Kunst und der Akademie der Künste, Berlin 1968.

Bern 1936. Deutsche Malerei im 19. Jahrhundert, Kunsthalle Bern, 1936.

Bremen 1967. Berliner Biedermeier von Blechen bis Menzel, Gemälde, Handzeichnungen, Aquarelle, Druckgraphik, Kunsthalle Bremen, Bremen 1967.

Cologne 1949. Deutsche Malerei und Zeichenkunst im Zeitalter Goethes, Wallraf-Richartz-Museum, Cologne 1949.

Cologne 1950. Köln 1900 Jahre Stadt, Wilhelm Leibl und Gustave Courbet, Kölnischer Kunstverein, Wallraf-Richartz-Museum der Stadt Köln, Cologne 1950.

Darmstadt 1961. Zeichnungen der Romantik. Ausstellung des Kunstvereins Darmstadt in der Kunsthalle Darmstadt, 1961.

Duisburg 1970. *Industrie und Technik in der deutschen Malerei von der Romantik bis zur Gegenwart*, Duisburg 1970.

Edinburgh 1960. *The Blue Rider Group*, Royal Scottish Academy, Edinburgh 1960.

Essen 1958. *Brücke, 1905–1913, Eine Künstlergemeinschaft des Expressionismus*, Museum Folkwang Essen, Essen 1958.

Heidelberg 1965. *Schlösser, Burgen, Ruinen in der Malerei der Romantik, Gemälde, Aquarelle und Graphik deutscher, österreichischer und schweizer Künstler 1770 bis 1860, Ausstellung des Kurpfälzischen Museums im Ottheinrichsbau des Heidelberger Schlosses*, Heidelberg 1965.

Innsbruck 1970. *Österreichische Malerei des 19. Jahrhunderts aus Privatbesitz*, Innsbruck 1970.

Karlsruhe 1960. *Max Liebermann, Lovis Corinth, Max Slevogt, Badischer Kunstverein Karlsruhe*, Karlsruhe 1960.

Karlsruhe 1965. *Romantiker und Realisten. Maler des 19. Jahrhunderts in Baden. Ausstellung des Badischen Kunstvereins in Karlsruhe*, 1965.

Laxenburg 1968. *Romantik und Realismus in Österreich. Gemälde und Zeichnungen aus der Sammlung Georg Schäfer, Schweinfurt*, Castle Laxenburg near Vienna 1968.

Leipzig 1926. *Deutsch-römische Malerei und Zeichnung 1790–1830, Ausstellung des Museums der bildenden Künste und des Leipziger Kunstvereins*, Leipzig 1926.

London 1959. *The Romantic Movement*, 5th exhib., Council of Europe, Tate Gallery, London 1959.

London 1964. *Painters of the Brücke*, Tate Gallery, London 1964.

London 1968. *Nineteenth-century German drawings and water-colours*, Victoria and Albert Museum, London 1968.

London 1972. *The age of Neo-classicism* (Council of Europe Exhibition), London 1972.

Lübeck 1957. *Die Bildniszeichnung der deutschen Romantik*, St. Annen-Museum und Overbeck-Gesellschaft, Lübeck 1957.

Lübeck 1969. *Deutsche Zeichnungen 1800–1850 aus der Sammlung Winterstein,*

Ausstellung zum 100. Todestag Friedrich Overbecks, Museen für Kunst und Kulturgeschichte der Hansestadt Lübeck, Lübeck 1969.

Marbach 1960. *Expressionismus. Literatur und Kunst, 1910–1923,* Schiller-Nationalmuseum, Marbach 1960.

Munich 1949. *Der Blaue Reiter, München und die Kunst des 20. Jahrhunderts,* Haus der Kunst, Munich 1949.

Munich 1950. *Deutsche Romantiker in Italien,* Städtische Galerie, Munich 1950.

Munich 1958. *Deutsche Zeichenkunst der Goethezeit. Handzeichnungen und Aquarelle aus der Sammlung Winterstein, München. Staatliche Graphische Sammlung.* Munich 1958 (and in Nuremberg, Hamburg and Heidelberg).

Munich 1958. *München 1869–1958, Aufbruch zur modernen Kunst. Rekonstruktion der Ersten Internationalen Kunstausstellung 1869, Leibl und sein Kreis, Vom Jugendstil zum Blauen Reiter, Gegenwart.* Haus der Kunst, Munich 1958.

Munich 1962. *Vor 50 Jahren. Neue Künstlervereinigung. Der Blaue Reiter.* Galerie Stangl, Munich 1962.

Munich 1964. *Secession, Europäische Kunst um die Jahrhundertwende.* Haus der Kunst, Munich 1964.

Nuremberg 1966. *Klassizismus und Romantik in Deutschland. Ausstellung aus der Sammlung Georg Schäfer, Schweinfurt, im Germanischen Nationalmuseum,* Nuremberg 1966.

Nuremberg 1967. *Der frühe Realismus in Deutschland 1800–1850. Ausstellung aus der Sammlung Georg Schäfer, Schweinfurt, im Germanischen Nationalmuseum,* Nuremberg 1967.

Paris 1966. *Le Fauvisme français et les débuts de l'Expressionisme allemand.* Musée National d'Art Moderne, Paris 1966.

Salzburg 1959. *Romantik in Österreich. Malerei und Graphik. Ausstellung in der Residenz-Galerie,* Salzburg 1959.

Torino 1954. *Espressionismo et Arte tedesca del 20° secolo,* catalogo, Torino 1954.

Vienna 1961. *Der Blaue Reiter und sein Kreis.* Österreichische Galerie, Oberes Belvedere, Vienna 1961.

251

Wiesbaden 1947. *Deutsche Malerei des neunzehnten Jahrhunderts.* Ausstellung im Central Collecting Point (Landesmuseum), Wiesbaden 1947.

Winterthur 1933. *Deutsche und Schweizer Maler des 19. Jahrhunderts aus der Sammlung Oskar Reinhart,* Kunstmuseum Winterthur, Winterthur 1933.

Winterthur 1955. *Europäische Meister 1790–1910, Kunstverein Winterthur, Ausstellung im Kunstmuseum Winterthur,* Winterthur 1955.

Yale 1970. *German Painting in the Nineteenth Century,* New Haven, Cleveland, Chicago, Cologne 1970.

3. Museum Catalogues

(Berlin) Zeichnungen deutscher Romantiker, East Berlin 1964. Staatliche Museen zu Berlin, Zeichnungen Deutscher Romantiker, National-Galerie, Sammlung der Zeichnungen, ed. W. Geismeier, Berlin 1964.

East Berlin. Deutsche Kunst 19/20. Jahrhundert, Staatliche Museen zu Berlin, Altes Museum—National-Galerie, Berlin n.d. (1966).

West Berlin 1968. Staatliche Museen Preussischer Kulturbesitz, Nationalgalerie, Verzeichnis der vereinigten Kunstsammlungen, Nationalgalerie (Preussischer Kulturbesitz), Galerie des 20. Jahrhunderts (Land Berlin), Berlin 1968.

Cologne 1964. Katalog der Gemälde des 19. Jahrhunderts im Wallraf-Richartz-Museum, ed. R. Andree, Cologne 1964.

Dresden 1960. Gemäldegalerie Dresden—Neue Meister 1800–1960, Dresden n.d. (1960).

Düsseldorf 1967. Die Düsseldorfer Malerschule, Bildhefte des Kunstmuseums Düsseldorf, ed. I. Markowitz, Düsseldorf 1967.

Düsseldorf 1968. Kunstmuseum Düsseldorf, Die Gemälde des 19. Jahrhunderts, mit Ausnahme der Düsseldorfer Schule, ed. R. Andree, Düsseldorf 1968.

Düsseldorf 1969. Die Düsseldorfer Malerschule. Kataloge des Kunstmuseums Düsseldorf. Malerei, Band 2, Düsseldorf 1969.

Essen 1963. Museum Folkwang Essen, Gemälde 19. und 20. Jahrhundert, Essen 1963.

Hamburg 1966. Katalog der Alten Meister der Hamburger Kunsthalle, 5th ed., Hamburg 1966.

Hamburg 1969. Katalog der Meister des 19. Jahrhunderts in der Hamburger Kunsthalle, ed. E. M. Krafft and C.-W. Schümann, Hamburg 1969.

Hamburg 1969 (20th century masters). Katalog der Meister des 20. Jahrhunderts in der Hamburger Kunsthalle, ed. H. Hofmann and J. Müller-Hauck, Hamburg 1969.

Karlsruhe 1964. Deutsche Meister 1800–1850, Aus der Staatlichen Kunsthalle Karlsruhe, Karlsruhe 1964.

Karlsruhe 1965. Deutsche Meister 1880–1930, Aus der Staatlichen Kunsthalle Karlsruhe, Karlsruhe 1965.

Munich 1966. Französische Meister des 19. Jahrhunderts—Kunst des 20. Jahrhunderts, Ausgestellte Werke I, Neue Pinakothek und Staatsgalerie München, ed. Bayerische Staatsgemäldesammlungen, Munich 1966.

Munich 1967. Meisterwerke der deutschen Malerei des 19. Jahrhunderts, Ausgestellte Werke II, Neue Pinakothek und Staatsgalerie München, ed. Bayerische Staatsgemäldesammlungen. Munich 1967.

Munich 1969, Schack-Galerie. Bayerische Staatsgemäldesammlungen, Schack-Galerie, ed. E. Ruhmer, R. Gollek, Ch. Heilmann, H. Kühn, R. Löwe, Munich 1969.

Stuttgart 1962. Katalog der Staatsgalerie Stuttgart, Alte Meister, Stuttgart 1962.

Stuttgart 1968. Katalog der Staatsgalerie Stuttgart, Neue Meister, ed. P. Beye and K. Löcher, Stuttgart 1968.

Vienna 1966. Die Neue Galerie des Kunsthistorischen Museums Wien, ed. F. Klauner, G. Heinz, E. Mahl, Vienna n.d. (1966).

Winterthur 1951. Stiftung Oskar Reinhart Winterthur, Katalog der Gemälde und Skulpturen, Winterthur 1951.

Index